LEONARDO DA VINCI
AND THE SPLENDOR OF POLAND

A History of Collecting and Patronage

Milwaukee Art Museum Yale University Press

LAURIE WINTERS

LEONARDO DA VINCI
and the
SPLENDOR OF POLAND

A HISTORY OF COLLECTING
AND PATRONAGE

Essays by Dorota Folga-Januszewska, Paul W. Knoll,
Wojciech W. Kowalski, Donald Pienkos, Andrzej Rottermund, Janusz Walek,
Piotr S. Wandycz, Laurie Winters, and Antoni Ziemba

CONTENTS

FOREWORD

RUSSELL BOWMAN, DIRECTOR

"Leonardo da Vinci and the Splendor of Poland: A History of Collecting and Patronage" is an exhibition of singular importance in the history of the Milwaukee Art Museum and one with implications far beyond the framework of the institution. The project was conceived by Curator of Earlier European Art Laurie Winters, as the museum considered major exhibitions that might follow the grand opening of the Santiago Calatrava – designed Quadracci Pavilion in October 2001. The museum's goal was to develop an exhibition of meaningful scholarship and broad popular appeal that would bring visitors back to the museum at the close of its inaugural season. We were also anxious to organize an exhibition that would prove attractive to other major venues in the United States. "Leonardo da Vinci and the Splendor of Poland" has met those goals and extended them in important ways to become an exhibition of international significance.

It was almost six years ago that the Milwaukee Art Museum first approached the Polish national museums and private collections in the hope of strengthening an already existing bond between our city and the Republic of Poland. Along with its close neighbor, Chicago, Milwaukee has remained the chief point of Polish immigration to America from the later nineteenth century until today. At some 1.5 million people, the community of Polish ancestry in Chicago and Milwaukee is the nation's largest. Furthermore, we felt that the collections of Poland, just emerging from four decades of Communist suppression, were both widely significant and little known in

this county. The few exhibitions that have traveled from Poland to the United States since the 1950s have concentrated largely on decorative objects or Polish art of the nineteenth century. It was determined that "Leonardo da Vinci and the Splendor of Poland" would focus on the paintings collections of Poland spearheaded by Leonardo's Renaissance masterpiece *Lady with an Ermine*. Known to a wide audience as one of the world's treasures, the picture would exemplify an innovative exhibition examining how painting was collected in Poland; how such collections contributed to a national identity, particularly in times of domination and division by surrounding nations; and how these collections impacted the development of Poland's own artistic tradition. Such a developmental and analytic exhibition had never been undertaken in the United States, and the Milwaukee Art Museum is proud to have been involved in this pioneering, fundamental study upon which others can build. Indeed, much of the information provided in the exhibition's accompanying catalogue is either new research or available to the public for the first time in English.

The exhibition has become a symbol of international cooperation between the United States and Poland. We are most grateful to Aleksander Kwaśniewski, President of the Republic of Poland, for his support and honorary patronage of the exhibition. We would also like to recognize the members of the Honorary Committee, listed at the opening of this book, for their devotion to Poland and for lending their distinguished names in support of the

exhibition. We are also deeply grateful to the Ministry of Culture, the American and Polish embassies, and the Consulate General of the Republic of Poland in Chicago for their enthusiastic support and assistance throughout the entire development of the exhibition. Anna Niewiadomska, cultural affairs counselor of the Polish Embassy, and Mariusz M. Brymora, deputy consul general in Chicago, deserve special mention for their tireless dedication to the success of this project.

The collaboration of the museums participating in the exhibition has been crucial in bringing to the public these important works of art and the ideas they represent. We are pleased to acknowledge the contributions of the late Tadeusz Chruścicki, former director of The National Museum and president of The Princes Czartoryski Foundation, Cracow, with whom our negotiations first began several years ago, and his successor, Zofia Gołubiew; Prince Adam Karol Czartoryski, founder, The Princes Czartoryski Museum; Jolanta Lenkiewicz, director, The Princes Czartoryski Museum; Andrzej Rottermund, director, The Royal Castle, Warsaw; Ferdynand B. Ruszczyc, director, The National Museum, Warsaw; Dorota Folga-Januszewska, director, Collections and Research, The National Museum, Warsaw; Jan K. Ostrowski, director, The Wawel Royal Castle, Cracow; Tadeusz Piaskowski, director, The National Museum, Gdańsk; Wojciech Suchocki, director, The National Museum and The Raczyński Foundation, Poznań, and his predecessor, Konstanty Kalinowski; and Stanisław Waltoś, director, Museum of the Jagellonian University, Cracow. Special thanks also go to Count Andrew S. Ciechanowiecki in London for kindly agreeing to lend the seminal portrait of Prince Adam Czartoryski by Vigée-LeBrun.

At the Milwaukee Art Museum, this exhibition could not have happened without the vision, commitment, and tenacity of Laurie Winters. She initiated and refined the concept of the exhibition and took part in all the communications with museum officials and diplomatic support agencies during a number of trips to Poland. Her leadership is evident in the very formation of the exhibition, in its scholarly catalogue, and in its development into a forum for international cooperation. Supported by colleagues in the museums and foundations of Poland, by international and regional advisory councils, and, of course, by the entire Milwaukee Art Museum staff, her efforts have resulted in an exhibition and publication in which all can take great pride.

For their generous support of this exhibition, I would like to extend my gratitude to We Energies, Christopher Seton Abele, Polish National Alliance, Trust for Mutual Understanding, Spirit of Milwaukee, and The Kościuszko Foundation, Inc., An American Center for Polish Culture, Polanki, The Polish Women's Cultural Club of Milwaukee, Fine Arts Society of the Milwaukee Art Museum, Wisconsin Humanities Council, the National Endowment for the Humanities, the Federal Council on the Arts and Humanities, Milwaukee Journal Sentinel, LOT Polish Airlines, and all those whose support have made this project possible.

To my colleagues Peter Marzio, director of the Museum of Fine Arts, Houston, and Harry Parker III, director of the Fine Arts Museums of San Francisco, goes my great appreciation for bringing this exhibition to a broader national audience. In this endeavor, I would also like to thank the respective curators at those institutions for their support and assistance throughout, Edgar Peters Bowron and Lyn Orr.

In all exhibitions, a wide range of individuals is necessary to bring them to realization. In the case of "Leonardo da Vinci and the Splendor of Poland," the international array was even greater than usual, but their efforts have resulted in an exhibition that promotes not only the artistic, but the historical and cultural understanding of Poland and its place in an increasingly connected world. The Milwaukee Art Museum is indeed privileged to present this exhibition in America and, again, my deepest appreciation to all those who have made it a reality.

LENDERS
TO THE EXHIBITION

CRACOW

Cloisters of the Franciscan Friary
Klasztor OO. Franciszkanów

Collegium Maius of the Jagiellonian University
Muzeum Uniwersytetu Jagiellońskiego
Collegium Maius

The National Museum
Muzeum Narodowe

The Princes Czartoryski Museum
Muzeum Książąt Czartoryskich

The Wawel Royal Castle
Zamek Królewski na Wawelu

GDAŃSK

The National Museum
Muzeum Narodowe

POZNAŃ

The National Museum
Muzeum Narodowe

The Raczyński Foundation at the National Museum
Fundacja im. Raczyńskich przy Muzeum
Narodowym

WARSAW

The Ciechanowiecki Foundation at The Royal Castle
Fundacja Zbiorów im. Ciechanowieckich w Zamku
Królewskim

The National Museum
Muzeum Narodowe

The Royal Castle
Zamek Królewski

HONORARY COMMITTEE

Prince Adam Karol Czartoryski
Founder, The Princes Czartoryski Foundation

His Excellency, The Honorable Włodzimierz
Cimoszewicz
Minister of Foreign Affairs of the Republic
of Poland

His Excellency, The Honorable Andrzej Celiński
Minister of Culture of the Republic of Poland

His Excellency, The Honorable Przemysław
Grudziński
Polish Ambassador to the United States

The Honorable Christopher R. Hill
United States Ambassador to the Republic
of Poland

The Honorable Henry A. Kissinger, PhD
Former Secretary of State of the United States

The Honorable Zbigniew Brzeziński, PhD
Counselor, Trustee, and Co-Chairman,
Advisory Board, Center for Strategic and
International Studies

The Honorable Scott McCallum
Governor of the State of Wisconsin

The Honorable Rick Perry
Governor of the State of Texas

His Excellency Franciszek Adamczyk
Consul General of the Republic of Poland, Chicago

His Excellency Leonard M. Krażyński
Honorary Consul of the Republic of Poland,
Houston

Professor Andrzej Ciechanowiecki, FSA
Scholar of Polish art and culture

Paweł Potoroczyn
Director, Polish Cultural Institute

His Eminence Adam Cardinal Maida
Archbishop of Detroit

Lady Blanka A. Rosenstiel, OSJ
Founder and President, The American
Institute of Polish Culture

Dr. Michael G. Sendzimir
Honorary Chairman and Trustee,
The Kościuszko Foundation

Edward J. Moskal
President, Polish National Alliance
of the United States

Edward J. Piszek
Chairman, Copernicus Society of America

Professor Czesław Miłosz
Nobel Prize for Literature, 1980

Count Adam Zamoyski
Writer and historian of Polish culture

Professor Norman Davies
Writer and historian of Polish culture

PRESIDENT'S
HONORARY PATRONAGE
ALEKSANDER KWAŚNIEWSKI, THE REPUBLIC OF POLAND

Aleksander Kwaśniewski, President of the Republic
of Poland, has graciously endorsed the exhibition
"Leonardo da Vinci and the Splendor of Poland:
A History of Collecting and Patronage." It is a rare
occasion when an exhibition can both bring together
great works of art and create an unprecedented
exchange of cultural ideas and values to encourage
understanding in an increasingly global environment.

SPONSORS' STATEMENTS

RICHARD A. ABDOO, CHAIRMAN AND CHIEF EXECUTIVE OFFICER, WE ENERGIES

We Energies is pleased to support the world-class exhibition "Leonardo da Vinci and the Splendor of Poland," which exemplifies the human commitment to persevere against all odds.

This breathtaking selection of paintings includes some of the world's greatest masterpieces of European and Polish art, drawn from public and private collections in Poland. These paintings are not only significant achievements as works of art, they are symbols of Poland's tenacious and triumphal struggle to reclaim its property, culture, and identity. We are delighted to work in conjunction with the Milwaukee Art Museum to bring such a rich history and heritage to the city and to the people of Wisconsin.

We believe this historic art exhibition will inspire all those who see it to focus in their own way on the power of the human spirit as manifested in the arts.

CHRISTOPHER SETON ABELE

The opportunity to take a leadership role in this exhibition has been inspiring. From its inception, I recognized the exceptional beauty and historical significance of the paintings brought together in "Leonardo da Vinci and the Splendor of Poland."

The museum's ability to serve as a window to the world through the presentation of great art is one that I wholeheartedly support. "Leonardo da Vinci and the Splendor of Poland" reflects the power and poignancy of art through the centuries, from Leonardo's *Lady with an Ermine* to masterpieces of Dutch realism to distinctly Polish works by Piotr Michałowski and Jacek Malczewski, many of which have never traveled beyond Poland.

I am extremely pleased to help make this exhibition, an international treasure reflecting Poland's indomitable art and culture, a reality.

ACKNOWLEDGMENTS

LAURIE WINTERS, CURATOR OF EARLIER EUROPEAN ART

The seed for this exhibition was sown almost six years ago in conversations with Milwaukee Art Museum Director Russell Bowman, whose unbounded enthusiasm for a project devoted to the great collections of Poland both spurred my thinking and strengthened my resolve. Originally conceived as a masterpiece show of great works, the exhibition quickly evolved into a more serious look at the history of collecting and patronage in Poland – a project that seemed not only necessary, but long overdue. Although many aspects of the exhibition seemed at times insurmountable, particularly its overlap and timing with the construction and opening of the Milwaukee Art Museum's Quadracci Pavilion, Russell Bowman's perspicacity helped make the impossible possible. I am deeply grateful to him for his unwavering and whole-hearted commitment to this project. Quite simply, it would not have happened without him.

My greatest debt of thanks is to the lenders – institutions as well as foundations and private individuals – who graciously consented to part with cherished paintings for almost nine months. Each and every lender has been identified elsewhere in the catalogue, but I would like to single out The Princes Czartoryski Foundation in Cracow for allowing Leonardo da Vinci's *Lady with an Ermine* to be the centerpiece of this important exhibition on the history of collections and patronage in Poland. Certain significant paintings, such as Jacques-Louis David's *Equestrian Portrait of Stanisław Kosta Potocki*, were unobtainable for this exhibition because of the legal complexities surrounding pressing claims of restitution. This painting and a few others that were unavailable for similar reasons have been reproduced in the catalogue for reference.

A project of this magnitude would not have been possible without the collaboration of the directors and curators of numerous institutions in Poland, and all those who brought to the catalogue their knowledge and expertise. The contributions by almost forty authors, two thirds of them of Polish-speaking origin, bear eloquent testimony to the degree of collaboration and shared enthusiasm for the exhibition. The eight essays in the catalogue not only elucidate the exhibition's themes of collecting and patronage, but are an enduring contribution to scholarship on Poland's cultural heritage. I would like to take this opportunity to offer a special note of gratitude to essayists Dorota Folga-Januszewska, director of Collections and Research, The National Museum in Warsaw; Paul W. Knoll, professor of history, University of Southern California; Wojciech Kowalski, professor of law, University of Silesia; Donald Pienkos, professor of political science, University of Wisconsin – Milwaukee; Andrzej Rottermund, director, The Royal Castle in Warsaw; Janusz Wałek, deputy director and curator of foreign paintings, The Princes Czartoryski Museum; Piotr S. Wandycz, Bradford Durfee Professor of History Emeritus, Yale University; and Antoni Ziemba, curator of Dutch and Flemish paintings, The National Museum in Warsaw. All of the individual authors who worked on the entry texts are identified in the catalogue's Note to the Reader.

Almost from the beginning, the Polish communities in Milwaukee and Chicago demonstrated outstanding support for the exhibition. A Regional Advisory Committee was created early on in the project to assist with the promotion and celebration of the exhibition throughout the Midwest. More than 100 members strong, the organization has not only assisted with the difficult task of fundraising, but with the educational programming and marketing of the exhibition. Special thanks go to Donald Pienkos, Susan Mikoś, Conrad Kamiński, and Walter Kunicki for their commitment to the entire project. To everyone who helped to create the unprecedented community involvement and support of the exhibition, I would like to offer my heartfelt appreciation.

I would also like to acknowledge Bohdan Gorczyński, curator of The Polish Museum of America, in Chicago, who has offered indispensable support in a multitude of ways. Polanki, The Polish Women's Cultural Club of Milwaukee, must be recognized for a significant financial contribution that permitted the conservation of Stanisław Samostrzelnik's *Portrait of Piotr Tomicki*, which enabled it to be part of the exhibition. The law firm of Quarles & Brady LLP also deserves mention for assisting with a number of complex contractual and transportation issues throughout the entire development of the exhibition.

Colleagues in every department of the Milwaukee Art Museum have worked tirelessly behind the scenes to help bring the exhibition and the accompanying catalogue to fruition. I am particularly grateful to Catherine Sawinski, curatorial assistant, who helped with every aspect of the exhibition and catalogue and has become a dear friend. For her energy and enthusiasm, I also thank Beata Pawlikowska, who took charge of the bibliography and countless other details that ultimately made this book possible.

Among the many others who provided assistance are Lucia Petrie, director of Development, and Betsy Erskine, Development associate, who took on the daunting task of fundraising for the exhibition. Very much appreciated were the efforts of Brigid Globensky, director of Education, who, with her staff, planned the innovative programming for the exhibition in Milwaukee. My sincere thanks also go to Leigh Albritton, registrar, who dealt with the often complex matters of insurance and shipping. For their help in many ways it is a pleasure to also thank Steve Biel, Jennifer Chartier, James DeYoung, Christopher Goldsmith, Melissa Hartley, James Horns, John Irion, Pam Kassner, Peggy MacArthur, Larry Stadler, and John Vinci.

For the beautiful book that accompanies this exhibition, I am grateful to Kathy Fredrickson, Matt Simpson, Cheryl Towler Weese, and Garrett Niksch of studio blue, inc. Their sensitivity and clear-sightedness have produced a book of exceptional elegance. I want also to acknowledge Patricia Fidler of Yale University Press for so enthusiastically agreeing to distribute this catalogue for the Milwaukee Art Museum. Krystyna Małcharek is also much appreciated for her excellent translation of the Polish essays and entries.

My greatest debt, as always, is in many ways to Terry Ann R. Neff of t.a.neff associates, inc., who shepherded the manuscript to completion with the assurance of a seasoned but benevolent general. She not only immeasurably improved the text, but her enthusiasm for the exhibition and the accompanying catalogue have inspired and sustained me throughout the many difficulties of the project. Lastly, I thank my husband, Brian D. Winters, for his invaluable counsel, support, and relentless good humor throughout.

NOTE TO THE READER

GRAŻYNA BASTEK {GB}
HANNA BENESZ {HB}
BABETTE BOHN {BB}
EDGAR PETERS BOWRON {EPB}
ELŻBIETA CHARAZIŃSKA {EC}
IWONA DANIELEWICZ {ID}
DOROTA DEC {DD}
MARIA GOŁĄB {MG}
KRYSTYNA GÓRECKA-PETRAJTIS {KG-P}
ANNA JASIŃSKA {AJ}
DOROTA JUSZCZAK {DJ}
JOANNA KILIAN-MICHIELETTI {JK-M}
MARIA KLUK {MK}
MAŁGORZATA KOCHANOWSKA-REICHE {MK-R}
KAZIMIERZ KUCZMAN {KK}
ANNA KRÓL {AK}
BARBARA LEWIŃSKA {BL}
HANNA MAŁACHOWICZ {HM}
EWA MICKE-BRONIAREK {EM-B}
M. PIOTR MICHAŁOWSKI {MPM}
MACIEJ MONKIEWICZ {MM}
BEATA PURC-STĘPNIAK {BP-S}
ANDRZEJ ROTTERMUND {AR}
DOROTA SUCHOCKA {DS}
BEATA SZTYBER {BS}
ANNA TYCZYŃSKA {AT}
JOANNA WINIEWICZ-WOLSKA {JW-W}
LAURIE WINTERS {LW}
KRZYSZTOF ZAŁĘSKI {KZ}
KRYSTYNA ZNOJEWSKA {KZN}

Leonardo da Vinci and the Splendor of Poland: A History of Collecting and Patronage consists of eight essays and seventy-seven entries on artworks that range in date from the early fifteenth to the late nineteenth century. Paired essays are followed by the chronologically and thematically related plates. An introductory timeline and maps in each essay are guides to the complex history referenced throughout the book.

The common thread running throughout the varied works of art is an emphasis on the works as examples of particular forms of patronage, changing attitudes in taste, the traumatic effects of war, and the present-day character of both public and private museums in Poland. A number of outstanding authors have written entries in their areas of expertise; they are identified by their initials at the end of each entry.

LAURIE WINTERS

INTRODUCTION

WHILE THE MASTERPIECES OF THE LOUVRE, Uffizi, and the Hermitage are of at least passing familiarity to many Americans, the great national and private collections of Poland – once a cultural center of international importance – still remain virtually unknown in North America. "Leonardo da Vinci and the Splendor of Poland: A History of Collecting and Patronage" is the first exhibition to explore the cultural vitality of Poland through the history of its artistic patronage and collection development from the Renaissance to the end of the nineteenth century. Briefly stated, the goal of this project has been to establish the museums and collections of Poland as important artistic centers that reflect a vibrant, but tumultuous, history of artistic patronage and collecting that has been overshadowed by the prominence of cultural centers in France, Italy, and Russia.

For those Americans educated after World War II, an artificial line drawn on a map in 1945 created the impression that Poland was in some sense not really part of Europe. With the end of the Cold War, that perception is rapidly being corrected, and to hasten that process, some of the most important museums in Poland have loaned seventy-seven European and Polish paintings from varying periods that demonstrate the enduring brilliance, history, and cross-cultural influences of Poland's artistic heritage. The impact of these works on such a grand scale suggests the necessity of repositioning, in the minds of both the general public and scholars, the national and private collections of Poland as subjects eminently worthy of scholarly investigation and exhibition activity.

Long mistakenly viewed only as a quasi-exotic country with a charming folk culture that was distinct from the rest of Europe, Poland was in fact one of the liveliest cultural centers in Europe. It was a meeting ground for artists and intellectuals of many nationalities; a center for rich and diverse forms of royal patronage that incorporated Italian, Netherlandish, and French influences; a hub for international trade that gave rise to a pluralism of taste; and a country that tenaciously clung to its artistic culture and traditions in the face of geopolitical devastation that minimized its sphere of influence in the nineteenth and throughout much of the twentieth century. Indeed, the importance of Poland as a major European intellectual center during the early modern period is underscored in relation to the changing social, political, economic, and geographic history of the country.

By presenting a judicious selection of works of art from the various periods, the aim of the exhibition and its accompanying catalogue is to shed light on issues related to religious patronage, royal and magnate patronage, the formation of private collections, the development of art academies and national museums in the nineteenth century,

and the tragic history of Poland's museums and private collections during the two World Wars. Such an approach is intended to expand the traditional boundaries of conventional art and exhibition history.

The works in this exhibition counter the negative view that Polish culture was virtually nonexistent in the Renaissance and in later periods was inferior to that found in the neighboring Prussian, Austrian, and Russian empires. The partitions of Poland in the late eighteenth century and the attempt to even obliterate its name from historical records contributed to a distorted perception of the country's artistic culture at the very moment when art history as a critical discipline began to take form. Havoc thrust upon Central Europe during the two World Wars further postponed and complicated a meaningful reassessment of the arts and culture of Poland.

The critical fortune of Poland as a mysterious and provincial land originated at the end of the nineteenth century as part of the nationalist fervor that linked the survival of Polish identity with the indomitable spirit of the peasant. A reevaluation of Polish culture apart from such outdated historical and highly politicized viewpoints has been slow to surface. A few exhibitions in the twentieth century have helped to bring Polish art and culture back into the mainstream of historical examination. In 1966, to commemorate Poland's Millennium, The Art Institute of Chicago organized the first exhibition in North America on the art of Poland, featuring masterpieces of painting, sculpture, and decorative arts, but with scant analysis of Poland's historical cultural life. Four subsequent decades of scholarship have produced only limited changes in the traditional perception of Polish culture. Exhibitions focusing specifically on Polish artists of the nineteenth century were organized for the first time in the mid-1980s and early 1990s by The Detroit Institute of Arts; the National Academy of Design, New York; and the North Carolina Museum of Art, Raleigh. In 1993 the Trust for Museum Services organized "Master European Drawings from Polish Collections," which brought together outstanding works from museums in Poland. In 1999 "The Land of the Winged Horseman," also organized by the Trust for Museum Services, made a significant contribution to the study of Polish art and culture when it raised the question of a Polish national identity in the decorative arts and architecture of the Baroque period. Still, however, broad cultural themes engaging questions of patronage and the history of collecting have been largely overlooked.

Among the many well-entrenched historical biases confronted in this exhibition is the misconception that Poland had no significant early artistic patronage or collections. Yet by the sixteenth century, Poland had come into its own as a distinctive participant in

the family of early modern European nations. Its union with Lithuania in 1572 created the second largest nation in Europe (after Russia); enlarged the scope of its cultural interests; and increased the role of the nobility, thereby ensuring a growing patronage of the arts. The Jagiellonian dynasty of kings (1386–1572), in particular, Sigismund the Old and his Italian wife, Bona Sforza, significantly shaped Polish culture and taste through their humanistic interests and royal patronage. Following models established in Western Europe, they are often credited with assembling the first modern collections of art in Poland.

As Paul W. Knoll points out in his essay, the Church was also an influential patron of the arts. The *Pietà* by an unidentified painter from the region of Little Poland and the complex *Virgin and Child with St. Felicity and St. Perpetua* by an artist active in the region of Great Poland are excellent examples of Poland's artistic flourishing during the Renaissance. Religious tolerance and favorable economic conditions added to this cultural dynamism by creating an environment attractive to foreign artists – mainly Dutch, Italian, and German – who exerted a commanding influence on local artists and patrons. This complex period – the so-called *złoty wiek* (golden age) in Polish history – is broadly represented in the exhibition by Renaissance altarpieces, portraiture, and a rare drawing by Veit Stoss.

Poland's increasingly favorable economic conditions created a hub for international trade that gave rise to a pluralism of taste. Although royal preference inclined toward Italian and French styles, the realism of the Netherlandish painters also found a large audience. The northern port city of Gdańsk, in particular, became a center for the importation of Dutch and Flemish works into Poland. Northern and Netherlandish-inspired painting flourished there from the late fifteenth century to at least the late seventeenth century. As essayist Antoni Ziemba explains, the catalyst for much of the Netherlandish enthusiasm in Gdańsk was the fortuitous arrival in the late fifteenth century of Hans Memling's altarpiece *The Last Judgment*. Its extraordinary beauty prompted numerous imitations and a host of collectors who favored Northern trends over Mediterranean. Active in Gdańsk were artists of Flemish and German origin, others who came from Silesia and Prussia, and Polonized painters of foreign ancestry. This thriving internationalism is demonstrated in this exhibition's outstanding paintings by Bol, van Goyen, Stom[er], Luttichuys, and the magnificent Memling.

In concert with general European trends, a lively interest in collecting developed in Poland at the beginning of the seventeenth century. Royal and magnate foundations were heavily influenced by a doctrine popular in the sixteenth century, which stated that

activity in the arts distinguishes eminent people and enhances their family's reputation. Sigismund III, king of Sweden and Poland, and his son Prince Ladislas Sigismund, assembled outstanding collections of European paintings purchased by envoys in Italy and the Netherlands. Ladislas Sigismund even personally toured the studios of Rubens and Reni. These and other noble collections were dealt a shattering blow during the wars with Sweden, when cartloads of paintings were hauled off to Sweden. Despite an already declining economic situation during the second half of the century, King John III Sobieski, who defeated the Turks in Vienna in 1683, managed to build the royal Palace at Wilanów – an architectural wonder intended to rival Versailles – and acquired no fewer than five Rembrandts.

In the second half of the eighteenth century, under the influence of intellectual and aesthetic developments elsewhere in Enlightenment Europe, family and personal interest in art patronage was replaced by a national pride in maintaining Poland's cultural standing. King Stanislaus II Augustus Poniatowski created a style of patronage appropriate to his international ambitions and his wide interest in almost every sphere of art. In addition to creating a gallery of almost 2,500 paintings and extensive collections of sculpture and graphic arts, he employed as court artists some of the finest painters in Europe, including Pillement, Norblin, Bellotto, and Bacciarelli. The royal splendor of this period is demonstrated in the exhibition by a selection of Bellotto's magnificent cityscapes of Warsaw from the so-called Canaletto Room of The Royal Castle and by Bacciarelli's state portrait of the king and his more intimate but foreboding portrait of the king in 1793, executed just before the final partition of Poland.

Equally significant for the advancement of Polish culture in the late eighteenth century was the patronage of Prince Adam Kazimierz Czartoryski and Izabela Czartoryska, whose collecting, unlike that of the first half of the century, was characterized by connoisseurship. Janusz Wałek's essay on the aristocratic collections of the late eighteenth and nineteenth centuries highlights the significance of the Czartoryskis' collection of paintings and decorative arts at their residence at Puławy. Composed of such important works as Rembrandt's *Landscape with the Good Samaritan*, Raphael's *Portrait of a Young Man*, and Leonardo's *Lady with an Ermine,* their collection ranked among the very best in Europe in the early nineteenth century. Having survived two tumultuous centuries, including confiscation by the Nazis in 1939, Leonardo's dramatic and enigmatic portrait – the showpiece of this exhibition – remains an icon of the Polish people, an embodiment of their rich artistic heritage, and an enduring symbol of survival.

Other patrons of the arts who followed the Enlightenment model in stimulating the cultural life of Poland were Isabella Lubomirska at Łancut, Wincenty Potocki in Warsaw, Stanisław Kostka Potocki at Wilanów, and Edward Raczyński at Rogalin. After the loss of Polish independence in 1795, however, a new emphasis on nationalist values awakened a dramatic shift in their collecting activities, evident particularly in the first few decades of the nineteenth century, when the leading patriots Stanisław Kostka Potocki and Edward Raczyński built residences to house their collections and serve as centers for a wide range of public and cultural activities. Among their impressive contributions to the exhibition are Vigée-LeBrun's *Portrait of Princess Pelagia Sapieha, née Potocka*, and, from the Raczyński collection, works by German painters Overbeck, Sohn, and Wach.

At the end of the eighteenth century, Poland basically ceased to exist. In 1795 the Polish people watched helplessly as the Austrian, Russian, and Prussian empires imposed a final partition that ended 800 years of Polish independence. As Piotr S. Wandycz explains in his essay, nineteenth-century efforts to regain Poland's freedom took many forms, from diplomacy to violence, but to no avail. This intense political and social situation is reflected in the collections and in the nationalistic subject matter of the art of the period. With none of the usual institutions necessary to maintain a national life, the unifying role that in other countries was played by politicians and generals was assumed in Poland by the only group in firm possession of a discernible Polish identity: its poets and artists.

Preoccupation with sociopolitical and ideological conditions of Poland's status as an oppressed nation became the dominating feature of Polish art in the nineteenth century. This was accompanied by a marked shift toward a distinctly Polish art and local production. Artists such as Matejko and Grottger attained the stature of national heroes. Dorota Folga-Januszewska's essay outlines the emergence of Poland's first academies and national museums in response to the struggle for independence. Their establishment in the nineteenth century can be linked directly to the preservation of Poland's national heritage. Only in the aftermath of the First World War, with the simultaneous collapse of Germany, tsarist Russia, and the Austro-Hungarian Empire, was Poland reestablished as an independent nation (1918) and state patronage revived under the umbrella of the Ministry of Culture and Arts.

The history of Poland's collections is ultimately one of impermanence. During the Second World War, Poland lost over six million people and almost fifty percent of its material wealth. Historic architecture was most affected, but art museums and private

collections were also destroyed or confiscated. Total losses from the national museums are estimated at over 2,500 foreign paintings, about 10,000 Polish paintings, and over 1,300 sculptures; private collections fared even worse. Essays by Andrzej Rottermund and Wojciech Kowalski address the radical dismantling of collections and museums during the war; the full-fledged looting after 1945; and the complex history of Poland's present-day museums as bitter disputes of restitution are evaluated in the courts. Adding poignancy and power to this exhibition is the determination that Poland has displayed over the last fifty years in its efforts to recover and restore national treasures. The fate of important national and private collections is told for the first time and a number of paintings are making their first public appearance since recovery and conservation.

This extraordinary combination of Polish and European works in a single exhibition is intended to give the visitor a sense of Poland's rich artistic heritage and shed new light on its cultural position in Europe, thereby generating new appreciation for the role of its culture and artists in the history of Western art. "Leonardo da Vinci and the Splendor of Poland" is a fitting complement to Poland's current economic and political resurgence. Poland's independence in 1989 and its entry into the North Atlantic Treaty Organization (NATO) in April 1999 represent a political transition of historic importance. This project is a forceful reminder that Poland has always been an integral part of Europe's past and will continue to play an important role in Europe's – and North America's – future.

DONALD PIENKOS

THE HISTORICAL EXPERIENCE

OF POLAND

Since it first emerged in 966 A.D. as a formally recognized European state, Poland has undergone a series of dramatic transformations that fall into four broadly defined eras of Polish history: the First Era (966–1386), the Second Era (1386–1795), the Third Era (1795–1918), and the Fourth Era (1918–present).

FIRST ERA
966–1386

Poland began as a relatively medium-sized, compact entity whose people, the Polanie, occupied the flat lands between the Odra River to the west, the Bug River to the east, the Baltic Sea to the north, and the Tatra Mountains to the south – a territory comparable to the country of today. The Vistula River was Poland's main artery; among its cities were the medieval capital of Cracow and the Hanseatic port of Gdańsk. During this feudal period, rival dukedoms vied for ascendancy. The population was overwhelmingly Polish by nationality, Catholic by religion, and agricultural by occupation, though a sturdy entrepreneurial class in the towns included Germans, Jews, and Armenians.

900

966 Polish nationhood is born, marked by Polish leader Mieszko's acceptance of Western Christianity, not Eastern Orthodoxy.

1000

1025 Bolesław the Brave is crowned the country's first king, in Gniezno, the first capital.

1100

1200

1241 Poland is invaded by the Tatar "Horde"; the capital, Cracow, is destroyed.

1264 The Edict of Kalisz entends tolerance to Jewish people. It eventually becomes the law in Poland for 500 years. By the eighteenth century, Poland has the world's largest Jewish population.

1300

1364 King Casimir III ("the Great") establishes the Jagiellonian University, the first Polish institution of higher learning, in Cracow.

1386 The marriage of Polish queen Jadwiga of Anjou and Lithuanian grand duke Jogaila, later Władysław Jagiełło, king of Poland, unites Poland and Lithuania in a vast commonwealth that lasts over four centuries.

1410–1434 King Władysław Jagiełło founds the Jagiellonian dynasty, which continues until 1572.

1400

SECOND ERA
1386–1795

The marriage between Poland's queen, Jadwiga of Anjou, and grand duke Jogaila, the ruler of then pagan Lithuania, brought a union of the two lands for more than four centuries. The Polish-Lithuanian Commonwealth was a vast multiethnic, multilingual, multireligious arrangement, in which Polish and Lithuanian Catholics, barely sixty percent of the population, lived with Orthodox and Uniate Christian Eastern Slavs, Protestants of a multiplicity of traditions, Jews, and Muslims. The capital moved from Cracow to the more centrally located Warsaw in the early 1600s, during a cultural "golden age" that affirmed the country's strong ties with Western Europe. By the seventeenth century, however, the state was being threatened from the East by the Ottoman Turks, Swedes, and the expanding Muscovite Russian autocracy.

Poland's governmental system was based on a traditional sharing of authority between a king with constitutionally limited powers and an assertive parliament increasingly dominated by the "magnates," rich and powerful nobles. Efforts to establish an elective monarchy and lawmaking by unanimous consent had disastrous consequences. By the start of the eighteenth century, Poland had been reduced to virtual satellite status by the Russian emperor Peter the Great. His successor, Catherine II, joined by the rulers of Austria and Prussia, completed Poland's ruin through a series of three massive seizures of land known as the partitions.

1500

1543 Priest and scholar-astronomer Nicholas Copernicus publishes *De Revolutionibus Orbium Coelestium* on the theory of the heliocentric solar system.

1569 Union of Lublin: Poland is formally joined with Lithuania to become a "Commonwealth of Two Nations."

1572 Following the death of the last Jagiellonian king, Sigismund II Augustus, an elected monarchy is established.

1596 The Union of Brest calls for the unification of Roman Catholics and Greek Orthodox peoples.

1600

1609 Poles arrive in Jamestown in North America to work as professional glassblowers.

1605–1613
Poles interfere in Russia's conflicts over the royal succession in Moscow, earning the hostility of the new Romanov dynasty.

1647–1667
The Commonwealth is deluged by a series of invasions by Cossacks from the Ukraine and Russia; eventually half of Poland's Ukranian lands are lost to Russia.

1655–1657 The Swedes invade and devastate Poland in the so-called "Deluge."

1683 King John III Sobieski and his army defeat the Ottoman Turks at Vienna, saving Austria and Western Europe from Ottoman rule.

1700

1733–1736 The War of the
Polish Succession ends with Russian
domination of Poland.

1772 The Polish-Lithuanian Commonwealth
suffers the loss of nearly thirty percent of its ter-
ritory as the armies of Russia, Austria, and
Prussia execute the first partition of Poland.

1791 The Polish parliament proclaims the reformist
"Third of May" Constitution, but Russia and Prussia
seize three-fifths of the country's remaining territory
in what becomes in 1792 the second partition.

1794 American revolutionary war hero Thaddeus
Kościuszko leads an unsuccessful uprising to restore the
state, but Poland is partitioned in 1795 for a third time.

1797 The Polish national anthem is composed, "Jeszcze
Polska nie zginęła" (Poland is not lost so long as we live).

1795–1918 Poland vanishes
from maps of Europe.

1800

1807 Napoleon sets up the Duchy of Warsaw.

1812 Many Poles support Napoleon Bonaparte
in the vain hope that his triumph over Russia will
mean the restoration of the Polish State.

1815 The Congress of Vienna creates the "Congress
Kingdom" of Poland, under Russian supervision.

1830–1831 An unsuccessful, year-long uprising to
drive the Russians from Poland results in Poles such as
the composer Frederyk Chopin, the poet Adam
Mickiewicz, and the leader of the rebellion, Adam
Czartoryski, seeking asylum in France.

1854 Polish emigrants from Silesia establish in
Texas the first Polish community in America.

1863–1864 An unsuccessful uprising against Russian
domination causes the emigration of thousands to
the West, including young Józef Korzeniowski (later
the English novelist known as Joseph Conrad); many
of these political émigrés come to America.

1893 Death of Jan Matejko, Poland's greatest artist,
renowned for his massive murals having patriotic themes.
In this period epic historical novelist Henryk Sienkiewicz
completes his most famous work, *Quo Vadis?*.

1892–1905 Founding of Poland's modern political
movements, the National Democratic movement, the
Polish Socialist party, and the Polish Peasants Party, all
of them committed to Polish independence.

THIRD ERA
1795–1918

The period of the partitions lasted for
123 years and was marked by foreign cap-
tivity, general oppression, and failed
uprisings. Six generations of Poles found
themselves living in three distinct
regions, in the tsarist Russian zone of
rule and in the lands under Austrian
and Prussian German control.

By 1914 more than three million
Poles had left their homeland, the
greatest numbers settling in the United
States, especially in the Midwest.
Burgeoning cities like Chicago, Buffalo,
Detroit, Milwaukee, and dozens of
others grew into dynamic centers of
Polish cultural life. They attested to the
continued identification by the immi-
grants and their offspring – some four
million in number by 1914 – with their
heritage and their interest in working
for Poland's reunification and rebirth.

FOURTH ERA

SINCE 1918

In 1918 Poland declared its independence, and by 1921 its borders were secure. On September 1, 1939, the Nazi German invasion of the country and its subsequent partitioning by the Reich and Soviet Russia changed everything. For Poland the war was extraordinarily tragic: over six million of its citizens died. Against the nation's will, its borders radically redrawn by the Great Powers and without its consent, Poland fell under Soviet domination after 1945.

The new Polish People's Republic, a country of 120,000 square miles, was nearly homogeneous ethnically and overwhelmingly Roman Catholic. It lasted until 1989 when Poland regained democracy and full national independence. This event heralded the rapid demise of Communist rule throughout Eastern Europe and the collapse in 1991 of the Soviet Union itself and with it the Cold War. Poland joined NATO in 1999, further cementing its historic ties to the Western democratic world.

1939–1945

Nazi Germany invades Poland on September 1, precipitating World War II; on September 17 the Soviet Red army invades Poland and the two powers agree to a fourth partition of the occupied country. More than six million Poles, including nearly all of its Jewish citizenry, perish.

1945–1989

U.S. President Franklin D. Roosevelt, Soviet leader Josef Stalin, and British Prime Minister Winston Churchill sign the Yalta Agreement in February 1945, consigning a devastated and reconfigured Poland of 120,000 square miles, to the Soviet zone of occupation. Communism is enforced for forty-five years.

1918 World War 1 ends; Poland regains its independence after 123 years of foreign rule.

1920 The Polish army conquers Bolshevik Russian forces at the Battle of Warsaw, halting the European spread of Communism and ending Poland's war with Soviet Russia that began in 1919.

1921 The new Polish state, 150,000 square miles in size, is established.

1944 The Polish resistance mounts an unsuccessful effort to drive the Germans from Warsaw and to send a declaration of independence to the oncoming Red Army; the city is destroyed. A year earlier, the Nazis had completed their annihilation of the city's Jewish population.

1953 The Death of Josef Stalin begins a slow weakening of Soviet Russian authority in Eastern Europe.

1956 Workers in Poznań demonstrate against Stalinist rule, resulting in the more moderate regime of Władysław Gomółka.

1968 A new twenty-year long period of mass unrest begins.

1978 Karol Cardinal Wojtyła of Cracow becomes Pope John Paul II.

1980 Nationwide strikes culminate in a massive sit down in Gdańsk, led by the newly created Solidarity union.

1981 General Wojciech Jaruzelski imposes martial law in the face of Solidarity demands, but the Solidarity movement survives underground.

1989 Negotiations lead to Solidarity's restoration and to free but limited elections, paving the way for the election of the first non-Communist government in Eastern Europe since 1948.

1990 Solidarity union leader Lech Wałęsa becomes Poland's first popularly elected president.

1991 Collapse of the Soviet Union and the end of the Cold War.

1999 Poland is admitted into the NATO Alliance along with the Czech Republic and Hungary.

PAUL W. KNOLL

HUMANISM

and

EARLY PATRONAGE

BY THE LATE MIDDLE AGES, the Polish state had succeeded in establishing its regional identity and in integrating the heritage of the European tradition as it had developed in Latin Europe. With the death of King Casimir the Great in 1370, however, the Piast dynasty came to an end. After a brief interlude, during which King Louis of Anjou of Hungary ruled, Poland entered a new era during which it founded, as the leading English-speaking historian of Poland has remarked, "one of the most original civilizations of early modern Europe."[1]

In 1384 Louis's younger daughter, Jadwiga, came to the Polish capital, Cracow, and, not yet eleven years old, was crowned as ruler. She was the choice of the Polish nobility whose privileges and power had grown markedly in previous decades. The following year they accepted the proposal of the pagan Grand Duke Jogaila of Lithuania that he should marry Jadwiga, convert to Christianity along with his subjects, and join Lithuania to Poland in a permanent union. In 1386 he took the Christian name Władysław and the two were married. Mentored and guided by the clergy of Catholic Poland, Władysław Jagiełło (the Polonized form of his name) learned to rule as a Christian king; fired by the enthusiasm and piety of his wife for the education of clergy and the completion of Lithuanian's Christianization, he reestablished a university in Cracow in 1400. For nearly two hundred years and through four generations, Jagiełło and his descendents were to rule the Polish-Lithuanian state.

This brief outline identifies some of the most important cultural elements that were to dominate Polish history from the 1380s to near the end of the sixteenth century: the monarchy, the church, the university, and the nobility, to which we should add the patriciate of the towns. These factors shaped the politics, the society, and – above all – the cultural values of the period. The following essay analyzes these elements in terms of their contributions to Polish culture and art patronage.

In the first century following the union with Lithuania, the Jagiellonian family firmly established the royal court as a center of culture and patronage. Two telling testimonies to this fact are Jagiełło's commission to decorate the interior of the royal chapel in Lublin Castle with frescos and by his benefactions to the university in Cracow. The former were executed in a Russo-Byzantine style that combined the iconographic traditions of the Orthodox world with the ideals of the Latin Catholic West, reflecting the multicultural and multinational character of the Polish-Lithuanian state. More explicitly, since

1 Norman Davies, *God's Playground. A History of Poland*, 2 vols. (New York: Columbia University Press, 1982), vol. 1, p. 105.

they were done to conform to Jagiełło's own directives, they reveal the degree to which the monarchy and the court had an international, even supranational, outlook. Thus, as has been noted, art for the Jagiellonians was not "limited to the hegemony of any one nation, form, or genre."[2]

The second example of Jagiełło's patronage was connected with the university. Founded originally by Casimir the Great in 1364, the *studium* had not prospered following his death. Jadwiga and Jagiełło, among others, had tried in the 1390s to revive the school, and eventually in 1397 they obtained papal permission for the establishment of a theological faculty. At her death in 1399, Jadwiga's will bequeathed her own jewelry for the support of the university; and when he refounded the school in 1400, Jagiełło gave it a large house in which to function. (This was the *lapidea magna* in the *platea Judeorum* at the intersection of what was to become St. Anne's Street and Jagiellonian Street[3] and

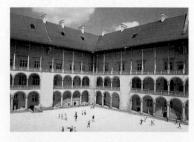

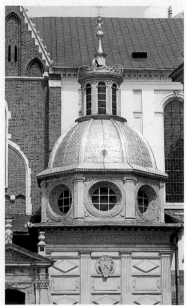

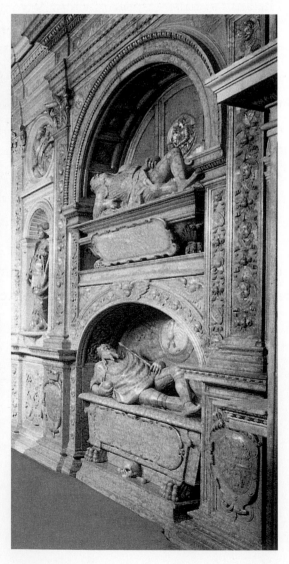

FIG 1, TOP LEFT
Courtyard of The Wawel Royal Castle, Cracow.

FIG 2, BOTTOM LEFT
Sigismund Chapel, Wawel Cathedral, Cracow.

FIG 3, RIGHT
The Tombs of Sigismund I (above) and Sigismund II Augustus (below), Sigismund Chapel, Wawel Cathedral, Cracow.

became the core of the eventual *Collegium Maius*.) Shortly thereafter he endowed nine professorships in theology to ensure the financial success of an institution that eventually came to bear his name, Jagiellonian University, *Universitas Jagellonica*.[4]

In these and many other ways, the monarchy was an important source of patronage in the fifteenth century. But it was the following century, under Sigismund I the Old (1506–1548) and his son Sigismund II Augustus (1548–1572), that saw the most significant accomplishments. Sigismund I had personal knowledge of the rich cultural environment of Hungary, where Renaissance tastes were already strong. The growing penetration of humanism and Italian influences directly into Poland and his eventual marriage to the Italian princess Bona Sforza ensured that during his reign, art and culture would bear the imprint of Renaissance patronage.[5] The first of three of his most important commissions was the massive rebuilding of The Wawel Royal Castle in Cracow in the Renaissance style by the sculptor and architect Francesco Fiorentino and the local Master Benedict of Sandomierz {*FIG 1*}. The king was also responsible for commissioning the Florentine Bartolomeo Berrecci to build the Sigismund Chapel in Wawel Cathedral; its classicizing style was fully abreast of Italian developments {*FIG 2*}. Inside the chapel Berrecci created a tomb for his patron that featured a distinctive reclining statue of the monarch. At a later time, the chapel was remodeled, Sigismund's tomb was raised, and the tomb of his successor installed beneath it in an original and highly influential double structure {*FIG 3*}.[6]

Sigismund's third important commission was for the decoration of the interior of his newly remodeled royal residence. In 1526 he ordered sixteen great tapestries from the Low Countries and seven years later ordered ninety-two more. These magnificent creations became the core of a collection that was vastly enhanced by his son, Sigismund II Augustus. During the latter's reign, more than 300 tapestries hung within the castle. The 136 pieces extant today depict scenes from the Old Testament, mythological stories, grotesques and satyrs, and allegorical representations of contemporary politics and

2 Thomas Da Costa Kaufmann, *Court, Cloister and City. The Art and Culture of Central Europe 1450–1800* (Chicago: University of Chicago Press, 1995), p. 58.

3 Details concerning these matters have been recently reexamined by Hanna Zaremska, "Jewish Street (*Platea Judeorum*) in Cracow: the 14th–the First Half of the 15th C.," *Acta Poloniae Historica* 83 (2001), pp. 27–57.

4 For Jadwiga's influence, see most recently in English, Paul W. Knoll "Jadwiga and Education," *The Polish Review* 44 (1999), pp. 419–31 and the illustration facing p. 419. The individual chapters in Kazimierz Lepszy, ed., *Dzieje Uniwersytetu Jagiellońskiego w latach 1364–1764* (Cracow: Państwowe Wydawnictwo Naukowe, 1964) remain the standard treatment of the school's history into the eighteenth century.

5 In general, see the comments of Władysław Tomkiewicz, "Le Mécénat artistique en Pologne à l'époque de la Renaissance et du début du Baroque," *Acta Poloniae Historica* 16 (1967), pp. 91–108, esp. pp. 91–92.

6 The rebuilding of The Wawel Royal Castle and the Sigismund Chapel – its exterior and interior – are well treated in Helena and Stefan Kozakiewicz, *The Renaissance in Poland* (Warsaw, Arkady, 1976), pp. 7–47 (with illustrations on pp. 50–124); Adam Miłobędzki, "Architecture under the Last Jagiellons in Its Political and Social Context," in Samuel Fiszman, ed., *The Polish Renaissance in its European Context* (Bloomington, Indiana: Indiana University Press, 1988), pp. 291–301; and, especially, in the classic work of Jan Białostocki, *The Art of the Renaissance in Eastern Europe* (Ithaca, New York: Cornell University Press, 1976), pp. 18–25, 35–44, and 52–58. Each has references to more detailed literature in Polish.

Polish-Lithuanian relations {*FIGS 4 AND 5*}. Collectively, they represent a cultural treasure that was given to the "Commonwealth of Both Nations" (as the two countries were known after the Union of Lublin in 1569 and the death of the last Jagiellonian king in 1572). But they also represent the passion for collecting and the imprint of Renaissance taste upon culture that were so characteristic of the sixteenth century and beyond.[7]

This passion and taste are also reflected in a second sector in society, the church. Following the conversion to Catholic Christianity of Duke Mieszko I in the tenth century, the Polish church was organized at the Congress of Gniezno in 1000 A.D. under an archbishop with his seat in Gniezno in the region of Great Poland (*Polonia maior, Wielkopolska*).[8] By the thirteenth century the clergy in Poland had come to play an important role in politics as well as exercising an independent ecclesiastical role; during Jagiełło's reign it was the clergy who provided advice and counsel on how he should rule as a Christian king.

Endowed with material resources and exercising a leading role in society, the church in Poland was an influential patron. The clergy was well positioned to commission numerous objects for its own use in religious services, to sponsor the ornamentation of ecclesiastical buildings, and to seek out consistently the best artists and artisans to create an impressive body of sacred art. The numerous patens, chalices, reliquaries, luxuriously bound sacred books, monstrances, chasubles, and other treasures that were produced at their initiative are evidence of clerical patronage.[9] In this activity the clergy were not merely expressing their own taste, but were instrumental in ensuring open distribution

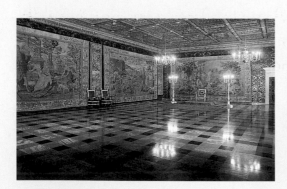

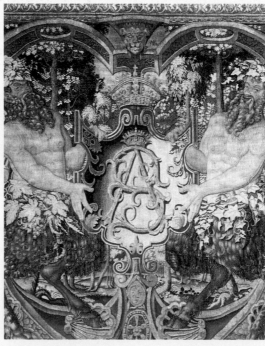

FIG 4
Senators' Chamber with tapestries,
The Wawel Royal Castle, Cracow.

FIG 5
Tapestry with monogram of Sigismund II
Augustus, The Wawel Royal Castle, Cracow.

of goods within society.[10] Rather than simply assigning a program to the artist, who then executed the patron's ideas, there was an interplay between the language of culture and the larger world of commerce.[11]

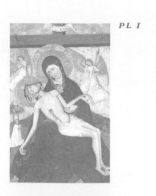

PL 1

Two particularly fine examples of the influence of the Polish church are the *Pietà* {PL 1} by an anonymous painter from the region of Little Poland (*Polonia minor, Małopolska*), the southern region around Cracow, and the complex *Virgin and Child with St. Felicity and St. Perpetua* {PL 2}, the work of an artist active in the region of Great Poland during the period when Jan Łaski was archbishop of Gniezno and primate of Poland. These regions had dominated the history of Poland until the end of the Middle Ages. (A third geographic region, Silesia, important in Polish history until the end of the thirteenth century, had slipped into the sphere of Bohemian control.) Great Poland's earlier political leadership in the state had been eclipsed by that of Little Poland after the thirteenth century, and Cracow had become the royal capital, but it was to remain influential for generations to come. In particular, since the Polish primate had his seat in this region, ecclesiastical patronage in Great Poland was strongly felt, and the work of the Great Poland Painter is almost surely an example of the influence of the episcopal court in the city of Poznań.

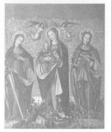

PL 2

The clergy in Little Poland often exercised as much influence in the Polish church as the archbishop himself. In the fifteenth century Bishop Zbigniew Oleśnicki of Cracow was de facto the ecclesiastical leader of Poland. His position as close advisor to the royal court ensured that the early Jagiellonians followed policies defined and articulated by the church. If we cannot associate the work of the Little Poland Painter firmly with episcopal patronage, it is nevertheless clear that clerical tastes and influences are powerfully reflected in it. In the following century, the dominance of the Bishop of Cracow in the Polish church and in Polish policy was equally pronounced. Piotr Tomicki was both royal

7 The best treatment of these tapestries, including a brief overview of their history after the sixteenth century, is Jerzy Szablowski's introduction to *Die Sammlungen des Königsschlosses auf dem Wawel* (Warsaw: Arkady, 1969), esp. pp. 5–12 and pls. 1–26.

8 See, most recently, Jerzy Strzelczyk, "Das Treffen in Gnesen und die Gründung des Erzbistums Gnesen," in *Europas Mitte um 1000. Beiträge zur Geschichte, Kunst und Archäologie*, 2 vols. (Stuttgart: Theiss, 2000), vol. 1, pp. 494–97; these volumes accompany the catalogue for the exhibition "Europas Mitte um 1000," on view in Budapest, Cracow, Berlin, Mannheim, Prague, and Bratislava between August 2000 and September 2002. On the Congress of Gniezno, see also Johannes Fried, *Otto III. und Boleslaw Chrobry* (Stuttgart: F. Steiner Verlag, 2000); this book is the second edition of a volume originally published in 1989 that has stimulated considerable discussion by Polish and German historians.

9 This was particularly well reflected in the exhibition of sacred art treasures mounted at The Royal Castle in Warsaw from May 15 to September 8, 1999; see *Ornamenta Ecclesiae Poloniae. Skarby sztuki sakralnej wiek X–XVIII* (Warsaw: Dom Polski, 1999), especially the article by Jerzy Kłoczowski, "Kościół katolicki a kultura artystyczna w dziejach Polski przedrozbiorowej," pp. 11–19, and items I-LII in the catalogue of the exhibition.

10 Lisa Jardine, *Worldly Goods. A New History of the Renaissance* (London: Doubleday, 1996); and Alison Brown, *The Renaissance*, 2nd ed. (London and New York: Longman, 1999), p. 71.

11 On this point, see Creighton Gilbert, "What Did the Renaissance Patron Buy?" *Renaissance Quarterly* 51 (1998), pp. 392–450.

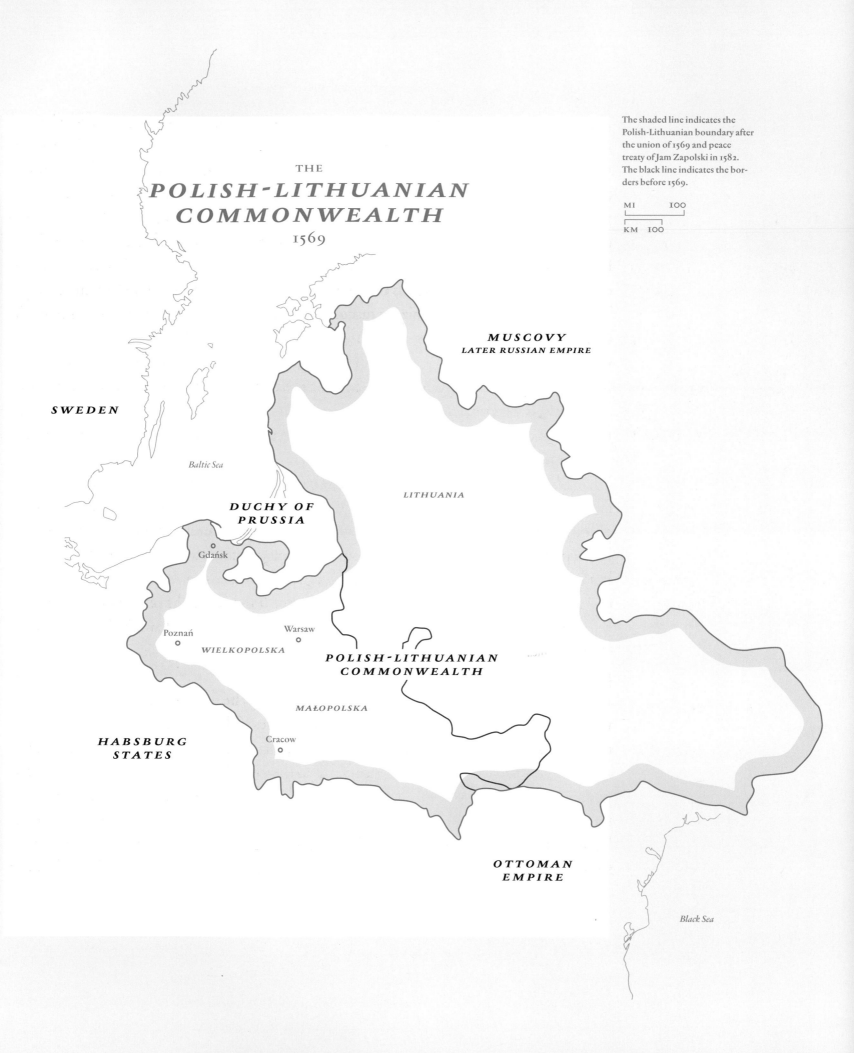

THE
POLISH-LITHUANIAN COMMONWEALTH
1569

The shaded line indicates the
Polish-Lithuanian boundary after
the union of 1569 and peace
treaty of Jam Zapolski in 1582.
The black line indicates the bor-
ders before 1569.

MI 100

KM 100

MUSCOVY
LATER RUSSIAN EMPIRE

SWEDEN

Baltic Sea

LITHUANIA

**DUCHY OF
PRUSSIA**

Gdańsk

Poznań

Warsaw

WIELKOPOLSKA

**POLISH-LITHUANIAN
COMMONWEALTH**

MAŁOPOLSKA

Cracow

**HABSBURG
STATES**

**OTTOMAN
EMPIRE**

Black Sea

vice-chancellor for Sigismund I and bishop. He undertook a vigorous program of religious reform, resisted the beginnings of Lutheran influence in Poland, and also, in his capacity as chancellor of the University of Cracow, promoted an educational reform that brought humanistic influences fully into the school's curriculum. Tomicki also commissioned the greatest Polish painter of the day, Stanisław Samostrzelnik, to undertake the illustration of a volume devoted to the lives of the archbishops of Gniezno. Samostrzelnik's famous portrait of his patron (long attributed to Hans Dürer) {PL 3} is ample evidence of his own skills, but also records the presence of a dominant figure in Polish culture. Tomicki was famous for organizing discussions at the royal court on humanistic, scientific, and artistic themes. He also was responsible for ensuring that the sculptor and architect Gian Maria Mosca, known as Padovano, came to Poland. Active in projects within the Wawel Cathedral, Padovano may have worked on the chapel and tomb for his patron and may have been involved with the Sigismund Chapel, the work of Berrecci. Indeed, to this day, there continues to be discussion about what was the product of Padovano's efforts and what was the work of Berrecci.[12]

Although the works of the Great Poland Painter and the Little Poland Painter are in the late Gothic tradition, at the time they were created, the new cultural influences of Italy were already being strongly felt within Poland. By the end of the fifteenth century, for example, humanism was an important movement within the University of Cracow. Earlier in the century, there had been harbingers of what was to come. Gregory of Sanok had included lectures in the early 1440s on antique literature within the *studium*; later he moved into a clerical career that culminated in his being named archbishop of Lwów, where the literary circle he presided over was famous for its interests in humanistic culture. The official orator of the university in the late 1440s, John of Ludzisko, had mastered Renaissance rhetoric during his years studying in Italy; he used it in sophisticated ways when he represented the academy in public addresses. Changes under the leadership of the polymath professor John of Dąbrówka in 1449 had introduced into the arts curriculum a greater emphasis upon antique literature and rhetoric. Most importantly, after 1472 the Italian humanist Philip Buonaccorsi, called Callimachus Experiens, made his home at the university and in Cracow, where he was particularly influential in court circles. When he died in 1496, the faculty mourned him as one of their own; he left the *studium* a handsome bequest. Finally, from 1489 to 1491, the German humanist and poet Conrad Celtis

12 This discussion is most easily followed in Białostocki (note 6), p. 53 and no. 68.

studied mathematics and astronomy in Cracow and presided over the literary society (the *Sodalitas Litteraria Vistulana*) he founded there.[13]

Outside the realm of curricular and intellectual developments, Renaissance influence was also being felt in the physical home of the university, the *Collegium Maius*. The original building had been expanded during the century {see the exterior of the fifteenth-century structure in FIG 6} and then, following a disastrous fire in 1492, the interior core had been rebuilt in the Italian style, reflecting influences both of the Collegio di Spagna in Bologna and the Bargello in Florence. The arcaded vaulting {FIG 7} is not, however, purely Gothic, but points to humanist connections.[14]

It is not, therefore, surprising that the university should reflect a growing interest in humanism. The course assignment book for faculty at the school, the *Liber diligentiarum*, reflects the degree to which the literature of classical antiquity was coming to complement the philosophy of Aristotle in the arts faculty. Thus when Piotr Tomicki instituted the aforementioned curricular reforms, requiring the study of Greek and Hebrew, his own humanistic ideals were fully reflected. When the English Erasmian Leonard Coxe came to Cracow in 1518, he registered to lecture and delivered a humanist panegyric on the school that sums up the cultural progress humanism had made within the institution. Coxe called the university a "new Athens," containing within it all kinds of virtues.[15] Increasingly the university was seen as a cultural center that prepared students for roles in noble and royal courts, clergy for careers in the church that reflected the new learning, and teachers for the range of elementary and secondary schools that had come to characterize Polish parishes by the end of the Middle Ages.

As members of an important cultural center, the faculty themselves developed libraries that reflected these new Renaissance tastes, which they frequently willed to their university. In many ways they were patrons of their own school.[16] One of the finest examples of this practice came in 1559, when Benedict of Koźmin, professor and vice-chancellor of the university, willed his institution the contents of his extensive library

13 The best treatment in English of these developments to the end of the fifteenth century is Harold B. Segel, *Renaissance Culture in Poland. The Rise of Humanism, 1470–1543* (Ithaca, New York: Cornell University Press, 1989), pp. 18–106. See also Tadeusz Ulewicz, "Polish Humanism and Its Italian Sources: Beginnings and Historical Development," in Fiszman (note 6), pp. 215–35. I offer a minor corrective to Ulewicz on one point in Paul W. Knoll, "Italian Humanism in Poland: The Role of the University of Kraków in the Fifteenth and Early Sixteenth Centuries," in Jean R. Brink and William F. Gentrup, eds., *Renaissance Culture in Context. Theory and Practice* (Aldershot, England: Scolar Press, 1993), p. 168, n. 32.

14 In great detail, see the work of Karol Estreicher, *Collegium Maius. Dzieje Gmachu* (Cracow: Universytet Jagielloński, 1968), esp. pp. 66–117; more briefly, see the comments of Kaufmann (note 2), pp. 54–55.

15 For a fuller analysis of his speech, and of his role in Cracow, see Henryk Zins, "Leonard Coxe i erazmiańskie koła w

Polsce i Anglii," *Odrodzenie i Reformacja w Polsce* 17 (1972), pp. 27–62, esp. pp. 32–42.

16 For a sampling of these kinds of bequests, see the treatment by Jerzy Zathey, "Biblioteka Jagiellońska w latach 1364–1492," pp. 87–130; and Anna Lewicka-Kamińska, "Biblioteka Jagiellońska w latach 1492–1655," pp. 133–75, both in Jerzy Zathey, Anna Lewicka-Kamińska, and Leszek Hajdukiewicz, *Historia Biblioteki Jagiellońskiej, vol. I: 1364–1775* (Cracow: Uniwersytet Jagielloński, 1966).

17 A more famous version of this same painting, in which the setting is slightly different, Anna's jewelry is more ornate, and her seal identifies her, hangs in the collection of the Wilanów Palace outside Warsaw.

and a sum of one thousand Polish złotys, from which fifty złotys per year were to be used for its upkeep. The university's *Collegium Maius* honors him to this day as one of its greatest patrons. An outstanding mid-sixteenth-century portrait of him, with Venetian background elements, by an anonymous Cracovian (or perhaps a Central European) painter, is one of the treasures of the institution {*FIG 8*}. The inscription below the figure calls attention to his benefaction.

But the university was also the recipient of patronage from outside the academy. In recognition of the importance of the school in the national and cultural life of the country, Anna the Jagiellonian, sister of King Sigismund II Augustus {*FIG 9*}, visited the university in 1584, presenting an endowment for the paupers' hostel and a sumptuously bound book covered with pearls in the form of the traditional Polish symbol, the white eagle {*FIG 10*}. Her portrait – one of several attributed to Marcin Kober – depicting a forbidding and rather unglamorous visage, is today part of The Wawel Castle collection.[17]

The Polish nobility had come to play an important role in the politics and society of the country by the end of the Jagiellonian period, and subsequent generations were

FIG 6
Collegium Maius, Jagiellonian University, Cracow, with the oldest part of the building in the background.

FIG 7
Collegium Maius, Jagiellonian University, Cracow, interior of the arcaded courtyard.

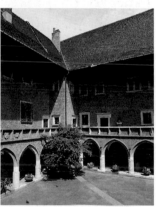

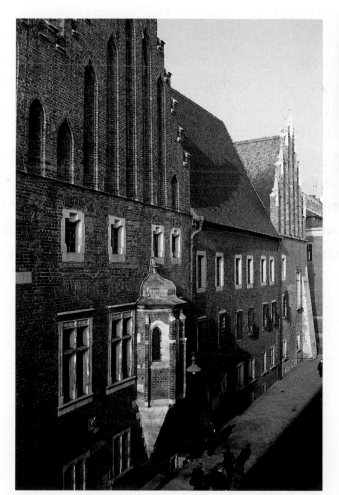

regarded by them as a period of "golden freedom" to complement the "golden age" (*Złoty wiek*) of the last two Jagiellonian kings. Indeed the power of the nobility had been growing since the fourteenth century. Casimir the Great had recognized them as an estate (status; in Polish, *stan*), and the failure of the Piast and Angevian dynasties had resulted in extensive privileges being granted to the nobility (*szlachta*) by those who sought support for their own rule. In the fifteenth century the Jagiellonians had granted them rights of due process and of habeas corpus, the right to be consulted in regional assemblies (dietines or *sejmiki*) before deputies were sent to the national Diet (*Sejm*), and eventually, in the decree *Nihil novi* of 1505, the principle that "nothing new" be enacted without the consent of the nobility as a whole. As the popular phrase put it, there was to be "nothing about us without us." The nobility were well on the way to becoming the only political and social force in Poland-Lithuania. They were to make the state, as one study put it, "a republic of nobles."[18]

Ultimately these noble freedoms were part of the process by which the Polish-Lithuanian Commonwealth was destroyed in the eighteenth century, but long before that time the nobility came into their own as patrons and collectors. In the Jagiellonian period, however, those roles were filled by the monarchy and the church. The nobles followed behind, supporting the styles and tastes set by the king, court, and clergy. For example, the noble Krzysztof Szydłowiecki, who served Sigismund I as chancellor, was the first after the king to construct a Renaissance palace at his ancestral home in Ćmielów. In 1542 Sigismund I's secretary, Hieronim Szafraniec, transformed the family fortress in Pieskowa Skała north of Cracow into a castle inspired by Italian Renaissance models and, not coincidentally, with an arcaded courtyard reminiscent of The Wawel Castle itself. John Firlej, the crown marshal and palatine of Cracow under Sigismund Augustus, along with his family built, among other structures, a transitional Gothic-Renaissance-style palace in Janowiec, another constructed on a plan of Sansovino in Dąbrowica,

18 Jan K. Fedorowicz, ed., *A Republic of Nobles. Studies in Polish History to 1864* (Cambridge, England: Cambridge University Press, 1982). In the context of this chapter, see especially the entries by Henryk Samsonowicz, "Polish Politics and Society under the Jagiellonian Monarchy," pp. 49–69, and Andrzej Wyrobisz, "The Arts and Social Prestige in Poland Between the Sixteenth and Eighteenth Centuries," pp. 153–78.

19 For this tradition, see Stanisław Cynarski, "The Shape of Sarmatian Ideology in Poland," *Acta Poloniae Historica* 19 (1968), pp. 5–17; and Janusz Tazbir, *Kultura szlachecka w Polsce* (Warsaw: Wiedza Powszechna, 1978). A good overview in English is to be found in the chapter "Oriental Baroque" in Adam Zamoyski, *The Polish Way. A Thousand-year History of the Poles and their Culture* (London: John Murray, 1987), pp. 189–205. A visual depiction of this culture is contained in Alexandria, Virginia, Arts Services International, *Land of the Winged Horsemen. Art in Poland 1572–1764*, ed. Jan K. Ostrowski (Alexandria, 1999).

20 Towns were economically prosperous in the sixteenth century, but many were under royal or private control, and many urban dwellers had no autonomous political force. Eventually towns were excluded from representation in the national Diet, the *Sejm*. This process is conveniently traced in English by Antoni Mączak, "The Structure of Power in the Commonwealth of the Sixteenth and Seventeenth Centuries," and Maria Bogucka, "Polish Towns Between the Sixteenth and Eighteenth Centuries," both in Fedorowicz (note 18), pp. 113–34 and 135–52 respectively. A fuller treatment may be found in Bogucka and Henryk Samsonowicz, *Dzieje miast i mieszczaństwa w Polsce przedrozbiorowej* (Wrocław: Ossolineum, 1986).

and Palladian style villas in a number of locations. They also began a substantial collection of paintings and other art objects.

Though the Firlejs and other great nobles of the Jagiellonian era declined in subsequent years and were replaced by a new social order of magnates, they represented a noble class that remained a constant of Polish history into the nineteenth century. Within a generation of the end of the Jagiellonian era, the nobility, especially the great magnates, with wealth and property of astonishing degree, would take the initiative within society to gather personal art collections drawn from throughout Europe. They would patronize both local and foreign artists, and the culture they would shape would have a distinctive character that has come to be known as "Sarmatian."[19]

One final element that played an important role in patronage in this period deserves treatment here: urban society. Although towns in Poland and Lithuania never developed the political power they did in other countries,[20] they were nevertheless dynamic social, economic, and cultural centers, especially in the sixteenth century. Great patrician families that had emerged from the Middle Ages dominated most cities. They

FIG 8, LEFT
Unidentified Central European artist, *Portrait of Professor Benedict of Koźmin*, mid-16th century, Cracow, The Museum of the Jagiellonian University, *Collegium Maius*.

FIG 9, TOP RIGHT
Attributed to Marcin Kober, *Portrait of Anna the Jagiellonian*, mid-16th century, Cracow, The Wawel Royal Castle, State Art Collections.

FIG 10, BOTTOM RIGHT
Book Cover, embroidered satin encrusted with pearls, 1582, gift of Anna the Jagiellonian in 1584 to the *Collegium Maius*, Cracow, The Museum of the Jagiellonian University, *Collegium Maius*.

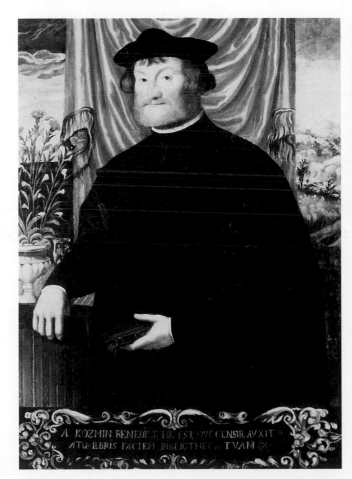

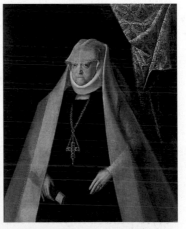

had significant wealth from commercial and professional activity, and they spent it in building impressive residences on the town squares of their cities. They also commissioned and appreciated artists from outside the local scene.

Nowhere is this more clearly seen than in late fifteenth-century Cracow, a city of about 18,000 in the southern part of Poland. There the collegiate church of St. Mary on the town square was the "local" church for many of the city's elite. That these individuals were also the political leaders of the city is reflected in the fact that in the 1470s the town council – ethnically mixed between German and Polish speakers – commissioned the sculptor Veit Stoss of Nuremberg to execute a great altarpiece for the church {*FIG 11*}. For nearly twenty years, Wit Stwosz (as he is known in Poland) worked at a number of projects in the Polish capital. His oak and limewood altar for St. Mary's, standing more than thirteen meters high and containing numerous larger-than-life-size figures, is a magnificent gilded and polychromed polyptych that depicts the Dormition, Assumption, and Coronation of the Virgin in its central parts. Biblical subjects are shown on the interior of the wings, with scenes from the Life of Mary on the exterior. Throughout, the background panels reflect details of the city of Cracow itself.

Justly regarded as one of the triumphs of late medieval Gothic sculpture, the altarpiece was by no means the sum total of Stoss' activity in Poland.[21] Before he left in

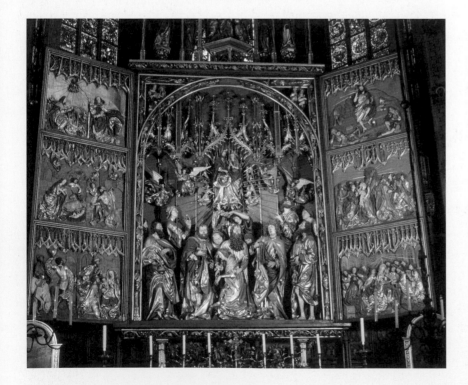

FIG 11
Veit Stoss, *Altarpiece of the Virgin Mary* (detail), 1477–79, church of St. Mary, Cracow.

1496 to return to Nuremberg, he executed a marble tomb for King Casimir the Jagiellonian, a great stone crucifix for one of the parishioners of St. Mary's, and other funerary monuments, particularly one in bronze for the tomb of the humanist Philip Callimachus. This last work (cast in the Vischer workshop in Nuremberg) stands fully in the humanist tradition of Renaissance sculpture.[22] It suggests both the degree to which Stoss was able to meet the ideals of his patrons and the way in which late Gothic and Renaissance tastes mixed within the aesthetic sensibilities of Jagiellonian Poland. After his return to the German lands, Stoss continued to be active. One of the glories of his later years was his design in 1520 for yet another altar masterpiece, that depicting the Birth of Christ for the church of the Most Sacred Savior in Nuremberg. A drawing for the project {*PL 5*} has been in Polish collections for more than a century, having been acquired largely because of the close associations the sculptor had with Poland.

PL 5

Below the social stratum of the patricians were the commoners, organized into various merchant and craft guilds, and the poor and unskilled. The life of these guilds has been vividly preserved for us because one of the leading citizens of Cracow, the lawyer and city scribe Balthazar Behem, decided that the collection of Cracovian rights and guild legislation he had commissioned in 1505 should be illustrated with illuminations depicting the various crafts and trades that functioned in the city.[23] His magnificent codex, today in the Library of the Jagiellonian University, reveals to us the cultural values that his patronage represented. But it also shows us the details of urban life for, among others, dressmakers and painters {*FIGS 12 AND 13*}. While these groups did not participate to any great degree in patronage or collecting, they nevertheless represent a part of the urban scene that was an integral element of the larger picture of patronage in Jagiellonian Poland.

In northern Poland, on the Baltic littoral, lay the city of Danzig. Lost to the Knights of the Teutonic Order in 1306, this thriving entrepot and Hanseatic League member at the mouth of the Vistula River had been returned to the kingdom in 1466. Predominantly a German-speaking city, it was the largest urban site in Poland, with a

21 There is a comprehensive survey of Veit Stoss' Polish activity in Lech Kalinowski and Franciszek Stolot, eds., *Wit Stwosz w Krakowie* (Cracow: Państwowe Wydawnictwo Naukowe, 1987); see also Adam S. Labuda, ed., *Wit Stwosz: Studia o Sztuce i Recepcji* (Poznań: Państwowe Wydawnictwo Naukowe, 1986).

22 For the various funerary works he created in Poland, see the text and illustrations in Piotr Skubiszewski, *Rzeźba nagrobna Wita Stwosza* (Warsaw: Państwowy Instytut Wydawniczy, 1957).

23 Zofia Ameisenowa, *Kodeks Baltazara Behema* (Warsaw: Auriga, 1961). Numerous scholars, including the great historian of medieval Cracow, Jerzy Wyrozumski, have mined this manuscript for an understanding and appreciation of the social history of the city in this period; see his *Dzieje Krakowa. Kraków do schyłku wieków średnich*, vol. 1 of *Dzieje Krakowa*, ed. Janina Bieniarzówna and Jan M. Małecki (Cracow: Wydawnictwo Literackie, 1992), pp. 331–71, esp. pp. 370–71.

population of over 30,000. Its citizenry was growing increasingly wealthy from the flourishing grain trade, and in the course of the late fifteenth through the seventeenth centuries, Danzig was internationally important. The multistoried houses, magnificent public buildings, and various commercial structures all bear elegant witness to Danzig's prosperity.[24] How aggressively the inhabitants of the city defended one of their great artistic treasures indicates how the subjects of the Kingdom of Poland were in close and appreciative contact with other European nations.

In April 1473 a sea captain from Danzig captured a ship in battle off the coast of England. Among the goods that came into his possession was a painting by the master Netherlandish painter Hans Memling, a triptych of The Last Judgment {PL 4}. This great and very large work was eventually brought back to Danzig and installed in a chapel of St. Mary's church. Despite immediate demands that the painting be returned to those for whom it had originally been intended, the citizens of Danzig refused, and the painting remained in its new home. The artist was already famous and the painting was appreciated from the beginning as a very great accomplishment. The citizenry regarded it as a prize to glorify and adorn the city, and henceforth the Memling and Danzig were to be identified with one another. The resistance of Danzig to any future effort to relocate the Memling became legendary, continuing even through the period when Danzig was part of an independent Prussia and, eventually, of Germany. In the twentieth century, when Danzig once again became Gdańsk, the painting was considered anew as one of the treasures of the city.

PL 4

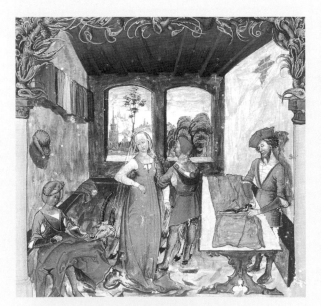

FIG 12
Dressmaker's Shop in Cracow, illustration from Behem Codex, ca. 1505, Cracow, The Library of the Jagiellonian University.

FIG 13
Painter at Work in Cracow, illustration from Behem Codex, ca.1505, Cracow, The Library of the Jagiellonian University.

There is something appropriate about the way this great painting has transcended national histories to remain associated with one city. Although it derives from the late Gothic period, its relocation to Danzig came at precisely the time when the spirit of Renaissance humanism was beginning to shape the culture and patronage values of Poland. This spirit transcended state and nation. It emphasized values derived from classical antiquity that had been harmonized with the Christian traditions of Latin Western Europe. It found expression in Poland in the effort of many different elements in society that sought to expand the boundaries of patronage and collecting, and it brought Poland fully into the mainstream of European culture. It is not coincidental that Erasmus, the personification of sixteenth-century European humanism, felt that Poland was where he was most appreciated. He wrote once to the archbishop of Canterbury in England and commented that "Poland is mine"; on another occasion he wrote to congratulate the Polish nation "which...can now compete with the foremost and most cultivated in the world."[25]

The artistic and cultural vitality that marked Poland as a European intellectual center by the end of the Jagiellonian era had found expression in a program of patronage exercised by the various elements of society and executed in an environment that was increasingly informed by the values and ideals of Renaissance humanism. Poland was in many ways distinctive, not least in that it already had an Eastern orientation as the result of its union with Lithuania. But it was as vital a part of the European scene as any other region. Subsequent generations were to confirm that Polish patronage and collecting were to be profoundly European in their intent, scope, and content.

24 Much written about Danzig by Polish and German scholars in the last two centuries has been vitiated by nationalist agendas, valuable though they may be with regard to details. This applies also to larger assessments of the city's artistic and cultural life. One recent exception is Teresa Grzybowska, *Złoty wiek malarstwa gdańskiego na tle kultury artystycznej miasta; 1520–1620* (Warsaw: Państwowe Wydawnictwo Naukowe, 1990).

25 Quoted by Zamoyski (note 19), pp. 105 and 123. For these and similar sentiments, see the fuller discussion in George Hunston Williams, "Erasmianism in Poland: An Account and an Interpretation of a Major, Though ever Diminishing, Current in Sixteenth-Century Polish Humanism and Religion, 1518-1605," *The Polish Review* 22, 3 (1977), pp. 3-50. Erasmus's library, consisting of 413 volumes, was purchased by the political theorist and reformer Andrzej Frycz Modrzewski (Modrevius) and shipped to John Łaski (the nephew of the former Polish primate) in Cracow in 1537; see Williams, p. 26 and n. 78, and more fully, Konstanty Żantuan "Erasmus and the Cracow Humanists: The Purchase of His Library by Łaski," *The Polish Review* 10, 2 (1965), pp. 3-36.

ANTONI ZIEMBA

INTERNATIONALISM

and

A PLURALISM OF TASTE

IT IS WELL KNOWN THAT BETWEEN the sixteenth and the eighteenth centuries, Poland looked primarily to Italy for its cultural influences. Evidence for this influence abounds in the activity of the Italian-born queen Bona Sforza, who inspired the Florentine origins of Renaissance art in Poland; The Wawel Royal Castle courtyard and the Sigismund Chapel and its numerous seventeenth-century imitations based on Italian Renaissance models; and a multitude of Jesuit and Carmelite churches based on Italian prototypes. The Hyperborean land of the Sarmatians therefore more or less consistently looked to Southern Europe, choosing the Italian, Roman model in its culture as well as its religion. The list of artists of Italian descent or educated in Italy who were active in Poland during this period is exceedingly long. Even though the eighteenth century witnessed a strong French influence in the circles of the Czartoryski family and Stanislaus Augustus Poniatowski, the impact of the Italian Marcello Bacciarelli at the royal court significantly outweighed that of the Frenchman Jean-Pierre Norblin.

However, within this clearly defined preference for Italian culture, there emerged in the late sixteenth and early seventeenth centuries a recognizable internationalism and a pluralism of taste that encompassed the cultural heritage of the Netherlands. The earliest examples of these cultural influences can be found in the patrician culture of Gdańsk, a great port and trading center on the Baltic Sea; the tapestry commissions of kings Sigismund Augustus and Ladislas IV; and in the general use in architecture and sculpture of Netherlandish ornamentation originating from the pattern books of Cornelis Floris or Hans Vredeman de Vries. Such affiliations have been sufficient enough to warrant an exploration of the notion of a Polish Netherlandism, suggesting not a mere superficial borrowing or imitation, but a considered system of cultural references.

Netherlandish connections with Polish art and culture have been the subject of individual studies and a few attempts at a broader synthesis. The best studies, such as those written by Andrzej Borowski, show the fluidity of the classification into "Netherlandism" and "Germanism" in the culture of the Polish territories rooted in the tradition based in the Hanseatic League (Royal or West Prussia and Pomerania with Gdańsk and Toruń). There has been a misleading tendency among Polish historians to merge the Netherlandism (of Gdańsk, Toruń, Królewiec, and other places) with Germanism. However, the German cultural tissue is distinct from the modern notion of Netherlandism.

While Netherlandism in Polish architecture and sculpture has been fairly well investigated, such is not the case with Netherlandish painting. Although there are some clear-cut and competently studied examples, such as the imports of Antwerp altarpieces

in the region of Gdańsk and Pomerania, Netherlandish influence on Gdańsk painting, and the reception of Rubens in Poland, no comprehensive study exists on the collecting of Netherlandish paintings in Old Poland. The present essay can offer only a summary presentation of the issue.

Two events bracket the history of important Netherlandish acquisitions in Poland. The first is the seizure by a privateer in 1473 of Hans Memling's altarpiece *The Last Judgment* {PL 4} and its presentation to the church of St. Mary in Gdańsk.[1] The second is the purchase by Jean-Pierre Norblin in 1774 of Rembrandt's *Landscape with the Good Samaritan* {FIG 1}. This painting entered the museum that Izabela Czartoryska created at Puławy to present historical relics and portraits after the final partition of Poland in 1795. Although these two events are sometimes treated as accidental and exceptional cases, demonstrating only a superficial interest in Netherlandish painting in Old Poland, Polish museums today contain about 2,000 Dutch and Flemish paintings that represent the various epochs and genres. The amassing of these works was a cyclical phenomenon, subject to brief peaks of interest when compared with the largely uninterrupted emphasis placed on the culture of Italy and France.

The beginning was fascinating and extremely promising. In April 1473 the Gdańsk privateer Paul Benecke, during the war between the Hanseatic League and England, captured the galley *San Mateo*, sailing from the Netherlands to London. According to one Caspar Weinreich, an eye witness: "On that ship there was a picture which was

PL 4

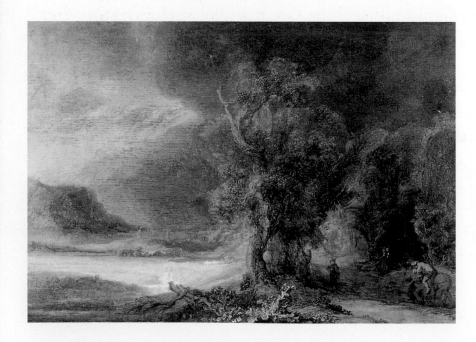

FIG I
Rembrandt van Rijn, *Landscape with the Good Samaritan*, 1638, oil on canvas, Cracow, The Princes Czartoryski Museum.

46

[then] set up on the altar of St. George [in the church of St. Mary], and which is a beautiful painting rich in noble art [*edelkunstreich*], and represents the Last Judgment."[2] The chronicler gave the date inscribed on the altarpiece, 1467, which was later taken as the year the work was completed or, more precisely, as the date of its commission by Angelo Doni, an agent of the Medici bank in Bruges. At first believed to be a work by Jan van Eyck, the Memling altarpiece was greatly admired from the beginning – less for its religious value than for its pictorial beauty. It became a symbol of the wealth and glory of Gdańsk. Although never directly imitated, Memling's work generated a vogue for large painted and carved altars from Bruges, Antwerp, and other towns in the Netherlands to be mounted in St. Mary's and in other churches in and around the city. Thus an accident of history gave rise to an important cultural phenomenon, and the church of St. Mary became a treasure house of Netherlandish as well as German works of art. Chance was transformed into a cultural custom.

However, apart from this case in Gdańsk, fifteenth- and sixteenth-century Poland was not noted for any intentional assembling of early Netherlandish painting. The one extremely important exception was the commission of a gigantic series of Brussels tapestries for The Wawel Royal Castle by King Sigismund II Augustus. In this commission, he departed from the tastes and traditions of his royal predecessors – his uncle Alexander the Jagiellonian, who initiated the rebuilding of the Wawel residence in the Italian Renaissance style, his mother, Bona Sforza, who brought Italian Renaissance furniture to Cracow, and his father, Sigismund the Old, the founder of the "Tuscan" Sigismund Chapel. Sigismund II Augustus's new-found interest in tapestries may have resulted from his desire to vie with the splendor of great contemporary European courts such as those of the emperors Maximilian (the *Hunts of Maximilian* tapestries) and Charles V (the *Conquest of Tunis* series woven in Brussels by Willem Pannemaker).[3]

Whatever the case, Sigismund II Augustus commissioned a magnificent set of tapestries, created on a scale without parallel in Renaissance Europe. The magnitude of the commission necessitated that the tapestries be woven at several of the best workshops over nearly two decades (1553–71). Such a commitment of time and money indicates that it was not a question of a single commission or a random aesthetic whim on the part of a capricious monarch, but a deliberate and well-articulated decision to make the royal residence a symbol of the splendor of the royal power.

1 See Jan Białostocki, *Corpus des primitifs flamands, Les Musées de Pologne*, vol. 9 (Brussels: Centre National de Recherches, 1966); Michał Walicki and Jan Białostocki, *Hans Memling. Sąd Ostateczny*. (Warsaw: Auriga, 1981)

2 Michał Walicki and Jan Białostocki, *Hans Memling. Sąd Ostateczny* (Warsaw: Auriga, 1981) and Prezmysław Trzeciak, *Tryptyk Sądu Ostatecznego w Gdańsku* (Warsaw: Akademia Sztuk Pięknych w Warszawie, 1990).

3 Jerzy Szablowski, *Arrasy flamandzkie w Zamku Królewskim na Wawelu* (Warsaw: Arkady, 1975; there exists an English version: *Flemish Tapestries in the Wawel Royal Castle in Cracow*). See also Maria Hennel-Bernasikowa, *Arrasy Zygmunta Augusta – The Tapestries of Sigismund Augustus* (Cracow, The Wawel Royal Castle, 1998).

Various formats and changes in the tapestry compositions support the conclusion that the commission involved a well-considered aesthetic and iconographic program. The tapestries fall into three distinct categories: a biblical cycle, designed by Michiel Coxcie, a second group with landscape and animal subjects, and a set of ornamental pieces with grotesques and armorial insignia. Brussels tapestries of this period were famous for their Italianate style and may, as a consequence, have appealed on a number of levels to the increasingly international tastes and expanding political position of Sigismund II Augustus. His collection established, if not precisely a custom, at least a point of reference for subsequent generations of Polish royalty. His successor, Ladislas IV Vasa, the only seventeenth-century Polish monarch to have a clearly outlined program of collecting, continued – undoubtedly consciously – the campaign to accumulate Flemish tapestries.

As Poland's contact with Western European countries increased in the seventeenth century, so did the pluralism of its taste. In concert with general European trends, there emerged a lively interest in collecting paintings. King Sigismund III made purchases in Rome, Venice, and the Netherlands, on the recommendation of envoys and his personal agent. On his Grand Tour of Europe in 1624–25, his son, Crown Prince Ladislas Sigismund, the future King Ladislas IV Vasa, visited Vienna, the Germanic lands, the Netherlands, France, and Italy. The purpose of his tour was both political and artistic: he hoped to win support for the plans of his father to recover the Swedish throne for the Vasa as well as the prince's personal artistic education. The tour also gave him the opportunity to purchase works of art. Details of this important journey, recorded by his traveling companions, indicate that he visited the studios of such internationally renowned artists as Rubens in Antwerp and Guido Reni in Italy. [4]

The well-known *Kunstkammer of Crown Prince Ladislas Sigismund Vasa* {FIG 2} was probably painted in Warsaw in 1626 as a document of the prince's acquisitions, after his

4 *Podróż królewicza Władysława Wazy do krajów Europy Zachodniej w latach 1624–1625 w świetle ówczesnej relacji*, ed. Adam Przyboś (Cracow: Wydawnicto Literackie, 1977); there exists a German version: *Die Reise des Kronprinzen Wladyslaw Wasa in die länder Westeuropas in den Jahre 1624–1625* (Munich: C.H. Beele, 1988); Juliusz A. Chrościcki, "Een reis van de Poolse Kroonprins (1624–1625)," in Antwerp, Koninklijk Museum voor Schone Kunsten, *De prinselijke pelgrimstocht. De "Grand Tour" van Prins Ladislas van Polen (1624–1625)* (Antwerp, 1997), pp. 33–42.

5 Juliusz A. Chrościcki, "De 'kunstkamer' van de Poolse kroonprins van 1626," in Antwerp (note 4), pp. 47–59.

6 Eric Duverger, "Annotations conbsernaant 'Sieur Jefan Bierens, agent et domesticque de son Alteze le Serenissime Prince Wladislaus Sigismundus, Prince de Pologne et de Suede' à Anvers," *Gentse Bijdragen tot de Kunstgeschiedenis en Oudheidkunde* 30 (1995), pp. 119–57. For another royal agent, see Ryszard Szmydki, "Joris Deschamps, agent du roi de Pologne...," in Brussels, Archives Générales, *Autour de J. Brueghel l'Ancien, P.P. Rubens, A. van Dyck...* (Brussels, 1999), cat. no. 989.

return to Poland. The medal in the foreground, on the table, represents a portrait of the prince and his titles. Ladislas commissioned the medal in 1624 in Vienna from the goldsmith Alessandro Abondio. The paintings represented are predominantly Flemish and Dutch. The large center painting is one of several versions of the *Drunken Silenus* by Rubens (until World War II in the Kaiser Friedrich Museum, Berlin). Among the other paintings are works by Jan Breughel the Elder, David Vinckboons, and engravings by Hendrick Goudt after Adam Elsheimer's *Tobias*, and on the right, Giambologna's sculpture *The Rape of the Sabines*. The painting has been variously interpreted as a specific record of the prince's collection and more generally as an allegory of royal taste. The style suggests significantly that the picture is the work of a Flemish artist, perhaps from Antwerp, who was working in Warsaw in 1626. [5]

Clearly the crown prince was steeped in contemporary European culture and identified with the leading artists and styles of the day, both Flemish and Italian. Later, as the king of Poland, he would purchase many Netherlandish works of art through his permanent agents, Jan Bierens in Antwerp and Hendrick van Uylenburgh in Amsterdam.[6] He also took part through intermediaries in the posthumous auction of Rubens's collection, competing for his works with representatives of the courts of Madrid and Bavaria, and with Cardinal Richelieu.

Prince Ladislas Vasa was only one of many Polish dignitaries to visit the studios of Dutch and Flemish artists in the early seventeenth century. Such visits are recorded in travel journals and in several rare cases in pictures that document Polish collectors in prestigious studios. Rubens's studio in Antwerp was favored among Polish notables:

FIG 2
Unidentified Antwerp Painter, *Kunstkammer of Crown Prince Ladislas Sigismund Vasa*, 1626, oil on panel, Warsaw, The Royal Castle.

FIG 3
Willem van Haecht, *Kunstkammer of Cornelis van der Geest*, 1628, oil on panel, Antwerp, Rubenshuis.

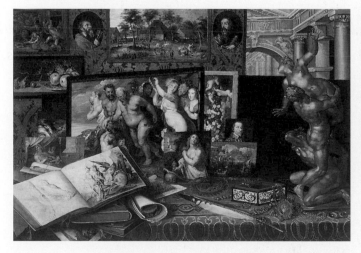

Albrecht Stanisław Radziwiłł is recorded there in 1613; Piotr and Stanisław Daniłowicz in 1619; Jerzy Ossoliński, 1621; Krzysztof and Łukasz Opaliński, 1626/29; and Bogusław Radziwiłł, before 1640.[7] The most famous example of the so-called studio visit type is the *Kunstkammer of Cornelis van der Geest*, painted by Willem van Haecht in 1628 {*FIG 3*}. This work is more remarkable for the group of visitors than for its painterly achievement: among those admiring the paintings are several Flemish painters, including Rubens; Archduke Albrecht of Habsburg and his consort, Isabelle; Nicolaes Rockox, Mayor of Antwerp; Ambrogio Spinola; and Crown Prince Ladislas Vasa, who wears the swash-buckling courtier's hat. Rather than recording a specific moment when these individuals gathered together, the painting is more likely a historical document of the important people who visited Cornelis van der Geest's collection.

Still, it is almost impossible to determine whether the Polish monarchs and aristocrats showed in their collecting tastes any particular fondness for Netherlandish art during this period. They seem to have collected works first by Italians and then by German masters. When they did acquire pieces by renowned Flemings, they seem to

FIG 4
Workshop of Rubens, *The Equestrian Portrait of King Sigismundus III Vasa*, 1630s, oil on canvas, New York, The Metropolitan Museum of Art, on long-term loan to Cracow, The Wawel Royal Castle.

FIG 5
Workshop of Rubens, *The Descent from the Cross* (now detroyed), until 1973 in Kalisz, church of St. Nicolas.

have done so less for the aesthetic quality of the works than for their subject matter, which were mainly portraits – for example, those commissioned from Rubens's studio by Sigismund III and Ladislas Vasa – or scenes of battle, such as those commissioned by Sigismund III from Jan Brueghel the Elder.[8] The portraits by Rubens and similar Flemish examples seemed to meet the general standard of expectations in this genre {*FIG 4*}. The same is true of the battle scenes commissioned by Sigismund III.

Nevertheless, one cannot deny that the Poles were fascinated by the wealth of artistic production and the abundance of paintings in houses and public buildings in the Netherlands. Sebastian Gwarecki, who accompanied Marek and Jan Sobieski (the future King John III) on their tour of Europe, recorded in his diary for 1646–48 that the Dutch people "are extremely fond of pictures..., so much so that you would not practically find one poor house in which the room would not be embellished with paintings."[9] Yet specific examples of collecting among the early seventeenth-century Polish aristocracy are scarce. In 1620 Piotr Żeroński, a royal secretary, brought back from his diplomatic mission a large-format *Deposition* (destroyed in 1973) for the church of St. Nicholas in Kalisz {*FIG 5*}; he also made purchases in the studio of Jan Brueghel the Elder.[10]

One especially notable collector was Krzysztof Opaliński, whose correspondence with his brother (1641–50) shows him to have been an avid collector of Netherlandish works. In 1641 he brought in through Toruń "quite a number of Rubens engravings, not yet seen" and in 1642 he bought a group of copperplates by Rembrandt (a very early instance of interest in this master outside Holland). He rebuked his agents in the Netherlands when they bought him nothing but "silly antics" and demanded more ambitious works. In 1645 Opaliński himself wrote from Antwerp that, with the help of the Jesuits, he had bought there lots of "originals and excellent copies," which must have been Flemish pieces. From Amsterdam in turn he brought "this and that, namely, countless tapestries and golden leathers *et hic similia.*"[11]

7 Ewa Manikowska, "Kolekcjonerstwo obrazów mistrzów europejskich w dawnej Polsce," in Warsaw, The National Museum, *Sztuka cenniejsza niż złoto. Obrazy, rysunki i ryciny dawnych mistrzów europejskich ze zbiorów polskich* (Warsaw, 1999), p. 26.

8 Jan Białostocki, "Jan Brueghel a Polska," *Biuletyn Historii Sztuki* 12 (1950), pp. 322–23.

9 Michał Walicki, "Wstęp," in Jan Białostocki and Michał Walicki, *Malarstwo europejskie w zbiorach polskich 1300 –1800* (Warsaw: Państwowy Instytut Wydawniczy, 1958), p. 18; there exists a German version: *Europäische Malerei in polnischen Sammlungen* (Warsaw, Państwowy Instytut Wydawniczy, 1957).

10 Jan Białostocki, "'Zdjęcie z krzyża' w twórczości P.P. Rubensa i jego pracowni (Uwagi o znaczeniu obrazu w kościele św. Mikołaja w Kaliszu)," in *Sztuka i historia. Księga pamiątkowa ku czci profesora Michała Walickiego* (Warsaw: Wydawnictwo Artystyczne i Filmowe, 1966), pp. 117–39; Eric Duverger, *Le Commerce d'art entre Flandre et l'Europe Centrale au XVIIe siècle.*

Evolution générale et développements régionaux en histoire de l'art. Actes du XXII-ème Congrès International d'Histoire de l'art (Budapest, 1972), pp. 157–81; Juliusz A. Chrościcki, "Rubens w Polsce," *Rocznik Historii Sztuki* 12 (1981), pp. 133–219; Chrościcki, "Een reis..." (note 4); Szmydki (note 6); Juliusz A. Chrościcki, "Obrazy religijne Petera Paula Rubensa," in Warsaw, The National Museum, *"Zdjęcie z krzyża" ze zbiorów Państwowego Ermitażu w Sankt Petersburgu. Z tradycji przedstawień pasyjnych w malarstwie i grafice północnoeuropejskiej XVI i XVII wieku, Arcydzieło Petera Paula Rubensa* (Warsaw, 2000), pp. 32–38.

11 Walicki (note 9), pp. 18–19. Cf. Stanisław Wiliński, "Krzysztofa Opalińskiego stosunek do sztuki," *Biuletyn Historii Sztuki* 17 (1955), pp. 191–205.

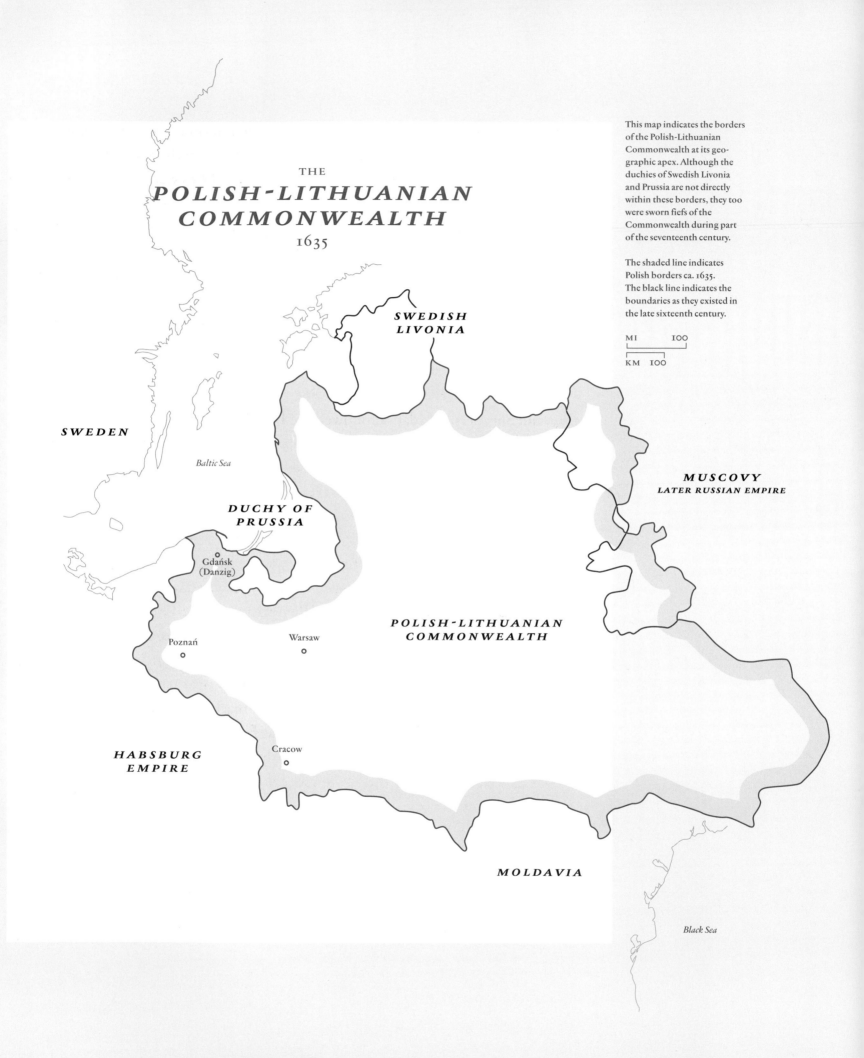

THE
POLISH-LITHUANIAN COMMONWEALTH
1635

This map indicates the borders of the Polish-Lithuanian Commonwealth at its geographic apex. Although the duchies of Swedish Livonia and Prussia are not directly within these borders, they too were sworn fiefs of the Commonwealth during part of the seventeenth century.

The shaded line indicates Polish borders ca. 1635. The black line indicates the boundaries as they existed in the late sixteenth century.

MI 100

KM 100

SWEDISH LIVONIA

SWEDEN

Baltic Sea

DUCHY OF PRUSSIA

Gdańsk (Danzig)

MUSCOVY
LATER RUSSIAN EMPIRE

POLISH-LITHUANIAN COMMONWEALTH

Poznań

Warsaw

HABSBURG EMPIRE

Cracow

MOLDAVIA

Black Sea

Netherlandish paintings increasingly formed an important part in the collections of Polish aristocrats in the second half of the seventeenth and in the eighteenth century. In addition to the Opalińskis were the Radziwiłłs at Biała, Nieśwież, and Nieborów; and the Leszczyńskis and Sułkowskis at Rydzyna. The remaining aristocratic collections, so far as they can be estimated today, remained Italian in their profile (for example, those of the Kazanowski, Ossoliński, and Lubomirski families).[12]

Only occasionally did middle-class circles show an interest in Netherlandish painting. One instance is documented in the 1672 will of a Cracow councilor, Jan Pernus, in which he bequeathed to the church of the Presentation Nuns in Cracow a *Presentation in the Temple*, attributed to Rubens.[13] In this respect Gdańsk remained an exception: collecting Netherlandish paintings in that city had been encouraged by custom. In a diary of his visit to Poland in 1635–36, Charles Ogier, a French merchant, noted that the patricians and burghers of Gdańsk followed the Dutch fashion and that he himself felt in this city as if he were in Amsterdam.[14] Here, as nowhere else in Poland, there developed a kind of erudite collecting that expressed itself in several varieties of *Raritätenkammern* that ranged in content from collections of paintings, numismatic items, and small sculptural items to wonders of the natural world.[15]

Netherlandish, including Dutch, paintings figured prominently in the seventeenth-century Gdańsk collections of Arnold von Holten and Georg Schröder. In the eighteenth century, Henrich Zernecke is known to have admired the works of Van Dyck; and the Van Mierises and Karl Friedrich Gralath collected paintings by Rubens, Van Dyck, and Jordaens, as well as examples of the Dutch *fijnschilders* (fine-painters). At the turn of the century, the impressive collection of paintings, engravings, and drawings assembled by Jacob Kabrun would eventually become the nucleus of the future National Museum in Gdańsk; the collection of Christian Schumacher, which included works by Wijnants and Netherlandizing Germans such as Bartholomäus Milwitz and Daniel Schultz, was also notable.[16] Perhaps significantly, the core of these collections was not paintings at all, but easily transportable items such as numismatic pieces, small Italian sculptures, and, above all, *naturalia*.

12 Walicki (note 9), pp 23-24; cf. also Bohdan Marconi, "Jedenaście obrazow z nieznanej galerii Sulkowskich w Rydzynie," *Bivletyn Historii Sztuki* 19 (1957), pp. 169–77.

13 Walicki (note 9), p. 19.

14 Teresa Grzybkowska, *Artyści i patrycjusze Gdańska* (Warsaw: Wydawnictwo DiG, 1996), p. 16; Antoni Romuald Chodyński, "Kolekcjonerstwo," in Gdańsk, The National Museum, *Aurea Porta Rzeczypospolitej.*

Sztuka Gdańska od połowy XV do końca XVII wieku, ed. Teresa Grzybkowska (Gdańsk, 1997), pp. 348–63.

15 Jean Bernoulli, *Reisen durch Brandenburg, Pommern, Preussen, Russland und Polen in den Jahren 1777 und 1778*, vol. 1 (Leipzig: C. Fritsch, 1779).

16 Gdańsk (note 14), pp. 351–58.

Thus the most important assemblages of Netherlandish paintings in Old Poland remained those of the successive kings, and even these were not without problems. Because of the elective system of monarchy and the separation of the state treasury and the king's property, there existed no hereditary crown. Consequently, there was no royal state collection in Poland as there were in France or England, but only the private collections built up by particular monarchs. This lack of continuity in royal collecting was exacerbated by political instability and wars, especially by the so-called Swedish Deluge, the invasion of the Swedish army in 1655–60. The "art room" of King Ladislas IV Vasa was scattered during the Swedish wars, and so was that of his brother and later king, John Casimir. The posthumous inventory of John Casimir's property, drawn up in Paris in 1672, though only partial (150 paintings were taken to France in 1668 after his abdication), mentions in addition to Italian masters, works by Rubens, Jordaens, Rembrandt, Nicolaes Maes, Govaert Flinck, and Simon de Vlieger.[17] Two Rembrandts that are now at the Gemäldegalerie in Dresden (*Rabbi*, 1654; and *Portrait of a Man*, ca. 1650), were probably once part of John Casimir's collection.[18]

The 1696 inventory of the property left by John III Sobieski reveals a wealth of textiles, tapestries, carpets, weapons, and items of the goldsmith's art, beside which the picture collection appears rather modest. Yet of the two hundred and forty-one paintings documented in his collection, thirteen were identified, and five of those were attributed to Rembrandt (*Rabbi*, *A Jewess in a Cap*, *The Three Magi*, *Abraham and Hagar*, and *An Old Man*), and one to Van Dyck (*Christ in the Garden of Gethsemane*).[19] In all likelihood the so-called Dutch Study that John III Sobieski created at his palace at Wilanów, which was situated on the main axis behind the Great Hall, was intended as an ideological and functional equivalent of the Marble Study that the Vasa kings had created at the Royal Castle in Warsaw. The existence of the Dutch Study in Sobieski's Italian *Villa Nuova* (that is, Wilanów) is of symbolic significance for royal art collecting in the second half of the seventeenth century, suggesting a highly charged infusion of the Netherlandish model into the king's still highly Italianized taste.

The collections of the two monarchs of the Saxon Wettin dynasty, Augustus II the Strong and Augustus III, were among the foremost in the Europe at the end of the seventeenth and beginning of the eighteenth centuries, also with regard to Flemish and Dutch painting. Built for the purpose of demonstrating the royal prestige newly acquired by the Saxon electors, largely with funds of the Polish Kingdom, these constitute a separate chapter and belong in the history of German, not Polish, collecting.

The first Polish collector truly aware of the artistic importance of Netherlandish, especially Dutch, painting, was the last king of Poland, Stanislaus Augustus Poniatowski. He became acquainted with Dutch art during his travels in Europe as a young man, beginning in 1748. In 1754 in Paris he met the intellectual and artistic elite in the renowned salon of Madame Geoffrin. From the Rococo artists he came to know there, he acquired a taste for the painting of Rembrandt and his circle. Starting in 1774 he began an intensive campaign of purchasing Dutch pictures through his agents in Amsterdam, The Hague, Paris, Hamburg, Berlin, and London. The London agents, Noel Desenfans and Francis Bourgeois, who worked for him from 1790 to 1795, accumulated a collection that in the end was not sold to the king, but became the nucleus of the Dulwich Picture Gallery.[20]

The collection of Dutch and Flemish paintings amassed by Stanislaus Augustus was surpassed only by the royal collections in London and Berlin, the imperial collection in Vienna, and the collections of the electors in Schwerin, Munich, and Dresden. In the group of 2,289 paintings entered in the last inventory of the royal gallery in 1795, about 225 pieces are identifiable as Dutch.[21] Works from other schools, including the dominant Italian and French pieces, were assembled according to the late Baroque taste or as a result of a fascination with the painterly quality and courtly finesse of the Rococo. Among the large number of Dutch pieces, at least sixty-nine paintings have survived in Polish collections, mainly in The Royal Castle, The National Museum, and Łazienki Palace in Warsaw.[22]

This collection of "Hollanders" had for the first time in the history of collecting in Poland a definite, clear-cut profile. It should be emphasized that the king bought Dutch pieces because they were usually quite cheap, small, and easily available on the contemporary art market. Nevertheless, their number and even their prices provide

17 Władysław Tomkiewicz, *Z dziejów polskiego mecenatu artystycznego w wieku XVII* (Wrocław: Ossolineum, 1952); Ryszard Schmydki, *Wyprzedaż mienia po Janie Kazimierzu w roku 1673* (Warsaw: Arx Regia, 1995).

18 Tomkiewicz (note 17).

19 Walicki (note 9), p. 22.

20 Washington, DC, National Gallery of Art, *Collection for a King. Old Master Paintings from the Dulwich Picture Gallery in London*, text by Giles Waterfield et al. (Washington, 1985); there exists a Polish version: *Kolekcja dla króla. Obrazy dawnych mistrzów ze zbiorów Dulwich Picture Gallery w Londynie* (Warsaw: Zamek Królewski w Warszawie, 1992).

21 Tadeusz Mańkowski, *Galeria Stanisława Augusta* (Lwów: Wydawnictwo Zakładu narodowego imienia Ossolińskich, 1932). This number is not entirely reliable, as the inventory

covers not only the pictures purchased by the king, but also a remainder of the collections of the Vasas and the Wettins as well as gifts, items acquired as various family legacies, etc. See also Antoni Ziemba, "Stanisława Augusta holenderski 'pochop.' Obrazy holenderskich mistrzów XVII wieku w kolekcji królewskiej," in *De gustibus. Studia ofiarowane przez przyjaciół Tadeuszowi Stefanowi Jaroszewskiemu* (Warsaw: Polskie Wydawnictwo Naukowe, 1996), pp. 41–52.

22 Among those that have remained outside Poland are Rembrandt's *Polish Rider*, in The Frick Collection, New York, and the *Self-Portrait* of Aert de Gelder, in the Hermitage, St. Petersburg.

insight into the king's tendencies and taste. In the group of sixty-seven Dutch landscapes, at least forty-one were Italianate pieces, which also were recorded with the highest values in the king's inventory; picturesque and fanciful landscapes were also highly regarded. There is a striking lack of interest in realistic landscapes of the kind painted by Salomon van Ruysdael or Jan van Goyen, the only exception being a panoramic landscape by Jan van der Meer and rare townscapes by Jan van der Heyden.

A similar taste for dramatic imagery is evident in the group of animal pictures, such as those by Melchior d'Hondecoeter, and generally lush, ornamental still lifes. Genre pieces included mostly works by the Leyden *fijnschilders* (Gerrit Dou, Pieter Slingelant, Philips van Dyck, Dominicus van Tol). These small cabinet pictures demonstrated the painter's skill in handling detail and they enjoyed considerable popularity among European collectors during the seventeenth and especially the eighteenth century. "Low" genre was strongly represented in the collection with works by Dou, Jan Steen, and Cornelis Saftleven, chosen no doubt for their picturesque values but priced very low.

Within the group of twenty-eight identified portraits and physiognomical studies (*tronies*), Rembrandt's circle predominated with seventeen pieces, including the well-known *Polish Rider* {FIG 6}, now in The Frick Collection in New York, and *A Scholar at His Desk*, as well as paintings no longer certainly attributed to the master, such as the *Girl in a Hat* (The Royal Castle, Warsaw) {FIG 7}, *Portrait of Maerten Soolmans* (The National Museum, Warsaw), *Portrait of the Young Rembrandt* (Tarnowski Collection, Warsaw), and the so-called *Portrait of Rembrandt's Brother* (Musée du Louvre, Paris).[23]

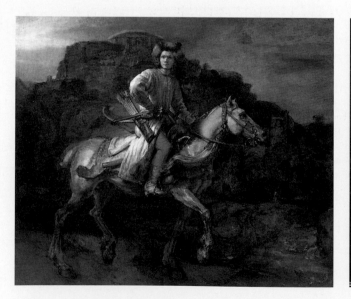

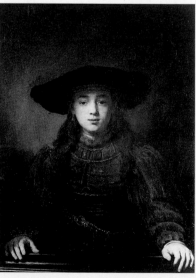

FIG 6
Rembrandt van Rijn, *Polish Rider*, ca. 1655, oil on canvas, New York, The Frick Collection, originally in the collection of King Stanislaus Augustus Poniatowski.

FIG 7
Rembrandt, attributed to, *A Girl in a Hat*, 1641, oil on canvas, Warsaw, The Royal Castle, originally in the collection of King Stanislaus Augustus Poniatowski.

The *tenebrist,* "psychologizing" Rembrandt-school type of portrait was assessed fairly high, while purely realistic portraits were less favored and valued lower.

Among the twenty-seven Dutch mythological and biblical scenes in the king's gallery, works by Haarlem or Utrecht Mannerists and, surprisingly, by the *Caravaggisti,* were very rare. Thirteen scenes were "stories," painted by artists from Rembrandt's circle, such as the *Ecce Homo* (in fact, *Flagellation*), today at the Hermitage and now attributed to Willi Drost, which at 500 ducats was the highest valued Dutch painting in the collection. Alongside them were paintings by the Leyden *fijnschilders* and their later followers.

This survey demonstrates the salient features of the king's collection: his clear preference for the Baroque and distinct avoidance of anything realistic, documentary, or devoid of "imagination." Moreover, despite the Baroque tendency, little attention was paid to the non-Rembrandtesque tendencies in Dutch historical painting (Caravaggism, Haarlem classicism). Stanislaus Augustus filled this gap by acquiring Flemish paintings, mainly those from the circles of Rubens, Van Dyck, and Jordaens, and with works by Teniers, Snyders, and other exponents of lower genres of painting. In his Dutch works he preferred first of all the picturesque merits of a pictorial form (Rembrandt and his circle); secondly Baroque exuberance, dynamism, and sumptuousness (still lifes, Ruisdael-style landscapes, Flemish-type portraits, d'Hondecoeter-type animals); thirdly the meticulous, highly finished manner of the Leyden *fijnschilders*; and finally, the idyllic canon of Italianate landscapes. The Rembrandts ranked the highest are imbued with an intense, sentimental, lyrical mood (*Jewish Bride,* Drost's *Flagellation*).

King Stanislaus Augustus's vision of Dutch painting had an immediate and on-going impact on art collecting in Poland. A new appraisal of Rembrandt, which the king had acquired from Madame Geoffrin's circle, manifested itself in Jean-Pierre Norblin purchase of the master's *Landscape with the Good Samaritan* in 1774 in Paris. There is nothing to indicate that Norblin bought this painting for Izabela Czartoryska, who was his patron beginning that year, but had not yet begun to build her museum. She probably acquired the painting much later, around 1810, after Norblin had returned to Paris (1804) from Anna Potocka, née Tyszkiewicz.[24] The king's taste for Dutch art left its stamp on the now-dispersed Sapieha collection begun in 1795, in which alongside Italian and

23 Michal Walicki, "Rembrandt w Polsce," *Biuletyn Historii Sztuki* 18 (1956), pp. 319–48; Jan Białostocki, *Rembrandt et ses élèves: trois problèmes, Biuletyn Historii Sztuki* 18 (1956), pp. 349–69; Antoni Ziemba, "Dwa obrazy z kolekcji Lanckorońskich: Rembrandt i Bol, *Ikonotheka* 13 (1998), pp. 11–24; Antoni Ziemba et al., "'Bildnis eines jungen Mannes' aus der Werkstatt Rembrandts im Lichte physikalisch-chemischer Untersuchungen, part II: Bericht über die Untersuchungen zum Gemalde, seine Geschichte, Probleme mit der Identifizierung des Porträtierten und mit der

Zuschreibung des Werkes," *Bulletin du Musée National de Varsovie* 38 (1997 [1998]), nos. 1–4, pp. 52–65; Antoni Ziemba, "Obrazy Rembrandta w Polsce," in Warsaw (note 7), pp. 56–68.

24 Marek Rostworowski, *Rembrandta przypowieść o miłosiernym Samarytaninie* (Warsaw: Wydawnictwo Artystyczne i Filmowe "Auriga", 1980), p. 110. The paintings in the Czartoryski collection had always reflected the owner's preference for Italian and French rather than Northern art, even after the death of Princess Izabela.

French masters was a sizable representation of seventeenth-century Netherlandish painters, including Jacob van Ruisdael, Gabriel Metsu, and Casper Netscher.

Part of the king's collection (including Rembrandt's *Polish Rider*) passed through Hieronim Stroynowski to the Tarnowski family. In the nineteenth century, Netherlandish paintings found permanent places in the collections of the Mniszech family, Bishop Ignacy Krasicki, Józef Ossoliński, Stanisław Kostka Potocki, and especially in that of Helena (née Przeździecka), and Michał Radziwiłł at Nieborów and in Królikarnia, and, in the second half of the century, in the collection of Seweryn Mielżyński at Miłosław. The Mielżyński collection, along with that of Atanazy Raczyński, formed the nucleus of the gallery of the present National Museum in Poznań. Nevertheless, the majority of the renowned collections (of, for example, Izabela Działyńska, née Czartoryska, at Gołuchów and the Potockis in Cracow and Krzeszowice) continued to focus on Italian and French masters.

The canons of these aristocratic collections, evolving from a palace gallery to a modern museum, were to be continued in the form of cabinet collections intended for education and study and put together by a wealthy intellectual elite (Tomasz Zieliński in Kielce, Wojciech Kolasiński in Warsaw, Jan Popławski and the Krosnowski family in St. Petersburg, and many others), which formed the nucleus of public museums. The year 1862 witnessed the establishment of the Warsaw Museum of Fine Arts as a result of the purchase of Johann Peter Weyer's collection of Old Masters, dominated by valuable Netherlandish paintings such as those by Jean Bellegambe, Ambrosius Benson, and Jacob Jordaens.

PLATES

1–26

LITTLE POLAND PAINTER

POLISH, ACTIVE MID-15TH CENTURY

PIETÀ

CA. 1450

TEMPERA ON
WOOD PANEL
51 ⅛ X 33¼
INCHES
130 X 84.5
CENTIMETERS
WARSAW,
THE NATIONAL MUSEUM
ŚR. 312

Stylistic analysis situates the origin of this *Pietà* in mid-fifteenth-century Little Poland, the province that assumed political dominance in the Middle Ages and a center of art and culture. Cracow, the largest city and the capital of the kingdom, was also home to the largest diocese and the royal university, the second oldest in Eastern Europe, after the university in Prague. Its many workshops attracted and trained artists both local and foreign, including the sculptor Veit Stoss of Nuremberg, who worked in Cracow from 1477 to 1496.

This *Pietà* is one of the oldest surviving pictorial representations of this scene, a subject from the Passion of Christ that developed in Polish art in the fourteenth century and became popular in the fifteenth, especially in sculpture. The representation of the Mother of God holding the body of Christ on her knees is defined by the Italian term *Pietà*, derived from the Latin word *pietas* which denotes godliness, piety, and, by extension, charity. In this interpretation, Mary holds in her lap the inert body of her son, with one hand supporting his head and the other clasping his elbow. Bleeding wounds in his side and his hands and feet bear witness to his suffering, as does the blood that has trickled from under the crown of thorns onto Christ's shoulders. Symbols of the Passion surround the figures. Mary sits on the grass against a hill, but the earthly landscape has been replaced in the center of the composition by a mystical, golden background, symbolizing the heavenly sphere and the sacred character of the event. Depicted at the side of the picture in reduced scale is the kneeling figure of the donor, an unknown clergyman.

Because the development of the Little Poland painting is closely connected with the stylistic phases of Gothic art as a whole, it is not surprising that this *Pietà* displays features of the International Style, adopted from Bohemian art, that mirrored the ideals of knightly culture so popular during the first half of the fifteenth century. Idealized forms and delicate modeling create a lyrical mood; Mary is a type reminiscent of Italian Madonnas. The tragic content has been depicted here in a very subdued manner. Mary's pain, though evident, does not distort her beautiful face. The inclination of her head and her delicate, subtle gestures render her tenderness and love of her son, not outward despair. The youthful and fragile figure of Christ additionally heightens the mood. During the second half of the century, greater realism entered Gothic art, stemming from Netherlandish painting and its adaptation in German workshops. During the Baroque period, the *Pietà* was extensively repainted and cut down to fit the frame of the new altar. Conservation carried out at The National Museum has restored its original colors. MK-R

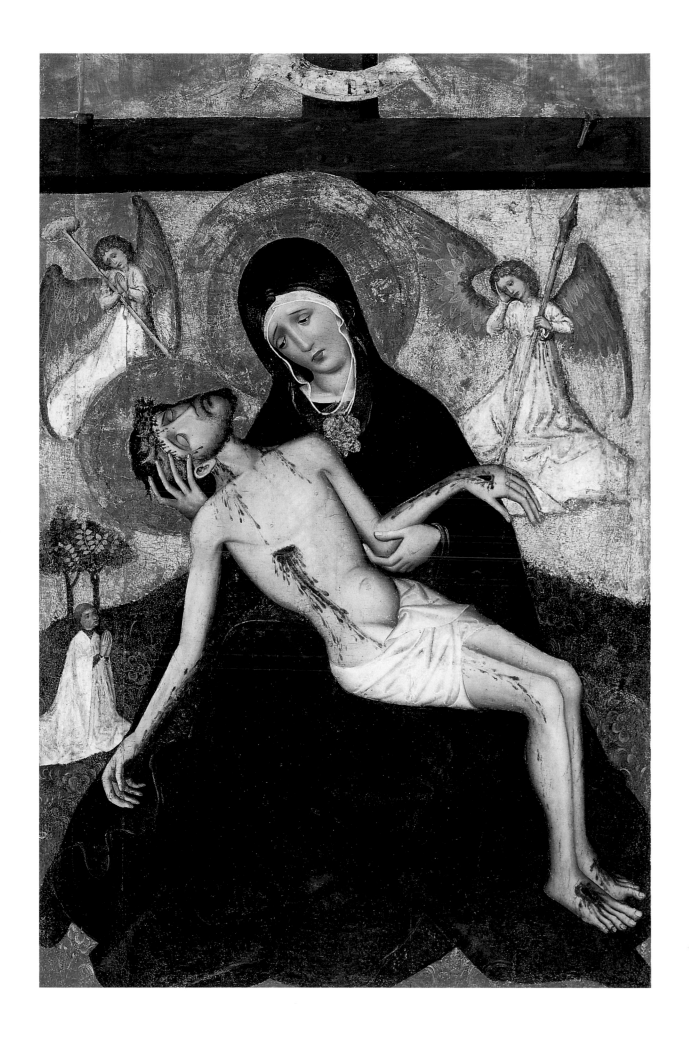

GREAT POLAND PAINTER

POLISH, ACTIVE EARLY 16TH CENTURY

VIRGIN AND CHILD
WITH ST. FELICITY AND
ST. PERPETUA
CA. 1525

TEMPERA ON
WOOD PANEL
73 1/4 X 60 1/4
INCHES
186 X 153
CENTIMETERS
WARSAW,
THE NATIONAL MUSEUM
ŚR. 37

This *Virgin and Child with St. Felicity and St. Perpetua* is one of the finest examples of Late Gothic painting in Great Poland. Its artistic quality, erudite iconographic program, and historical data suggest a link with an episcopal patronage and with the capital of Great Poland: Poznań. The oldest Polish region, Great Poland in the tenth century became a political nucleus around which neighboring territories united to form the Polish State. In the thirteenth century, the transfer of the capital of the Polish Kingdom to Cracow, the principal city of Little Poland, brought a decline in the political and, consequently, cultural status of Great Poland. Despite the lack of royal patronage, the church and leading families continued their support. Nevertheless, only random examples of the Gothic painting of Great Poland have survived, perhaps because of the ravages wrought by the wars with Sweden in the seventeenth century and the widespread practice of modifying the interior decoration of churches in the Baroque style.

Guild records list the names of a considerable number of artists working in Great Poland, their styles evidently influenced by the painting of Little Poland, the main art center in Poland. The most exuberant and creatively independent period of Great Poland's medieval painting took place in the first quarter of the sixteenth century, when Late Gothic and Early Renaissance elements came together, often in colossal winged altarpieces. The *Virgin and Child with St. Felicity and St. Perpetua* probably formed the central part of such a triptych painted by an unidentified artist active in Great Poland from the second decade of the sixteenth century.

Based on the numerous stylistic affinities of this painting with the works associated with the Master of the *Warta Triptych* and his circle, especially in the facial types of the figures in the predella, the artist may have collaborated with that master or have been a member of his workshop. The painting demonstrates the transition from medieval to Renaissance art in its looser grouping of figures and in the sweeping landscape in the lower zone, which is closely akin to examples of the Danube School. Influences from the circle of Lucas Cranach the Elder are discernible in the robes of saints, especially in the highly sophisticated palette enhanced through glazes.

The symbolism of the *Sacra Conversazione* theme has been extended in the present picture by allegorical content and by personifications. Mary and the Child are attended by the Early Christian martyrs Felicity and Perpetua, whose names, inscribed in Latin, form the maxim *Felicitas Perpetua* – perpetual felicity, thereby personifying heaven's eternal bliss. Mary, who is being crowned by angels, is represented as the Queen of Heaven, while the apple in her hand additionally shows her as the new Eve. The background symbolizes the heavenly sphere, in contrast to the earthly sphere of suffering below, exemplified by a man drowning in the sea, wounded men (probably victims of attack), a beggar, a blind man, and a dying man. These examples may also refer to Mary as the *Mater Misericordia* and *Stella Maris,* whose mercy is sought by the suffering. MK-R

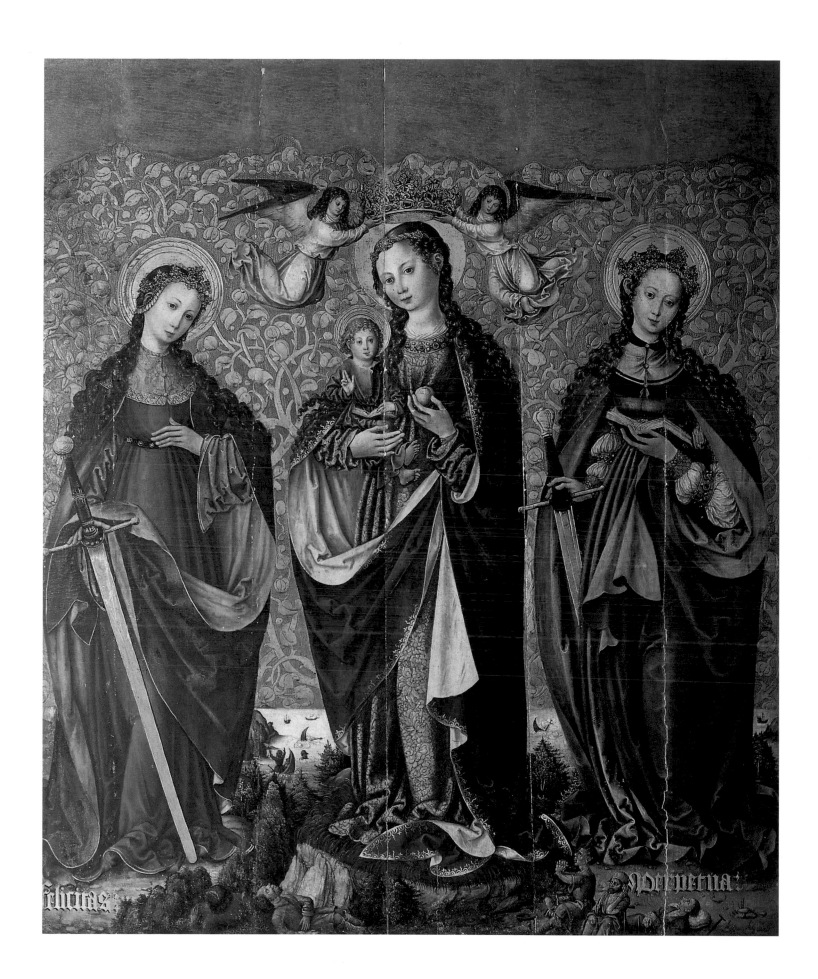

3

STANISŁAW SAMOSTRZELNIK

POLISH, CA. 1480–1541

PORTRAIT OF
PIOTR TOMICKI
1530–1535

TEMPERA ON
WOOD PANEL
94 7/8 × 55 7/8
INCHES
241 × 142
CENTIMETERS
CRACOW,
CLOISTERS OF THE
FRANCISCAN FRIARY

For some 500 years, Cracow was the political and cultural capital of Poland. From the early Middle Ages to the close of the sixteenth century, the city's fortunes coincided with the glittering and stimulating life of the royal court on Wawel Hill. As the kingdom of the last rulers of the Piast line and the succeeding Jagiellonian dynasty climbed to an important political and economic position in Europe, Cracow became an international center for ideas and influences that fanned out over the vast territory of Poland and beyond. This rich intellectual environment stimulated an active interest in the arts and the emergence of Polish artists of the first rank.

Stanisław Samostrzelnik was a Cistercian monk and artist who lived in the order's monastery in the village of Mogila outside of Cracow between 1513 and 1530. The author of illuminated manuscripts, mural decorations, and paintings, he worked for the court of King Sigismund I and for the households of the Grand Chancellor of the Crown, Krzysztof Szydłowiecki, as painter and chaplain, and for Piotr Tomicki (1464–1535), Vice-Chancellor of the Crown and Bishop of Cracow.

Portrait of Piotr Tomicki shows this advisor to King Sigismund as a humanist and patron of the arts, as well as a bishop. Larger than life and dressed in pontificals painted in minute detail, he is standing in front of an arcade supported by candelabra columns and a half-drawn tapestry above which can be seen a patterned gold ground. Similarities exist between this hieratic treatment of the bishop and representations of holy bishops in the Little Poland school of Late Gothic altarpieces; the candelabra and other details are probably modeled on elements of Cracovian and German book design.

The realistic, forthright characterization of Tomicki's features makes this painting one of the outstanding examples of early sixteenth-century Polish portraiture. Ever since its completion, it has hung in the cloisters of the Franciscan friary in Cracow, where beginning in the fifteenth century, portraits of the bishops of Cracow were assembled, at first painted directly on the walls and subsequently on panels and then on canvas. Tomicki's is the earliest surviving portrait in this still ongoing gallery, and the first in which the subject's features were individualized. Its composition set the tone for portraits of bishops up to the late sixteenth century. LW

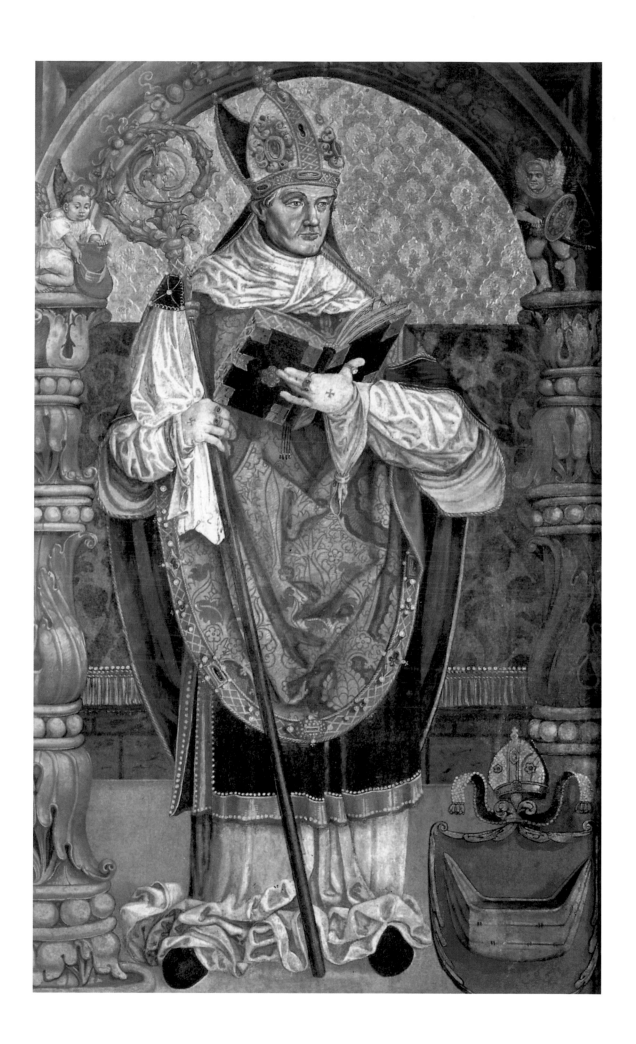

HANS MEMLING

NETHERLANDISH, ACTIVE 1465–1494

THE LAST JUDGMENT
1467–71

TEMPERA AND OIL
ON WOOD PANEL
CENTRAL PANEL:
92 ¹/₄ × 71 ¹/₈
INCHES
242 × 180.8
CENTIMETERS
WINGS:
92 ¹/₄ × 35 ³/₈
INCHES
242 × 90
CENTIMETERS EACH
GDAŃSK,
THE NATIONAL MUSEUM
SD/413/M

The most important work of art in The National Museum in Gdańsk is the triptych *The Last Judgment*, one of two large-scale paintings by the master painter from Bruges, Hans Memling. The altarpiece unexpectedly found its way to Gdańsk in 1473, when it was captured by a Gdańsk pirate, Paweł Benecke, during the Fourteen Years' War between England and the Hanseatic League. The triptych, en route from the Netherlands on the galleon the *San Matteo,* was originally destined for the church of Badia Fiesolana in Florence, specifically for the family chapel of Angelo di Jacopo Tani, the banker of the Medicis, who had commissioned the painting. The Gdańsk pirate seized the ship's precious cargo during a blockade, and subsequently presented the altarpiece to the church of St. Mary's in Gdańsk. Despite the protests and complaints of the Duke of Burgundy, Charles the Bold, and Pope Sixtus IV, the work by Memling remained in Gdańsk.

In the course of Gdańsk's stormy history, numerous attempts were made to buy the much coveted triptych and to remove it by less scrupulous means. Emperor Rudolf II of Prague offered 40,000 thalers for it, while Tsar Peter I of Russia, who was in Gdańsk in 1716 during the Northern War, demanded the painting as an additional contribution. The town council emphatically objected and the painting remained safe for a while longer. It was only in 1807 that Napoleon Bonaparte's emissary, Baron Vivant-Denon, managed to confiscate the triptych for Napoleon's museum in Paris. On the downfall of Napoleon, the Prussians took the painting to Berlin as revindication of plundered art works. The Gdańsk

town authorities, however, were relentless in their desire to have the painting back and it was returned in 1816. During World War II, the Germans removed the painting and took it to Thuringia, where it was found by the Red Army. After being taken to the Hermitage Museum in Leningrad, where the painting underwent conservation, it was returned to Gdańsk on September 22, 1956, and put on exhibition at The National Museum.

Hans Memling painted the triptych at the beginning of his artistic career and his stay in Bruges, in all likelihood between 1467 and 1471. The scene of The Last Judgment, visible when the altar is open, has an integral, clear composition organized around the central figure of Christ – Judge, Savior, and King of the New Covenant. Below Christ in Judgment is the Archangel Michael wearing knight's armor and towering above the naked souls on all sides awaiting salvation or damnation. The wing on Christ's right is filled with figures climbing the crystal steps to Paradise, while the wing on Christ's left shows the damned being thrust into the burning depths of hell. On the outside of the wings, the artist has portrayed the kneeling donor, Angelo di Jacopo Tani, and his eighteen-year-old wife, Caterina de Tanagli, accompanied by their patron saints, the Virgin Mary and the Archangel Michael.

Memling's scene of The Last Judgment depicts the moment of transition from finite time to eternity. The vision of the "eighth day" – that is, the depiction of the end of time – in Memling's interpretation combines a number of iconographic motifs introduced into medieval depictions of this subject (Christ

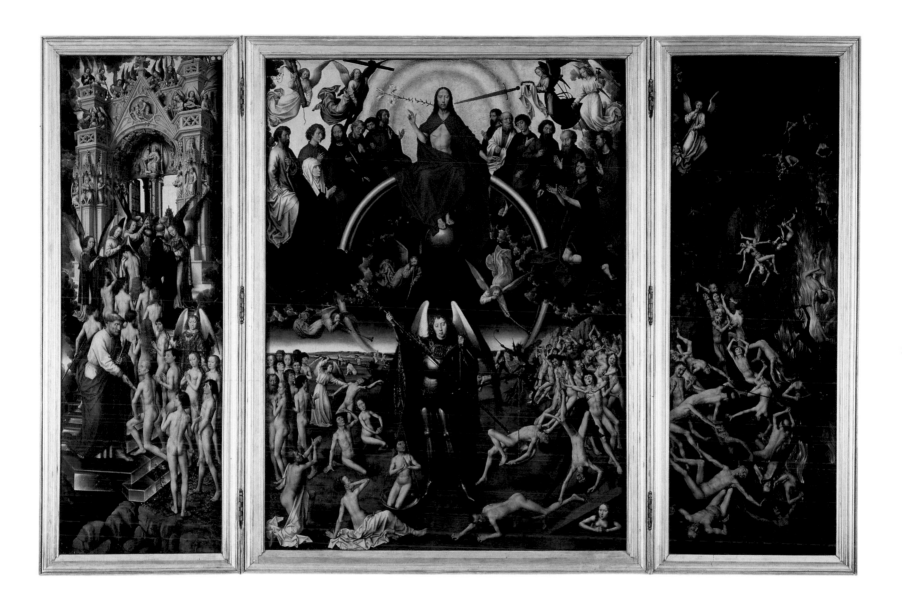

enthroned on the rainbow, the resurrection of souls, the Archangel Michael weighing the judged, etc.). Memling uses them skillfully to form a pictorial theological treatise, expounding all Church tenets of the faith. The triptych not only presents a detailed history of events associated with The Last Judgment of Christ, drawn from the Old Testament and the New Testament as well as from writings of theologians and mystics, but also expresses a sincere profession of faith in the donors, who are shown in humble attitudes of eternal prayer.

Memling's eschatological vision is dominated by Christ. Wrapped in a red mantle, with the gesture of his hand he sets everything around him in motion, dividing good from evil forever. The gates of the Garden of Eden, shown as the Gothic portal of a cathedral, are a symbolic representation of the Church, the only way for the faithful to gain salvation. Depicted without reference to her maternal role and devotion, Mary on the Day of Judgment is presented in the heavenly realm as the intercessor on behalf of mankind, but above all as the second Eve, bringing salvation to the world. This program is underscored by scenes in Paradise, such as the Annunciation and the Creation of Eve. The elaborate symbolism of plants, precious stones, and even animals enables the viewer to identify the virtues that line the crystal steps to the gates of the New Jerusalem. Lush grasses and increasingly exuberant flowering plants accompany the saved. The flowers of spring and early summer represent virtues (a daisy: modesty; a violet: humility; a columbine: suffering and self-mortification; and an orange lily: the blood shed by martyrs). Scattered at the foot of the crystal steps are some precious stones. Pearls symbolize innocence and chastity; sapphires: fidelity to God; rubies: love and sacrifice; and a crystalline diamond – frequently associated with Christ – courage and fortitude in suffering.

In a parallel scheme, Memling named the sins and vices that cause eternal damnation, which are personified by devils. One of them has been given a peacock's tail as a symbol of pride. A devil fighting for a human soul has the wings of a nettle butterfly, a symbol of inconstancy of faith. A reddish-brown bear symbolizes the sin of gluttony; a devil with a wild boar's snout: debauchery; and a lion: anger. There is no vegetation on the infernal side; the scorched earth is barren.

The Archangel Michael, weighing good and evil, acts in accordance with the Augustinian theology of grace: the man full of grace turns the scales, whereas a lack of grace causes the individual on the other pan to be totally insubstantial, weighing nothing at all. These acts of judgment on the Last Day take place not only on the temporal plane of the altarpiece, but also in the real time of the viewer. On the archangel's golden breastplate are recorded all the events of Judgment Day, even those that are not included within the picture, but are reflected as if on the surface of a convex mirror from beyond the picture plane. Through this device, the artist has intentionally involved the viewer in these mystical events. With all elements of the iconography and precisely painted details thereby forming a theologically and artistically coherent composition, Memling created *The Last Judgment* to inspire the faithful with a fear of eternal damnation, and to invoke deep religious reflection and contemplation. BS

THE LAST JUDGMENT

DETAIL

5

VEIT STOSS

GERMAN, 1447–1533

DESIGN FOR AN ALTAR
AT THE CARMELITE CHURCH
IN NUREMBERG
CA. 1520

PEN AND INK ON PAPER
17 3/4 × 13
INCHES
45.2 × 33.1
CENTIMETERS
CRACOW,
THE MUSEUM OF THE
JAGIELLONIAN UNIVERSITY,
COLLEGIUM MAIUS
INV. 9600-2617/II

Veit Stoss' earliest and most characteristic work is the gigantic altarpiece carved between 1477 and 1489 for the church of St. Mary in Cracow. Influenced by the intense realism of Nicolaus Gerhaert, Stoss' art is even more dramatic and monumental. The Cracow shrine is dedicated to the Life of the Virgin and displays all the vividness of a medieval mystery play. The figures are carved in the round and some of them are well over life-size. Stoss was little concerned with human anatomy and correct proportion, but achieved his striking effects through a rich display of draperies that create bold patterns of light and shadow. He settled in Nuremberg in 1489, but his career was sporadic because he forged a document and consequently was involved for years in criminal proceedings.

This extremely valuable drawing, *Design for an Altar at the Carmelite Church in Nuremberg,* was made in connection with Stoss' last important work, a carved high altar for the church of the Most Sacred Savior, a commission he had received in 1520 from the Carmelites in Nuremberg; the artist's son Andrew was at the time the prior of the monastery. Although the altar was completed in 1523, the artist never received his final payment. Following his death, the Municipal Council of Nuremberg consented in 1542 to give the altar to his heirs, who subsequently sold it to the parish church in Bamberg. Shortly before the outbreak of World War II, the altar was transferred to the local cathedral, where it remains today.

Design for an Altar at the Carmelite Church in Nuremberg is a preliminary drawing for the triptych, which rests on a predella and is crowned by a superstructure in the form of a trefoil. The large center scene depicts the Nativity, enclosed by a semicircular arch with figural ornamentation; a single Corinthian column emphasizes the vertical orientation of the altarpiece. To the left of the column are the figures of Mary and Joseph, and to the right is a group of angels and shepherds adoring the Child. The wings of the triptych depict scenes from the Life of Mary: on the upper left is the Annunciation with the Visitation below. On the right wing at the top is the Adoration of the Magi, and at the bottom the Presentation of Christ in the Temple. The predella bears scenes of the Creation of Eve, the Expulsion from the Garden of Eden, and the Sacrifice of Isaac. The trefoil superstructure is topped by three standing figures: Christ Triumphant in the center, with the Virgin Mary on the left and St. John on the right. In the arches crowning the wings are Elijah in the Wilderness on the left and the Rest on the Flight to Egypt on the right.

The drawing itself was undocumented for a long time and is still little known today – perhaps because it was in the hands of the artist's descendants, in the Carmelite monastery, or in the municipal archives in Nuremberg. It turned up at auction in 1871 in Munich and eventually was bought by Prince Władysław Czartoryski, who presented it to the Jagiellonian University. Seized in 1940 by the Nazis, the drawing surfaced again only in 1977, in the print collection of the Staatliche Museen in Berlin. In 1980 the German authorities turned the drawing over to the Ministry of Culture and Art in Poland. It was initially placed in The National Museum in Warsaw, but returned to The Museum of the Jagiellonian University in January 1981. BL

6

JAN SANDERS VAN HEMESSEN

FLEMISH, CA. 1500–1566

HOLY FAMILY

MID-1540S

OIL ON WOOD PANEL

38 X 27 ³/₄

INCHES

96.7 X 70.4

CENTIMETERS

CRACOW,

THE WAWEL ROYAL CASTLE,

STATE ART COLLECTIONS

INV. 1151

Jan Sanders van Hemessen was the most important artist working in Antwerp during the second quarter of the sixteenth century. His moralizing genre and biblical scenes reveal a trenchant Northern realism counter-balanced by the classical ideals of antiquity and the Italian Renaissance. An extensive trip to Italy in the 1520s and a later trip to Fontainebleau in the mid-1530s brought him into contact with the heroic, muscular figures of Michelangelo, the soft modeling and atmospheric *sfumato* of Leonardo, and the tightly intermeshed compositions of Mannerist painters like Rosso Fiorentino and Frans Floris. Hemessen's own eclectic yet very popular combination of these influences brought him fame and fortune and put him squarely at the forefront of the International Mannerism movement. His paintings were owned by such important collectors as Emperor Rudolf II, Queen Christina of Sweden, and the Elector Maximilian I of Bavaria.

This *Holy Family* has been securely linked to Hemessen on the basis of an engraving by J. A. Prenner, which includes the following inscription: *JOANN. HEMESEN PINXIT*. Prenner reproduced this picture, along with a number of others, when it was still part of the collection of Emperor Charles VI in Vienna. The attribution to Hemessen has been widely accepted in the literature and the painting is regarded as a remarkably fine example of the artist's work. Hemessen repeated the composition of this *Holy Family* in several other versions, most notably in paintings in Munich (Bayerische Staatsgemäldesammlungen) and Cologne (Wallraf-Richartz Museum); on the basis of comparison

with a painting in Stockholm (Nationalmuseum) that is signed and dated 1544, the present work may also be assigned to the mid-1540s.

The depiction of the Holy Family with the additional presence of St. Elizabeth and the young St. John the Baptist, who holds a banderole with the inscription *ECCE AGNUS DEI*, suggests a deeply religious message within the context of the Counter-Reformation that emphasizes the role of the Christ Child as the future Savior and Redeemer. The Mannerist poses, intricate arrangement of the figures, and foreshortening are all characteristic traits of Hemessen's expressive, Italianizing style, while the breathtaking passages of landscape and expressive physiognomic detail link him firmly to the Northern tradition of naturalism. JW-W

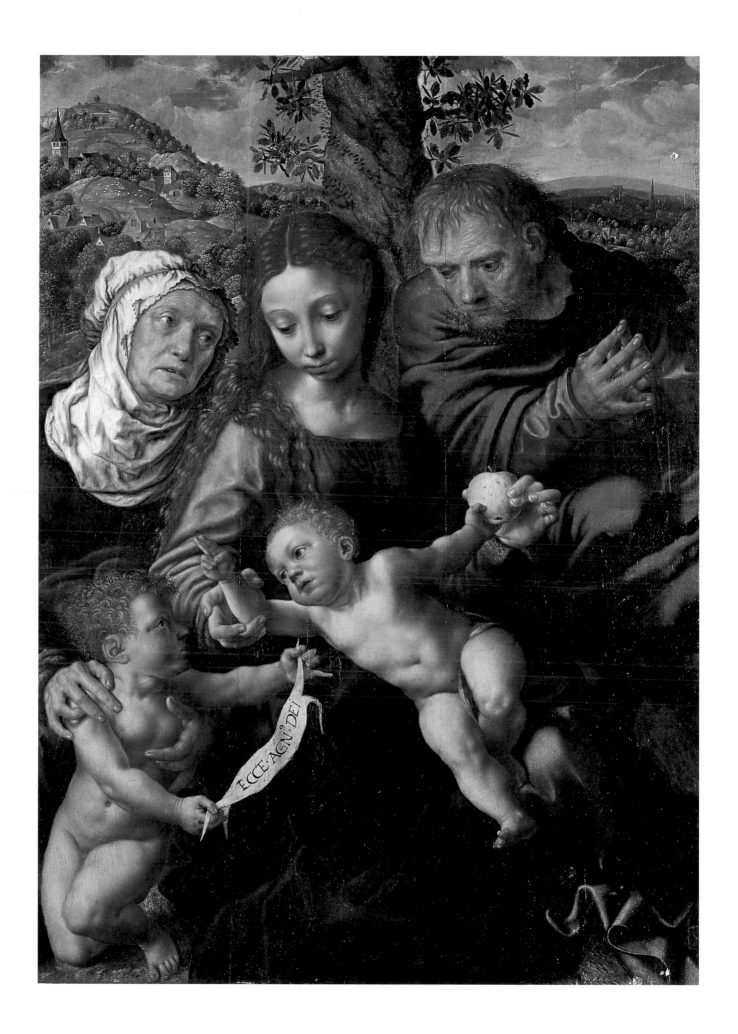

7

JAN MASSYS

FLEMISH, 1509–1575

VENUS AND CUPID

CA. 1560

OIL ON WOOD PANEL

52 X 37

INCHES

132 X 94

CENTIMETERS

CRACOW,

THE MUSEUM OF

THE JAGIELLONIAN UNIVERSITY,

COLLEGIUM MAIUS

INV. 15790

Venus and Cupid is an outstanding work of the Netherlandish master Jan Massys. Jan trained under his father, Quinten Metsys, whose studio he may have taken over following the father's death in 1530. Two years later he was admitted as a master in the Guild of St. Luke in Antwerp and shortly thereafter may have worked for a brief period at Fontainebleau. In 1544, together with his brother Cornelis and several other artists, he was accused of the clandestine dissemination of heresy and was exiled from Brabant. He traveled as a fugitive to Italy, France, and perhaps also Germany, before being allowed to return to Antwerp in 1555. Most of his paintings date from this second, highly productive Antwerp period: 1555–78.

Throughout his career Jan Massys worked in the traditional style and subject matter of his father. His paintings of the female nude are, however, truly exceptional. As was often the case in the mid-sixteenth century, Old Testament, allegorical, and mythological subjects served as a pretext for the depiction of the nude. *Venus and Cupid* is one of three paintings that feature the same large-scale, classicizing figure reclining awkwardly in the foreground, with a topographical landscape in the distance. The other two paintings probably represent *Flora* or *Venus Cythereia,* one with a view of the harbor at Genoa in the distance (1561; The Royal Museum, Stockholm) and the other with the shipping lanes of Antwerp (1559; Kunsthalle, Hamburg). The landscape in *Venus and Cupid* has never been successfully identified. Some speculation exists as to whether or not the landscapes in Jan's pictures were actually painted by him or by his brother Cornelis. In any

case, Cornelis died in 1556-57 and therefore cannot be linked to this particular group of works.

The overt sensuality of the motif of the reclining female nude can be linked to the School of Fontainebleau, and particularly to the works of Jean Cousin and Primaticcio. Cousin's *Eva Prima Pandora* (ca. 1545; Musée du Louvre, Paris) may have been a direct inspiration for Massys's painting. Italian prototypes may also be found in Titian's *Venus and the Organ Player* (Museo del Prado, Madrid) and his famous *Venus and Cupid* (Galleria degli Uffizi, Florence).

During the German occupation in World War II, Massys's *Venus and Cupid* was taken from the Pusłowski Palace and carried away by the Reich. In 1976 it was discovered in Heidelberg by a former director of the Germanisches Nationalmuseum in Nuremberg. Thanks to the efforts of Dr. Andrzej Ciechanowiecki, a well-known Polish art historian residing in London, the painting was returned to Poland in 1984. It underwent conservation treatment and is now the property of The Museum of the Jagiellonian University. AJ

BARTHOLOMÄUS SPRANGER
FLEMISH, 1546–1611

VANITAS

CA. 1600

OIL ON CANVAS

26 ³/₈ × 38

INCHES

67 × 96.5

CENTIMETERS

CRACOW,

THE WAWEL ROYAL CASTLE,

STATE ART COLLECTIONS

INV. 9354

Bartholomäus Spranger was one of the most important Netherlandish artists of the sixteenth century. He traveled widely in Italy and France before he finally settled in Prague in 1581 at the court of Emperor Rudolf II. There he became a leading figure in the later Mannerist movement, combining the Netherlandish tradition with Italian influences, particularly the Roman brand of Mannerism, so as to achieve a style of his own that had a lasting influence on other artists in Prague. His sensually elegant yet intellectual paintings embody an ideal of beauty distinctive to the Rudolfine court. As Karel van Mander recorded in his life of Spranger, the emperor often came to watch the painter at work, and until 1601 Spranger was not allowed to receive private commissions.

The image of a putto resting against a skull is one of the traditional representations of death in the guise of the youthful god Thanatos. In this *Vanitas*, the expression of the themes of mortality and transience is emphasized by an hourglass and the words *HODIE MIHI CRAS TIBI* [Mine today, yours tomorrow], inscribed in Roman letters on the tablet supported by the putto. The painting was probably executed around 1600, which was the year Spranger's wife Christina Müller died. Spranger did at least one other work that commemorated the death of his wife – an allegory that was later engraved by Aegidius Sadeler. Although this *Vanitas* does not contain any references to a particular person or event, the small format and the refined, Mannerist pose of the putto may suggest that the picture was intended for a private *cabinet d'art*.

In all probability the motif of a putto with a skull appeared for the first time on a medal wrought by the Venetian medallist Giovanni Boldù in 1458; it was popularized in painting, and especially in sixteenth- and seventeenth-century Netherlandish engraving, for example, in works by Aegidius Sadeler, Frans Floris, Crispijn de Passe, Jan Sanders van Hemessen, and Abraham Bloemaert. It can also be found in the ample emblematic literature of the period. The Spranger picture may have served in turn as a model for the Amsterdam painter Pieter Heseman (1592–1624), who repeated the putto's attitude almost unchanged in his *Allegory of Death and Resurrection* (Gemäldegalerie der Akademie der bildenden Künste, Vienna). JW-W

JAN VAN GOYEN
DUTCH, 1596–1656

HUTS BY A CANAL
1630

OIL ON CANVAS
39 × 36
INCHES
99 × 91.5
CENTIMETERS
GDAŃSK,
THE NATIONAL MUSEUM
MNG/SSD/275/ME

Jan van Goyen, who spent the last years of his life at The Hague, was held in high esteem as a painter, but earned his living by speculating in real estate, frequently running into debt and eventually dying insolvent. He traveled extensively throughout Holland, drawing and sketching to record his experiences. The influence of his last teacher, Esaias van de Velde, is discernible in his paintings and drawings of 1620–26, but he soon went on to create his own, new style of Haarlem tonal painting, distinguished by a monochromatic palette with a predominance of yellows, browns, and greens.

In the 1630s van Goyen began concentrating on rural landscapes, dune scenes with rivers, focusing on depicting the beauty of his own country in as natural a manner as possible. Signed and dated 1630 (and possibly cut down at the left side), *Huts by a Canal* is one of the first of the artist's works in this style and also one of the most notable paintings in Polish collections. It depicts several rustic huts by a canal, among tall, exuberantly green trees. A swineherd with his pigs approaches a footbridge across the water. Nearby are two busy fishermen in a boat moored to the bank. The impression is of a split-second glimpse into reality: a piglet that has strayed from the herd, tools abandoned in the modest farmyard, a bird soaring in the sky. The monochromatic tone of the painting helps to create a strong sense of atmosphere. The exceptional feeling for nature and its interpretation in Dutch painting appeared first in the works of Seghers and Rembrandt. Van Goyen created a new space viewed fragmentarily and differentiated through gradations of light in which several zones are joined together by landscape elements, such as water, roads, trees, and buildings. A similar harmonious accord exists between nature and the people. In van Goyen's universe, despite its air of "reportage," nature is invariably imaginary and its primary structural role is played by light and the ambient air. Such landscapes are imbued with the symbolism of human existence and transience of this world or with religious aspects and praise of the Protestant work ethic. BP-S

SIMON LUTTICHUYS, ATTRIBUTED TO

DUTCH, 1610–1661

STILL LIFE WITH SKULL

CA. 1635–40

OIL ON CANVAS

17 7/8 X 13 5/8

INCHES

45.2 X 34.8

CENTIMETERS

GDAŃSK,

THE NATIONAL MUSEUM

MNG/SD/330/ME

This early work by Simon Luttichuys illustrates the transitory nature of life. The inclusion of the skull reveals the theme of *"vanitas,"* the vanity of human life. A number of elements support this meaning. The anatomy book, mirroring sphere, and heavenly globe are all objects frequently used in *vanitas* still lifes by Dutch artists of the seventeenth century. This particular painting belongs to a group of the so-called Learned Still Lifes, which emphasize tables scattered with writing materials, books, old documents, globes, and literary texts. They functioned as symbols of both knowledge and transience, and were popular with scholars as well as artists.

The works of art portrayed in Luttichuys's picture–engravings and paintings – actually existed, as did the atlases and books. Next to the skull, on the left, is a small, unfinished canvas of a male bust, painted after a Jan Lievens engraving. On the left side, propped against the wall, is a canvas picturing a male head that also resembles a figure from a Lievens engraving. Tossed below it are two Rembrandtesque prints by Lievens, featuring old men (one probably a portrait of Rembrandt's father). These various "tronies," or head studies, date from Lievens's Leiden period, around 1630–31, and help to reinforce the theme of a *vanitas*, or, more precisely, the idea of *vita brevis, ars longa*. The juxtaposition of the skull next to the painted and engraved portraits supports the idea that art will remain while people will return to dust.

The book in the foreground, Gabriel Rollenhagen's *Selectorum Emblematum*, underscores the emblematic nature of the subject matter, while the tome on human anatomy further defines the transitory nature of human life. Suspended above the entire scene is a lustrous glass ball on a cord, in which are reflected part of the still life, a painter at an easel, and a woman standing behind him, within a studio with a large window. The fact that Luttichuys has depicted himself as a reflection and in the act of painting illustrates not only his exemplary skill as a artist, but reaffirms the idea that only the painted surface will remain. Hence, the appearance of the artist's own likeness on the suspended base emphasizes both the illusory power of his art and its enduring nature.

Still Life with Skull was attributed in the nineteenth century to Rembrandt and in the later twentieth century to Rembrandt's pupil Gerrit Dou. Placed correctly within their orbit because of its small format and subtle tonal gradations, the painting is, however, very probably by Simon Luttichuys, an artist who worked in Amsterdam and specialized in still lifes and portraits. The stylistic analysis of a second version of this painting, which appeared at auction in New York in 1995, has now allowed the Gdańsk painting to be reattributed with some certainty. BP-S

II

MATTHIAS STOM[ER]

DUTCH, CA. 1600–CA. 1652

In the darkness of night brightened by an oil lamp, a gray-haired, bearded old man with a furrowed face and tearful eyes keeps a prayerful vigil, his hands folded and tightly clasped. He sits at a table on which lie books, papers, and a key – the attributes of St. Peter. During the period of the Counter-Reformation, devotional pictures of saints doing penance or meditating on sin and guilt were particularly recommended by the Catholic Church as moral examples for the faithful. Exceptionally popular were images of Mary Magdalene and St. Peter, especially as recounted in Jacobus de Voragine's thirteenth-century *Golden Legend*, which told of the apostle's tears of contrition and despair whenever he recalled the sweetness of his closeness to Christ and the bitter guilt of having denied him. Following this legend, the artist has depicted the nighttime vigil in a close-up, large format in which the expressive realism and dramatic *chiaroscuro* help to create an emotional response in the viewer.

In the inventory of the Krosnowski collection, *St. Peter with Candlelight* was recorded as by Gerrit van Honthorst, with a question mark. Slightly later the word "copy" was added in pencil, which probably saved the picture from being confiscated during the war. However, this is undoubtedly a painting by Matthias Stom, an artist from Amersfoort, near Utrecht, who spent most of his life in Italy. From 1630 to 1632 he was in Rome, then went to Naples, where there are a number of paintings by his hand in churches, and then farther south, to Caccamo, Sicily (1641), and on to Palermo between 1646 and 1649. In Sicily he created his most important pictures and counted among his patrons the Duke of Messina and the Archbishop of Monreale, Giovanni Torresiglia.

Stom's large-format pictures are mostly of religious subjects, but he also painted mythological, historical, and genre scenes. They are distinguished by a close vantage point, *chiaroscuro* effects, and a realistic, even exaggerated, accentuation of textural folds, wrinkles, and gesticulation, and intricate, ornamental draperies. These stylistic features originate from Caravaggio's art, but were also assimilated through the works of Honthorst and Dirck van Baburen of Utrecht, as well as Paulus Bor of Amersfoort. The Warsaw canvas was probably painted in Naples between 1633 and 1640, when Stom's works reveal the influence of Neapolitan painters such as Bernardo Cavallino, Giovanni Ricco, and Jusepe de Ribera. MK

DAVID TENIERS THE YOUNGER

FLEMISH, 1610–1690

The subject of *Daniel in the Lions' Den* is described in the Book of Daniel, which relates how Daniel and other faithful young Israelites brought as hostages to Babylon by King Nebuchadnezzar in 605 B.C., survived torments for remaining true to their God then and later under the reign of Darius. This painting refers to Daniel's night in a den of lions where he remained unharmed.

David Teniers the Younger has placed the biblical story in a scenic setting. Against the dark background of a rocky grotto, a group of majestic, royal lions are posed in the middle distance. A macabre still life of human and animal bones and skulls in the foreground emphasizes the dire situation. Framed among the beasts in a lighted arch is the figure of Daniel (according to iconographic tradition, depicted as a youth, though he was actually eighty years old at the time), his eyes confidently turned upwards to God, his hands folded in prayer. The radiance surrounding him symbolizes a spiritual bond with God as the only true guarantor of safety and peace. In addition to the beauty and naturalistic study of the exotic animals and interesting plants, the painting thus serves as an allegory of the religious virtues of faith and hope.

Originally attributed to Roelant Savery and then tentatively to David Teniers the Younger, it now seems to be an indisputable early and exceptionally high quality work of the latter artist. His almost monochromatic early compositions often feature landscapes with the picturesque grotto motif, a frequent setting for depictions of hermits in their rocky abodes. Likewise typical of the Warsaw painting is the mode of painting rocks in wide, soft brush strokes and the handling of characteristic vegetation and still life. The small figure of Daniel with a delicate face is very characteristic of Teniers's style.

The photographic documentation of the Rijksbureau voor Kunsthistorische Dokumentatie at The Hague includes a photograph of a Teniers painting signed and dated 1649 (Staatliches Museum, Schwerin, Germany), which represents a composition identical to that of the Warsaw painting. Almost twice as large and painted on canvas, rendered from a slightly more distant vantage point, and much lower in artistic quality, the scene is clearly related to the Warsaw example. HB

JAN RUTTGERS NIEWAEL

DUTCH, CA. 1620–1661

Portraits of women dressed as shepherdesses were very popular with both artists and their patrons in the Netherlands during the seventeenth century. A special vogue existed for pictures of lovers in a landscape setting, thanks to Pieter Cornelisz Hooft, whose drama, *Grandida,* ushered in countless plays and poems with a pastoral motif. In the 1620s and 1630s, shepherds and shepherdesses were painted by numerous artists of the Utrecht and Amsterdam schools. Portraits in pastoral guise also became fashionable, and a portrait of a woman was often paired with that of a man dressed as a shepherd and playing a flute. The present painting hovers ambiguously between an actual portrait, an allegory, and a moralizing depiction of erotic character.

The yellow straw hat, the low-cut and revealing dress, and the subject's equivocal gesture with a shepherd's crook in her hand, carry deep erotic implications, while the roses adorning her hat may symbolize the sorrows of love. The woman's lush and sensual beauty and direct, inviting gaze embody the opulence of earthly existence and personify the life-giving powers of nature.

Pastoral garb, so ambiguous in its symbolism, was initially used only in the theater, and only later worn in spring by young women from the middle and upper classes, when they went on excursions into the country, affording a kind of pastoral amusement. Believed to be invariable, timeless, and synonymous with the purity and simplicity of the soul – unlike urban attire – these costumes represented the simplicity and earthiness of love. This style of dress can be found as well in graphic illustrations of the period, including print series depicting the most beautiful courtesans of the past. Viewed in this perspective, the Niewael painting corresponds to the ideal of feminine unaffectedness and ease, free from the fetters of middle-class morality. The stylistic conventions of the painting are Flemish and based most notably on works by Rubens and Jordaens. BP-S

14–16

FERDINAND BOL

DUTCH, 1616–1680

14

HAGAR AND THE ANGEL
MID-17TH CENTURY

OIL ON CANVAS
38 ³/₈ × 45
INCHES
97.3 × 114.4
CENTIMETERS
GDAŃSK,
THE NATIONAL MUSEUM
MNG/SD/269/ME

Ferdinand Bol was born in Dordrecht, where he was probably a pupil of Jacob Cuyp. After 1635 he moved to Amsterdam, continuing his education in Rembrandt's atelier until 1641, when he began working independently. Bol's early paintings were considerably influenced by Rembrandt, and despite his switch in the latter half of the 1640s to the courtly, Baroque style of Bartholomeus van der Helst, he reverted from time to time to his earlier models. A master of mellow *chiaroscuro* painting and decorative coloring, Bol created works that appealed to and were eagerly commissioned by the most affluent burghers of Amsterdam. He frequently preceded his idealized compositions by preparatory sketches and study drawings, which enabled him to choose the best compositional solution. After 1660 the artist received more and more public commissions from institutions and private clients. He was highly appreciated as a painter of historical and allegorical pieces, but also as a notable portraitist. It is a pity that after 1669, when he married a rich widow, Anna van Erckle, he abandoned painting; in the records of 1670–80, he no longer appears as a painter, but as a merchant.

The painting *Hagar and the Angel* depicts a story from the Old Testament. Sarah, the wife of Abraham, was unable to bear children, so she asked her husband to take her Egyptian slave Hagar as his wife. Nonetheless, when Hagar became pregnant, the jealous Sarah humiliated the slave, who fled her home. In the wilderness on the way to Shur, the despairing Hagar stopped at a well of clear water. An angel appeared and commanded her to return, comforting her with the knowledge that she would give birth to a son whose name would be Ishmael and who would have many descendants (Gen. 16: 1–16).

The composition is divided symmetrically and marked by contrasting light and shadow – an aspect of classical painting of the school of Rubens. On the right side is a frightened and humble Hagar, who kneels and submissively bows her head. Dominating the left half of the canvas, the majestic angel clothed in shimmering white is illuminated by light filtering through the dark clouds and accompanied by cherubs. Although the influence of Rembrandt in Bol's works is always apparent, Bol did develop his own subtle treatment of light and palette. And although his figures never attained the spiritual depth of his master's characters, Bol, too, was interested in their inner experience as expressed through their gestures and attitude. This angel seems more earthbound than transcendent as he coquettishly lifts the hem of his robe while gazing at the kneeling Hagar. Bol has set the figures in a specific and atmospheric space. Light plays the principal role in integrating the various shades of gold, brown, and red into a brilliant golden glow and a rich gradation of tonal values.

Depicted against a neutral ground, framed by the white of a lace cap and a simple collar, is the face of an old woman. Her high, finely shaped forehead is contracted at the root of a rather large nose by two folds that give the face a concentrated, anxious look. Thin, pale eyebrows emphasize the fleshy folds over the expressive eyes. The lips, closed with one corner slightly raised, contribute a bit of a skeptical smile.

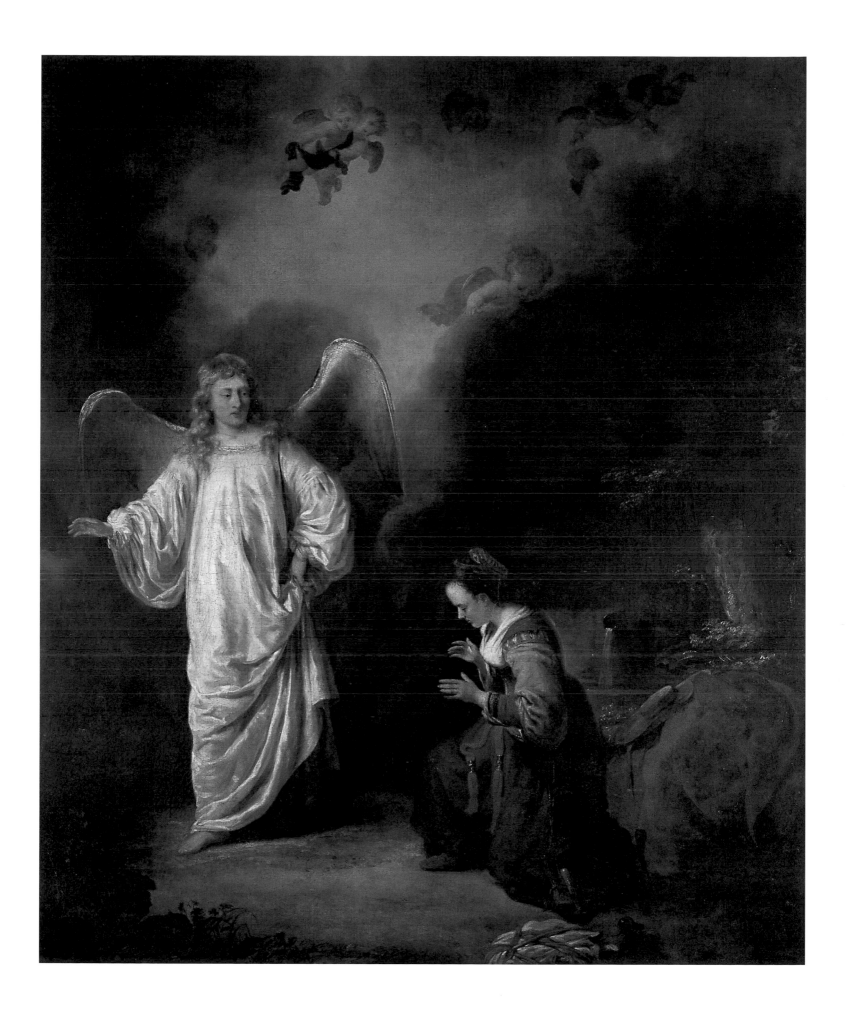

Remarkable psychological insight has been achieved by a simple composition, the reduction of decorative elements, and the use of light focused mainly on the woman's face.

The attribution of *Portrait of an Old Woman* has been a subject of debate. It had been bought by King Stanislaus Augustus Poniatowski as a Rembrandt (royal inventory of 1795), but as early as 1895 was identified as a work by Bol – an attribution largely supported by scholars. Subsequent conservation has revealed the subtle colors of the painting that further align it with the work of Bol: the old woman's dark-blue dress, the golden-brown fur edging her vest, which beautifully harmonizes with the brown back of the armchair; the delicate blush of her complexion was formerly obscured by thick varnish. The paintings closest to the Warsaw portrait are the *Portrait of Elisabeth Jacobsdr. Bas*, attributed to Bol in 1911 but originally regarded as a Rembrandt (Rijksmuseum, Amsterdam) and the *Portrait of a Woman with a Handkerchief* (Art Gallery of Ontario, Toronto, signed *Rembrandt* and dated *1644*). Also closely related are the *Portrait of a Young Lady with a Glove in Her Left Hand* (National Gallery of Ireland, Dublin, identified as a Rembrandt, ca. 1640–42) and the *Portrait of an Old Lady* (Gemäldegalerie, Berlin, signed *Bol* and dated *1642*). Regardless of the questions surrounding the artist and the identity of the sitter, the painting was one of the 172 pictures (out of 2,289) that the last Polish king took with him into exile.

Johanna de Geer was the second wife of Hendrick Trip, a rich Amsterdam arms trader (both he and his brother Louis were called "cannon kings" [*de kanonenkoningen*]). In 1660 the popular Amsterdam portraitist Ferdinand Bol depicted the married couple in a manner conventional for the burgher portrait, against a landscape and with attributes referring to the profession of the master of the house (pendant portraits, Musées Royaux des Beaux-Arts, Brussels). The following year Bol painted Warsaw's *Portrait of Johanna de Geer-Trip*, showing the young mother in a more formal interpretation, seated against a column and heavy drapery and wearing a rich gown with one strand of pearls over a rather low-cut dress and another coiled round the right hand. A fine beret with an ornamental plume lies nearby. On Johanna's knees stands the little Cecilia, clasping her mother's forefinger with her right hand and in the left holding the end of the gold chain girding her pinafore. Serenity, affirmation of life, and affluence emanate from the faces of the subjects, the scheme of composition, and the wealth of colors. In all probability the picture is a companion to a similar portrait of Johanna's husband (Museo d' Arte de Ponce, Puerto Rico). The pair of portraits once adorned the Trip house (*Trippenhuis*) in Amsterdam, built in 1660–62 by Justus Vingboons. Hendrick Trip died within a few months after the completion of the building.

Bol portrayed Johanna Trip-de Geer once more, as *Charity*, together with two of her children (Rijksmuseum, Amsterdam). The portraits created for the Trip family afford an excellent opportunity to trace the development of Bol's style, from the influence of Rembrandt in the Brussels painting to the more decorative and formal solution of the Warsaw picture to the Amsterdam painting that reflects Italian and French Late Baroque allegorical portraits. BP-S and MK

15

PORTRAIT OF AN OLD WOMAN

CA. 1640–42

OIL ON CANVAS
31 7/8 × 26 3/4
INCHES
81 × 68
CENTIMETERS

WARSAW,
THE NATIONAL MUSEUM
M.OB.555

16

PORTRAIT OF JOHANNA
DE GEER-TRIP
1661

OIL ON CANVAS
49 5/8 × 35 7/8
INCHES
126 × 97
CENTIMETERS

WARSAW,
THE NATIONAL MUSEUM
M.OB.556

DANIEL SEGHERS

FLEMISH, 1590–1661

FLOWERS WITH A
PORTRAIT OF POUSSIN
1650–51

OIL ON CANVAS
38 ¹/₂ × 31 ³/₈
INCHES
98 × 79.8
CENTIMETERS
WARSAW,
THE NATIONAL MUSEUM
M.OB.566

Daniel Seghers, a Jesuit painter, specialized in flower painting, usually depicting garlands or bouquets encircling a stone cartouche with a figural, usually religious, scene in the center. Following typical seventeenth-century Antwerp workshop practice, the figures were for the most part painted by other artists, such as Erasmus II Quellinus, one of Seghers's most frequent collaborators. This illusionistic convention of a picture within the picture was originated by Jan Brueghel the Elder and continued in numerous versions by Daniel Seghers.

Seghers's subtle flower arrangements frequently showcase plants flowering in different seasons. In *Flowers with a Portrait of Poussin*, five bouquets are rather symmetrically disposed and linked by a creeping ivy. At the bottom an illusionistic stone relief painted in *grisaille* features a bust of the famous French classical painter Nicolas Poussin (1594–1665). Such a rare departure from a religious subject represents an homage to the French master. Seghers met Poussin in Rome in 1625–27, and the two artists painted at least two pictures together. The prototype for the portrait was a self-portrait that Poussin painted for the Paris banker Charles Pointel in 1649 (Gemäldegalerie, Berlin), which Jean Pesne used as a model for an engraving made in 1650–60. The print probably was the basis for the image in the Warsaw canvas, where it imitates a marble relief. The absence of carved pupils heightens the illusion of its being a work in stone. A seemingly ancient, cracked marble slab reveals only two words of the original inscription: *TRIA EGO*, a possible circuitous reference to Poussin's thoughts on beauty in his *Observations on Painting* (1672).

A second Seghers painting featuring the likeness of another famous seventeenth-century painter, Peter Paul Rubens, is in the Princeton University Art Museum, New Jersey. In this painting Seghers's portrait is done in a monochromatic style that emphasizes the painterliness of Rubens. Both pictures were created after 1649 and both likenesses were based on engravings related to self-portraits. Furthermore, the two celebrated painters were the leaders of two different, even opposing, Baroque traditions: Poussin representing the classical, sculpturesque, and rationalist mode based on drawing, and Rubens the spontaneous, painterly style, strongly dependent upon color. Seghers's modes of depiction correspond with these two trends and such an early comprehension of this dichotomy in seventeenth-century painting was remarkable. It was not until 1671 that a famous discourse began within the French Académie concerning the superiority of drawing over color. The conflict between the Poussinistes and the Rubénistes continued until at least 1677. Another possibility, however, is that the portraits were added at a later date, a practice occasionally followed by Seghers. A later insertion supports the interpretation of the inscription of the Poussin as relating to his treatise on beauty, not published until 1672. HB

HERMAN SAFTLEVEN

DUTCH, 1609–1685

By 1911 the museum in Poznań had acquired a number of paintings from the rich collection of the German merchant Otto Wesendonck (1815–1896), whose wife, Mathilde (1828–1902), was the muse of the famous composer Richard Wagner (see his "Wesendonck-Lieder," 1857/58). Wesendonck's collection contained works by prominent contemporary German artists and some of the finest examples of European Old Master paintings.

Among the many seventeenth-century Dutch paintings in the collection was *Winter Landscape* by Herman Saftleven, an esteemed painter from Utrecht. His early landscapes reveal a strong influence of Abraham Bloemaert and especially Jan van Goyen. By the mid-1640s Saftleven traveled regularly along the Moselle and the Rhine in Germany, making numerous topographic drawings, which he subsequently often used in his compositions, leading to his nickname "De Rijnstroomschilder" (Painter of the Rhine River). After 1650 his paintings exhibited great ease and freedom in his observation of nature, and he tended to specialize in panoramic, more or less fantastic landscapes, frequently animated with the staffage of tiny figures.

This imaginary mountainous landscape in *Winter Landscape* reflects the artist's journeys to the Rhine valley and the tradition of Netherlandish panoramic landscape. The high vantage point recalls the Flemish tradition of the "cosmic landscape," as practiced by Joachim Patinir and Jan Brueghel. The lofty ice-covered rock formations and snow-capped peaks over wide river valleys dotted with fortresslike hamlets are illuminated by an extraordinary lilac-

blue light responsible for a veritable fairyland atmosphere that spreads over the mountains. Discernible in the background are groups of peasants busy talking and gathering dry wood onto sledges. Their red clothes are the sole warm accent in the winter surroundings. Other small figures climb and move about in the glistening landscape. The tiniest detail is rendered with striking precision. While this subject matter is exceptional among Saftleven's works, the composition and light tone are typical of his late pieces. The visionary effect is enhanced by the painterly technique, with the use of white glazes on a blue ground. The artist's well-known predilection for bluish cool tones in his paintings of 1645–65 permits the dating of the present landscape to that time, the best period in Saftleven's work. MPM

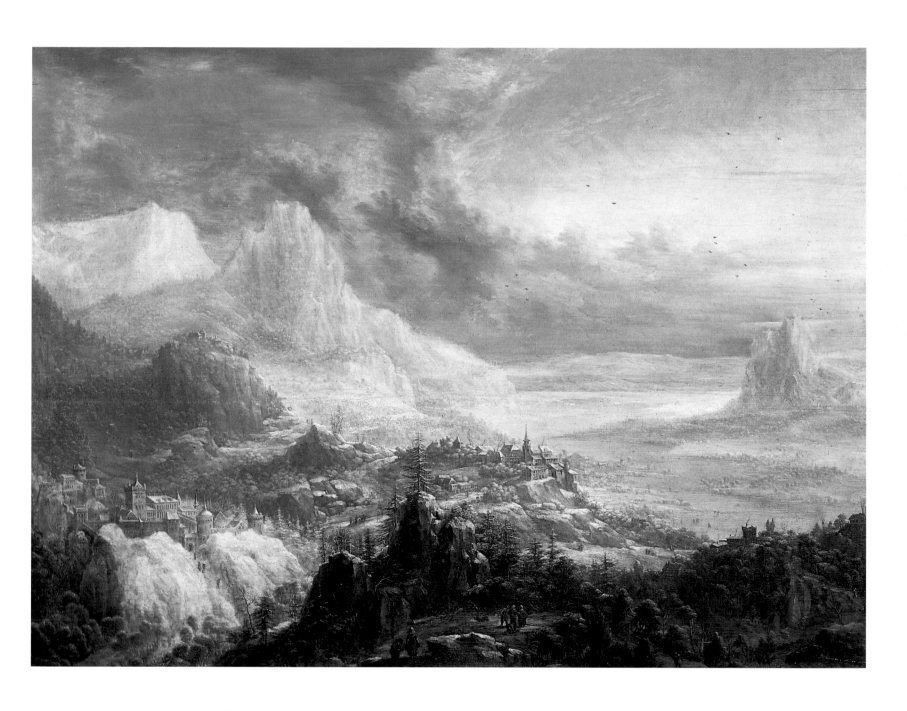

19

ABRAHAM HONDIUS

DUTCH, CA. 1625/30–1691

DOG AND HERON
1667

OIL ON CANVAS
53 1/2 X 45 1/4
INCHES
135 X 115
CENTIMETERS
WARSAW,
THE NATIONAL MUSEUM
M.OB.446

The Dutch painter Abraham Hondius, active in London from 1666, created dynamic, dramatic hunting scenes under the marked influence of Flemish painting. *Dog and Heron*, executed a year after the artist settled in London, marks an important turning point from his small, rectangular panels of the 1660s depicting dogs fighting large birds to his 1670s series of large-format canvases of hunting scenes with dogs and big game. The closest comparison for *Dog and Heron* is a painting by Hondius, also from 1667, showing a heron being attacked by dogs on the ground and by falcons in the air (Statens Museum for Kunst, Copenhagen). Also a vertical canvas, it features similar Italianate scenery, even repeating the motif of classical ruins of cornices, capitals, and, above all, an almost identical plinth with a vase and the silhouette of a poplar or cypress discernible behind it. However, the Warsaw composition is more coherent, featuring a rare monumentality. The dramatic combat in the Warsaw painting is set by a brook in a wide landscape and shown from a low vantage point, as though the event was taking place on stage. Sharp, focused lighting heightens this impression and the overall sense of drama. The low vantage point and large, brightly lit forms suggest that the painting was intended to be viewed slightly from below.

The scene is composed along diagonal lines typical of the Baroque, creating the impression of movement and emotional tension. Here the dog, its front paws raised, in its hunting fury clenches its teeth on the heron's leg; its bared fangs and the bloodshot eye in a masterly naturalistic rendition illustrate the determination to fight and win. The entire weight of the assailant's body rests on one leg, whereas the other is still in the brook. The heron, its wings spread wide, desperately endeavors to defend itself: its open beak, suggesting a piercing scream, is aimed at the dog's head, and the sharp claws of the bird's left leg plunge into the dog's back, staining its white coat with drops of blood.

Scenes of the hunt, a favorite pastime of the aristocracy, enjoyed great popularity. Hunting the heron with falcons and dogs was very fashionable in the last quarter of the seventeenth century. A heron that managed to survive had a ring put around its leg. The Warsaw painting, however, judging from its monumental scale, may also bear symbolic significance, as in the celebrated work of Jan Asselijn (1610–1652), *The Threatened Swan* (Rijksmuseum, Amsterdam), which functioned as a political allegory for the vigilance of Holland's Great Pensionary, Johan de Witt (1625– 1672), regarding numerous dangers threatening the young republic. In the case of Hondius, however, or the person who commissioned his picture, sympathy would have rather favored the restoration of the Orange dynasty following the second war between England and the Republic of the Netherlands in 1665–67, just when the artist was painting the Warsaw picture in London; and the dog here would represent the enemy of the Orange dynasty, perhaps Johan de Witt himself. However, it should be emphasized that such an interpretation is purely speculative. HB

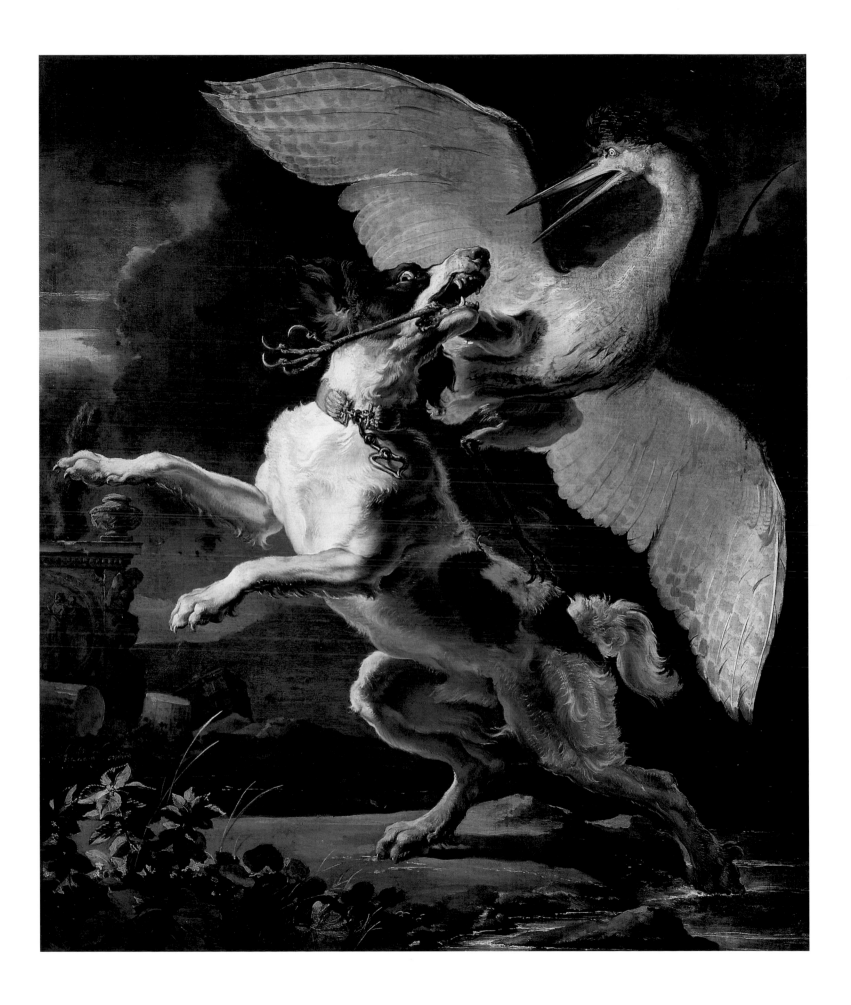

ANTON MÖLLER

POLISH, CA. 1563/65–1611

PORTRAIT OF A GDAŃSK
PATRICIAN FEMALE
1598

OIL AND TEMPERA
ON WOOD PANEL
39 1/2 x 30 7/8
INCHES
100.5 x 78.4
CENTIMETERS
GDAŃSK,
THE NATIONAL MUSEUM
MNG/SD/287/M

An inscription at the bottom of the frame, *1598 AETATIS SVAE 18*, dates this *Portrait of a Gdańsk Patrician Female* to the end of the sixteenth century. Initially associated with the artist Gerdt Jantzen, the painting has recently been attributed to Anton Möller of Königsberg (Królewiec) owing to its conspicuous stylistic and technical affinities with his female portraits (influenced by Netherlandish art of the second half of the sixteenth century) and especially with *Portrait of a Boy with a Goldfinch and a Hobby Horse* (painted in Gdańsk in 1586; now in the museum in Gliwice). The subject's facial features are identical with those in a small oval portrait from the 1620s in the church of St. Catherine (now in The National Museum, Gdańsk) by the well-known patrician Christian Henning, suggesting that the present portrait is a likeness of one of his daughters.

The character of the painting may indicate it was commissioned as a prenuptial portrait of a high-born young lady. Masterfully manipulating both oil and tempera, Möller followed the conventions of contemporary portraiture, setting the subject against a dark neutral background with a draped curtain bordered in thin lines of gold. The young woman, rendered in three-quarter length, with the noble features of a fair-complexioned, bright face, gazes ahead with no emotion. With her left hand she fingers the gold chains hung round her neck; in her right hand she holds a pomegranate, symbolizing love, chastity, fidelity, and fertility. The sumptuous costume worn at the time in Central Europe by unmarried and young married women of the upper middle class and aristocracy served as a kind of

elaborate setting for a precious gem. The fine red dress, trimmed on the sleeves and bodice with gold *passementerie*, the cuffs of delicate white lace, the apron edged with gold, a frilled ruff, rows of gold chains on her breast and bracelets on her wrists, along with the Gdańsk patrician close-fitting cap, embroidered with gold and dense rows of pearls, have been painted with painstaking care. The dignified, somewhat stiff pose; the vivid palette based on the juxtaposition of a few principal and nuanced colors – red, white, russet brown, and gold; the artist's concentration on the external features of the young woman with no attempt to study her psychological state; the symbolic significance of a pomegranate; and the high standard of workmanship combine to make the young patrician woman a Gdańsk Venus. Her portrait ranks among the finest examples of late sixteenth-century painting in Gdańsk. KG-P

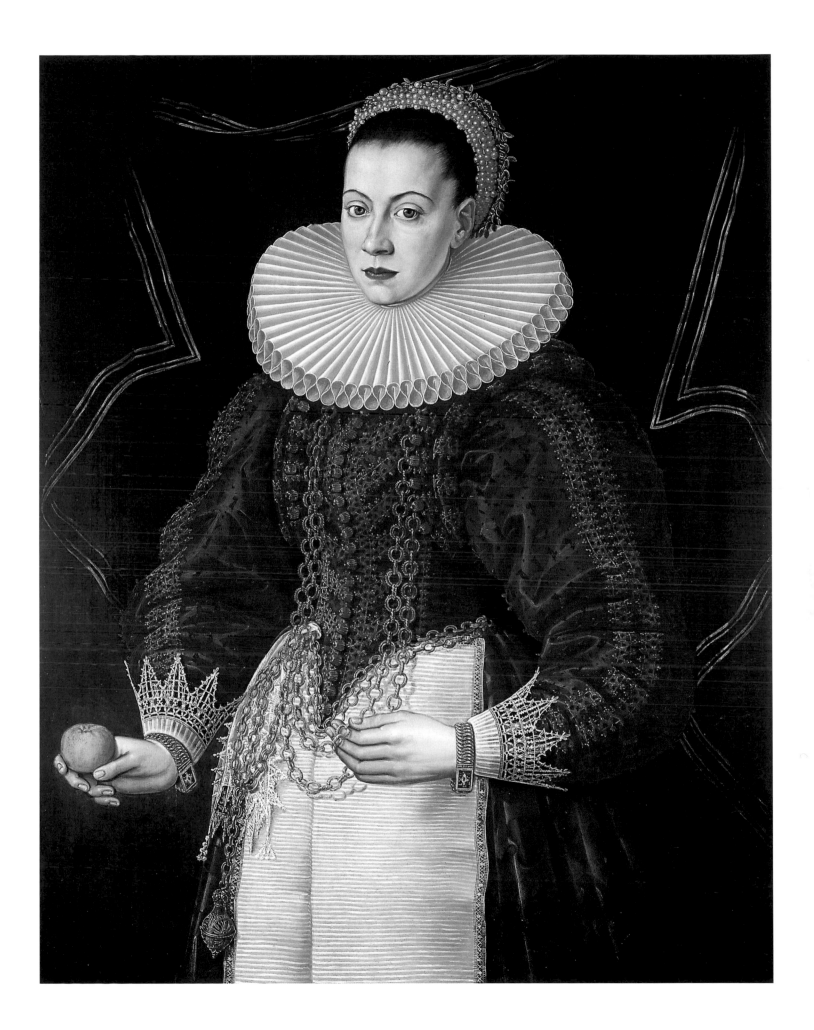

GIOVANNI BATTISTA CRESPI

CALLED CERANO
ITALIAN, 1557–1632/38

CHRIST AND THE
WOMAN OF SAMARIA
CA. 1620S

OIL ON CANVAS
39 ¹/₂ × 28
INCHES
100.5 × 71.2
CENTIMETERS
WARSAW,
THE NATIONAL MUSEUM
M.OB.649

Christ and the Woman of Samaria, probably executed in the 1620s, is an excellent example of the mature style of Cerano, the leading exponent of the Milanese Baroque. The figures of Christ, seated on the edge of the well of Jacob, and the standing Samaritan woman, are crowded into the frame in strained, twisted poses, still revealing lingering Mannerist tendencies. The characteristic Mannerist lack of static compositional equilibrium is additionally emphasized by the juxtaposition of unexpected colors of yellow, pink, and muted violet. A strong *chiaroscuro* and the impressionistically painted landscape in the background are rooted in the tradition of sixteenth-century Lombard painting. In his early youth Cerano was influenced by the Mannerism of Lombardy and Piedmont, patterned on the art of Gaudenzio Ferrari and Lanino, and later of Pellegrino Tibaldi. The style remained a source of inspiration for Cerano.

Brought up in the atmosphere of religious revival that prevailed in Milan toward the end of the sixteenth century, Cerano worked for numerous churches in Lombardy and earned the support of Cardinal Federico Borromeo, Archbishop of Milan. According to the injunctions of the Council of Trent, the aim of painting in the Counter-Reformation period was to move the viewer to piety or conversion through a sacred story appealing to the emotions. The meeting of Christ and a woman of Samaria, a land whose people did not embrace Judaism, is symbolically a scene of conversion. Christ asks the rustic Samaritan for a drink, illustrating the biblical words: "But whosoever drinketh of the water that I shall give

him shall never thirst" (John 4:14). The rhetorical, simple expression of the painting emphasizes the profound evangelical meaning.

Cerano executed copies of his own works. This painting is probably one of several of the artist's replicas of a work in the vestry of the cathedral in Toledo. Another example was sold at a Sotheby's auction on July 7, 1993. The Corsini Gallery in Rome has a smaller, inferior version. This painting was purchased for The National Museum in Warsaw in 1936, together with ninety-four other paintings, from the heirs of Doctor Jan Popławski (1860–1935). Popławski built his collection in St. Petersburg from 1885 to 1917, acquiring paintings locally and during his numerous travels abroad. The collection consisted mainly of Netherlandish works, along with Italian, French, and Spanish pieces. After the outbreak of the October Revolution, Popławski brought his collection to Warsaw. JK

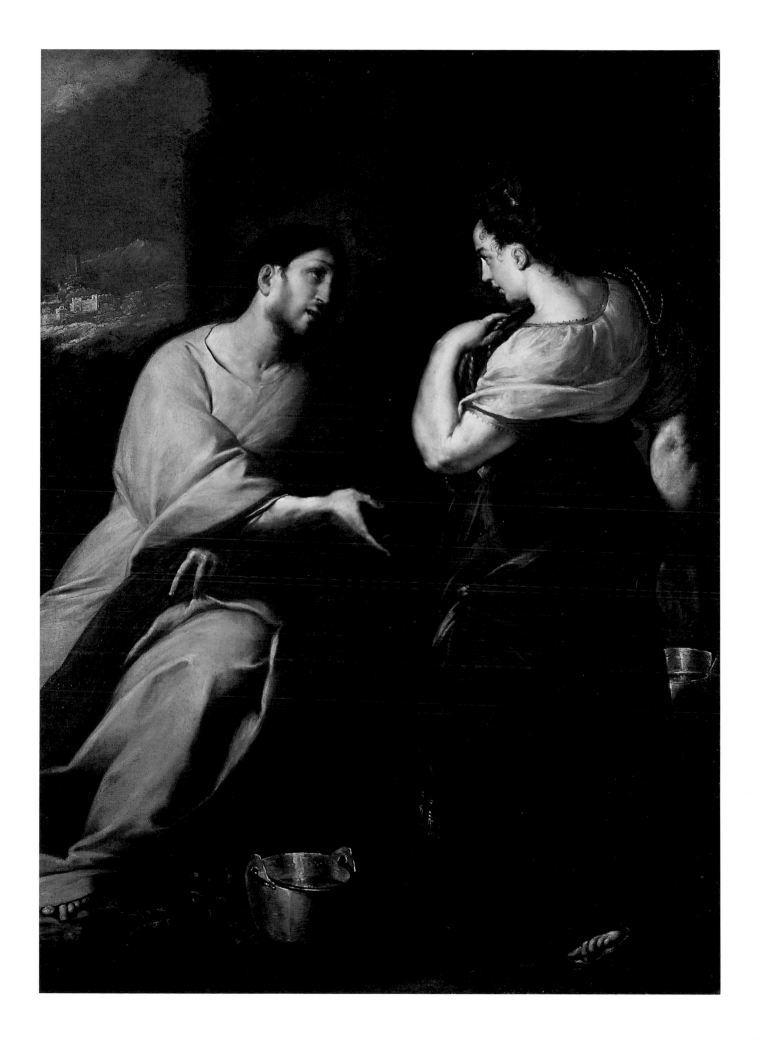

CECCO DEL CARAVAGGIO

ITALIAN, ACTIVE IN ROME CA. 1610–1620

The mysterious Cecco (Francesco) del Caravaggio, mentioned in Giulio Mancini's *Considerazioni sulla pittura* as one of the first and most faithful imitators of Caravaggio, has recently been identified with Francesco Boneri (Buoneri), an artist in the Bonera or Buoneri family of painters active in and around Bergamo beginning in the sixteenth century. The artist's only documented work is *The Resurrection of Christ* (1619–20) for the Guicciardini Chapel in the church of Santa Felicita in Florence and now in The Art Institute of Chicago. An oeuvre of about twenty works has been constructed on stylistic grounds. *The Martyrdom of St. Sebastian* in Warsaw has been the subject of prolonged discussion, with the painting being linked to other imitators of Caravaggio, such as Bartolomeo Manfredi and Domenico Finoglia. The association of the canvas with Cecco del Caravaggio is compelling, but still hypothetical.

The Martyrdom of St. Sebastian, a young Roman legionnaire condemned to death for professing the Christian faith, was a popular subject among the followers of Caravaggio. This painting, however, depicts an episode that does not appear in his legend, showing a scene immediately after his death with Sebastian surrounded by his executioners who are indifferent to his suffering and even check to see if the arrows have been effective. This interpretation of the subject suggests depictions of the Passion of Christ (Mocking, Crowning with Thorns, and Flagellation). The concentrated flow of light within the dark scene illuminates the martyrdom and symbolically highlights the body of the saint. Sebastian's face, devoid of classical decorum, fades into the shadows.

The shallow composition of massive figures densely set against a dark, indefinite background is reminiscent of Caravaggio's Roman works of the early seventeenth century. Additional Caravaggesque elements are the strong, symbolically treated *chiaroscuro* effects, meticulous handling of textures, and plasticity of the figures emerging out of the darkness. Most telling is the rigorous composition, in which all artistic devices have been subordinated to the drama and brutality of the scene. The narration is likewise succinct: the executioners and witnesses are few and no superfluous details distract attention from the martyrdom of the saint, suffered in silence. GB

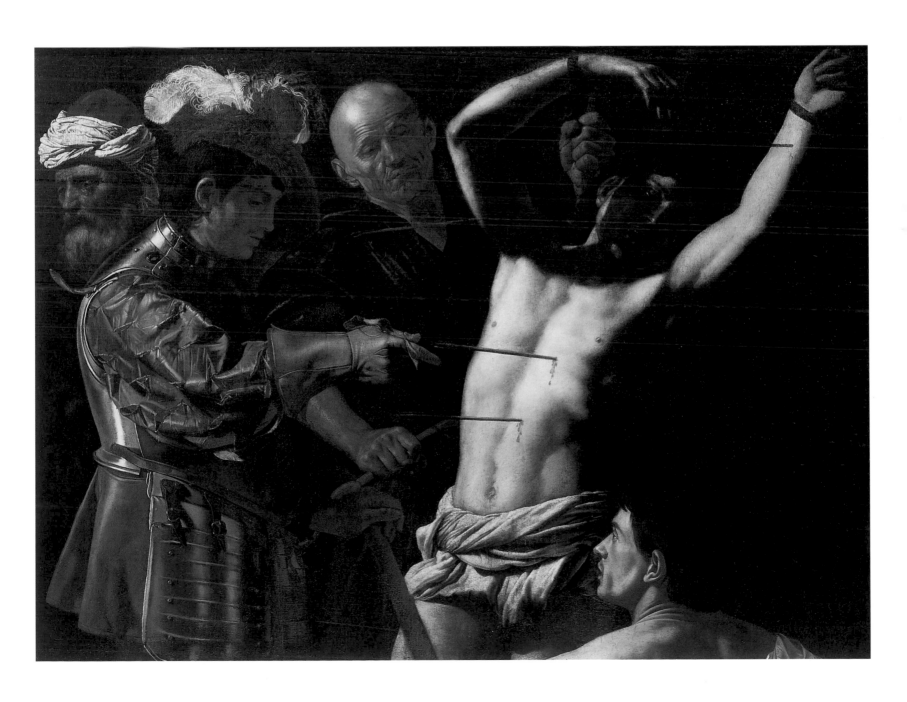

MATTIA PRETI

ITALIAN, 1613–1699

ADORATION OF
THE SHEPHERDS
1656

OIL ON CANVAS
58 1/2 × 77 3/4
INCHES
148.5 × 197.5
CENTIMETERS
WARSAW,
THE NATIONAL MUSEUM
M.OB.666

Born in Calabria, Mattia Preti assimilated various trends of Baroque painting during his extensive travels in Italy. Arriving in Rome in 1630, he saw the works of Caravaggio and his followers as well as paintings by classicizing artists such as Mola, Testa, and Poussin. In the 1640s he worked in the environs of Bologna, where he could study the paintings of Lanfranco, Domenichino, and Guercino. From 1656 to 1660 he stayed in Naples, but then spent the last forty years of his life in Malta as a painter and a knight of the Order of Malta. His acquaintance with Roman Caravaggism, Venetian colorism, and Bolognese classicism did not prevent Preti from developing an individual, easily recognizable style of his own: a monumental, even theatrical, composition, achieved through strong foreshortening, depicting the figure from below, and sharp contrasts of intense light and darkness. His characteristic palette is cool, with a predominance of deep blacks, blues, and numerous grays.

In all likelihood the *Adoration of the Shepherds* dates from the artist's stay in Naples. The scene is set within the ruins of monumental architecture, perhaps the blocks of stone and remnants of columns of an ancient temple. The strong but diffused light penetrating the dark interior gives the impression of intense sunlight falling through the dilapidated roof of the structure – a speciously casual illumination of figures and elements of the interior: the Virgin and Child, the face of St. Joseph, standing in prayer to the right of the Virgin, and the profile of a shepherd on the left. Also picked out from the dark distant plane is the head of a bagpiper in a fool's cap, discernible

beyond the foreground figures – a character typical of Preti but enigmatic in the present scene. The interpenetrating light and shadow clearly construct the pictorial space of the composition, casting into relief the monumental foreground figures and the immensity of the structure in which the scene takes place. However, for all its theatricality, the painting retains the intimate, warm character of the biblical event. The Holy Family and the shepherds greet the Savior with silent, rapt attention – Mary hugs the sleeping infant and Joseph raises his head in prayer.

The tentative provenance of the painting as being from the Alarcón de Mendoza collection in Naples is based on a 1703 inventory of that collection that mentions Preti's *Adoration of the Shepherds* together with its pendant *Adoration of the Magi* (location unknown), although the dimensions cited are slightly larger than those of the Warsaw canvas. GB

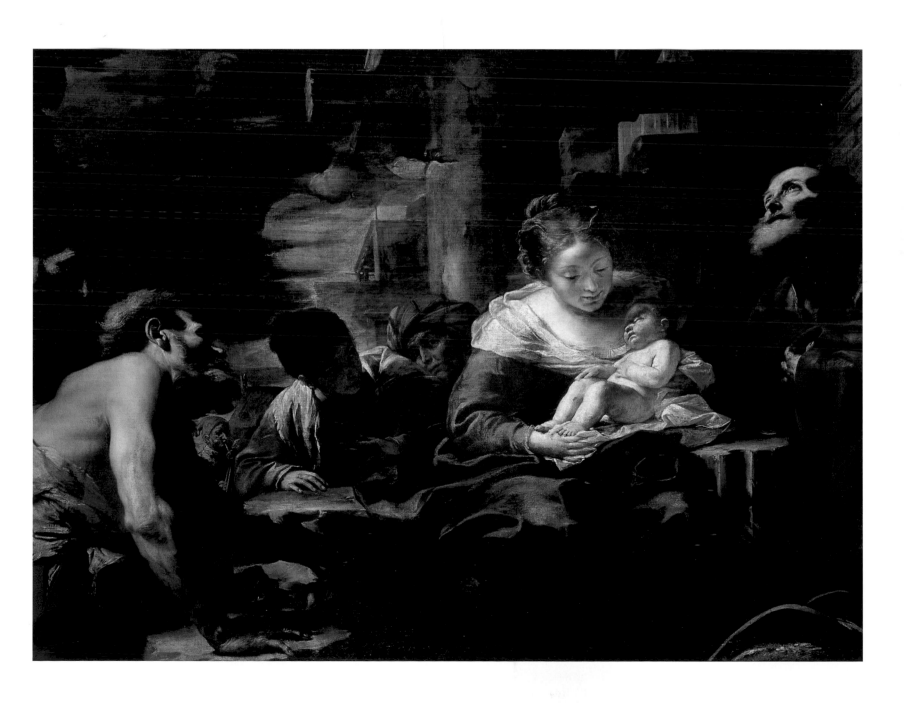

ELISABETTA SIRANI

ITALIAN, 1638–1665

PORTRAIT OF
VINCENZO FERDINANDO
RANUZZI AS CUPID
1663

OIL ON CANVAS
28 X 23
INCHES
71 X 58.5
CENTIMETERS
WARSAW,
THE NATIONAL MUSEUM
M.OB.669

One of the first Bolognese women to establish a successful public career as a painter, Elisabetta Sirani became a local celebrity whose workshop was visited by eminent tourists and art lovers. She founded the first school of women painters outside the convent in early modern Italy, training a dozen students and revolutionizing the prospects for women artists in Bologna. Sirani was the first Bolognese woman to specialize in history painting, the most highly regarded type of painting in seventeenth-century Italy. Earlier women painters in Italy had usually specialized in portraiture, which was generally regarded as intellectually less demanding for both the artist and the viewer.

A list of her works compiled by the artist and published by a biographer in 1678 includes thirteen portraits (five extant) among Sirani's two hundred known paintings. Eight of these portraits were done between 1660 and 1665, as is the case with the *Portrait of Vincenzo Ferdinando Ranuzzi as Cupid*, dated 1663. Moreover, all but one of the extant portraits are historicized – that is, they depict the sitter in the guise of a saint, mythological figure, or allegorical personification, testifying to the artist's interest in history painting.

According to Sirani's list, her portrait of Ranuzzi was painted for his uncle, the Marchese Ferdinando Cospi, who owned four of her paintings. A wealthy Bolognese senator who served as an art agent to the Medici Grand Duke of Florence, Cospi had an important art collection that included both antique and contemporary works. Having no son of his own, he bequeathed his fortune to his nephew Vincenzo

Ranuzzi, on the condition that Vincenzo assume the name Cospi. Since Vincenzo was a second son, he complied with the request and inherited his uncle's estate in 1686. The Ranuzzi family was also prominent in Bologna. Vincenzo's father, Annibale, was also a senator and he too owned four paintings by Sirani, including a 1665 portrait of his sister as an allegory of Charity.

The *Portrait of Vincenzo Ferdinando Ranuzzi as Cupid*, like that of Vincenzo's aunt, is a historicized image: a bow and a quiver of arrows identify the sitter as Cupid, the ancient god of love. In every other respect, however, the subject is a denizen of the seventeenth century: clothed in a rich, red, embroidered costume, decorated with a long ruff, red bows, and coral beads, he sports an elaborate feathered hat trimmed with red bows. Vincenzo is depicted in almost three-quarter length, filling most of the picture space, with some interior architecture and a thin sliver of distant landscape visible in the now-darkened background of the picture. Set off from the background by a strong light, the figure makes eye contact with the viewer, adding to the sense of immediacy and vitality. Painted only two years before the artist's premature death at age twenty-seven, the Warsaw portrait is a fine example of Sirani's mature style and the interest in antique subject matter that was characteristic of both the artist and her patron. BB

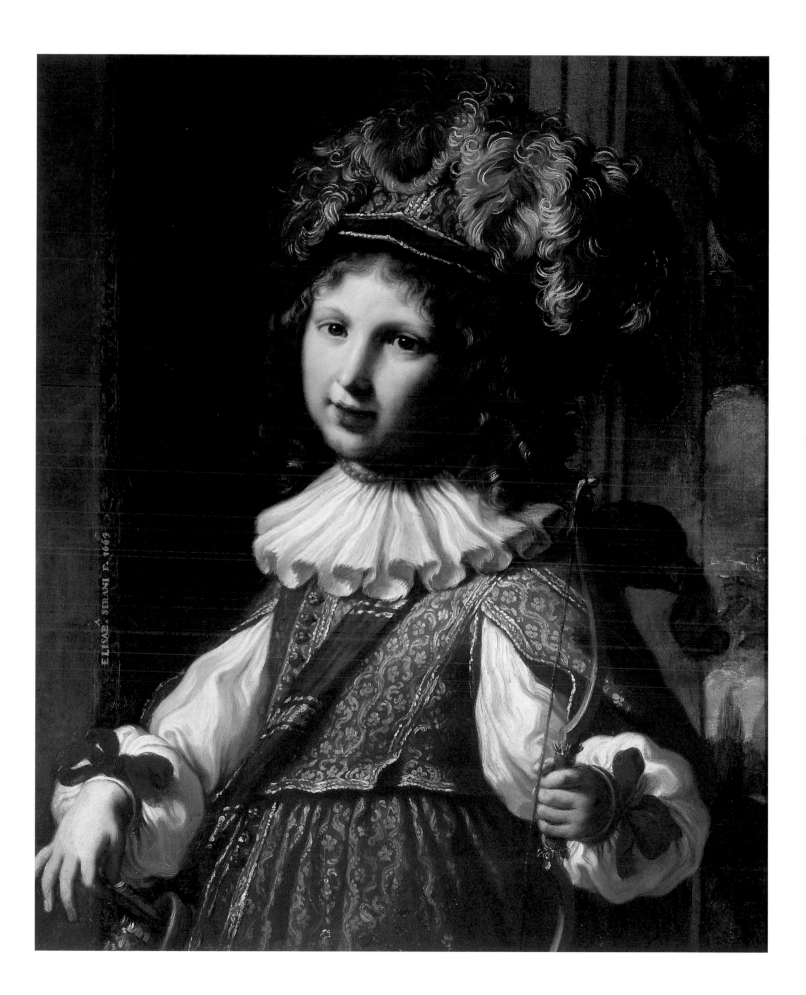

MARCO RICCI
ITALIAN, 1676–1730

SEBASTIANO RICCI
ITALIAN, 1659–1734

LANDSCAPE WITH A
WINDING ROAD
CA. 1720

OIL ON CANVAS
48 × 67 ⅝
INCHES
122 × 172
CENTIMETERS
WARSAW,
THE NATIONAL MUSEUM
M.OB.676

Marco Ricci, the outstanding Venetian landscape painter of the early eighteenth century, combined the classicism of Nicolas Poussin, Claude Lorraine, and Gaspard Dughet, and a more expressive current inspired by Pieter Mulier, Salvatore Rosa, Joseph Heintz II, and Johann Eisman. Marco Ricci probably studied in Venice under his uncle, Sebastiano, and with a landscape painter of Ancona, Antonio Francesco Peruzzini. He was active mainly in Venice, additionally perhaps in Split (Dalmatia), as well as in Florence and Rome, and for a longer time in England. He collaborated with Alessandro Magnasco, Giovanni Antonio Pellegrini, and Sebastiano Ricci. He also designed stage scenery and created etchings.

Sebastiano Ricci played a key role in the rise and development of the Venetian Rococo. He specialized in figure painting and sought the assistance of specialists for his architectural and landscape settings; sporadically, in turn, he painted the figures in the pictures of other artists, mainly in works by Marco Ricci.

Marco Ricci's paintings are usually small, restrained compositions, painted in tempera on goatskin. *Landscape with a Winding Road*, however, belongs to a group of large-format paintings on canvas, coupling realistic with fantastic elements and theatrical decorativeness and expression. Together with its pendant, *Landscape with a Bridge*, it is an example of the influence exerted by the dynamic and scenic landscape visions of Pieter Mulier, called Tempesta (1637–1701). On the basis of monograms, Jan Białostocki attributed the two paintings to Marco Ricci. The only serious challenge to this attribution was made in 1993 by the curators of the Marco Ricci exhibition in Belluno, Italy, who named Peruzzini the chief painter of the landscapes and

Sebastiano Ricci the author of the figural staffage. This present author in 1999 accepted Sebastiano as the painter of the figures, but maintained Marco as the landscape artist.

The zigzag diagonals, impasto technique, and individual motifs indeed recall Peruzzini's works. However, according to contemporary documents, Marco Ricci was probably a pupil of this friend and collaborator of his uncle, and may have been influenced by him. Some similarities, such as broken trees, may be attributed to a common artistic tradition. For all their theatricality, the pictures seem more realistic than Peruzzini's works. The mood of the Warsaw pair is serene, largely because of the light and the subtle play of warm and cool hues.

The mode of handling architecture recalls a group of early eighteenth-century landscapes by Marco Ricci, especially *Landscape with a Windmill and Bathers* (Gemäldegalerie Alte Meister, Dresden), which contains the dominant tower and bridge motifs and an expressive tree on the right that flanks the view in the way the broken trunks do in the Warsaw pendants.

Supporting the attribution of the figures to Sebastiano Ricci is the sharp, birdlike face of the man sitting by the water in the foreground of *Landscape with a Winding Road*. Another argument in favor of the authorship of an artist other than Marco is the fact that the staffage was added later, as evidenced by landscape details visible through the figures. A collaboration with Sebastiano Ricci as well as stylistic reasons permit the dating of the two Warsaw pictures to before 1720, that is, prior to Sebastiano's departure from Venice for Vienna. MM

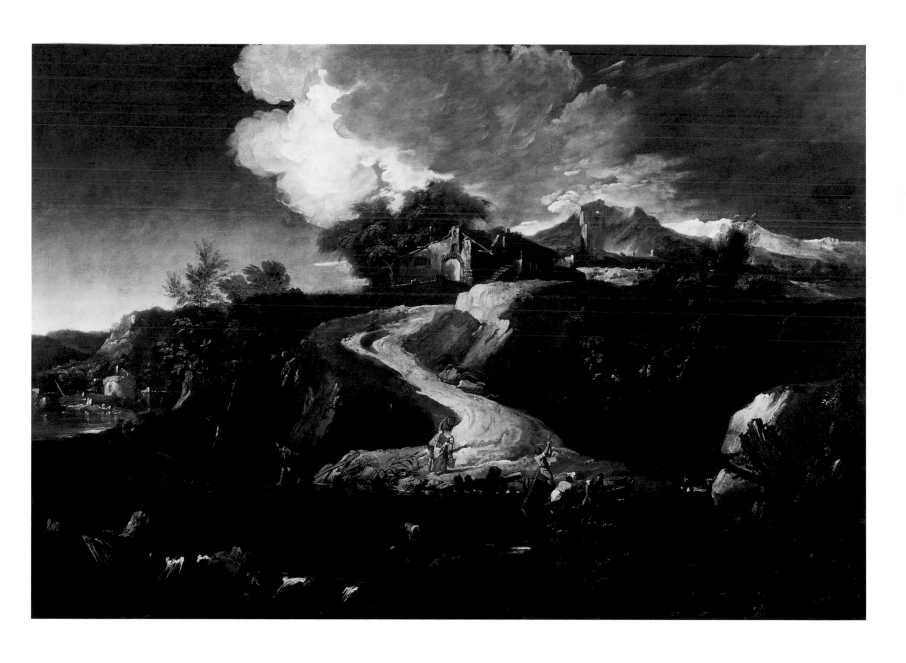

JUSEPE DE RIBERA
SPANISH, 1591–1652

JOHN THE BAPTIST
IN THE WILDERNESS
CA. 1640

OIL ON CANVAS
70 1/8 x 63 3/8
INCHES
178 x 161
CENTIMETERS
POZNAŃ,
THE NATIONAL MUSEUM
MPN MO 1292

Poznań is the only city in Poland where one can see works from the "Golden Age" of Spanish painting. Works by Jusepe de Ribera, Antonio Pereda, Francisco Zurbarán, Juan Carreño de Miranda, and Diego Velázquez are the most precious of a collection whose core was formed by Count Atanazy Raczyński (1788–1874), and which has been exhibited in the Poznań museum since 1903.

Among the acquisitions after 1945, Jusepe de Ribera's *John the Baptist in the Wilderness* is the most interesting. Ribera, one of the most important artists of the Spanish Baroque, moved after 1610 to Italy, where he later painted in Naples under the influence of Caravaggio. Because of his short stature, he was nicknamed with the diminutive "Lo Spagnoletto." He is perhaps the most direct exponent of the legacy of Caravaggio, although Ribera's compositions are more brutal and more powerfully expressive.

An excellent example of the artist's style from his early period, the latter half of the 1630s, *John the Baptist in the Wilderness* fully demonstrates Ribera's skill as a superb draftsman and a refined colorist painting *alla prima* and without applying glazes. In contrast to another and contemporaneous version of St. John (Museo del Prado, Madrid), the Poznań St. John is more mature and displays more Baroque features. His mood is also more solemn and austere; the gesture of his finger pointing skywards reminds the viewer of the young man's prophetic mission.

Following the iconographic tradition of portraying John the Baptist, Ribera depicted the saint as a youth in his twenties, wearing a hair shirt under his red mantle. His weather-beaten complexion is testimonial to his long stay in the wilderness. Ribera has presented the traditional attributes of the saint: at his feet on the right is a cross (a symbol of Christ's sacrifice), on the left a lamb – a constant companion in the saint's images – which symbolizes the words uttered by him at his first meeting with Christ: "This is the Lamb of God...." Prototypes for this interpretation of John the Baptist as a handsome youth, stripped to the waist, may be found in the Italian Caravaggisti, following the images by Caravaggio himself. MPM

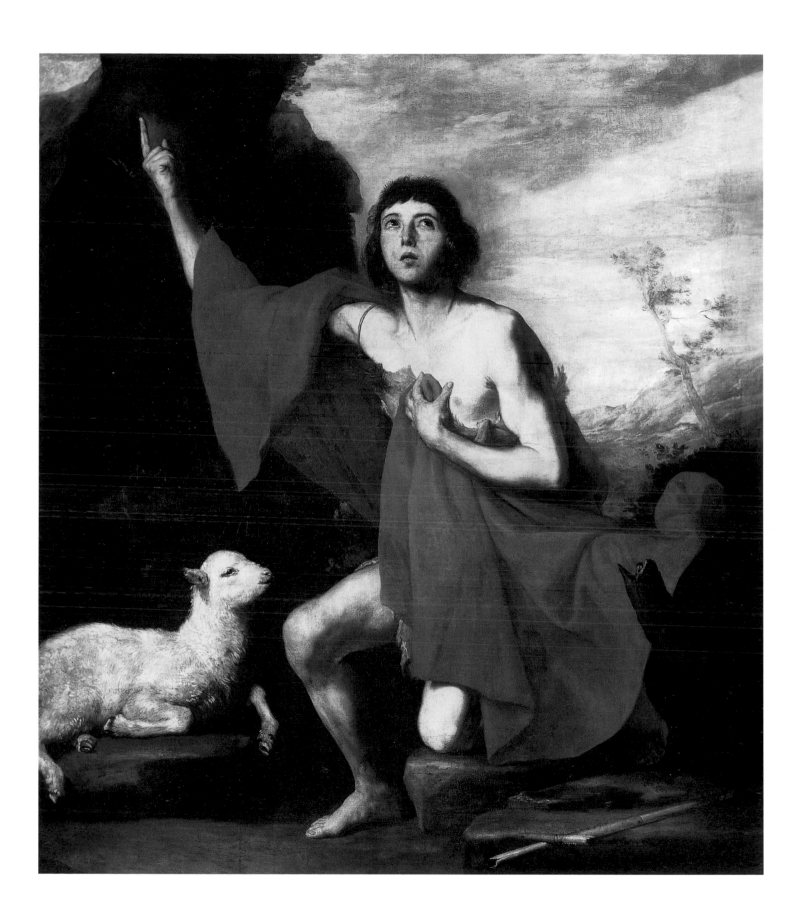

LAURIE WINTERS

ENLIGHTENMENT

and

ROYAL PATRONAGE

THE FIRST SIGNIFICANT ART COLLECTIONS and patronage in Poland are connected to the court of the last Jagiellonians – kings Sigismund I and Sigismund II Augustus. The kings of the Swedish Vasa dynasty that followed throughout much of the seventeenth century expanded their European connections as well as the scope and scale of their collections. It was, however, in the mid-eighteenth century during the enlightened reign of Poland's last king, Stanislaus Augustus II Poniatowski, that royal patronage and collecting found their fullest and most meaningful forms of expression. The novel political and educational aspirations that Stanislaus Augustus established with his royal collections ended abruptly with the devastating final partition of the Polish Kingdom in 1795.

King Sigismund I – who reigned from 1506 to 1548 – initiated what has become known as the "Wawel Renaissance" through his patronage of Italian artists, architects, and humanists at The Wawel Royal Castle in Cracow. Sigismund I rebuilt large parts of the castle in the spirit of the Italian Renaissance and refurnished it to the taste of his Italian wife, Queen Bona Sforza. It was, however, his son, Sigismund II, the last ruler of the Jagiellonian dynasty and the creator of the united Polish-Lithuanian Commonwealth in 1569, who vastly enlarged the conception of royal patronage. The most eminent artists joined his court and received regular salaries and even titles, such as the knighthood conferred on Gian Giacomo Caraglio. Sigismund probably used this occasion to com-

PL 27

mission the allegorical portrait of Caraglio by Paris Bordone {PL 27}. The king's love of craftsmanship resulted in a very rich collection of goldsmiths' and jewelers' works, textiles, arms and armor, and a vast array of harnesses and cannons.[1]

Sigismund II Augustus's most dramatic and lasting contribution to the cultural heritage of Poland was his commission of Flemish tapestries for The Wawel Royal Castle. He commissioned in Flanders a set of about 170 tapestries depicting biblical scenes, animals, and emblems of the dynasty and state. Woven in the best Brussels workshops, they are perhaps one of the most important accomplishments in art collecting in Europe of the time. The tapestries completely covered the walls of The Wawel Castle in the sixteenth century, leaving little room for paintings, which the Jagiellonian king also possessed. Although not specifically identified, apparently they were imported both from Venice and Flanders and executed by local Polish artists. The king's patronage may have also included Hans Dürer, the brother of Albrecht Dürer, but none of his works have

1 The best English summary of the Jagiellonian dynasty appears in Jan Białostocki's *The Art of the Renaissance in Eastern Europe: Hungary, Bohemia, Poland* (Oxford: Phaidon Press, 1976); and in Vienna, Niederösterreichisches Landesmuseum, *Polen im Zeitalter der Jagiellonen, 1386–1572* (Vienna: Die Abteilung, 1986).

been identified with certainty. A fire at the Wawel toward the end of the sixteenth century unfortunately destroyed and dispersed much of the Jagiellonian collections.[2]

The kings of the Swedish Vasa dynasty, Sigismund III, Ladislas IV, and John Casimir, who reigned in Poland from 1587 to 1668, were perhaps the first real collectors in Poland, acquiring works from a number of European art centers. Initially King Sigismund III had his court in Cracow, but by 1611 he had moved it to Warsaw, where it remained. His patronage reflected his profound religious devotion and many of the architectural projects undertaken during his reign are indebted to the austere early Baroque architecture of Rome. Once in Warsaw, he began the much needed renovation of the derelict Royal and Ujazdów Castles and the Kazimierzowski Palace.

Sigismund III enjoyed dabbling in goldsmithery and assembled an outstanding collection of paintings from Venice, Rome, Naples, and the Netherlands. He was aided in his acquisitions by Italian and Spanish envoys and by Polish magnates traveling throughout Europe as special agents. From Venice, Sigismund brought to Poland a pupil of the painter Vassilacchi, Tommaso Dolabella, who decorated the royal residences with portraits and large historic and military scenes {FIG 1}. Sigismund's stable of court painters included the Dutch Pieter Claesz. Soutman as well as Hans von Aachen, Aegidius Sadeler II, and Herman Hahn from the Prague court of Emperor Rudolph II.[3]

FIG 1
Tommaso Dolabella, attributed to, *Stanisław Tęczyński*, ca. 1630, oil on canvas, Cracow, The Wawel Royal Castle.

FIG 2
Guido Reni, *The Rape of Europa*, ca. 1638–40, oil on canvas, collection of Sir Denis Mahon, London.

Sigismund's son, Ladislas IV, toured Europe in 1624–25 while still a prince, as part of his education. What began as a pilgrimage to Loreto and Rome turned into a year-long artistic journey that took him to famous art collections and the studios of outstanding painters such as Jan Breughel the Elder and Rubens (who sketched a portrait of him). There he made purchases to enrich the collections established by his father. In Brussels he commissioned ten narrative tapestries depicting *The Odyssey* and ten landscape tapestries that were later used to decorate the Wawel Cathedral in Cracow for Ladislas's coronation ceremonies. The prince also visited the Bologna studio of Guido Reni, from whom he commissioned the famous picture *The Rape of Europa* {**FIG 2**}.[4]

The painting *Kunstkammer of Crown Prince Ladislas Sigismund Vasa,* representing the prince's study in The Royal Castle in Warsaw, demonstrates that Ladislas was a consummate collector {**SEE ZIEMBA, FIG 2**}. The interiors of the Vasa residences – The Royal Castle and the Ujazdów Castle in Warsaw and The Wawel Royal Castle in Cracow – must have been magnificent in that period.[5] It was under Ladislas IV that the architect Giovanni Battista Ghisleni designed the Marble Room at The Royal Castle in Warsaw, in which dynastic claims were expressed by heraldic cartouches and by ceiling paintings by Tommaso Dolabella, depicting the king's military victories, and by twenty-two royal busts illustrating the dynastic origins of the family.[6]

In his passion for collecting, the successor to Ladislas, King John Casimir, followed in the footsteps of his predecessors. He inherited the collections of his father and his brother and expanded them with works he purchased on trips made in the 1630s and 1640s. After his abdication in 1668, John Casimir left Poland for Paris, taking with him about 150 pictures from the Vasa collection, including Guido Reni's *The Rape of Europa*. He spent the rest of his life in Paris as the abbot of St. Germain-des-Prés. The inventory compiled after his death included a *St. Peter* by Rubens, now in a private collection in New York, an *Actaeon* and a *Diana Bathing* by Rembrandt, now in Dresden, pictures by Herri met de Bles and Jan Breughel the Elder, as well as Flemish tapestries,

2 For a general overview of the tapestries and their history, see Jerzy Szabłowski, ed., *The Flemish Tapestries at Wawel Castle in Cracow: Treasure of King Sigismund Augustus Jagiello* (Antwerp: Fond Mercator [under the auspices of the Banque de Paris et des Pays-Bas], 1972); and Stanisław Cynarski, *Zygmunt August* (Wrocław: Zakład Narodowy im. Ossolińskich, 1988).

3 On the royal patronage of Sigismund III, see Czesław Lechicki, *Mecenat Zygmunta III i życie umysłowe na jego dworze* (Warsaw: Kasa im. Mianowskiego – Instytut Popierania Nauki, 1932); Henryk Wisner, *Zygmunt III Wasa* (Warsaw: Wydawnictwa Szkolne i Pedagogiczne, 1984); and Władysław Tomkiewicz, "Mecenat artystyczny i kolekejonerstwo Zygmunta III," in *Z dziejów polskiego mecenatu artystycznego w*

wieku XVII (Warsaw: Ossolineum, 1952), pp. 11–29.

4 The patronage of Ladislas IV is amply described in both Polish and French in Władysław Tomkiewicz, "Zbiory artystyczne Władysława IV," in *Z dziejów polskiego mecenatu artystycznego w wieku XVII* (note 3), pp. 30–46.

5 Alexandria, Virginia, Art Services International, *Land of the Winged Horseman: Art in Poland 1572–1764,* ed. Jan K. Ostrowski (Alexandria, 1999), p.109. This catalogue entry by Hanna Małachowicz synthesizes and clarifies earlier problematic interpretations of the painting.

6 Tomkiewicz, "Zbiory artystyczne Władysława IV" (note 4), pp. 30–46.

crowns, and reliquaries. Part of the decorative arts holdings entered the French royal collections of King Louis XIV.[7]

In addition to the early royal collections, there developed in Poland great collections assembled by the magnate families. Among the most remarkable were those of the Radziwiłł, one of the richest Polish families, which were scattered among numerous Lithuanian castles and are said to have comprised thousands of pictures painted in Poland and acquired abroad. Apart from a great number of family portraits, they would have included works by Dürer, Cranach, Veronese, and a large number of Dutch and Flemish pieces, which enjoyed great popularity among Polish collectors. In the seventeenth century the Lubomirski family possessed a substantial collection of foreign paintings with works attributed to Raphael, Titian, Domenichino, and Albani. The brothers Krzysztof and Łukasz Opaliński likewise boasted quite a large and impressive art collection.

However, the Swedish invasion of 1655–56 dealt a terrible blow to the Polish kingdom and its culture. The Swedes burnt magnate palaces, churches, and monasteries, plundering works of art on a scale hitherto unprecedented in Poland. Massive quantities of furniture, textiles, sculptures, and paintings were carried off in cartloads to Sweden and to this day remain in Swedish collections. Political events and the numerous wars with Moscow, Sweden, Turkey, and the Cossacks wreaked havoc with developing art collections in the seventeenth century, including that of King John III Sobieski, who is best known for defeating the Turks at the Battle of Vienna in 1683 {*FIG 3*}.

Despite a declining economic situation and political turmoil during the second half of the century, John III Sobieski, elected king in 1674, sponsored some of the finest Baroque art in Poland. He admired Italian architecture as well as French and Dutch paintings, sculpture, and gardens. Not fond of the long neglected Royal Castle in Warsaw, he commissioned Augustyn Locci, a Polish architect, to build a suburban residence, an Italianate *villa nuova*: the royal palace at Wilanów – an architectural wonder intended to rival Versailles in France. The two-story country palace (built in three architectural campaigns, 1677–79, 1681–83, and 1688–96) has a central belvedere, two corner towers, and a balustraded roof, situated between a forecourt and flanked by side wings and surrounded by French-style gardens.[8]

7 On the inventory compiled after John Casimir's death, see Władysław Tomkiewicz, "Pośmiertny inwentarz zbiorów Jana Kazimierza," in *Z dziejów polskiego mecenatu artystycznego w wieku XVII* (note 3), pp. 62–258. The text appears in both Polish and French.

8 On architecture in seventeenth-century Poland, including a brief discussion of the Palace at Wilanów, see Adam

Miłobędzki, *Architektura polska XVII wieku* (Warsaw:Polskie Wydawnictwo Naukowe, 1980), pp. 396–405.

9 Jan Starzyński, "Dwór artystyczny Jana III," *Życie Sztuki* 1 (1934), pp. 137–56.

Sobieski is principally remembered today for his contributions to Baroque architecture, but he also created extremely rich collections of art at his castles at Żołkiew and Jaworów, and above all at Wilanow, that included textiles, arms and armor, and paintings by Raphael, Van Dyck, and no fewer than five Rembrandts. Among his court artists were the sculptor Andreas Schlüter, and the painters Claude Callot, François Desportes, Jan Tricius, and the Rome-trained Jerzy Eleuter Szymonowicz-Siemiginowski. However, this important collection was also dispersed after the king's death in 1696. Unlike their counterparts in France and England, royal collections in Poland were considered private in ownership and not part of the state's cultural heritage. Following Sobieski's death, his widow, Marie-Casimire de La Grange d'Arquien, took part of the picture collection to Rome and his sons divided the remainder; a portion of the collection later passed into the hands of the Radziwiłł family.[9]

The royal and magnate collections in Old Poland unfortunately remain largely unknown. Occasional surviving inventories frequently give incomplete and unreliable data. Sometimes they merely describe – and that usually rather inaccurately – the subjects of the paintings or mention only the countries of origin, such as Italy, Holland, and so on. When names of artists, often famous ones such as Raphael, Titian, Veronese, Rembrandt,

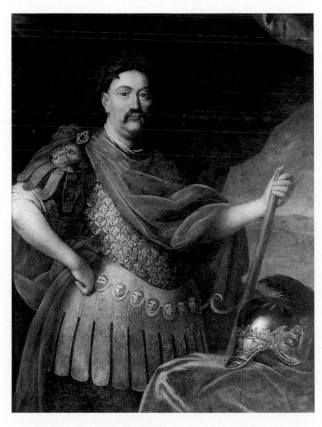

and Poussin, are listed the correctness of the attributions must always be questioned, since studio replicas and copies were often optimistically regarded as originals. What is certain, however, is that thousands of pictures from this period fell victim to wars, natural disasters, and the division of families. Only a very few works now in Polish and European museums can be identified as originating from the collections of Old Poland.

Catalogues and lists, however, do enable us to determine the kinds of pictures that were favored. At the top of this list were portraits, especially family likenesses, handed down from one generation to the next, for the most part painted by native artists. Dutch and Flemish genre scenes in particular were also popular with Polish collectors, as were Italian religious paintings with subjects taken from both the Old and New Testaments. Pictures with mythological subjects also appear on inventories, though these, surely owing to the frequent nudity in them, were sometimes regarded as immoral in

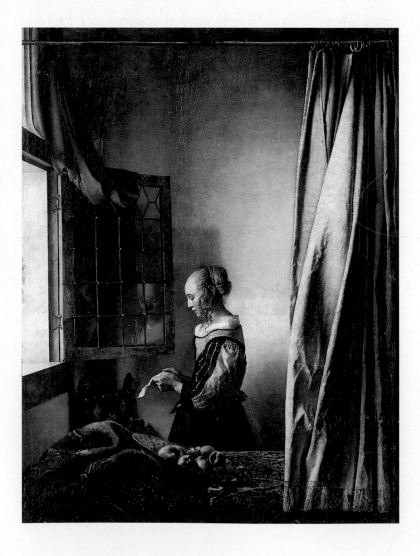

FIG 5
Jan Vermeer, *A Woman Reading a Letter at an Open Window*, ca. 1657, oil on canvas, Dresden, Gemäldegalerie Alte Meister, Staatliche Kunstsammlungen Dresden.

Catholic Poland. There was even a period when the clergy launched an official campaign aimed at destroying these "bawdy pictures," as they were described in 1629 by the Dominican monk Fabian Birkowski, one of the originators of the campaign. It was then that Marshal Mikołaj Wolski, a keen collector, obediently burned his "bawdy" paintings, but what they actually were will never be known.[10]

At the beginning of the eighteenth century, Poland, as Adam Zamoyski has described it, "lapsed into a condition of institutionalized anarchy."[11] The central structures of government had been eroded by the pressures of foreign invasion from the neighboring states of Prussia and Russia; internal strife only further complicated attempts at reform and the creation of a an independent sovereign state. The situation was compounded by the fact that between 1696 and 1763, Poland was ruled by the Wettin Electors of Saxony, Augustus II and his son Augustus III, who was attached to Saxony, but treated Poland as little more than a colony.

The Wettin Electors were great lovers of art, and over several dozen years they created one of the most magnificent picture galleries in all of Europe, which they located in the Saxon capital of Dresden. Their acquisitions, made through eminent specialists, included the *Sistine Madonna* by Raphael, the *Tribute Money* by Titian, Rembrandt's *Self-Portrait with Saskia in the Parable of the Prodigal Son*, and *A Woman Reading a Letter at an Open Window* by Jan Vermeer – to mention only a few that are now the true jewels of the Dresden Gemäldegalerie Alte Meister {*FIG 5*}.[12] It is unfortunate that none of these exquisite paintings, bought in part with Polish funds, ever reached the royal residences in Warsaw or Cracow.

The successor to the Saxons, the last king of Poland, Stanislaus II Augustus Poniatowski (1732–1798, reigned 1764–1795), was an exceptional personality with wide-ranging interests and highly developed artistic taste. Profoundly influenced by a brief stay in England and at the royal court in France, he believed in the decorative arts as both a spur for industry and a means of influencing political and social consciousness. Together with a number of progressive activists, he attempted to carry out an ambitious program of reform in the spheres of Polish political and cultural life. The period of his reign saw the flowering of literature, the reform of the educational system, the establishment of a Polish national theater, and the burgeoning concept of a Polish national museum.

10 Władysław Tomkiewicz, ed., *Pisarze polskiego odrodzenia o sztuce*, vol. 4 of Juliusz Starzyński, ed., *Teksty źródłowe do dziejów teorii sztuki* (Wrocław: Zakład im. Ossolińskich, 1961), pp. 243–51. I would like to thank Janusz Wałek for the information and citation.

11 See especially London, Dulwich Picture Gallery, *Treasures of a Polish King: Stanislaus Augustus as Patron and Collector* (London, 1992), p.15. Adam Zamoyski's introductory

essay provides invaluable background on the political context and vision of Stanislaus Augustus.

12 For a general survey of their collections and collecting patterns, see Karl Czok, *August der Starke und Kursachsen* (Leipzig: Koehler und Amelang, 1987); and Washington, D.C., National Gallery of Art, *The Splendor of Dresden: Five Centuries of Art Collecting* (Washington, 1978).

Following his election as king in 1764, he immediately began a dramatic renovation of The Royal Castle and the creation of a great studio within the castle that would become a center for artistic production and training for future generations. Architects from around Europe gave form to the king's ideological aspirations in the renovated Royal and Ujazdów Castles and Łazienki Palace.[13] The Royal Apartments and the Apartments of State were completely renovated between 1772 and the mid-1780s with a carefully crafted political program intended to assert the king's legitimacy to sovereign authority. The increased ceremonial character of the interiors bolstered the king's international reputation, putting him on a par with his French and English contemporaries.

Stanislaus Augustus's campaign of "enlightened" embellishment attracted artists from all over Europe. Portrait painters Johann Baptist Lampi and Per Krafft came to Warsaw from Austria and Sweden, respectively, and the decorative artist and designer Jan Chrystian Kamsetzer came from Saxony. The Italian court painter Marcello Bacciarelli ran the *malarnia* (painting studio) at The Royal Castle. He worked initially for Augustus III in Saxony, but in 1762 moved to Warsaw and after 1776 settled there permanently as court painter and artistic advisor to Stanislaus Augustus. He played an important role in creating and running the art academy – the first in Poland – and in 1786 he was appointed director of the Royal Buildings.[14] Bacciarelli's state portrait of the king in coronation dress is included in the exhibition {PL 28}, as is his more intimate but foreboding portrayal, *Portrait of King Stanislaus Augustus with an Hourglass* {PL 29}. Painted in 1793, the latter is often interpreted as a prescient intimation of future political events.

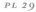

The most important painter at the court of Stanislaus Augustus was, however, another Italian, Bernardo Bellotto, a pupil and nephew of Canaletto, who stopped in Warsaw in 1767 on his way to St. Petersburg to work for the Empress of Russia Catherine II. Stanislaus Augustus immediately offered him employment and appointed him court painter in 1768. The first painting produced by Bellotto in Warsaw may have been *Ideal Architecture with Self-Portrait of the Artist*, in which the artist, draped in crimson robes, steps forward with a proud gesture of display, as if to present the viewer with an example of his extraordinary abilities {PL 30}.[15] A young peasant at the left points to the

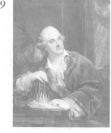

13 London, Dulwich Picture Gallery (note 11), pp. 25–28. Andrzej Rottermund's essay focuses on the evolution of the architecture and its propaganda program in the creation of a sovereign king.

14 Ibid., pp. 32–34, 46.

15 The best and most recent source on Bellotto is Venice, Museo Correr, *Bernardo Bellotto and the Capitals of Europe*, ed. Edgar Peters Bowron, trans. Studio Globe, Foligno (New Haven, Connecticut, and London: Yale University Press, 2001)

(orig. pub. Milan: Electa, 2001), pp. 33–39, 252–67. The essay in this catalogue on Bellotto in Warsaw was written by Andrzej Rottermund. For a description and interpretation of *Ideal Architecture with Self-Portrait of the Artist*, see Stefan Kozakiewicz, *Bernardo Bellotto*, 2 vols. (Greenwich, Connecticut: New York Graphic Society, 1972), vol. 2, pp. 263–65.

16 Venice, Museo Correr (note 15).

painter as if to underscore that he is the intended subject of the painting. By the time Bellotto arrived in Warsaw, he had already worked in some of Europe's greatest cities and his reputation as a painter of cityscapes in the Venetian tradition of *veduta* was firmly established.

Bellotto's most important work executed for the king is a stunning series of twenty-six views of Warsaw for the so-called "Canaletto Room" in The Royal Castle {*FIG 6*}. Bellotto often signed his works with his nickname, "Il Canaletto," to draw attention to his relationship with his celebrated uncle. In his lifetime Bellotto was called Canaletto, and even today in Poland he continues to be known by that name. The magnificent series of cityscapes he produced for the Canaletto Room capture the splendor and vitality of Warsaw in the last decades of the eighteenth century {*PLS 31–34*}. Comprised of three differently sized formats, these vistas were created with a precise knowledge of where each would be placed and this determined the subject and perspectival construction of each painting. Bellotto's urban subjects included broad panoramas, vistas with gardens, and views of streets and squares from the center of Warsaw. The palaces of magnates and Baroque churches are featured prominently throughout.[16] These realistic views significantly influenced later generations of Polish artists, who quickly turned native vistas into a uniquely popular Polish genre. The intense realism of Bellotto's paintings is considered so accurate that they were used as models for the reconstruction of individual buildings and entire quarters following the devastation of Warsaw during World War II.

PL 31

PL 32

PL 33

PL 34

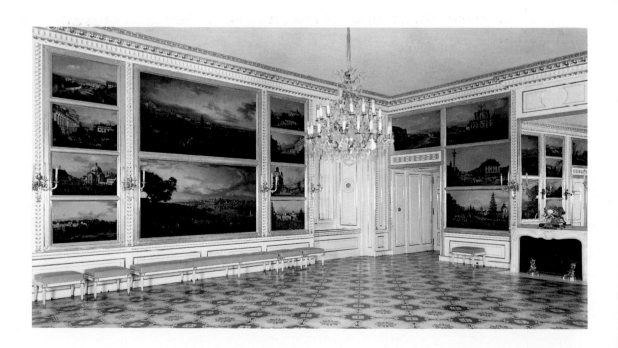

FIG 6
Bernardo Bellotto, *Canaletto Room*,
Warsaw, The Royal Castle.

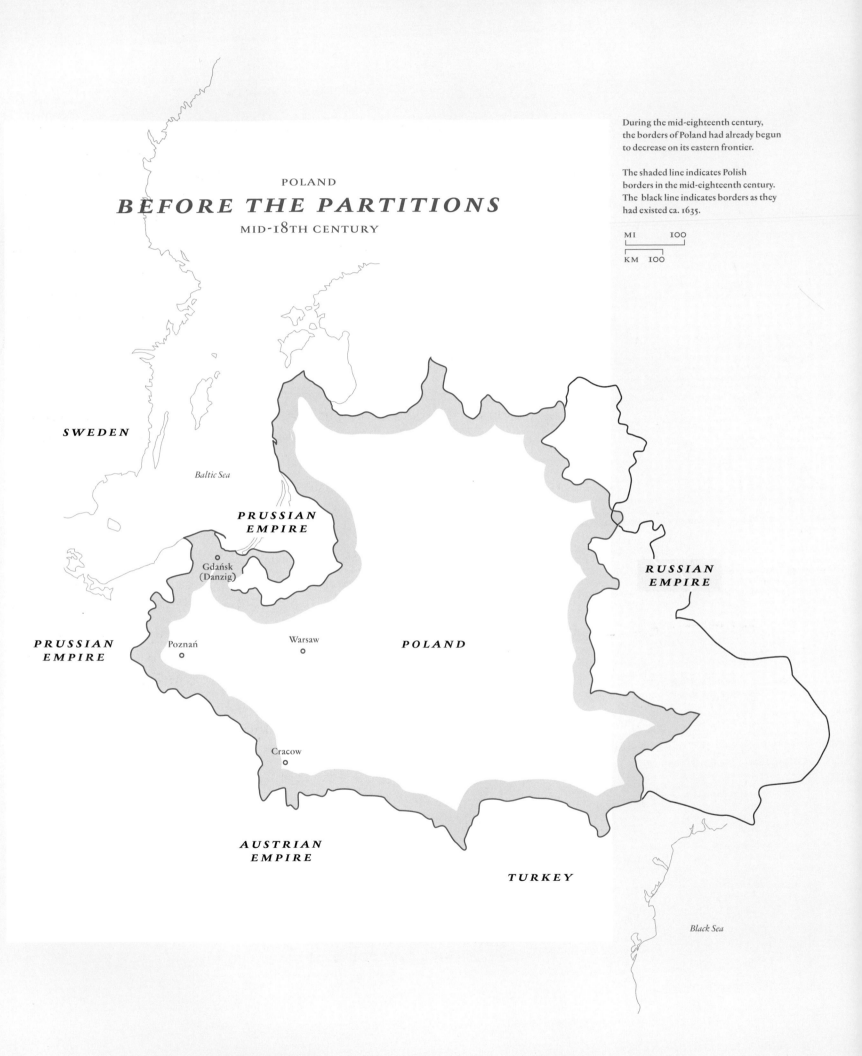

POLAND

BEFORE THE PARTITIONS

MID-18TH CENTURY

During the mid-eighteenth century, the borders of Poland had already begun to decrease on its eastern frontier.

The shaded line indicates Polish borders in the mid-eighteenth century. The black line indicates borders as they had existed ca. 1635.

MI 100

KM 100

SWEDEN

Baltic Sea

PRUSSIAN
EMPIRE

Gdańsk
(Danzig)

RUSSIAN
EMPIRE

PRUSSIAN
EMPIRE

Poznań

Warsaw

POLAND

Cracow

AUSTRIAN
EMPIRE

TURKEY

Black Sea

Throughout his reign Stanislaus Augustus labored to create a rich collection, which he considered primarily as a teaching resource, providing the royal studios with model compositions. August Moszyński, director of the Royal Buildings until 1772, managed the king's collections and artistic interests with great skill, rapidly increasing the holdings in all areas. According to Andrzej Rottermund, Moszyński used a number of agents to help Stanislaus Augustus acquire prints, medals, antiques, intaglios, jewels, and other rare objects.[17] Under his supervision the number of engravings in the print collection alone rose to 70,000, many of them by eighteenth-century artists, and an exceptional collection of drawings included works by Fragonard, Boucher, Rubens, Rembrandt, and Italian Renaissance masters such as Allori and Vasari. Originally the collection contained 4,000 drawings; 2,300 have survived and are now in the Print Room of the Warsaw University Library.

Bacciarelli succeeded Moszyński in 1786 as the king's artistic advisor and turned his attention to the expansion of the picture gallery at the Łazienki Palace and to a sculpture gallery, to be housed in the Great Orangery at Łazienki. The royal collection of sculpture did not include masterpieces of antiquity, but rather marble copies commissioned by the king that were intended largely for educational purposes in order to elevate the caliber and education of Polish artists. Contemporary sculptures were fewer in number, but included works by Falconet, Pigalle, and Houdon.[18]

An inventory of the royal picture gallery in 1795 lists 2,289 paintings plus several hundred miniatures, framed pastels, and gouaches.[19] Catalogue entries from this period are often inaccurate or overly optimistic in their attribution, making a true assessment difficult. However, about four hundred of the paintings have been correctly identified and approximately one hundred were certainly of the highest quality. These included Rembrandt's *Polish Rider* {*see ziemba, fig 6*}, Fragonard's *Stolen Kiss*, Benjamin West's *Romeo and Juliet*, and paintings by Fragonard, Watteau, Greuze, Hubert Robert, Largillière, Nattier, and Jordaens.

The catalogue also attributes works to such famous artists as Correggio, Guido Reni, Annibale Carracci, Titian, Veronese, Rubens, Van Dyck, and Jan Breughel, but these have never been specifically identified. In accordance with eighteenth-century tastes, paintings by Dutch and Flemish artists comprised the bulk of the collection, with about 500 works by such artists as Honthorst, Bol, Flinck, Steen, and Metsu. The king

17 London, Dulwich Picture Gallery (note 11), p. 32.
18 Ibid., pp. 33–34.
19 Ibid., pp. 34–36.

housed his Dutch collection on the first floor of the Łazienki Palace; in all likelihood Rembrandt's *Polish Rider* was the most precious item in the royal collection.

To facilitate the acquisition of works abroad, Stanislaus Augustus and Bacciarelli created an international network of agents who would purchase works on the king's behalf. One of their directives was to buy only originals, never copies. Among his most renowned agents was Noel Desenfans, who in France and England amassed an outstanding group of works that included Rubens's *Venus, Mars, and Cupid* (ca. 1630, London, Dulwich Picture Gallery) and Poussin's magnificent *Blind Orion Searching for the Rising Sun* {FIG 7}. The works had been very expensive and because the king was unable to pay the price, they were never sent to Poland. Desenfans's heirs later sold off the collection, which found its way into various museums throughout the whole of Europe. A substantial portion was turned over to the Dulwich Picture Gallery in London.[20] The Poussin many years later ended up in The Metropolitan Museum of Art in New York.

When the king left Poland in 1795, upon its final partition, he took one hundred of his favorite paintings to St. Petersburg. After his departure, his collections were gradually dispersed; sales continued until 1821. Many works were acquired by private Polish collectors, but only rarely were these spared the ravages of World War II. Only remnants of the king's original collections have been returned to the royal residences and the Warsaw University Library.

Poland's loss of independence in 1795 briefly arrested the development of artistic life. The artistic center that had developed at the royal court of Stanislaus Augustus

FIG 7
Nicolas Poussin, *Blind Orion Searching for the Rising Sun*, 1658, oil on canvas, New York, The Metropolitan Museum of Art.

ceased to exist, and the cultural nuclei around the universities in Warsaw, Cracow, Wilno (now Vilnius) were still only in their infancy. For the first three decades of the nineteenth century, Poland had no dominant political body to maintain the cultural heritage or promote the development of large-scale public museums of the kind that had begun to appear elsewhere in Europe. The great national Polish museum that Stanislaus Augustus had one day hoped to create was not to be realized during his lifetime.

The preservation of Poland's cultural heritage fell instead to private individuals who took it upon themselves to create museums at their country seats or palaces. One of the most important of these was Princess Izabela Czartoryska and her husband, Adam Kazimierz Czartoryski. Inspired by the king's example to build a public consciousness through the arts, they opened in 1801 the museum known as The Temple of Sibyl at their country estate in Puławy "to create in the midst of this Arcadian setting a kind of shrine, a national museum dedicated to preserving the memory of Poland's past and her place in history."[21] Their collections at the temple and at the later Gothic House, built in 1809, reflected an emotional and sentimental synthesis characteristic of the later Romantic ideology of collecting. Royal patronage ceased to exist.

20 See especially Peter Murray, *The Dulwich Picture Gallery: A Catalogue* (London: Philip Wilson Publishers Ltd. for Sotheby Parke Bernet Publications and the Governors of Dulwich College, 1980); and Giles Waterfield, *Collection for a King* (Washington, D.C.: National Gallery of Art, 1985). Stanislaus Augustus invited Desenfans in 1790 to assemble a collection of paintings suitable for a national gallery in Warsaw and appointed him Polish Consul General in London. Over a period of five years, Desenfans purchased some 150 pictures in France and England that were eventually to be sent to Warsaw. However, when Poland was partitioned for the final time in 1795, the king was no longer in a position to pay for the collection. Many of the works were subsequently sold off, but a core group favored by Desenfans remained intact until his death, when his heirs elected to create a museum at Dulwich College in London, which is known today as the Dulwich Picture Gallery.

21 Cracow, The Princes Czartoryski Museum, *The Czartoryski Museum*, text by Adam Zamoyski (London: Azimuth Editions on behalf of The Princes Czartoryski Foundation, 2001), p. 19.

JANUSZ WAŁEK

{ *CONNOISSEURSHIP* }

and

PATRIOTISM

To save from destruction national mementoes, to hand them down to centuries to come, has always and for all peoples been a bounden and dear duty.

STANISŁAW KOSTKA POTOCKI, 1821

COLLECTING IS CLOSELY ASSOCIATED with the consciousness of the value – historical and aesthetic above all – of the objects amassed. Historical value may attach to something quite modest that is a priceless testimony of people and events, in which the past has been preserved in a well-nigh magic way. The collecting and preserving of relics of the past strengthens the awareness of historical continuity in families and nations, awakens their consciousness of being rooted in history, and enables them to develop and maintain their national identity. This very important aspect of collecting and museums was of particular weight in Poland, a country from 1795 to 1918 deprived of its statehood and torn asunder by three partitioning monarchies, whose governments pursued consistent policies aimed at the denationalization of the Poles.

Aesthetic value is connected with a beautiful form, not infrequently with the refined shape of a specimen of natural history or artistic creation. Sublime works of art elicit admiration for man's creative power, for individual and unique performances in which – as Leonardo da Vinci would say – artists are sometimes equal to gods. The collecting of beautiful things requires a discerning taste and apt judgment, usually coupled with a high cultural level on the part of the collector and community whose representatives acquire these objects.

Polish collecting had its origin at royal and ducal courts and in medieval churches and monasteries, though it is impossible to establish whether this collecting was fully intentional. Insignia of authority, jewelry, armor, and the spoils of war at the courts, and golden and silver liturgical vessels, embroideries, and lavishly illuminated missals and prayer books in churches and monasteries formed rapidly increasing sets of valuable objects although they were still treated primarily as articles of daily use.

The beginnings of conscious art collecting are probably connected with the court of the last Jagiellonians – kings Sigismund I and Sigismund II Augustus, who in the sixteenth century thoroughly rebuilt The Wawel Royal Castle in the spirit of the Italian Renaissance

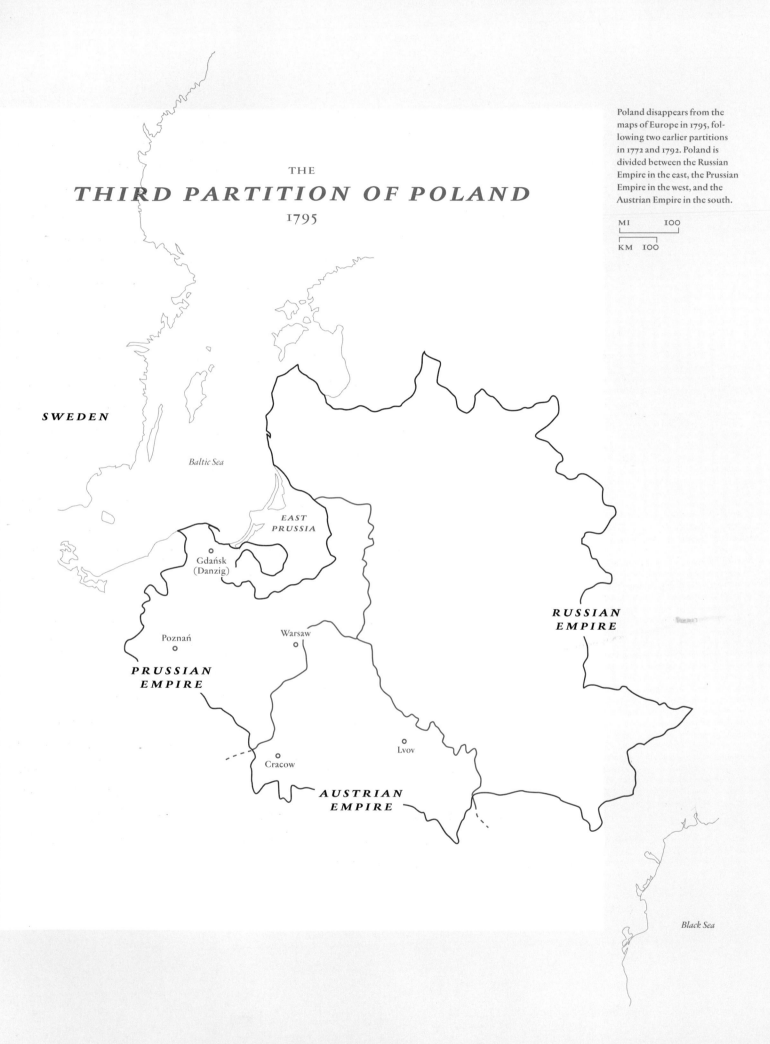

THE
THIRD PARTITION OF POLAND
1795

Poland disappears from the maps of Europe in 1795, following two earlier partitions in 1772 and 1792. Poland is divided between the Russian Empire in the east, the Prussian Empire in the west, and the Austrian Empire in the south.

MI 100

KM 100

SWEDEN

Baltic Sea

*EAST
PRUSSIA*

Gdańsk
(Danzig)

*RUSSIAN
EMPIRE*

Poznań

Warsaw

*PRUSSIAN
EMPIRE*

Lvov

Cracow

*AUSTRIAN
EMPIRE*

Black Sea

and furnished it with a splendid set of Flemish tapestries. The kings of the Swedish Vasa dynasty, Sigismund III, Ladislas IV, and John Casimir, who reigned in Poland from 1587 to 1668 and who transferred the capital from Cracow to Warsaw, were perhaps the first real collectors in Poland, acquiring works from a number of European art centers. However, the Swedish invasion of 1655–56 dealt a terrible blow to the kingdom and its culture. The Swedes burnt magnate palaces and churches and monasteries, plundering works of art on a scale hitherto unprecedented in Poland. Political events and numerous wars wreaked havoc with developing art collections, including that of John III Sobieski, elected king in 1674.

Augustus II and Augustus III, Electors of Saxony, great art lovers, and kings of Poland in the first half of the eighteenth century, created over several dozen years one of the most magnificent European picture galleries, which, alas, they located in Dresden in their home country of Saxony. Their acquisitions, made through specialists and dealers, are now true jewels of the Dresden Gemäldegalerie, and it is only to be regretted that none of these exquisite paintings, bought in part with Polish funds, ever reached their royal residences in the Warsaw Castle or The Wawel Royal Castle in Cracow.

The successor to the Saxons, Stanislaus Augustus Poniatowski (1732–1798, reigned 1764–1795), turned out to be an energetic collector and a great patron of artists, amassing about 2,000 pictures during the last tragic years of the Polish Kingdom, when hostile neighbors systematically were tearing it asunder at the end of its statehood and on the eve of his abdication. Indeed, the king was a greater collector than politician, which he expressed in a letter to his court painter and chief advisor on art, Marcello Bacciarelli: "Nous nous sommes dit souvent, que notre bonheur n'était qu'en peinture" [We have often told ourselves that our happiness is only in painting].[1]

Together with numerous progressive activists, Stanislaus Augustus attempted to carry out an ambitious program of improvement in several spheres of Polish political and cultural life. The period of his reign saw the flowering of literature, the reform of the educational system, and the establishment of the Polish national theater; moreover, there appeared in the monarch's circle some ideas concerning the creation of a Polish national museum. This was most emphatically expressed by Michał Mniszech: "Let us leave precious sculptures, priceless paintings, these pleasing darlings of the liberal arts, to the nations rightly boasting of the first light beams. Let them become examples to be

1 Tadeusz Mańkowski, *Galeria Stanisława Augusta* (Lwów: Wydawnictwo Zakładu narodowego imienia Ossolińskich, 1932), p. 33.

followed, but with moderation, and especially in their most useful aspects. Let us find means that are cheaper, quicker, and easier, while being of similar utility. Let us keep within the boundaries of our homeland, get to know our own country, assess its riches, explore what nature has granted us. These discoveries should stir our interest, focus our efforts, and inspire our minds."[2] However, some dozen years were to pass before the *Musaeum Polonicum*, postulated by Mniszech, was established.

In the last years of the Polish Kingdom, despite the imminent political upheaval that in 1795 brought about the collapse of the state and its partitioning by the neighboring powers Russia, Prussia, and Austria, Polish magnates traveled throughout Europe, continuing to acquire new works of art there and sitting for their portraits. Izabela Lubomirska, née Czartoryska, in charge of an immense fortune and owner of numerous palaces and castles, was portrayed by, among others, Elisabeth Vigée-Lebrun and Angelica Kauffmann. She amassed a splendid collection which, after being housed in a variety of locations, finally was placed in a magnificent castle at Łańcut, in the south of Poland, where the works survived intact until World War II.

Izabela Lubomirska's son-in-law, Stanisław Kostka Potocki (1755–1821), a political and social activist of the Enlightenment, accumulated in the Palace at Wilanów, an exquisite collection of antique vases, sculptures, cameos and intaglios, and coins, as well as a considerable number of paintings, prints, and books. Depicted by Jacques-Louis

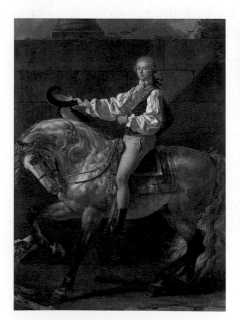

FIG 1
Jacques-Louis David, *Equestrian Portrait of Stanisław Kostka Potocki*, 1781, oil on canvas, Warsaw, The National Museum, on loan to the Palace of Wilanów.

FIG 2
Jean-Pierre Norblin, *Christian Piotr Aigner's Temple of the Sibyl, Puławy, 1801*, red chalk on paper, 1820, Cracow, The Princes Czartoryski Museum.

David in an excellent equestrian portrait, painted in the years 1780–81 in Naples, Potocki, whose interests in many spheres of life and art permit his being compared to Thomas Jefferson, was undoubtedly one of the most prominent art collectors in Poland {*FIG 1*}. A connoisseur of classical antiquity, the translator into Polish of Johann Joachim Winckelmann's famous work *Geschichte der Kunst des Altertums*, he was deeply aware of the national and social role of art collections. In 1805 he opened his Palace at Wilanów to the public, in order to – as written later – "make it easier for the Poles to cultivate their mental faculties" and "inculcate in the nation the will to perfect the arts of its age, to enlarge the world of beautiful objects."[3]

Nevertheless, no one understood the national and social functions of collections of historical art better than Princess Izabela Czartoryska, née Flemming, who in 1801 founded the first public museum in Poland, six years after the collapse of the Polish state as a result of the third partition of Poland {*PL 47*}. In the beautiful park at Puławy, the Rome-educated Polish architect Christian Piotr Aigner erected a special circular, colonnaded museum building – the first in Poland – modeled on the Roman Temple of Vesta in Tivoli {*FIG 2*}. Above the entrance to the edifice, called The Temple of Memory or The Temple of the Sibyl, was the inscription: Przeszłość Przyszłości [From the past to the future] – the motto of the Puławy museum, which excellently epitomizes Czartoryska's idea of saving from the threat of the partitioning powers the highest values of a state that had been erased from the map of Europe. These values were enshrined in symbolically treated memorabilia, books, and documents understood as signs of a bygone glory. They were to remain in the Puławy temple, as if in the ark, during the hard time of political bondage, to make their return after Poland recovered independence. Just like the Sibylline Books, diligently studied by priests and politicians during difficult moments for Rome, they were intended to maintain hope and fortify the Poles in their struggle for liberation. The museum at Puławy was primarily national and patriotic in character.

The Temple of the Sibyl contained, among other items, a royal casket with memorabilia of the Polish kings as well as banners and weapons captured during the victorious wars with the Teutonic Knights, Moscovy, Turkey, and Sweden. An important place was occupied by spoils of war captured from the Turks after the famous battle

2 Ludwik Dębicki, *Puławy (1762–1830). Monografia z życia towarzyskiego, politycznego i literackiego* (Lwów: Nakład Księgarni Gubrynowicza i Schmidta, 1887), vol. I, p. 66.
3 Stanisław Staszic, cited in Jan Białostocki and Michał Walicki, *Malarstwo europejskie w zbiorach polskich 1300–1800* (Warsaw: Państwowy Instytut Wydawniczy, 1955), p. 27.

of Vienna in 1683, when the Polish hussar cavalry under the command of King John III Sobieski saved Europe from the Turkish threat. There were mementoes of great hetmans, including Stanisław Żółkiewski and Stefan Czarniecki, and of the later heroes of the struggle for independence: Tadeusz Kościuszko, who had won fame in the American War of Independence, and Prince Józef Poniatowski, Marshal to Napoleon, who was killed at the Battle of the Nations near Leipzig in 1813.

In 1809 Izabela Czartoryska opened another museum building at Puławy, the Gothic House, again by Christian Piotr Aigner {*FIG 3*}. It was filled with a romantic assemblage of mementoes and documents connected with great figures in European his-

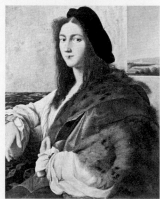

FIG 3
Wilibald Richter, *Christian Piotr Aigner's Gothic House, Puławy, 1809,* ca. 1840, watercolor, Cracow, The Princes Czartoryski Museum.

FIG 4
Raphael, *Portrait of a Young Man,* ca. 1515, oil on canvas, formerly in the collection of Cracow, The Princes Czartoryski Museum.

tory and culture. They included memorabilia of Petrarch, Shakespeare, William Tell, Jean-Jacques Rousseau, Voltaire, Napoleon, and James Cook. Extensive, handwritten catalogues contained descriptions of items and commentaries on particular people and events, hence they may be regarded as the first museum *catalogues raisonnés* in Poland. The only printed catalogue (1828) of the Gothic House gives in its introduction a lucid explanation of the intentions of the founder of the museum:

The Temple of the Sibyl was designed exclusively for national monuments. The Gothic House was to enclose only foreign antiquities; therefore, aggregated in it was everything that frequent travels and dispatches, and numerous gifts had provided. They had already included numerous souvenirs of France, Italy, Germany, and England, relics of ancient times, of the ages of chivalry, and of later epochs; some more mementoes came from Egypt, Asia, and America.

Nevertheless, the Gothic House was for long perceived as incomplete in a way, as lacking something important. It indeed lacked the most moving, most expressive, Polish mementoes. That is why not only The Temple of the Sibyl contains our antiquities. A substantial part of them have been assembled in the Gothic House – both inside and on its outer walls.

Please God! [that] in centuries to come our grandchildren may to these mementoes of Fame, Valor, Patriotism....add....the monuments of inseparable Glory and Good Fortune.[4]

Princess Izabela Czartoryska also acquired for the Gothic House a large collection of paintings, predominantly portraits, including those of Dante, Petrarch, Tasso, Mary Stuart, and the kings Henry IV and Louis XIII of France. The catalogues indicate that in paintings, Izabela Czartoryska sought not so much aesthetic values as "above all, narrative content or general reflections,"[5] for a museum that was definitely literary and historical in character, and consequently had an extremely important role in the education of the Polish people.

4 Izabela Czartoryska, *Poczet pamiątek zachowanych w Domu Gotyckim w Puławach* (Warsaw: Drukarnia Banku Polskiego, 1828), p. 2. The last part of the quotation is awkwardly phrased in its entirety: "Please God! in centuries to come our grandchildren may to these mementoes of Fame, Valor, Patriotism and, alas, so many national sufferings, please God! Our grandchildren may add to these mementoes the monuments of inseparable Glory and Good Fortune."

5 Zdzisław Żygulski, Jr., *Dzieje zbiorów puławskich (Świątynia Sybilli i Dom Gotycki)* (Cracow: Muzeum Narodowe, 1962), offprint from vol. 7 of *Rozprawy i Sprawozdania Muzeum Narodowego w Krakowie*, 1962, p. 219.

Three masterpieces of European painting, the greatest of all the foreign pictures assembled in Polish collections, were described as a "Portrait of Raphael, painted by himself" {FIG 4}, "Portrait of a woman called La Belle Ferronnière, mistress of Francis I, king of France, painted by Leonardo da Vinci" {PL 38}, and "A View of a thunderstorm, painted in oils by Rembrandt."[6] The first two paintings were purchased in Italy by Prince Adam Jerzy Czartoryski, Izabela's son, while the Rembrandt picture was brought from Paris to Poland by the French painter Jean-Pierre Norblin de la Gourdaine, who for thirty years (1774–1804) remained in the service of the Czartoryski family. Surviving intense scrutiny by art historians, the authorship of these paintings has been confirmed, and both the *Lady with an Ermine* and the *Portrait of a Young Man* (the latter unfortunately lost during World War II) hold prominent positions in the respective oeuvres of Leonardo da Vinci and Raphael.

PL 38

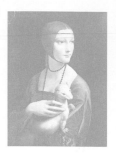

In 1830, during a national insurrection against Russia known as the November Uprising, the Puławy museum came to an end. The confiscation of the Czartoryski property by the tsarist authorities made it necessary to remove the collection from Puławy. The evacuation of the museum items and the library, carried out in extremely difficult conditions, was directly supervised by the eighty-four-year-old princess. The most valuable part of the collection went to Paris, where it was housed in the Hôtel Lambert on the Ile St.-Louis, the émigré seat of the Czartoryski family.

In the nineteenth century the collectors made their possessions more and more frequently accessible to the general public, thereby joining a growing movement toward a wider social access to cultural values, which was of vital importance in the Polish political situation. In Lvov, on the initiative of Józef Maksymilian Ossoliński, the owner of a magnificent library and a collection of drawings, the Ossoliński National Institute, a library and museum commonly known as the Ossolineum, was set up in 1823; transferred after World War II to Wrocław, it continues still today to play a prominent part in Polish culture.

From the very start, Józef Maksymilian Ossoliński accumulated his impressive collection with the intention of making it accessible to the public. He opened a public, admission-free gallery in 1814 in Warsaw on the initiative of his cousin Józef Kajetan Ossoliński. This first art gallery in Poland, functioning in a large city and thereby ensuring a wide impact, included paintings by Poussin and Jordaens (catalogued in 1817 by the painter Villani). Unfortunately the gallery closed in 1834, when the heirs of Józef Kajetan Ossoliński decided to sell the collection.

Regrettably, the plan to present the Polish people with the private collection of Jan Feliks and Waleria Tarnowski, assembled at Horochów and Dzików, was never carried out. Instead the splendid set of paintings and sculptures was dispersed. Rembrandt's *Polish Rider*, once part of the royal collection, and Canova's *Perseus* eventually ended up in New York, in The Frick Collection (1910) and The Metropolitan Museum of Art (1960), respectively.

In 1835 in Warsaw a public exhibition was arranged for the fine collection of paintings, sculptures, and antiquities amassed in Warsaw and at Nieborów by Michał Hieronim Radziwiłł and his wife, Helena, née Przeździecka. Catalogued by the painter Antoni Blank, the collection included works by Mattia Preti, Paulus Potter, Salomon von Ruisdael, and Jusepe de Ribera, as well as paintings attributed to Titian and Rembrandt. In addition, Helena Radziwiłł laid out at Arkadia near Nieborów a romantic park, where, in the tradition of Izabela Czartoryska at Puławy, she built pseudo-Antique and Neo-Gothic structures, among them the Temple of Diana, decorated with a ceiling painting by Jean-Pierre Norblin, as well as the Gothic House.

The second half of the nineteenth century witnessed a number of new and important achievements in collecting that had a far-reaching influence on the development of Polish museums in that period. Faced with a threat to their possessions during the Franco-Prussian War and the Paris Commune (1870–71), the Paris-based Czartoryski family resolved to bring their art collection and library – considerably increased by numerous acquisitions of Egyptian, Greek, Etruscan, and Roman art, French enamels and ivories, and paintings by Italian and Netherlandish Renaissance masters – back to Poland. Since Puławy, located in the Russian partition zone, was still under the tsar's control, Prince Władysław Czartoryski, Izabela's grandson, chose for its destination Cracow, the former capital of Poland {*FIG 5*}. Situated in the Austrian partition zone, this university town and seat of the Polish Academy of Science and Letters, was home to an elite group of Polish scholars. The year 1876 saw the opening of The Princes Czartoryski Museum, which soon became one of Poland's major cultural centers, attracting numerous scholars and artists. Jan Matejko, a prominent historical painter, was strongly connected with this museum, and time and again used its collection of arms and armor as props in his compositions.

6 These titles for the paintings by Raphael, Leonardo da Vinci, and Rembrandt are given in Czartoryska (note 4).

At about the same time, Izabela Działyńska, née Czartoryska, the sister of Prince Władysław Czartoryski, together with her husband, Jan Działyński, set up an impressive museum in the castle at Gołuchów near Poznań (1885). This collection, including high-quality Greek vases, medieval bronzes, and Renaissance enamels, along with decorative textiles and paintings (examples by Lorenzo Monaco, Dieric Bouts, and the Clouets), which she and her brother Władysław had been assembling in Paris since 1852, counted among the most remarkable in Poland until World War II, when it fell victim to plunder and, in large measure, destruction.

Another noteworthy Polish art collector of the period was Atanazy Raczyński. The nucleus of his excellent collection were the paintings purchased in 1810 from the estate left by King Stanislaus Augustus. During Raczyński's numerous travels around Europe, facilitated by his position as the diplomatic envoy of the king of Prussia in Portugal and Spain, he acquired excellent works, chiefly from the Italian Renaissance

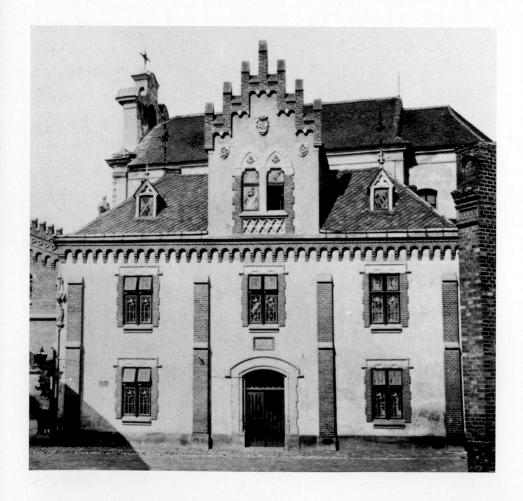

FIG 5
J. Krieger, *The Princes Czartoryski Museum, Cracow*, ca. 1900, photograph, Cracow, The Princes Czartoryski Museum.

PL 52

PL 53

PL 54

and nineteenth-century German painting {PLS 52–54}. He bought a great many pictures at major auctions, for instance, at the sale of the gallery of King Louis Philippe in 1855. Raczyński was an outstanding art connoisseur and the author of a number of scholarly publications, including a history of postmedieval German art, a history of Portuguese art, and a dictionary of Portuguese artists. He also compiled a catalogue of his own collection (1841). Among his most important paintings, were Sandro Botticelli's *Madonna among Angels*; Quentin Massys's *Madonna and Child in a Landscape*; Bernardo Strozzi's *Rape of Europa*, and Francesco Zurbarán's *Adoration of the Madonna by the Carthusians*. Alas, in 1903, several years after Raczyński's death, when his collection was being transferred to Poznań, the Botticelli remained in Germany. After World War II it was sold by the owner's descendants to the then Dahlem Museum; today it is one of the gems of the Staatliche Museen in Berlin.

In 1903 Raczyński's gallery was incorporated into the Regional Museum in Poznań (opened in 1894). Together with another important collection assembled by Seweryn Mielżyński, it was kept in the Museum of Polish Antiquities, also in Poznań (established 1857) and formed the core of one of the leading Polish museums, called the Wielkopolskie [Great Poland] Museum beginning in 1919 and only in 1950 renamed The National Museum.

The end of the nineteenth century saw a new era of collecting, preserving, and displaying all types of collections. Private possessions were increasingly brought into the public domain to serve society by awakening and maintaining patriotic feelings and educating the Polish people in history and aesthetics. The Enlightenment idea of a national museum institution was thereby put into effect, after first gaining expression during the reign of Stanislaus Augustus Poniatowski, by the previously mentioned Michał Mniszech and the Reverend Xawery Zubowski, who wrote in reference to museum collections in general: "All rarest collections, stores of ensigns of war and peace, mementoes of the valor, triumphs of Poles, masterly works by famous artists in sculpture and painting... curiosities of cabinets, treasuries, academies, libraries, museums, armories, monasteries, in short, everything worth seeing, hearing, reading, this common collection will contain.... Here, visible in its form would be this immense fabric of taste, monuments, vigor, and effort of the Old Polish people."[7]

The year 1862 saw the opening of the Museum of Fine Arts in Warsaw, the nucleus of the present National Museum, so named in 1916. The first National Museum in Poland was set up in 1879 in Cracow. Its collections were begun by spontaneous donations

1 Tadeusz Mańkowski, *Galeria Stanisława Augusta* (Lwów: Wydawnictwo Zakładu narodowego imienia Ossolińskich, 1932), p. 33.

made by numerous Polish artists working at home and abroad. An example was set by Henryk Siemiradzki, active in Rome, who presented the nascent museum with his painting *Nero's Torches*, whose subject matter related to the persecutions of the Christians in ancient Rome. The museum was housed in the Cloth Hall (Sukiennice), a medieval-Renaissance building in the middle of the Cracow Market Square, which soon after received monumental historical compositions by Jan Matejko.

Today numbering six institutions, including The Wawel Royal Castle in Cracow and The Royal Castle in Warsaw, the National Museums now house the major collections of art in Poland. They carry out an honorable mission for the benefit of society, recently formulated by the Board of Directors of The National Museum in Cracow, which consists above all in "testifying to the national and universal human values by popularization of works of world and Polish art."[8] It is worthwhile remembering that this mission is the result of centuries of patronage and collecting made possible by generations of Polish kings, magnates, clergy, and private patrons of the arts.

8 Zofia Gołubiew, "Czym jest Muzeum Narodowe? Trudne słowo," *Tygodnik Powszechny* 46 (November 18, 2001).

PLATES

27–54

PARIS BORDONE

ITALIAN, 1500–1571

PORTRAIT OF ITALIAN GOLDSMITH
GIAN GIACOMO CARAGLIO
CA. 1552

OIL ON CANVAS
54 3/4 × 42
INCHES
139 × 106.5
CENTIMETERS
CRACOW,
THE WAWEL ROYAL CASTLE,
STATE ART COLLECTIONS
INV. 5882

Mentioned for the first time by Carlo Ridolfi in 1648, *Portrait of Italian Goldsmith Gian Giacomo Caraglio* was referred to in 1664 as a work by Titian in the inventory of the Muselli gallery in Verona, which had been prepared for the purpose of selling the gallery to the Duke of Modena, Alfonso IV. However, it was not until the first quarter of the eighteenth century that a sale took place, and to a French antiques dealer, subsequently to become the property of Philip, Duke of Orléans, Regent of France. During the French Revolution the painting found its way to England. During the twentieth century it was briefly in the United States before landing once more in England. Finally, in 1972, Julian Godlewski of Lugano donated it to The Wawel Royal Castle on the 400th anniversary of the death of Sigismund Augustus.

Italian painter Paris Bordone worked for the European aristocracy, including royal patrons in France and Poland. He specialized in mythological and allegorical paintings that have affinities with the work of his later Venetian compatriot, Titian, and are distinguished by their skillful and monumental architectural settings. The well-known Italian engraver Gian Giacomo (Jacopo) Caraglio (ca. 1505–1565), probably through his friends the famed Pietro Aretino and Alessandro Pesenti, a musician to Queen Bona Sforza at Wawel, came to Cracow probably in 1538 and in 1545 was employed at the court of Sigismund Augustus, for whom he made intaglios and served as an armorer. In 1552 the last king of the Jagiellonian dynasty made him a Knight of the Golden Spur, and he was granted Cracow citizen-

ship. The following year, during a visit to his native country, Caraglio commissioned Bordone, who had been working in Venice for a year, to paint this allegorical portrait commemorating the king's gesture.

Portrait of Italian Goldsmith Gian Giacomo Caraglio is one of the most valuable paintings in the Wawel collection. The figure of Caraglio was first identified by Jan Bołoz Antoniewicz. Framed by the architecture of his native Verona, he bends humbly before the Polish Eagle, which bears the monogram *SA* [Sigismundus Augustus] on its breast and holds in its beak a knight's ribbon with the royal medallion. The eagle stands on one leg and places the other foot, with the ribbon, in Caraglio's hand. There are two interpretations for this enigmatic narrative. One is that the goldsmith is *receiving* the medallion as a symbol of his ennoblement. However, according to Jerzy Wojciechowski, the painting shows the artist *presenting* to the eagle the medallion portrait of King Sigismund Augustus. The eagle stands on a helmet around which are scattered a seal die, rings, and tools of the goldsmith's profession. The inscription on the plinth of the column – AETATIS / SVAE /ANN [O] XXXX/VII – gives the subject's age. Dating from the mature period of Bordone's creative activity, the portrait is one of his more remarkable works and a document as well of Caraglio's successful rise in society. KK

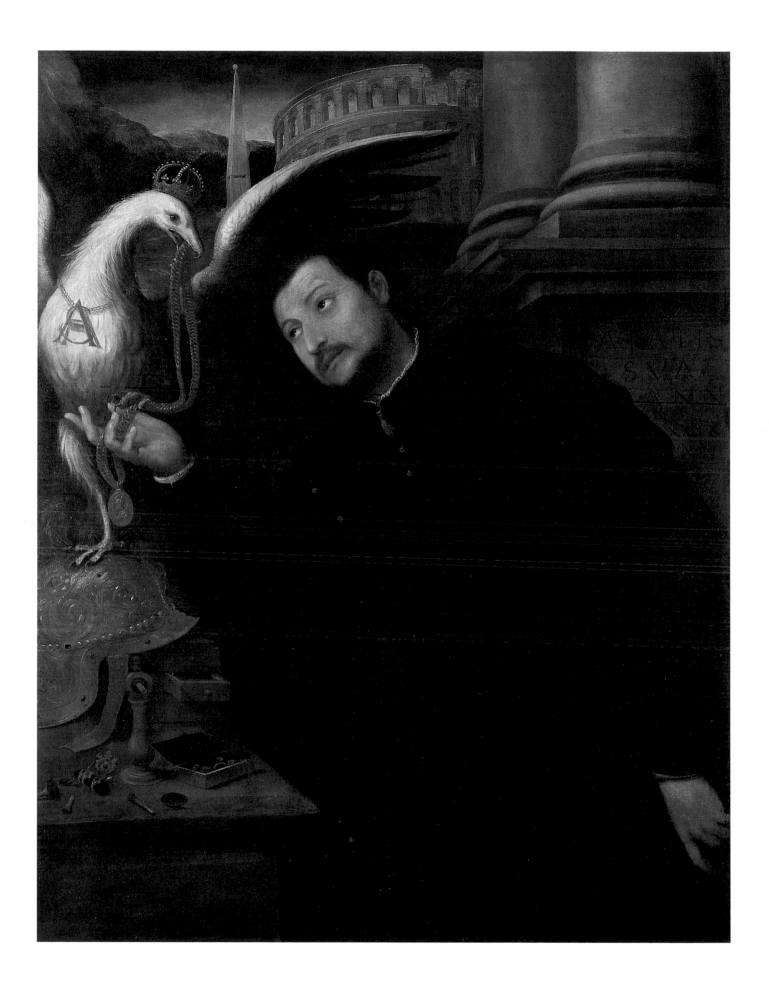

MARCELLO BACCIARELLI
ITALIAN, 1731–1818

28

STATE PORTRAIT OF
KING STANISLAUS AUGUSTUS
PONIATOWSKI

1792

OIL ON CANVAS

109 ¹/₂ × 62 ¹/₄
INCHES

278 × 158
CENTIMETERS

POZNAŃ,
THE NATIONAL MUSEUM
MNP DEP. 768

Stanislaus Augustus Poniatowski (1732–1798), elected king of Poland from 1764 to 1795, was an enlightened man and an art lover. Although he took an active part in the enforcement of the reforms and the preparation of the "Third of May" Constitution, he reigned during an extremely difficult period for the country: the three partitions of the Commonwealth among the neighboring powers, Russia, Prussia, and Austria. Prohibited from exercising power during the Kościuszko Insurrection of 1794, he abdicated after the third partition in 1795 and died three years later in St. Petersburg. One of the most controversial figures in Polish history, he has been praised for his intellectual qualities but censured as a politician.

Marcello Bacciarelli, an Italian painter trained in Rome, played an important role at the court of King Stanislaus Augustus. His artistic career began in 1750 when he was called to the court of Augustus III in Dresden. During the Seven Years' War, toward the end of 1756, he came with the court of Augustus III in Warsaw, where he met the future king, Stanisław Antoni Poniatowski. In 1764 he went to Vienna to the court of Maria Theresa, where he painted portraits of the imperial family. In 1766 he returned to Warsaw to become a court painter. On a royal commission, he drew up a proposal for a fine arts academy, which was never implemented; instead Bacciarelli's atelier in the castle served as a training ground for numerous Polish artists and a place where royal commissions were carried out. In 1768 Bacciarelli was knighted, which consolidated his position as court painter as well as the king's advisor and plenipotentiary for art. In 1777 he was appointed head of the Commission

for the Royal Edifices; in 1784 he became Director of Fine Arts, and in 1786 Director General of the Royal Edifices). He was an honorary member of European academies in Dresden, Vienna, Venice, Bologna, Rome, and Berlin.

Bacciarelli's full-length *State Portrait of King Stanislaus Augustus Poniatowski* was designed for the Marble Room of The Royal Castle in Warsaw, which housed a portrait gallery of Polish kings, their busts forming a frieze running around the room and culminating above the marble fireplace with the most sumptuous portrait of the reigning king.

Bacciarelli depicted the king according to the current canon of the so-called state portrait, originating in the representation of France's Louis XIV. Stanislaus Augustus is shown as a young man in a gray wig, wearing golden-silver coronation robes with an ermine-lined red mantle embroidered with gold eagles thrown over his shoulders. On an orange ribbon on his breast is the Order of the Black Eagle (the highest Prussian distinction) and a blue sash with the Cross of the Order of the White Eagle (the highest order in prepartition Poland) – the star of the latter order also embroidered on the left shoulder of the mantle. In his right hand he holds a commander's staff with eagles (a sign of military authority) and at his left side he carries a sword with a hilt in the form of an eagle's head; on the table beside him are the insignia of royal power: a crown, a scepter, and an orb.

Following Baroque portraiture convention, the figure's silhouette is described with a fluid, rippling line that repeats the contours of the background.

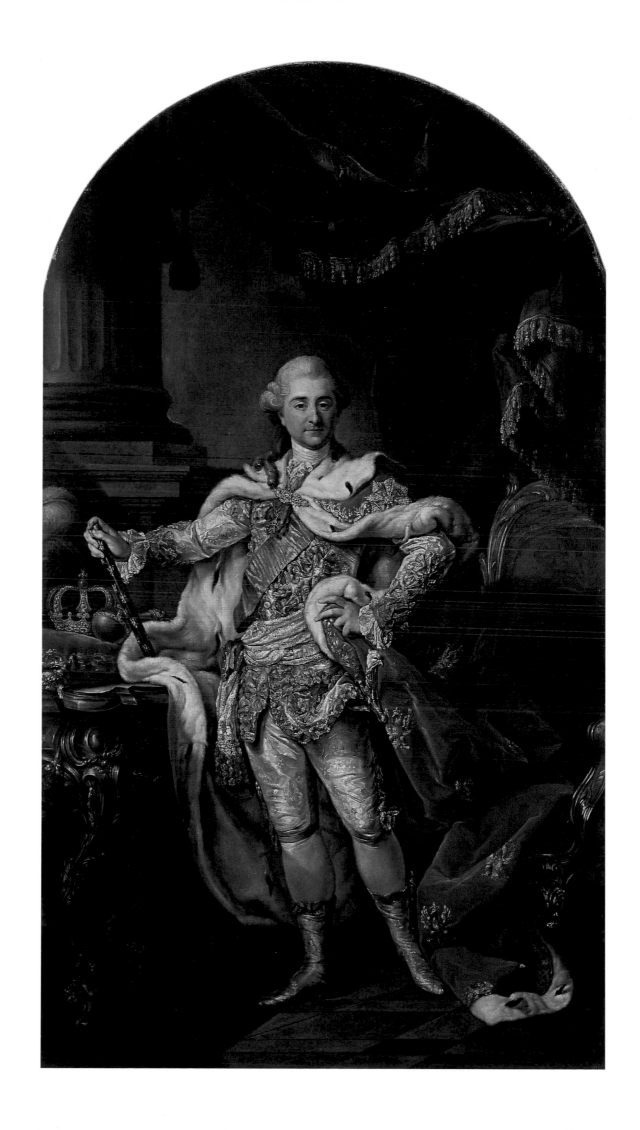

Conspicuous Rococo stylization and the simultaneous presence of Classicist decorative elements exemplify the painting's stylistic heterogeneity. The delicate contour and drawing, concern with rendering the materiality of objects, and the juxtaposition of bright local colors without their subordination to the dominant tone are typical of Bacciarelli's early works. Numerous replicas and copies of the portrait reached magnate castles and palaces and found their way to foreign courts as well, where they represented not only the Polish king, but also his court painter.

Bacciarelli was first and foremost a portraitist, but he also took up monumental allegorical and historical painting, working on the decoration of the royal residences. Among his many portraits, this *Portrait of King Stanislaus Augustus Poniatowski with an Hourglass*, which the king himself called "my allegorical portrait," is one of the most popular and most enigmatic. According to the king's correspondence with the painter, the picture was near completion in March 1793, when Stanislaus Augustus faced grave difficulties from a lost war with Russia and just before the second partition of the Polish Commonwealth.

The Romantic, allegorical portrait has been interpreted as a specific political testament of the last king of Poland who, in his sorrow, is ready to abdicate; his crown rests on the table, a window opens onto a cloudy sky. A second interpretation centers on the symbols of Freemasonry in Bacciarelli's paintings in the Solomon Room in the Łazienki Palace, which the artist was finishing at the time of this portrait. Not only did the king give financial support to the Freemasons, in 1777, using the name *Salsinatus Eques a Corona vindicata* (*Salsinatus* being an anagram of the king's name in Latin –*Stanislaus*), he joined the lodge of the Temple Rite of Strict Observance, founded in Warsaw by Count Alojzy Fryderyk Brühl. The artist was also a Freemason. Analyzing the painting in these terms, it may be observed that the accessories present in it (globe, crown, hourglass) are Masonic emblems and the landscape outside the window is almost identical with representations on the Masonic medals struck in the Warsaw mint in honor of the lodge "brethren" of merit Count August Moszyński and Piotr Gartenberg-Sadogórski. The motto of the picture, *Quaesivit coelo lucem* (He searched for light in the sky) may be interpreted as the Freemasons' task of "dispelling darkness."

Still other interpretations have focused on the iconographic tradition of representing scholars in their study. Another study found an analogy between the relationship of Stanislaus Augustus and Catherine II and that of Dido deserted by Aeneas. There is even an astrological interpretation based on the king's personality as a Capricorn, which is ruled by the planet Saturn, and his strong belief in his horoscope as well as his Stoic views. Such efforts at elucidation of the painting are inconclusive. What is clear is that the king attached great importance to this portrait, since from time to time he ordered Bacciarelli's studio to produce replicas of the portrait and also miniatures, which differ from the original in some details, such as mutations in the Latin motto. The king intended to commission an engraving from the Italian engraver Raphael Morghen, but it was not until 1798, after the death of Stanislaus Augustus, that an English engraver, A. Fogg, executed in London – on the initiative of Bacciarelli – a stippled copperplate, dedicated by the painter to the king's sister Izabela Branicka, wife of the Castellan of Cracow. DS and KZ

29
PORTRAIT OF KING STANISLAUS AUGUSTUS PONIATOWSKI WITH AN HOURGLASS
1793
OIL ON CANVAS
43 7/8 × 33 5/8 INCHES
111.5 × 85.5 CENTIMETERS
WARSAW, THE NATIONAL MUSEUM
MP 312 MNW

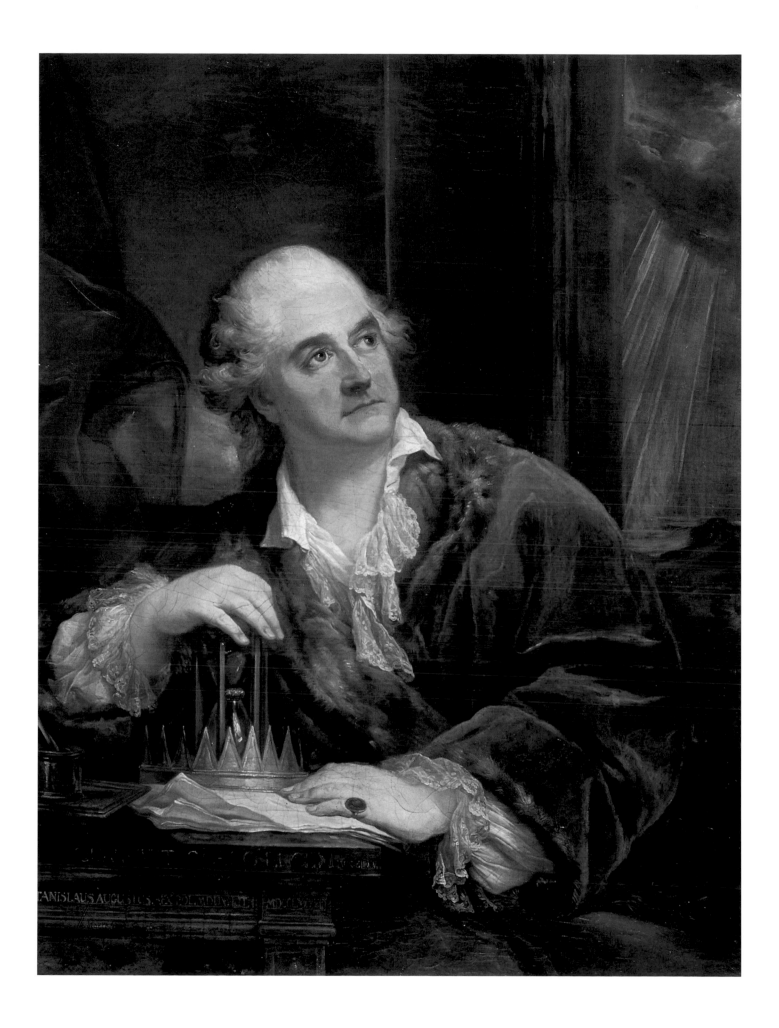

30–34

BERNARDO BELLOTTO

ITALIAN, 1721–1780

30

IDEAL ARCHITECTURE
WITH SELF-PORTRAIT
OF THE ARTIST
CA. 1765–66

OIL ON CANVAS
60 ¼ X 44 ⅞
INCHES
153 X 114
CENTIMETERS
WARSAW,
THE ROYAL CASTLE
ZKW 357

Among the many view painters who flourished in eighteenth-century Venice, none possessed a wider range nor attempted to enrich the conventions of the painted *veduta*, or view, more than Bernardo Bellotto (1722–1780). Trained as a painter of cityscapes, Bellotto produced vivid and memorable images of many of the greatest cities of Europe, including Venice, Florence, Rome, Dresden, Munich, Vienna, and Warsaw. His ability to capture the light and the life of the places he depicted was unparalleled, and his paintings are among the high points of European art in the eighteenth century.

Bellotto began as a painter of conventional views of Venice in the manner of his more famous uncle, Antonio Canaletto (1697–1768), but beginning with his earliest independent works, Bellotto's pictorial interests and ambitions were markedly different from those of the older painter. Over the years Bellotto expanded his range beyond traditional view painting, venturing into landscape, genre, portrait, allegory, and, in his Warsaw period, history painting.

The highpoint of Bellotto's artistic achievement is generally thought to be the series of views of Dresden, Pirna, and Königstein painted for Augustus III, elector of Saxony and king of Poland, and today in the Gemäldegalerie, Dresden. The Dresden views are astonishing in their topographical precision, control of light and mathematical perspective, clarity, and organization. Bellotto enjoyed many years of success in the Saxon capital, beginning with his appointment as court painter in 1748. In the 1760s, however, he experienced financial difficulties caused

by the destruction of his house during the Seven Years' War, the death of Augustus III in 1763, and a change in the direction of the artistic affairs of the Saxon court in favor of native artists.

In December 1766 Bellotto and his son Lorenzo (1742–1770) left Dresden with the intention of traveling to St. Petersburg to work for the Empress of Russia Catherine II. He probably arrived in Warsaw before the end of January 1767 and was immediately offered employment at the court of the last king of Poland, Stanislaus II Augustus Poniatowski (1732–1798). He was appointed court painter in 1768 (with a large salary that was supplemented with payments for a house and carriage), and spent the last twelve years of his life working for the king in relative comfort and security. His most important work from this period is a series of twenty-six views of Warsaw, intended for a particular suite, the so-called "Canaletto Room," in The Royal Castle. (Bellotto often signed his paintings with his given name and surname, as well as the nickname "Il Canaletto," no doubt to draw attention to his relationship with his celebrated uncle. In his lifetime Bellotto was called Canaletto, and in Germany, Poland, and Austria he continues to be known by that name.)

The first painting by Bellotto to impress the king and one of the works responsible for his appointment may have been *Ideal Architecture with Self-Portrait of the Artist* (ca. 1765–66), the artist's extraordinary self-portrait in the crimson robes and golden stole of the Venetian nobility. (Some believe that the portrait was painted in Dresden and taken to Warsaw; others

that Bellotto painted it in Warsaw in 1767 together with a companion painting, *The Cleansing of the Temple* [The Royal Castle, Warsaw; on long-term loan to the Musée du Louvre, Paris].) In the foreground the artist steps forward with a gesture of proud display, as if presenting to the viewer the imaginary architectural backdrop as a splendid example of his artistic capabilities and invention. He is attended by his faithful servant Checo (Francesco), and an elderly ecclesiastic carrying a folder, which may contain sketches. At the left, a young peasant boy points to Bellotto as if to encourage the viewer to take especial note of the painter and his finery.

The fantastic architectural setting possesses the character of a grand stage set, and the pillar on the right and the columns of the triumphal arch bear posters advertising theatrical presentations. Bellotto's declamatory gesture both recalls paintings by official Venetian portraitists and adds to the theatricality of the scene. This is heightened by the strong contrasts of light and shadow that play across the deliberately complex architecture behind the artist and his retinue. The two-storied colonnade surrounds an interior courtyard based on elements of the Libreria Vecchia by the Renaissance architect Jacopo Sansovino (1486–1570) that is separated from the viewer by a triumphal gateway. The viewer is invited to look through the majestic arches and into a sharply receding space defined in great detail. The balustrade curving into the distance unites the whole and emphasizes the heroic scale of the palatial setting; its steeply angled lines of perspective exaggerate the depth of the courtyard, at the rear of which tiny figures move about.

Following his election as king in 1764, Stanislaus Augustus took over The Royal Castle – the traditional residence of Polish monarchs – which he immediately began to adapt for ceremonial and official functions. In 1774 the arrangement of three important rooms in the Royal Apartment – the Audience Hall, the Senators' Antechamber (Canaletto Room), and the Chapel – was begun. In accordance with the ceremonial protocol displayed at other European courts, a prominent role was played by state antechambers, through which one progressed to the throne room. Of the rooms that preceded the visitor's progress in The Royal Castle to the king's Audience Chamber, the most important was the Senate Antechamber, later called the Canaletto Room, which was decorated with the series of views of Warsaw by Bellotto.

These paintings, the major achievement of Bellotto's Polish period, represent the last of his great cycle of urban views. The series comprises three differently sized formats: large (67 x 103 inches), used mainly for the panoramic views; medium (45 x 65 inches), for urban vistas, landscapes, and views of gardens; and small (33 x 41 inches), for views of streets and squares. Thanks to archival research, it has been possible to reconstruct the original scheme of the paintings in the Canaletto Room and confirm the organization of the compositions of the pictures as matching pairs. Bellotto created these views with a precise knowledge of where each would subsequently be hung and this determined the perspectival construction of each individual scene. Several paintings were clearly intended to be hung high in the ensemble and thus seen from below, others would have hung at lower levels, and, finally, there were compositions intended to be viewed at eye level.

Bellotto focused on the early eighteenth-century city; that is, Baroque Warsaw. The palaces of the magnates and the churches are the motifs he selected as his principal subjects in his views of the center of the city. But the Warsaw views are also animated by a powerful response to the inhabitants of the city and its environs, and the realistic treatment of the figures, which take up more space than in Bellotto's earlier views, anticipates the genre quality so pronounced in nineteenth-century paintings of the urban scene. One scholar counted nearly 3,000 human figures in Bellotto's views of the center of Warsaw, half of which can be assigned to a specific professional and social standing by their appearance and dress.

In paintings like the *View of Warsaw with the Ordynacki Palace* (1772), the figures and animals compete for attention with the architecture of the city. The ostensible subject of the view is the skyline of the city spread along the higher ground in the left half of the composition, above the little farms and wood houses of Powiśle on the slope below. But the viewer's attention is in fact riveted to the rustic figures and domestic animals in the lower left foreground. The most prominent building, at the extreme left of the composition, is the Ordynacki Palace, and the view takes in a number of important palaces (the Kazimierzowski Palace is in the center of the composition) and churches along the escarpment. On the farther bank of the Vistula River, at the extreme right, is the suburb of Praga with the Bernardine church of St. Andrew.

A second large panorama in the present exhibition, *View of Warsaw with the Terrace of The Royal Castle*, a view of the city looking south, commissioned by Stanislaus Augustus in 1773 for his own collection, is one of Bellotto's most carefully conceived

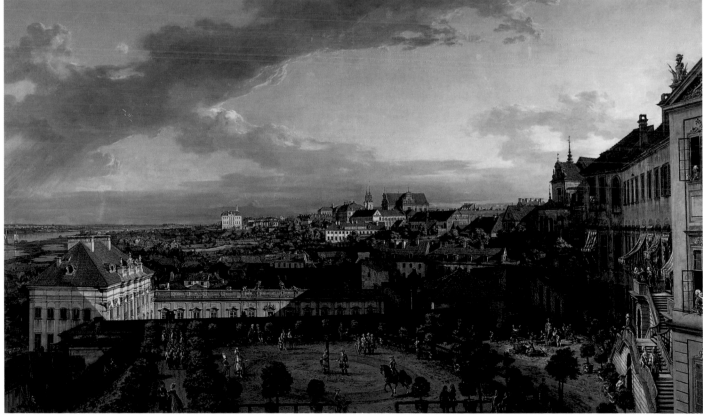

compositions among the Warsaw views. (The king does not seem to have been particularly possessive of the pictures of his palaces, and this painting almost certainly never hung with the rest of Bellotto's views of Warsaw in the Canaletto Room in his official residence.) On the left is the Vistula River and the semirural suburbs beyond; on the right, along the Krakowskie Przedmieście in the distance, the view takes in the Kazimierzowski and Radziwiłł palaces and a number of churches. The most intriguing feature of the painting, however, is the garden terrace in the foreground that has been laid out as a riding school with a lesson in progress. At the left of the terrace, the changing of the guard takes place; at the right, sculptors and stonemasons are engaged in work connected with the alterations made inside the palace by the king. Bellotto's realistic treatment of the scene has led to the identification of various figures in the composition as portraits of members of the court, although the only certain portrayal seems to be that of Stanislaus Augustus himself, shown in military uniform in a window at the extreme right, leaning against a red cushion.

The Church of the Bernardine Nuns and the Sigismund Column in Warsaw, Looking along Grodzka Street (ca. 1768–70), was created from a point near the pavilion at the south wing of the Royal Castle, looking west toward the Vistula and culminating in the column of Sigismund III. At the right, a corner of the south wing itself shows signs of the damage caused by the fire of December 15, 1767, which was repaired the following year. Although the painting was not included among the twenty-two views in the Canaletto Room during the time of Stanislaus Augustus, it was added to the ensemble in the early twentieth century and hung over a doorway. One of the earliest of Bellotto's Warsaw views, the composition is unique in the absence of human figures. Stefan Kozakiewicz, the great scholar of Bellotto's work, was struck by the eerie, almost Romantic atmosphere of the painting in which the buildings, bleak and abandoned, "rise up in a sublime stillness." The painting nonetheless provides a significant topographical record of the city, the site long having ceased to exist in its eighteenth-century form.

The Krakowskie Przedmieście from the Nowy Świat (1778), looks north from a point in front of the church of the Dominican friars, where the Nowy Świat ("new world") ends and one of the city's principal thoroughfares, the Krakowskie Przedmieście, begins. The scene is dominated on the left by its ostensible subject, the church of the Holy Cross, an important site of royal ceremonies, but one's atten-

tion is inevitably drawn to the throngs of merchants, traders, and peasants from outlying villages whose carts and wagons and farm animals fill the square. At this moment in Bellotto's career, he has given free rein to his desire to become an accurate recorder of facts, to adhere literally to what he saw or knew to be present. Bellotto's artistic personality from the beginning showed a striving toward the faithful depiction of reality, and in his late paintings this realism is paramount. No greater proof exists than the fact that the Warsaw paintings were used as models for the reconstruction of individual buildings and of whole quarters of the city following the Second World War.

The canvases set in the paneling of the Canaletto Room survived there until 1832, although a few of them had been sent by order of Emperor Napoleon I to Paris (they were returned in about 1820). However, in 1832 the entire series was carried away to Russia by order of Tsar Nicholas I. They were hung in turn at the Tauride Palace and at the Hermitage in St. Petersburg, and in the palace at Gatchina. The paintings were returned to The Royal Castle in Warsaw in 1922 and set once again in the Canaletto Room. In September 1939, though, only a few days after the outbreak of World War II, they were transported to The National Museum in Warsaw. From there, they were taken away in 1940 by the Nazis to Germany. Restituted to Poland in 1945, the canvases were shown among the collections of The National Museum in Warsaw. Here they awaited the rebuilding of The Royal Castle, to which they were finally transferred in 1984 and set in the paneling of the reconstructed Canaletto Room.

Following the return of the Warsaw series from the Soviet Union in 1922, the canvases underwent extensive conservation, which included wax relining. This diminished the luminosity of coloring so marked in Bellotto's earlier paintings and has led a number of observers over the years to suggest that the Warsaw paintings were not up to the creative levels of his earlier work. Fortunately the canvases have been restored to something approaching their original appearance during the latest conservation campaign in 2000–2001. In paintings such as *The Krakowskie Przedmieście from the Nowy Świat*, the final stage in the development of Bellotto's use of color can again be appreciated. AR and EPB

33

THE CHURCH OF

THE BERNARDINE NUNS

AND

THE SIGISMUND COLUMN

IN WARSAW, LOOKING

ALONG GRODZKA STREET

CA. 1775

OIL ON CANVAS

45 1/8 × 66 3/8

INCHES

114.5 × 170.5

CENTIMETERS

WARSAW,

THE ROYAL CASTLE

ZKW 440

34

THE KRAKOWSKIE

PRZEDMIEŚCIE, WARSAW,

FROM THE NOWY ŚWIAT

CA. 1775

OIL ON CANVAS

33 1/4 × 42 3/8

INCHES

84.5 × 107.5

CENTIMETERS

WARSAW,

THE ROYAL CASTLE

ZKW 446

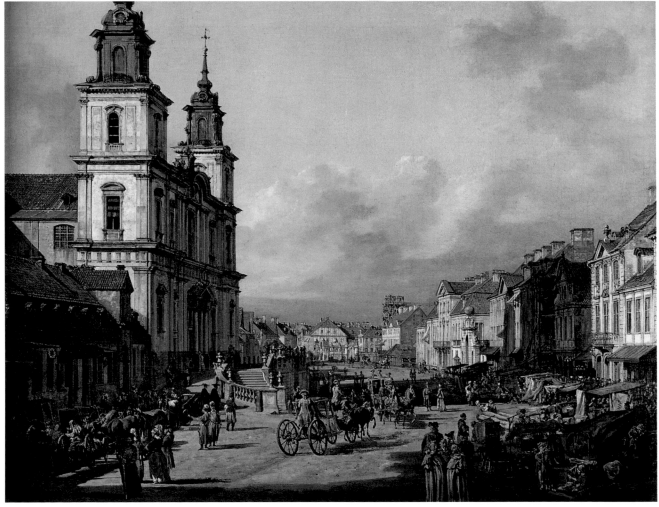

JEAN-BAPTISTE PILLEMENT

FRENCH, 1728–1808

Jean Pillement, a renowned French painter and decorator, arrived in Warsaw in the spring of 1765 from Vienna. He was one of the first French artists to be engaged by Stanislaus Augustus Poniatowski, crowned king of Poland in 1764, to work on the grand-scale modernization of the interiors of the Warsaw Royal Castle and the castle at nearby Ujazdów. The future court painter to the king and his chief art advisor, Marcello Bacciarelli, at that time still working for Maria Theresa in Vienna, in a letter of 1764 written from Vienna, recommended Pillement to the Polish monarch, praising the artist for his taste and his imaginative designs, whether in ornamentation, flowers, architecture, figures, grotesques, heroic or Chinese-style, theatrical or landscape. Within his brief, two-year stay in Poland (he left in July 1767), Pillement created painted decorations for the king's study in the castle, *chinoiserie* decorations for a room of the Ujazdów castle (later called "The Pillement Study"), numerous easel paintings and ornamental panels, as well as drawings and designs for a series of pictures from ancient history that were produced concurrently in Paris by other artists. Shortly before his departure from Poland, Pillement was officially granted the title of First Painter of the King of Poland, which he was to use in the course of his subsequent career in France.

The paintings *Seaside Landscape with a Ruin* and *Shepherds by a River with a Romantic Ruin* form part of a series of four oval over door decorations that once adorned the apartment of Stanisław Poniatowski, the nephew of King Stanislaus Augustus Poniatowski, located in the south wing of The Royal Castle in Warsaw. Fanciful, ornamental depictions, they are typical examples of French Late Rococo landscape, in which the character of the setting and staffage –

clearly inspired by the paintings of the Dutch Italianizers – is combined with the light, sketchy pictorial technique and bright, gay coloring characteristic of contemporary French art. The paintings have identical dimensions and inscriptions on their backs stating that they were painted on the king's commission in 1765. This ornamental cycle included three additional oval pieces of different dimensions, also by Pillement, which were lost, probably in the nineteenth century.

The history of the four Pillement over door paintings demonstrates well the vicissitudes of works of art from the castle. After the partitions of Poland and the death of Stanislaus Augustus, in 1815 The Royal Castle, together with the works of art that formed its permanent furnishings, became the property of the tsars of Russia. These and all the other pictures remaining in the castle were carried away to St. Petersburg or Moscow in the spring of 1915 by the Russian army as they retreated from Warsaw. The artworks were returned to the castle in 1922 under the terms of the Treaty of Riga concluded by Poland with the Soviet Union following the Polish victory of 1920, only to disappear once more in 1939, when Polish museum staff were ordered to take them down for Nazi confiscation. In 1945 occupying Soviet troops removed them yet again. Considered by Polish art historians as irretrievably lost, they nevertheless came back to the castle for the third time in their history. In 1989, after a fifty-year journey, museum workers at Pushkino (formerly Tsarskoie Selo) identified the pictures as the ones that came from the gallery of Stanislaus Augustus, and Soviet authorities returned them to Poland. DJ

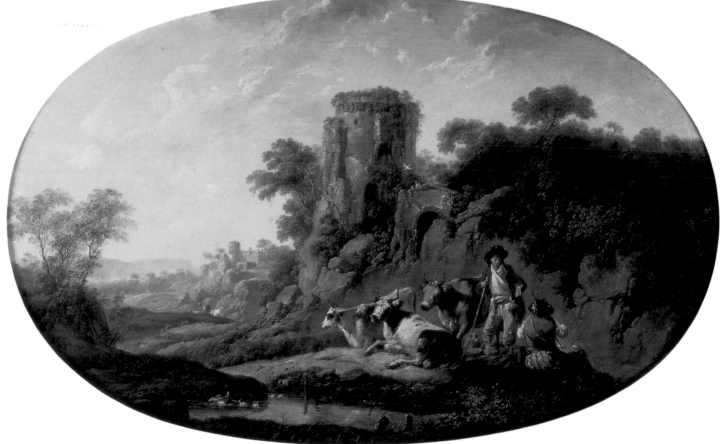

JEAN-PIERRE NORBLIN DE LA GOURDAINE

FRENCH, 1745–1830

A COMPANY TRIP

CA. 1777

OIL ON CANVAS

55 ¼ × 81 ¼

INCHES

140.5 × 206.5

CENTIMETERS

WARSAW,

THE NATIONAL MUSEUM

MP 294 MNW

Prince Adam Kazimierz Czartoryski, a cousin of King Stanislaus Augustus Poniatowski, general of the Podolia region, and commander of the Cadet Corps, met Jean-Pierre Norblin de la Gourdaine while journeying with his wife to Holland and England in 1772–74; he immediately brought the French artist to Poland, appointing him his court painter and tutor for his children.

A pupil of Francesco Casanova, Norblin studied at the Académie Royale de Peinture et de Sculpture and at the Ecole Royale des Elèves Protégés in Paris. His art reflects the influence of the style of Antoine Watteau. Among Norblin's earliest works in Poland was a decorative series intended for Powązki, a residence of the Princes Czartoryski in the suburbs of Warsaw, which had one of the first English-style landscape gardens in Poland. The chief designer of the estate was the architect Szymon Bogumił Zug, with the participation of Norblin and of Princess Izabela Czartoryska herself. The aesthetic was one of country cottages, tasteful but unpretentious. Erected along winding promenades were the ruins of a mill, tower, and ancient arch, with arbors and service buildings in the form of antique and Gothic structures. Around the peripheries spread the pastures, orchards, vegetable gardens, meadows, and hop plantations. Both the English-style of the Powązki garden and the pastoral style of life were a reflection of Jean-Jacques Rousseau's philosophy of simplicity and a return to nature.

The atmosphere of Powązki determined the choice of the pictures adorning the largest pavilion, occupied by Princess Czartoryska. Reminiscent of Watteau's *fêtes-galantes*, *A Company Trip* presents a loosely grouped composition of figures by the water, closely connected with the landscape and bathed in the poetic atmosphere of a summer evening evoked by harmonious pinkish-golden and gray hues – a palette lighter than that of the other Powązki canvases. Numerous preparatory studies document the evolution of the composition, which can now be convincingly dated to 1777. KZ

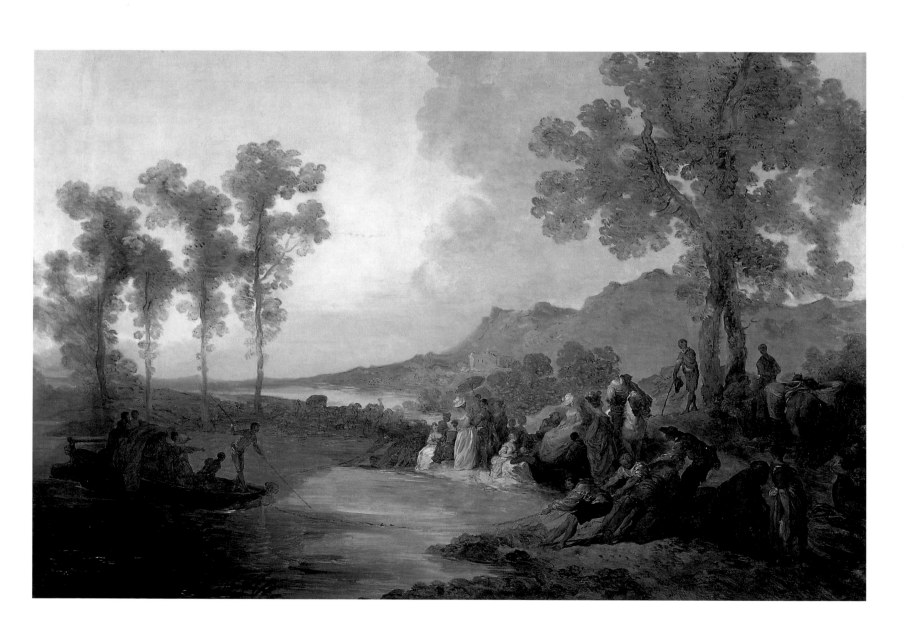

38

LEONARDO DA VINCI

ITALIAN, 1452–1519

LADY WITH AN ERMINE
(PORTRAIT OF CECILIA GALLERANI)
CA. 1490

OIL AND TEMPERA ON
WOOD PANEL
21 3/8 X 15 1/2
INCHES
54.4 X 39.3
CENTIMETERS
CRACOW, THE PRINCES
CZARTORYSKI MUSEUM
XII-209

One of those rare and haunting works that enigmatically define both beauty and artistic genius, *Lady with an Ermine* is one of only four extant female portraits firmly given to Leonardo da Vinci. The other two are the *Portrait of Ginevra de' Benci* (ca. 1470–80; National Gallery of Art, Washington, D.C.) and the *Mona Lisa* (ca. 1503–1506; Musée du Louvre, Paris).

This small group of portraits and their conceptual evolution had a profound impact on the history of portraiture. John Pope Hennessy called the *Lady with an Ermine* the first painting in European art to introduce the idea that a portrait may express the sitter's thoughts through posture and gestures. In accordance with Leonardo's own *Treatise on Painting,* the sitter's movements seem to correspond to "the motion[s] of [the] mind." The lady is captured at a specific moment, as if reacting to something beyond the picture frame; the pet ermine echoes the sitter's gesture. The painting marks the beginning of an evolutionary process in which the traditional iconography of the static profile portrait was replaced by a figure that activates and engages the surrounding space. Pietro Marani has called the picture the "'first modern portrait' in history."

Lady with an Ermine dates to around 1490, when Leonardo was working in Milan at the court of Duke Ludovico Sforza, Il Moro. There Leonardo organized festivities, worked for several years on the equestrian statue of Francesco Sforza (which he never completed), painted his famous fresco *The Last Supper*, and

made a name for himself as a portraitist. The sitter has now been firmly identified as Cecilia Gallerani (ca. 1473–1536), a lady-in-waiting at the court of Milan and the mistress of the duke. The inscription in the upper left-hand corner, *LA BELE FERONIERE LEONARD D'AWINCI,* dates from the nineteenth century and mistakenly identifies the portrait as a likeness of the mistress of François I, king of France. A similar description made in a manuscript catalogue compiled by Princess Izabela Czartoryska suggests that the error in identification occurred very early on, perhaps even before the painting entered the Czartoryski collection in the first decade of the nineteenth century.

A Polish art historian, Jan Bołoz Antoniewicz, first advanced in 1900 the now confirmed hypothesis that the painting is a portrait of Cecilia Gallerani. Although no known historical texts contain any specific reference to this painting, he identified several contemporary sources that link Leonardo to the work. Most notable of these is a sonnet by the court poet Bernardo Bellincioni:

ON THE PORTRAIT OF MADONNA CECILIA,
WHICH LEONARDO MADE

What has angered you? Whom do you envy, O
 Nature?
Only Vinci, who has painted a portrait of one of
 your stars;

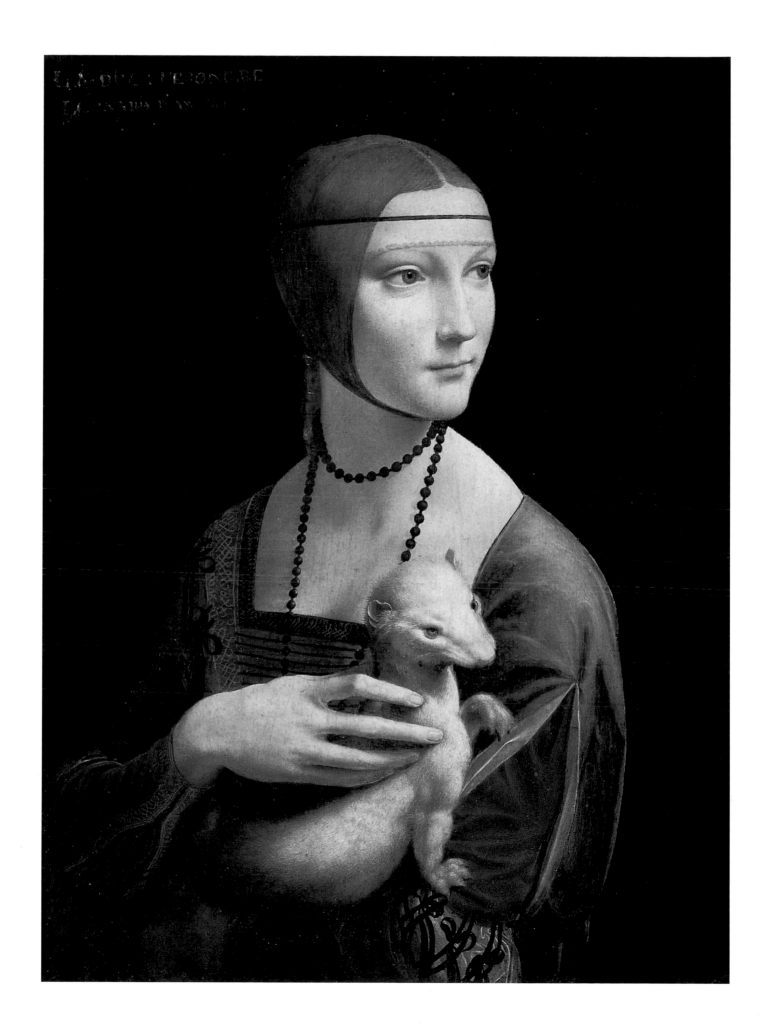

Cecila, who today is so beautiful
That in comparison with her lovely eyes the sun
 seems but a dark shadow.

The honor is yours if in his picture
He has made her seem [so lifelike] that she appears
 to be listening, and [only just] not speaking.
Remember that the more alive and beautiful she
 appears to future ages,
The more pleasure you will have.

Now therefore, you may thank Ludovico
And the genius and hand of Leonardo
Who wish to make her part of posterity.
Whoever sees her thus, although it be in a time long
 hence,
Shall say that she lives yet. For us it is enough
To comprehend now which is nature and which is art.

Bellincioni's sonnet, which was published in 1493, thus clearly connects the sitter to both Leonardo and Ludovico Sforza. Moreover, *Lady with an Ermine* can be dated to late 1489 or to 1490. Ludovico and Cecilia began their relationship in late 1489 and by January 1491, she had borne a son. The impropriety of an illegitimate birth would have weighed against an image that celebrated qualities of modesty and purity. Furthermore, the portrait could not have been done later than May 1491, when Ludovico married Beatrice d'Este. A letter dated 1498 from Isabella d'Este, marchesa of Mantua, to Cecilia Gallerani further connects the artist and the sitter. Isabella wrote to Cecilia asking to borrow Leonardo's picture and promising to return it. Cecilia, who had in the meantime become the Countess Bergamini, agreed to lend the picture, but warned that it no longer looked very much like her.

Bellincioni did not mention Cecilia's ermine, but its inclusion in the portrait adds multiple symbolic meanings to the image. First, the ermine is an allusion to the sitter's surname, for the sound of the name "Gallerani" is similar to the Greek word for ermine, *galee*. Second, according to legend the ermine would prefer to die rather than soil itself – and consequently symbolized wholesomeness. And finally, the ermine may be interpreted as an allusion to Ludovico Sforza, who received the insignia of the Chivalric Order of the Ermine from the King of Naples in 1488. Bellincioni referred to Ludovico elsewhere as "Italico

Morel, bianco Eremellino" or "Italian Moor, white Ermine." The way in which Cecilia Gallerani caresses and gently teases the animal thus takes on heightened meaning.

Leonardo's classically influenced ideas of feminine beauty are expressed throughout the painting in its emphasis on simplicity. Cecilia is modestly but elegantly dressed in a red gown adorned with gold embroidery and black ties; a blue cloak is throne over her left shoulder. Her hair, parted in the middle and gathered at the back into a plait, is covered with a gold-edged gauze veil held in place with a narrow black band. Around her neck is a string of black agate beads, a symbol of mortification. Leonardo's rich colors, the artful forms of the figures, the splendid glowing light, and the sheer beauty of the sitter remind us that in the Renaissance the depiction of a lovely woman could be a measure of the beauty of painting itself.

Crucial to any interpretation of this painting is the light, carefully articulated in several aspects. Falling clearly from one point, the probably artificial illumination models the figure and additionally affects the colors, with those closer to the light treated as more intense, and also the sharpness of the outlines – phenomena pointed out by Leonardo in his theoretical writings. The light was equally carefully and consistently rendered in the picture's background, which prior to being painted black in the nineteenth century had been bluish-gray. Recent technical examination of the picture, conducted in the Conservation Department at the National Gallery of Art in Washington in 1991 and 1992, has fully corroborated earlier theories that the background had been repainted while in the Czartoryskis' possession. The original ground on the right side was a lighter blue-gray, darker behind the model where she cast her shadow. Thus the subject was originally set within a space modeled by light; the contour of the figure was surely softer and more embedded within the background.

Janusz Wałek, in his interpretation of the painting, indicates that *Lady with an Ermine* was probably an allegorical portrait in which light served not only as a structural feature of the composition, but also as a symbolic element. It might signify Cupid, or even be a metaphor for Ludovico Sforza himself. He commissioned the portrait and may also have influenced its allegorical program, in conformity to the then

fashionable desire for hidden meanings and allusions. The now lost original frame might even have borne an inscription clarifying the meaning of the painting.

Poland's connection to *Lady with an Ermine* has been a long and complex one. Prince Adam Jerzy Czartoryski purchased the picture as an original Leonardo around 1800, probably in Italy, and presented it to his mother, Izabela Czartoryska, who placed it in the museum that she had founded at Puławy. She hung it in the Gothic House, which opened to the public in 1809, in the so-called Green Room. During the November Uprising of 1830 against Russia, tsarist authorities confiscated the Czartoryski estates in the Russian partition zone. With the assistance of the local people, the very elderly Izabela Czartoryska managed to rescue the endangered museum collection, sending the Leonardo, along with the rest of the artworks, to Sieniawa. Some years later the most precious part of the collection, including the Leonardo, was transported to Paris, where it was kept at the Hôtel Lambert, a seventeenth-century palace on the Ile St.-Louis, where, however, it could be viewed only by acquaintances and friends of the owners. After the collection was brought back to Poland, Izabela's grandson, Władysław Czartoryski, opened The Princes Czartoryski Museum in Cracow in 1876; Władysław hung the portrait in the picture gallery and it was again made accessible to the public in the late 1880s.

During World War I, *Lady with an Ermine* was taken for safekeeping to the Dresden Gallery, and was returned only in July 1920. Before the outbreak of World War II, along with other most valuable works from The Princes Czartoryski Museum, it was again hidden by the family at Sieniawa, where in September 1939 it fell into the hands of the Nazis. Carried away to Germany in December of that year, it was exhibited at the Kaiser Friedrich Museum in Berlin and designated to be one of the objects intended for an art museum planned for Linz. However, in December 1940, the German governor general Hans Frank ordered that it be it brought to Cracow and placed in The Wawel Royal Castle, which he used as a seat of operations in Poland. In June 1941 the painting was again moved to a depot of plundered artworks, set up in Wrocław, and again briefly returned to Cracow for an exhibition arranged at Wawel in March 1943. Toward the end of the war, the painting was sent to Frank's private villa in Bavaria, where it was later found by the Polish-American commission. In 1946 it was finally restored to its proper and rightful location at The Princes Czartoryski Museum. DD

39

HANS SÜSS VON KULMBACH

GERMAN, CA. 1480–1522

ST. CATHERINE
OF ALEXANDRIA
CA. 1511

OIL AND TEMPERA ON
WOOD PANEL
22 X 15
INCHES
56 X 38.2
CENTIMETERS
CRACOW, THE PRINCES
CZARTORYSKI MUSEUM
XII-328

A German artist of Franconian extraction, who was active mostly in Nuremberg, Hans Süss von Kulmbach probably visited Cracow twice, in 1511 and 1514–16. Beginning around 1500 he became a pupil and collaborator of Albrecht Dürer. He was also influenced by the Venetian Jacopo dei' Barbari and by the Danube School; the latter influence is most evident in the way he set figures in a landscape. Kulmbach painted religious pictures and portraits and designed stained-glass windows and woodcuts for illustrations. He is considered one of the most subtle and sensitive colorists in sixteenth-century German painting.

Kulmbach's *St. Catherine of Alexandria* portrays the Christian martyr as a young maiden dressed in rich and elegant attire (a red dress, a fur-lined bluish-pink cape, and an olive-green cloak) with her fair hair falling over her shoulders. Her full face bears some traits of a portrait. She wears a crown and a double string of pearls – appropriate to the legend that she was a princess living in Alexandria, Egypt. She stands slightly leaning against a stone window frame, with a beautiful, atmospheric mountainous landscape in the background. The identifying attributes of the saint's martyrdom – a wheel and a sword – surely once were painted in the lower part of the picture which was later cut down. The legend tells of a beautiful and wise Catherine who refused to renounce Christianity and instead persuaded fifty philosophers to convert to her faith. When she spurned the love of the Roman emperor Maxentius (ca. 280–312), he sentenced her to death by breaking on a wheel; the intervention of an angel precluded the carrying out of his order, so she was finally beheaded.

The present picture was cut down from a full-length image of St. Catherine that was painted on the outside of the left wing of a triptych designed for the Pauline church on Skałka (on the Rock) in Cracow. On the outside of the right wing was the image of St. Barbara (now lost). The two saints were very popular and were frequently represented together. Forming the central part of the triptych and bearing the artist's signature *HK* and the date 1511 was the *Adoration of the Magi* (Gemäldegalerie, Berlin). The insides of the wings contained four scenes from the life of the Virgin Mary, of which only the *Flight into Egypt* survives (Pauline Monastery, Skałka). DD

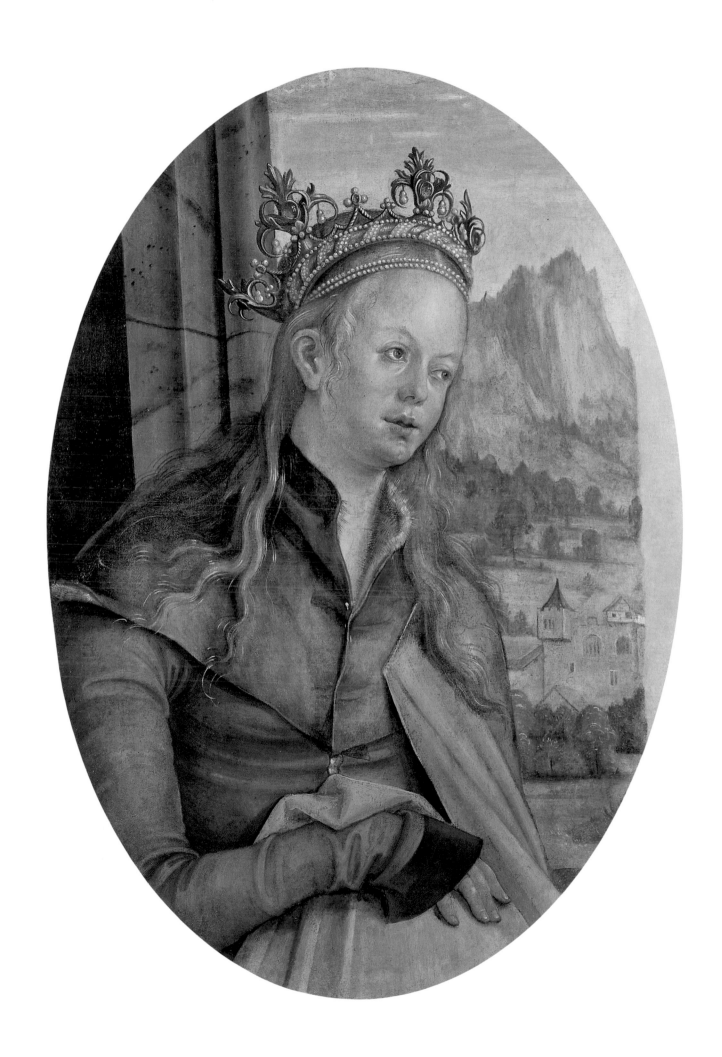

MASTER OF THE LEGEND OF ST. MARY MAGDALENE, ATTRIBUTED TO

FLEMISH, CA. 1490–CA. 1526

Formerly believed to be a portrait of Anne Boleyn, *Portrait of Isabella, Queen of Denmark* has now been firmly established as a likeness of Isabella (Elizabeth) of Habsburg, sister of the emperor Charles V. Isabella was born on July 18, 1501, in Brussels, as the second child of Philip the Handsome (1478–1506), Duke of Austria and Burgundy, and Joanna of Castile (1479–1555), known as the Mad Joanna. After her father had died and her mother had been moved into a cloister, Isabella was brought up at the courts of her aunt Margaret, her father's sister, Regent of the Netherlands, in Brussels and Mechelen (Malines). In 1515 she married the king of Denmark, Christian II. After her husband's abdication in 1523, Isabella returned to the Netherlands, where she died on January 19, 1526.

The portrait shows a rather plain young lady, virtually still a child, with a high forehead, full lips, and a slightly snub nose. She is rendered in bust-length and in profile, her hands clasped in front. On her right hand are two rings, one of which may be a wedding ring. She wears a gown of gold lamé fabric, lined with red velvet. Her reddish hair is covered with a cap whose white-and-red trimming frames her face. The picture was probably painted in the latter half of 1514 or the first half of 1515, between her marriage by proxy on June 11, 1514, in Brussels, with a representative of the king, Mogens Gøye, and her departure for Denmark. Her marriage with the king himself took place only on August 12, 1515, in the castle in Copenhagen.

The portrait may have been painted by a Netherlandish artist known as the Master of the Legend of St. Mary Magdalene, whose work has been identified on the basis of two panels from a dismembered polyptych of the Legend of St. Mary Magdalene (ca. 1515–20). From about 1490 onward, the painter worked for the Burgundian-Habsburg court in Brussels and Mechelen, executing many portraits of Philip the Handsome and his family as well as members of the court circle. These likenesses were frequently copied, perhaps even in the artist's own workshop. The Cracow portrait of Isabella (Elizabeth) of Habsburg was associated with the work of this anonymous Netherlandish artist by Marek Rostworowski in 1960. DD

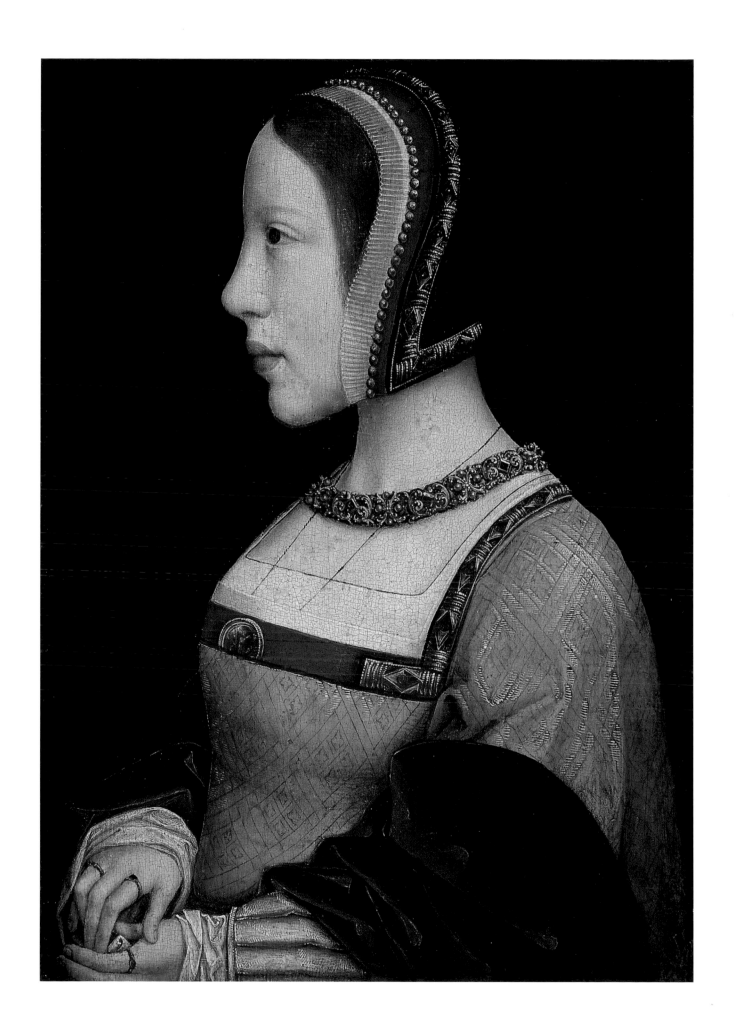

MASTER OF THE FEMALE HALF-LENGTHS

FLEMISH, ACTIVE SECOND QUARTER OF THE 16TH CENTURY

MARY MAGDALENE WRITING

CA. 1530

OIL ON WOOD PANEL

21 1/4 X 15 3/4

INCHES

54 X 40

CENTIMETERS

CRACOW, THE PRINCES

CZARTORYSKI MUSEUM

XII-254

The name Master of the Female Half-lengths has been adopted for a South Netherlandish painter or group of painters who worked in Antwerp, and possibly Bruges, Ghent, and Mechelin during the first half of the sixteenth century. Considerable stylistic differences exist in the works associated with the master and it is likely that the name actually encompasses a number of different hands in a large workshop or several distinct painters who worked in a similar style and carried out a great many commissions. None of the paintings ascribed to the master is signed or dated.

Paintings of the Master of the Female Half-Lengths are usually small-scale panel paintings of aristocratic young ladies shown half-length and in devotional scenes. They typically depict ladies of higher society in elegant costumes adorned with jewels, set in sumptuous interiors, reading, writing, or playing the lute or spinet. The composition is usually based on a single figure, though occasionally a group is depicted. The female type is very distinctive, with a heart-shaped face, often turned in three-quarter view, with lowered eyes. Frequently, as is the case in the Cracow painting, the lady wears a contemporary dress of red velvet with densely folded muslin sleeves gathered at the cuffs; a cap covers the top of her head. Next to the figure stands an ointment jar (its shape in the Cracow picture suggests an Antwerp product of about 1530–40), giving rise to the interpretation of the painting as a depiction of Mary Magdalene as a courtesan.

Little is known about the original function of these panels of half-length ladies, but Jan Białostocki proposed the theory that some of these paintings formed cycles with different meanings. *Mary Magdalene Writing* might belong to a series representing an allegory of the senses, as a personification of the sense of vision; a similar picture at The National Museum in Poznań, showing a woman playing the spinet, might illustrate the sense of hearing. DD

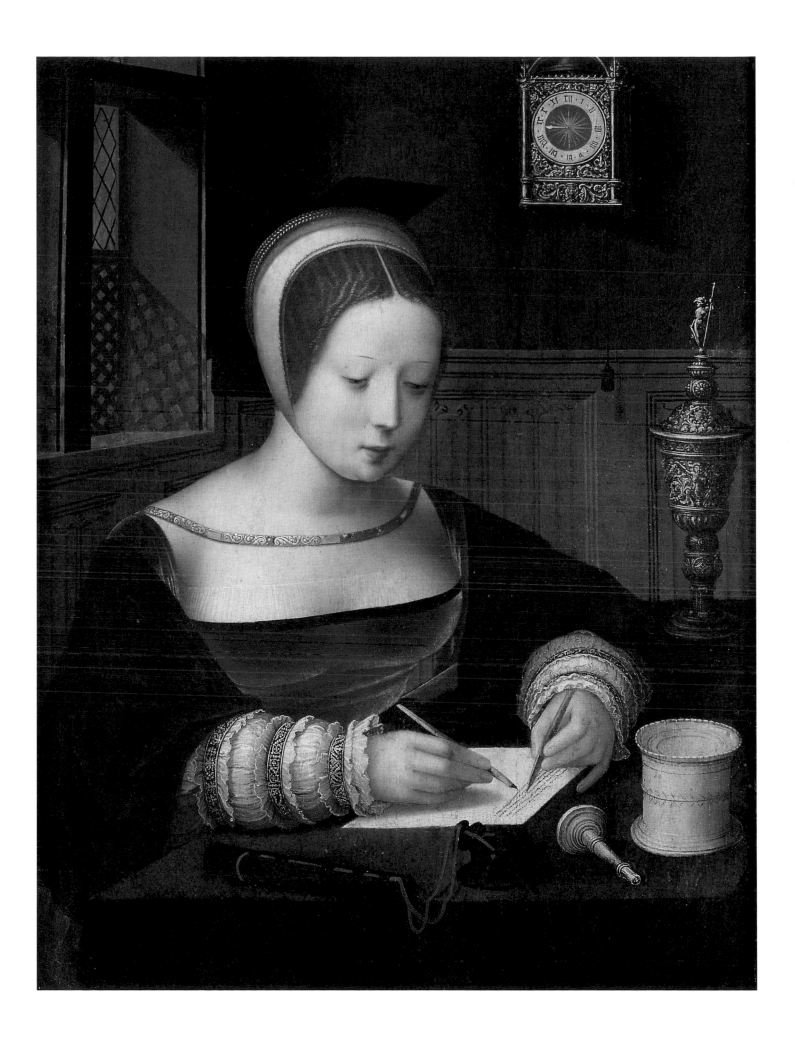

AELBRECHT BOUTS

FLEMISH, CA. 1452–1549

MATER DOLOROSA

CA. 1500

TEMPERA ON
WOOD PANEL
16 x 10 ¹/₂
INCHES
40.7 x 26.6
CENTIMETERS
CRACOW, THE PRINCES
CZARTORYSKI MUSEUM
XII-258

Dieric Bouts presumably trained in his native Haarlem before he moved south to Leuven [Louvain], where he established a sizable workshop. His two sons, Dieric and Albrecht, continued their father's activity, following his style and using the iconographic schemes invented by him, and in addition frequently copying his works. Albrecht established his own workshop and specialized in small-scale devotional works for the Antwerp market. Especially popular was an archaic type of icon in the form of a diptych that combined the bust of the Virgin with the bust of Christ as the Man of Sorrows. Although Albrecht perpetuated the compositions of his father and those of Rogier van der Weyden and Hugo van der Goes, his overall designs tend to be more crowded, his draperies fussier, and his colors less clear.

Mater Dolorosa presents an image of Our Lady of Sorrows that probably constituted one panel of a diptych, in which the other image was that of a bust of Christ as the Savior of the World or an Ecce Homo. The complete iconographic program would have been to show the Virgin Mary interceding with Christ to ask him to grant his grace to individuals in need. Diptychs of this kind were very popular in the Netherlands during the second half of the fifteenth and beginning of the sixteenth centuries. Although the general arrangement of figures is undoubtedly connected with some renditions by Rogier van der Weyden, there exists no exact prototype for the Cracow picture, which differs from other representations of this kind in that Mary's white wimple is not fastened under her chin, but instead leaves her neck uncovered. DD

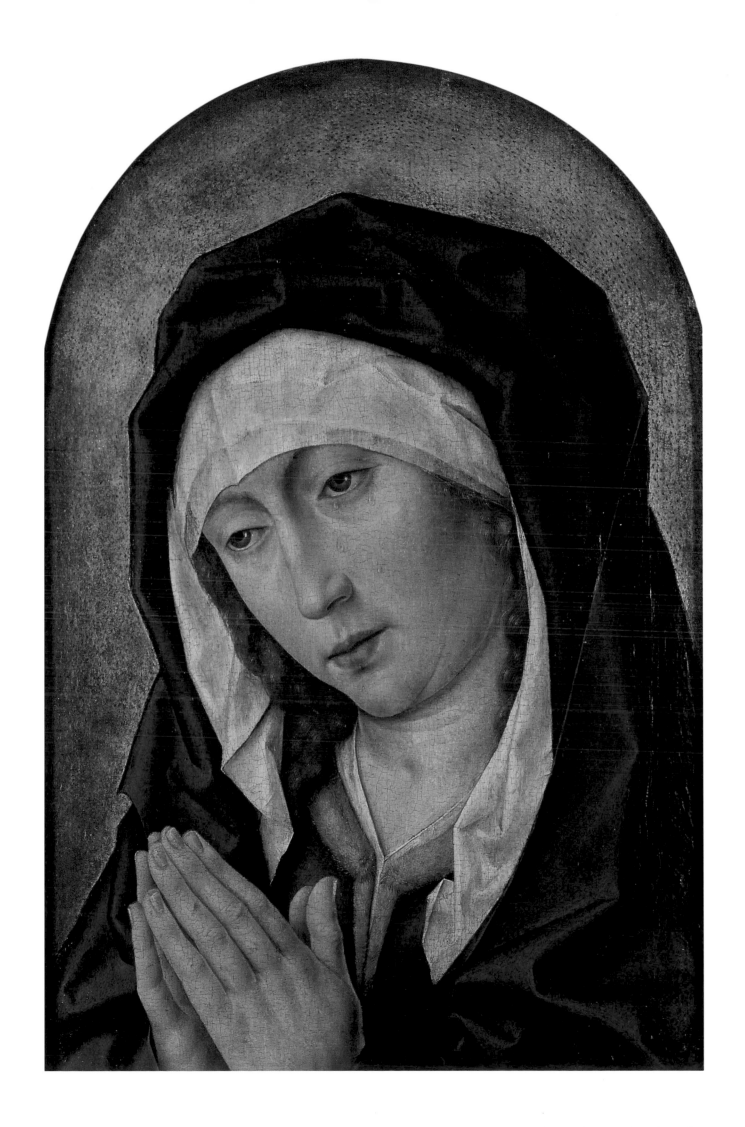

43

FRANÇOIS CLOUET, FOLLOWER OF

FRENCH, CA. 1510–1572

MALE PORTRAIT
(FORMERLY DON JUAN OF AUSTRIA)
CA. 1570S

OIL ON WOOD PANEL
12 1/4 X 9
INCHES
31 X 23
CENTIMETERS
CRACOW, THE PRINCES
CZARTORYSKI MUSEUM
XII-298

This *Male Portrait* represents a conventional type of sixteenth-century French court portrait. According to an identification reaching back to the seventeenth or early eighteenth century and maintained in the Czartoryskis' collection at Puławy, the sitter, wearing a doublet embellished with *passementerie* called *brandenbourgs*, is Don Juan of Austria (1547–1578), the hero of the battle of Lepanto in 1571. Although the model no doubt bears some resemblance to Don Juan, it is not close enough to support this traditional identification.

In the museum at Puławy, the portrait passed as a Holbein and the painting was inscribed with the words *DON JUAN HOLBEINS*. However, the manner of painting undoubtedly originates from the circle of François Clouet, as characterized by the strongly emphasized volume of the figure, the sharp *chiaroscuro*, and the vigorous modeling. Other conspicuous affinities are the portrait's linearity, meticulous handling of details, painstaking rendition of the costume, and a delicate use of color and light, as if they were applied by a miniaturist. These elements are characteristic of the portraitists imitating Clouet's style of the 1570s, who were draftsmen rather than painters. With regard to the palette – a restricted range based on a juxtaposition of cool silvery-bluish whites and warm yellowish hues in the costume with a slightly pinker complexion and the black of the background – the *Portrait of Margaret de Valois* at Chantilly, painted by a follower of Clouet, is the closest to the Cracow picture.

Clouet succeeded his father as the painter and *valet de chambre* to François I in 1540. After the death of the king in 1547, he continued to serve the Valois court as a portraitist, producing elaborate drawings and paintings that appealed to the formal tastes of an international court. His reputation was such, and the demand for his portraits so great, that he employed a large workshop whose members more or less followed his style. Among Clouet's followers are many of the most prominent artists of the next generation: Jean Decourt, Marc Duval, and Etienne and Pierre Dumonstier, François Quesnel, and Frans Pourbus. DD

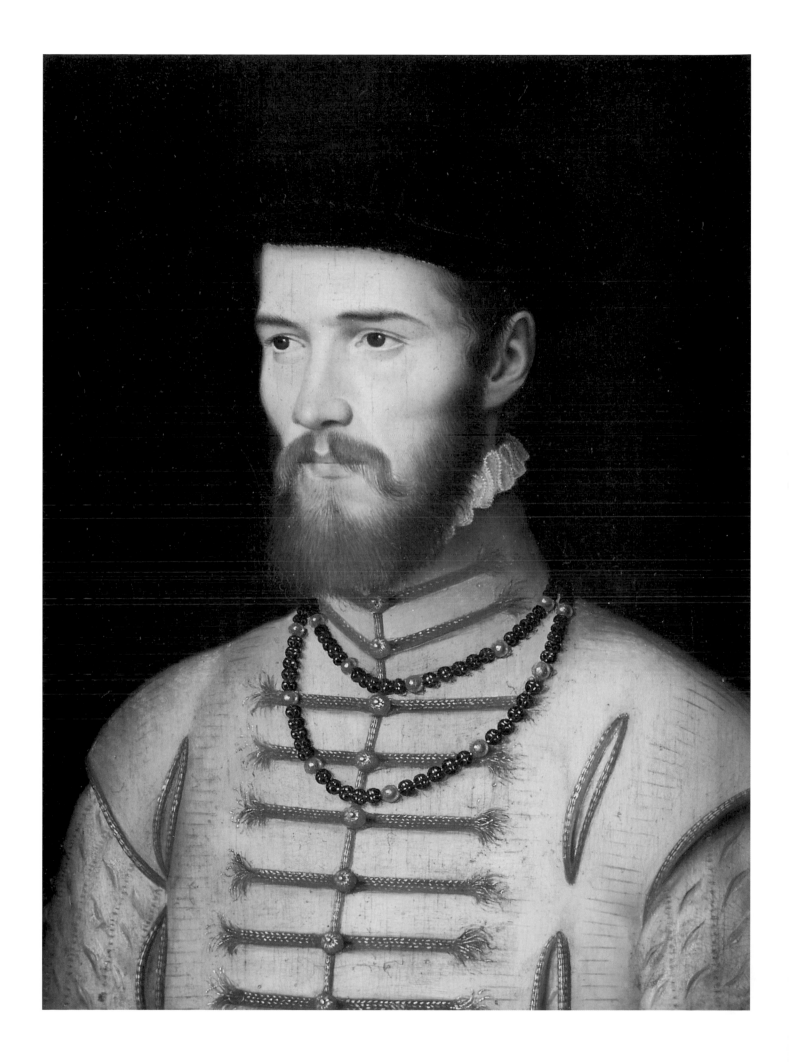

MICHELE TOSINI

ITALIAN, 1503–1577

VENUS VICTRIX
CA. 1530–50

OIL ON WOOD PANEL
17 3/8 X 13
INCHES
44 X 33
CENTIMETERS
CRACOW, THE PRINCES
CZARTORYSKI MUSEUM
XII-208

Michele Tosini (also called Michele di Ridolfo del Ghirlandaio) was trained in Lorenzo di Credi's atelier. His long-standing collaboration with Ridolfo Ghirlandaio began about 1525. Tosini was an eclectic painter, readily imitating the most fashionable artists of his time – Raphael, Andrea del Sarto, Parmigianino, and also Vasari and Michelangelo – and consequently modifying his style as needed.

Tosini's *Venus Victrix* is a faithful copy of a black crayon drawing by Michelangelo from around 1523 (Galleria degli Uffizi, Florence) that belongs to a series called *Teste Divine*. The drawings in this series frequently display fanciful coiffures and head adornments combined with idealized facial features – a style of representation anticipated in a group of idealized portraits of beautiful women rendered in profile and bust-length that were painted by Botticelli and his workshop in the last quarter of the fifteenth century. The subject of the drawing in question is obscure: in the center a woman is depicted bust-length, wearing rich attire that bares her breasts; her elaborate coiffure is covered in the back by a kind of helmet anchored by a headband centered on her forehead by a large brooch. Behind and to the right of the woman can be seen the head of a man, and at the bottom left a putto. Consequently, the subject is usually regarded as a depiction of Venus and Mars with Cupid, although it has also been interpreted as a depiction of a Sibyl or as Zenobia, Queen of Palmyra. Michelangelo used to present drawings from the *Teste Divine* series as gifts to his friends. The Venus drawing belonged to a young nobleman, Gherardo Perini, who, according to Vasari, sold the drawing to Francesco de' Medici.

Tosini repeated Michelangelo's prototype with only slight modifications. He placed a transparent veil over the woman's breasts and added a Mannerist head (Medusa?) and winged griffins on her decorative shoulder harness. The painting probably represents Venus Victrix (the victorious goddess of love) as a beautiful woman whose feminine attributes, enhanced by rich dress, jewels, and fine coiffure, arouse love in men's hearts. Stylistically it resembles Tosini's *Leda* and *Lucretia* (Galleria Borghese, Rome).

In the early nineteenth century, the painting was kept in the Czartoryskis' Gothic House at Puławy and was considered to be a representation of Beatrice, Dante's love. Later, on the basis of its resemblance to a drawing by Michelangelo in the British Museum, London, it was recognized as a portrait of Michelangelo's friend Vittoria Colonna, although some scholars saw in it a portrait of a courtesan. DD

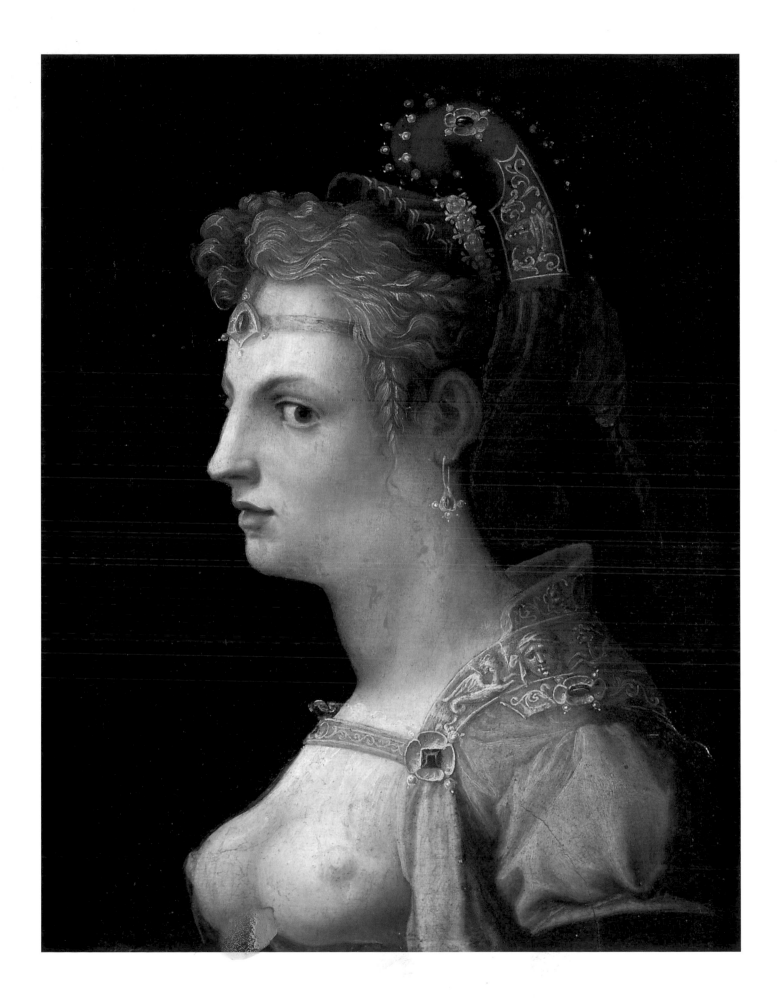

JAN LIEVENS
DUTCH, 1644–1680

PORTRAIT OF
A YOUNG MAN
CA. 1660–65

OIL ON CANVAS
39 3/8 X 31 7/8
INCHES
100 X 81
CENTIMETERS
CRACOW,
THE WAWEL ROYAL CASTLE,
STATE ART COLLECTIONS
INV. 600

Jan Lievens's *Portrait of a Young Man* recalls Raphael's *Portrait of a Youth* of 1516, believed to be the latter's self-portrait, which was lost during World War II. The Raphael portrait, purchased in Venice in 1808 by Prince Adam Czartoryski, had been kept in the Czartoryski collection in Cracow until September 1939. It is not quite clear whether Lievens actually saw this canvas or whether he painted this loose replica from a sketch made in 1622 by Anthony van Dyck or from an engraving by Paulus Pontius, made around 1625. Nor is it known how the Flemish engraver Pontius came to know Raphael's painting, assuming, as has been suggested by some researchers, that the Raphael never left Italy until its purchase by Czartoryski. However, some scholars believe the painting must have been in the Netherlands for some time and that Lievens may have seen the original there. Still another hypothesis holds that Lievens saw the portrait during his stay in England from 1632 to 1634.

Another parallel with the Raphael portrait is that the *Portrait of a Young Man* was thought to be a slightly idealized self-portrait of Lievens. However, this hypothesis is at variance with both the facial features of the subject and his age. A decisive argument against such an identification is provided by a comparison with Lievens's *Self-Portrait* of about 1637 (National Gallery, London) painted in the same convention, which represents the artist at about age thirty. Nonetheless, given the sitter's easy pose and indoor attire, it cannot be ruled out that the painting may indeed portray an artist.

Stylistically the fluid manner and the freely arranged, loose folds of the sitter's garment are strongly suggestive of the influence of Flemish painting, of Van Dyck in particular, and of Italian portraits such as the Raphael prototype. Despite the possible authorship of an artist such as Govaert Flinck or one of Flinck's imitators, the arguments in favor of Lievens are its stylistic affinity with the London *Self-Portrait* and also the landscape in the background, in which the monumental trees with gnarled trunks and withered branches are characteristic of Lievens's works from the second half of the seventeenth century. JW-W

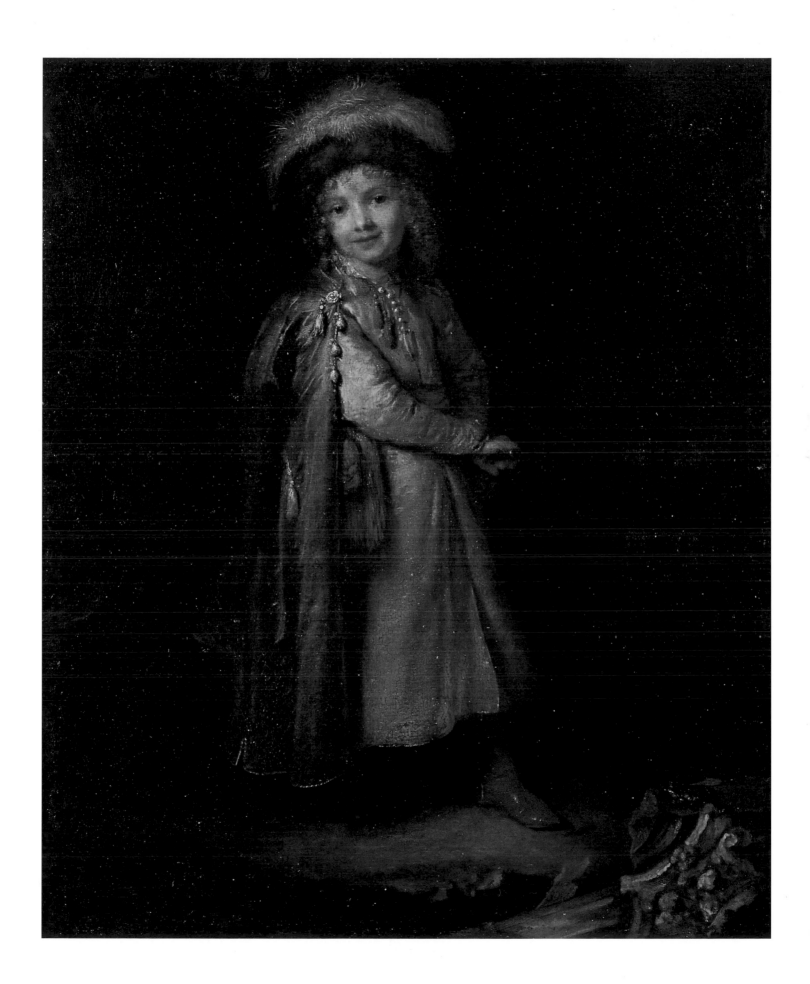

ALEXANDER ROSLIN
SWEDISH, 1718–1793

Alexander Roslin, a Swedish painter active mainly in Paris, was above all a portraitist. He rapidly attained success in Paris, becoming a member of the Académie in 1753. His position in Paris was not unlike that of Pompeo Batoni in Rome, who became famous for executing the portraits of foreigners traveling abroad. Roslin's oeuvre includes an impressive list of international royalty and aristocracy. His official court portraits are somewhat stiff, but in his informal likenesses he displayed a mastery for rendering details and the texture of fabrics, though he was never able to capture any deeper psychological characterization. Roslin exhibited regularly at the Paris Salon until 1791, and enjoyed the patronage of a large and admiring public long after his somewhat saccharine style had fallen out of favor.

Portrait of Princess Izabela Czartoryska, dated 1774, must have been painted before Izabela's departure from Paris in April of that year. One of her more interesting and artistically better likenesses, it became a model for numerous repetitions and copies. Izabela Czartoryska, née Flemming, wife of Adam Kazimierz Czartoryski, was one of the most intelligent ladies of the Polish Enlightenment. She is known as the founder of the oldest public museum in Poland, at Puławy, in which she assembled a great many works of art (such as Leonardo's *Lady with an Ermine*, Rembrandt's *Landscape with the Good Samaritan*, and Raphael's *Portrait of a Young Man*) as well as numerous fascinating mementoes of famous Poles and other Europeans that recall significant achievements and important historical and cultural events. Furthermore, she took part in organizing schools for peasant children, and her textbook of Polish history, *Pielgrzym w Dobromilu*, was once counted among the most popular books in the country. Around the palace at Puławy she laid out an extensive English-style park, which was made famous by Jacques Dellile, who described it in his poem "Les Jardins." In 1805 Izabela herself published a richly illustrated book on gardens.

At the age of eighty-five, Izabela was witness to the disaster that struck Puławy, when it was attacked by the Russians during the national uprising in 1830. With the aid of the local people, she managed to move the entire collection to Sieniawa. DD

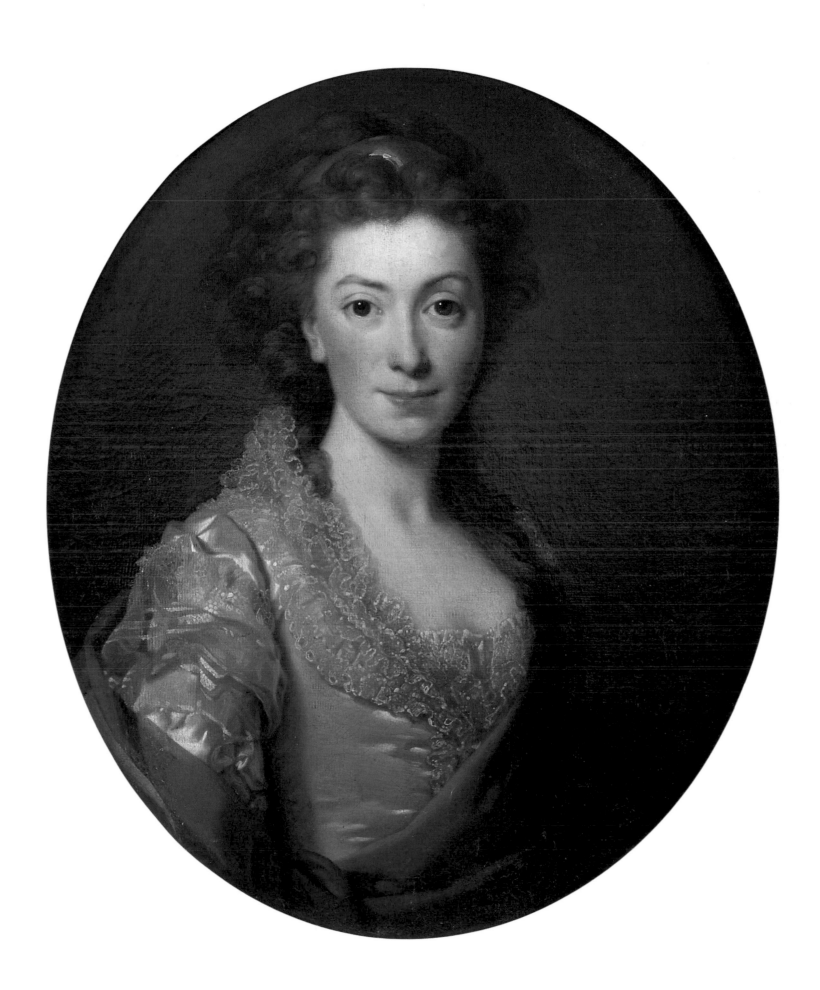

ELISABETH-LOUISE VIGÉE-LEBRUN

FRENCH, 1755–1842

48

PORTRAIT OF PRINCE ADAM
KAZIMIERZ CZARTORYSKI
1793
OIL ON CANVAS
39 × 30 3/8
INCHES
99 × 77
CENTIMETERS
WARSAW,
THE CIECHANOWIECKI
FOUNDATION AT
THE ROYAL CASTLE
ZKW (ON LOAN TO A
PRIVATE COLLECTION,
LONDON)

Elisabeth-Louise Vigée-LeBrun was one of the most popular portrait painters in eighteenth-century France. She studied under Vernet and Greuze, and was a friend of Marie-Antoinette, whom she is said to have painted twenty-five times. Upon the outbreak of the Revolution in 1789, she left France and traveled in Italy, Russia, Austria, Germany, and England, returning to Paris in 1805. In most countries she had great success as a portraitist and often commanded prices that far exceeded those of her competitors. The list of her European sitters reads like a social registry.

During her stay in Vienna from 1792 to 1795, Vigée-LeBrun had a large clientele of Polish aristocrats and painted more than ten portraits of the Polish nobility. She was on intimate terms with Princess Izabela Czartoryska and her husband, Prince Adam Kazimierz Czartoryski (1734–1823), who had been forced to leave their country after the second partition of Poland and the confiscation of their estates by the Russian partitioning authorities. Prince Czartoryski, general of the province of Podolia, was one of the most prominent figures in the political and cultural life of the Polish Commonwealth toward the end of the eighteenth century. He was the founder and commander of the Knights' School (Cadet Corps), co-author of the Constitution of the Third of May, and, after the partitions, the leader of the Polish Emigration in Paris.

The work exhibited here is one of two portraits of the prince, painted by Vigée-LeBrun when he was fifty-nine. In the catalogue of her works, she identified him with her inimitable spelling as "Prince Schortorinsky." The romantic use of the cloak clutched at the breast was probably inspired by Jean-Laurent Mosnier's portrait of the painter Lagrenée l'aîné which Vigée-LeBrun had seen at the Salon of 1789 (now in the Musée National du Chateau de Versailles). A full-sized version of the portrait, in which the sitter wears a blue cloak, was also owned by the prince and subsequently kept by his heirs at the Hôtel Lambert, the Czartoryski residence in Paris. The portrait later became the property of Prince Adam Czartoryski in Madrid.

In 1794 when Vigée-LeBrun painted *Portrait of Princess Pelagia Sapieha, née Potocka*, the sitter (1775–1846), was only nineteen years old. She was visiting Vienna with her husband, Franciszek Sapieha, whom she had married the year before. In the catalogue, which the painter compiled toward the end of her life when her memory was failing, she incorrectly described the picture as a likeness of Zofia Zamoyska, née Czartoryska – a misidentification that was corrected by later scholarship. In the same year Vigée-LeBrun painted another portrait of Pelagia, bust-length (until 1939 in the collection of Count Maurycy Zamoyski at the Blue Palace in Warsaw). This likeness was regarded as a study for the present portrait of Pelagia dancing with a shawl. The latter portrait is also known by two copies: one from the eighteenth century, property of the Czacki family, later of the Giguel des Touches family in Paris; the other, painted by S. Przewaliński, from the Mehoffer collection, now in the Mehoffer House Museum in Cracow

Portrait of Princess Pelagia Sapieha, née Potocka combines the traits characteristic of the sophisticated, Neoclassical portraiture of the late eighteenth

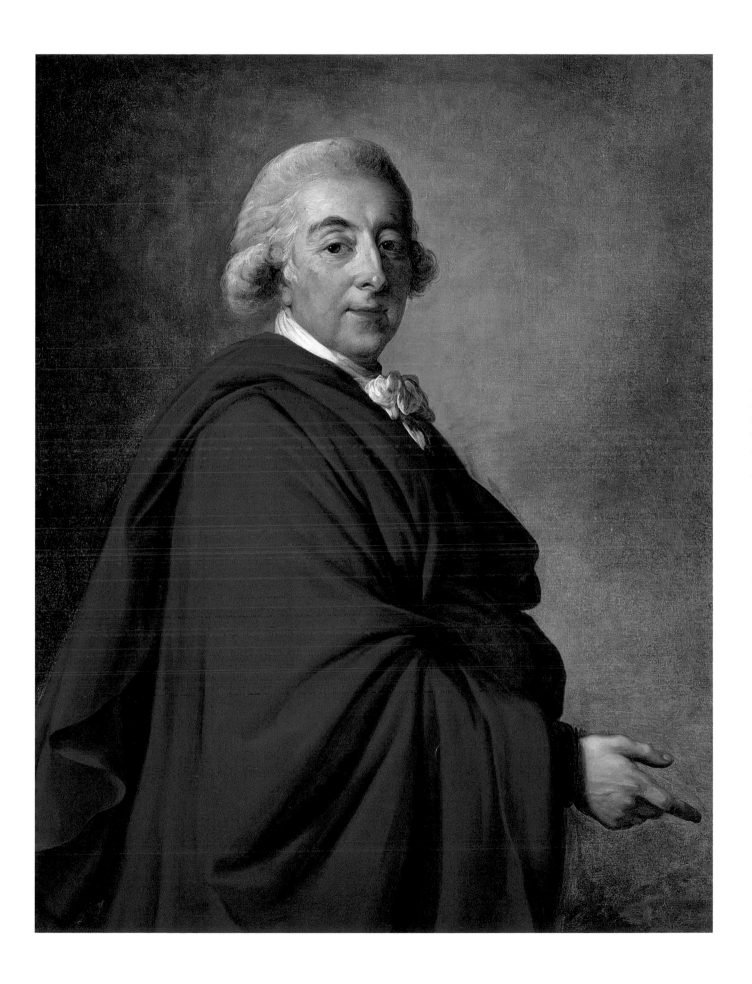

century. The subject, depicted in a fluid, dancing pose reminiscent of images of ancient prototypes of dancing Maenads or Bacchantes, wears a fashionable dress whose style resembles both ancient Roman fashion and the idealized costume of an Italian peasant. Set against a dramatic sky, the young woman's rhythmic gestures animate the composition and balance the smoking crater of Vesuvius seen in the distant background. Her dress is of dark green silk. The overall color scheme is low-keyed, but as usual, Vigée-LeBrun added a contrasting touch of brilliant red on the waist and hair bands.

Few painters have rendered with such infinite grace the trappings, pomp, and splendor associated with monarchy. Vigée-LeBrun excelled at painting women and demonstrated a rare ability to capture uniquely feminine qualities in the styles of dress, languorous forms, and sumptuous color schemes. She is justly identified as one of the greatest painters of the eighteenth century. HM

49

PORTRAIT OF PRINCESS PELAGIA
SAPIEHA, NÉE POTOCKA
1794

OIL ON CANVAS
54 3/4 × 39 3/8
INCHES
139 × 100
CENTIMETERS
WARSAW,
THE ROYAL CASTLE
ZKW 2090A,B

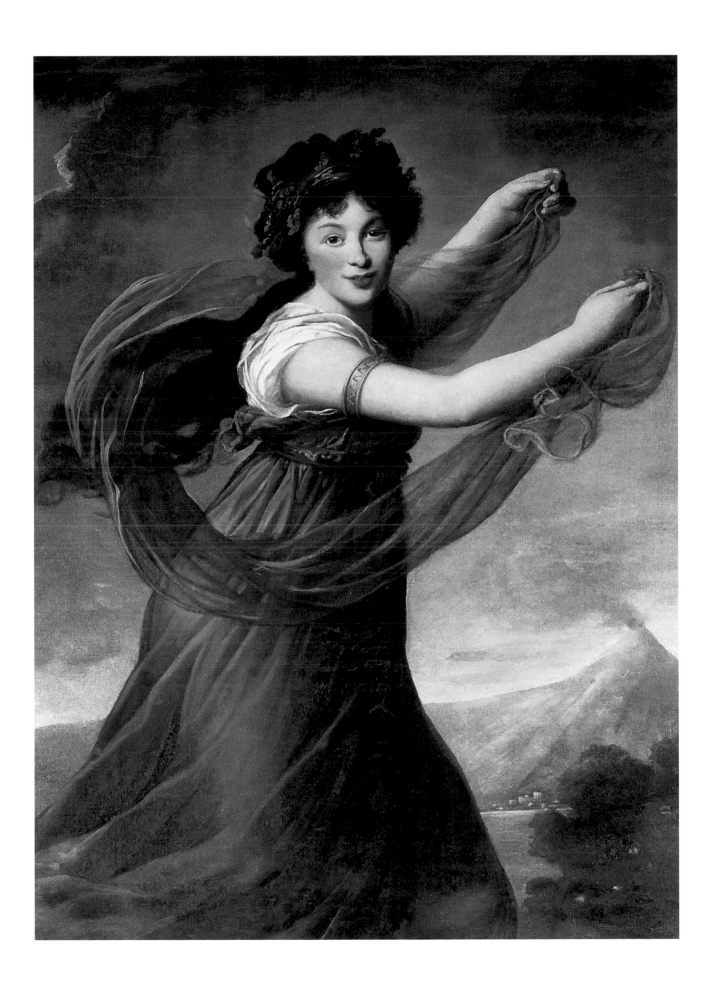

JEAN-AUGUSTE-DOMINIQUE INGRES

FRENCH, 1780–1867

ACADEMIC FIGURE
1801

OIL ON CANVAS
38 3/8 x 31 3/4
INCHES
97.5 x 80.6
CENTIMETERS
WARSAW,
THE NATIONAL MUSEUM
M.OB.292

This early *Academic Figure* by Jean-Auguste-Dominique Ingres was executed while Ingres was still working in the studio of Jacques-Louis David, in which he began his training in 1797. Ingres painted three studies of the same model, two in 1800, one of which was awarded a *Prix de torse* from the Ecole des Beaux-Arts, Paris. The Warsaw canvas, painted the following year, earned the artist another *Prix de torse*. The same model can be recognized in the works of other painters who studied in David's atelier at the turn of the century, among them Jean-Antoine Gros.

The *Prix de torse*, one of numerous awards given by the Ecole des Beaux-Arts, was established in 1784 by Quentin de La Tour. As for the *Prix de Rome*, the competition for this prize involved a kind of examination in the form of creating an oil sketch from a model during the course of six, seven-hour sittings. The artist was expected to use pencil to draw the head of the model and outline the composition, then in successive stages to rough out the work in paint and finally to mark out carefully the transitions from light to shadow. Although the didactic aspects of the exercise were clearly spelled out, it is equally evident that here Ingres was already emphasizing the elegant, refined contours and perfection of form through line that were to become the guiding principles of his art.

In accordance with the principles of execution of an *académie* – an oil sketch of a human figure – as practiced at the school, this composition remains unfinished in several areas, thereby intentionally showing the various phases of the artist's work. Beginning in 1803, the present work served for several years as an instructional model for students at the Ecole du Dessin at Montauban, where the artist's father was a professor. Ingres himself made use of the sketch in 1827, when he was working on *The Apotheosis of Homer* ceiling decoration for the Musée du Louvre. The figure of Longinus, in the foreground on the right, is identical with the academic figure – holding the same pose and with a slate in one hand and a pencil in the other. ID

FRANÇOIS-XAVIER FABRE

FRENCH, 1766–1837

PORTRAIT OF MICHAŁ
BOGORIA SKOTNICKI
CA. 1806

OIL ON CANVAS
25 1/8 x 19 1/2
INCHES
64 x 49.5
CENTIMETERS
CRACOW,
THE NATIONAL MUSEUM
INV. XIIA-4

A pupil of Jacques-Louis David, in 1787 François-Xavier Fabre won the *Prix de Rome*. Forced by political reasons to settle in Florence, he made contact there with the international aristocracy, including Polish emigrants. Fabre was above all a portraitist, only rarely painting pictures with mythological subjects. His portraits may be divided into two types: the Neoclassical portrait created by David, in which the human figure is shown against a neutral background and the emphasis is on the model's appearance, expression, and psyche; and one in which the model is depicted against an elaborate landscape background with numerous props and the emphasis is on the subject matter (for example, *Portrait of Skotnicki's Wife*, The National Museum, Cracow).

Portrait of Michał Bogoria Skotnicki, which was painted in Florence, belongs to the first group of portraits. It demonstrates the Neoclassical portrait style of David, but also hints at the encroaching elements of Romanticism in the liveliness and individualization of the sitter's facial features and in his ruffled hair. There are a number of analogous portraits by David and by his pupils, such as François Gérard.

Michał Bogoria Skotnicki (1775–1808), an art collector and artist, was an intelligent and sensitive man who suffered poor health. He went to Italy to rebuild his strength, but lived only thirty-three years and did not gain renown as an artist. Little is known about him, beyond the fact that around 1800 he was trained in Dresden under Józef Grassi. Only two works by Skotnicki are known, but his self-portrait in the Hôtel Lambert, Paris, suggests remarkable artistic abilities. After his death, his widow, Elżbieta, née Laskiewicz, who came from a rich Galician family, commissioned his tomb in the Florentine Church of Santa Croce, executed by Stefano Ricci. A replica of this monument was set up in the Wawel Cathedral in Cracow, in the chapel of the Skotnicki family. DD

CARL WILHELM WACH

GERMAN, 1785–1845

PORTRAIT OF COUNTESS
ANNA RACZYŃSKA
1827

OIL ON CANVAS
49 ¼ x 49 ¼
INCHES
125 x 125
CENTIMETERS
POZNAŃ,
THE NATIONAL MUSEUM/
THE RACZYŃSKI FOUNDATION
MNP FR 532

Intending eventually to exhibit it to the public in his native city, Poznań, Count Atanazy Raczyński built his art collection in Zawada Castle in the south of Poland, an edifice designed by the well-known German architect Friedrich Schinkel and located near the library founded by the count's brother Edward. In so doing, he aimed to create in Poznań a cultural center, the "Polish Athens." However, around 1826 Raczyński settled in Berlin, and political events in Poland in 1830 ("The November Uprising," of which he was very critical) convinced him that Berlin would be a safer place for his collection, and there he opened a gallery accessible to the public.

Carl Wilhelm Wach, a popular painter of the Berlin Biedermeier School, portrayed the count in 1826 and his wife a year later. In accordance with Raczyński's wish, the *Portrait of Countess Anna Raczyńska* refers both in his wife's pose and her fashionable gown to Raphael's likeness of Giovanna of Aragon (wife of Ferdinand I, king of Naples) (Musée du Louvre, Paris). Repeatedly copied, this Renaissance masterpiece was immensely popular and served as a prototype for a number of artists at the time. Wach used the format to portray Countess Anna Elżbieta Raczyńska (1793–1879), née the Princess Radziwiłł and from 1816 the wife of Atanazy Raczyński, clothed in a low-cut red dress and seated in a gilt armchair, holding a flower in her right hand. The heavy brocaded drapery in the background

reveals on the left side a view of the landscape – a convention in portraiture dating from the Renaissance period. Wach's portrait is close to the Italian prototype and constitutes a classical example of the "à la Raphael" vogue of the time. It also exemplifies a new, historicizing tendency in the portraiture of the 1820s, which consisted in depicting contemporary persons in folk, foreign, or historical costumes. JPM

JOHANN FRIEDRICH OVERBECK

GERMAN, 1789–1869

THE MARRIAGE
OF THE VIRGIN
1834–36

OIL ON CANVAS
45 5/8 x 37 1/4
INCHES
116 x 94.5
CENTIMETERS
POZNAŃ,
THE NATIONAL MUSEUM/
THE RACZYŃSKI FOUNDATION
MNP FR 509

In the first half of the nineteenth century, the Polish art collector and art historian Count Atanazy Raczyński was one of the very few collectors in Europe who sought works by Old Masters as well as by contemporary artists. He also wrote the first history of German art of the Romantic period, the three-volume *Geschichte der neueren deutschen Kunst* (Berlin, 1836–41, in French and German).

Raczyński was especially appreciative of the Italian Renaissance – inspired works by the Nazarenes, especially their leading master, Johann Friedrich Overbeck, from whom Raczyński commissioned this picture as early as December 1828. *The Marriage of the Virgin* is an excellent example of Overbeck's religious painting, which features a lyrical composition combined with an emphasis on line over color. The picture fully demonstrates his formal and emotional kinship with the art of Raphael and Perugino, and at the same time illustrates the problem the Nazerenes had in creating a personal interpretation of the Renaissance masters' originals. This deeply emotional work is typical in its glorification of Catholicism and the cult of Mary, a remarkably strong trend in Overbeck's oeuvre.

In accord with Raczyński's express wish, the picture was to be based on Raphael's early painting of the same subject from 1504 (Pinacoteca di Brera, Milan), itself probably modeled on a painting by Raphael's teacher, Perugino, for the cathedral of Perugia (now in the Musée des Beaux-Arts, Caen).

Raczyński had seen the Raphael picture in Milan in 1815, in the company of the celebrated Madame de Staël and her daughter. In Overbeck's interpretation, however, the prototype has been reduced and freely transformed. From the figural groups of his predecessors, he borrowed only three central characters: Mary, Joseph, and the priest. He also altered the architecture of the background to suit his formal conception. The perspective structure of the vast, geometrically divided square of Raphael's well-known painting has been reduced to the pavement of the dais upon which the scene unfolds, while in the background a fragment of Renaissance architecture symbolizes the Temple of Solomon. MPM

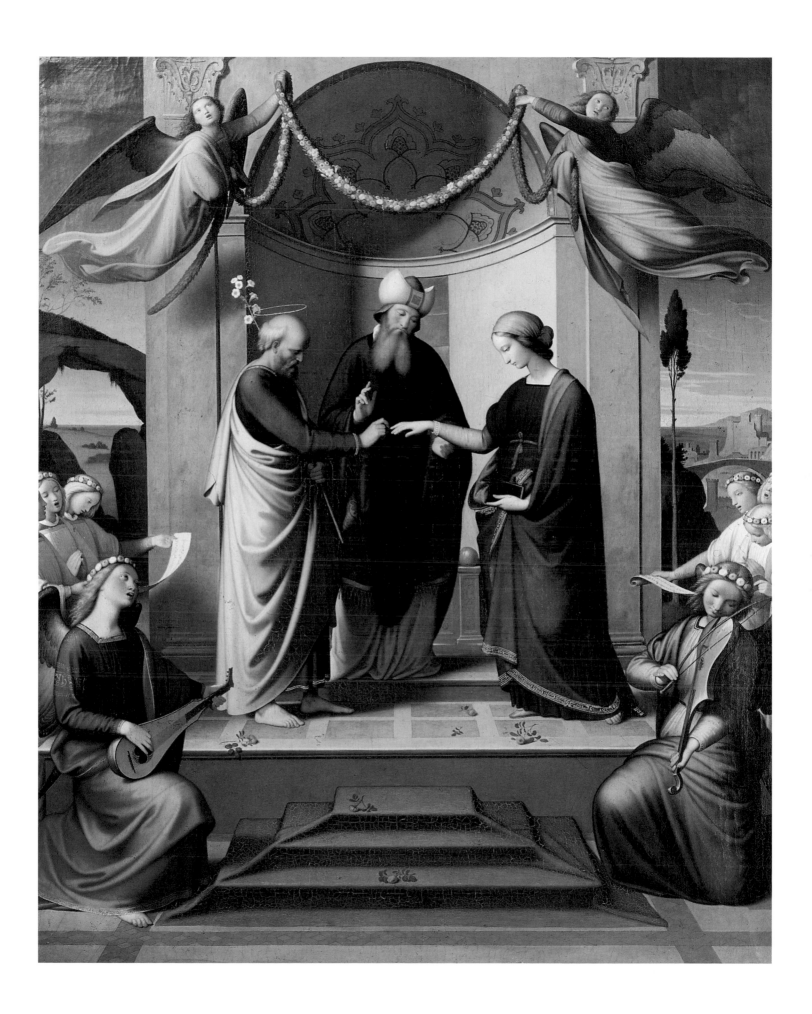

CARL FERDINAND SOHN

GERMAN, 1805–1867

THE TWO LEONORAS
(THE TWO ALLEGORIES)
1836

OIL ON CANVAS
27 X 22 7/8
INCHES
68.5 X 58
CENTIMETERS
POZNAŃ,
THE NATIONAL MUSEUM/
THE RACZYŃSKI FOUNDATION
MNP FR 492

By the first half of the nineteenth century, the Düsseldorf Academy had become one of the most important schools of fine arts in Europe. There developed around it a local "school" initially dominated by Nazarene-Romantic tendencies and later also by illustrations of subjects from German Romantic literature. Count Atanazy Raczyński was a devotee of this school and a patron of many of its artists.

Carl Ferdinand Sohn belonged to the oldest and closest circle of the Düsseldorf pupils of Wilhelm von Schadow. Known for his stylistic elegance and brilliant color, Sohn was in demand as a painter of women, thanks especially to the 1834 painting *The Two Leonoras*, one of the most popular works of the Düsseldorf school, known to us from the slightly reduced replica presented here, painted for Atanazy Raczyński two years later.

The painting depicts the Duchess Eleonora d'Este and Countess Eleonora Sanvitale from a play by Johann Wolfgang Goethe, *Torquato Tasso* (1790). These two differently characterized young women, holding hands, are shown on a terrace with a view onto a distant southern landscape. However, in comparison with a later treatment of the subject by Sohn, *Tasso and The Two Leonoras* (1839), this scene refers to a more general and symbolic representation of the allegory of friendship. A variant of a theme popular with the Nazarenes, the allegory of friendship was sometimes expanded into an allegory of the meeting of the South and North, of Italian and German art, and occasionally imbued with a melancholy tone of Romantic resignation. Sohn, however, interpreted the subject in a manner characteristic of "Düsseldorf school" painting, in this case with the addition of the palette of earlier Venetian painting. MMP

PIOTR S. WANDYCZ

{ THE GEOGRAPHY
of
POLISH CULTURE }

THE NINETEENTH CENTURY was truly a European Age. Two revolutions – the French and the Industrial – with all their consequences transformed Britain and a large part of the Continent in an unprecedented fashion. Out of the French Revolution stemmed the great ideological currents of liberalism, democracy, nationalism, and socialism. The Industrial Revolution not only engendered basic changes to economies and technology, but brought forth two new social classes: the bourgeoisie and the proletariat. In the field of culture in the broadest sense, changes were also profound.

On the eve of these great revolutions, the Polish-Lithuanian Commonwealth (*Respublica*) had been erased from the political map of Europe. Having been the second largest European state since the mid-sixteenth century, it was successively partitioned in 1772, 1793, and 1795 into three zones occupied by Russia, Austria, and Prussia . Did this mean that the Polish nation (state and nation were then virtually synonymous) would also disappear? Even some patriotic Poles thought so at first. The fact that the Polish nation – conceived in political-cultural rather than ethnic terms – survived, enlarged its social basis, and eventually regained independence by the end of World War I was due largely to the strength of its cultural identity.

The politically conscious part of the nation never fully accepted the verdict of partitions and directed its efforts again and again toward regaining independence. Polish efforts took a variety of forms, from diplomacy, foreign campaigns, and conspiracies to a series of unsuccessful national uprisings in 1830, 1846, 1848, and 1863. Costly failures, particularly that of 1863, were followed by way of reaction by strivings that focused on preserving, modernizing, and fortifying the nation. This latter trend encouraged reforms in the economy, public education, and health, and is often referred to as "organic work" or a "positivist" as opposed to an "insurrectionist" approach.[1]

Divided, redivided, and subjected to changing regimes, the lands of Old Poland were exposed to a varying degree to modernization processes. The partitions had inter-rupted progressive reforms symbolized by the Constitution of May 3, 1791, which affected culture, economics, and, partly, social conditions. Subsequently the Poles, ruled by the three empires whose political systems evolved from absolute monarchies to limited constitutional governments, shared only to some extent the benefits of change.

Customs barriers prevented the emergence of a common market, hence, the dif-ferent parts evolved and modernized mainly in relation to their partitioning powers.

1 For a useful discussion, see Stanislaus A. Blejwas, *Realism in Polish Politics: Warsaw Positivism and National Survival in Nineteenth Century Poland* (New Haven, Connecticut: Yale Russian and East European Publications, Yale Concilium on International and Area Studies, 1984).

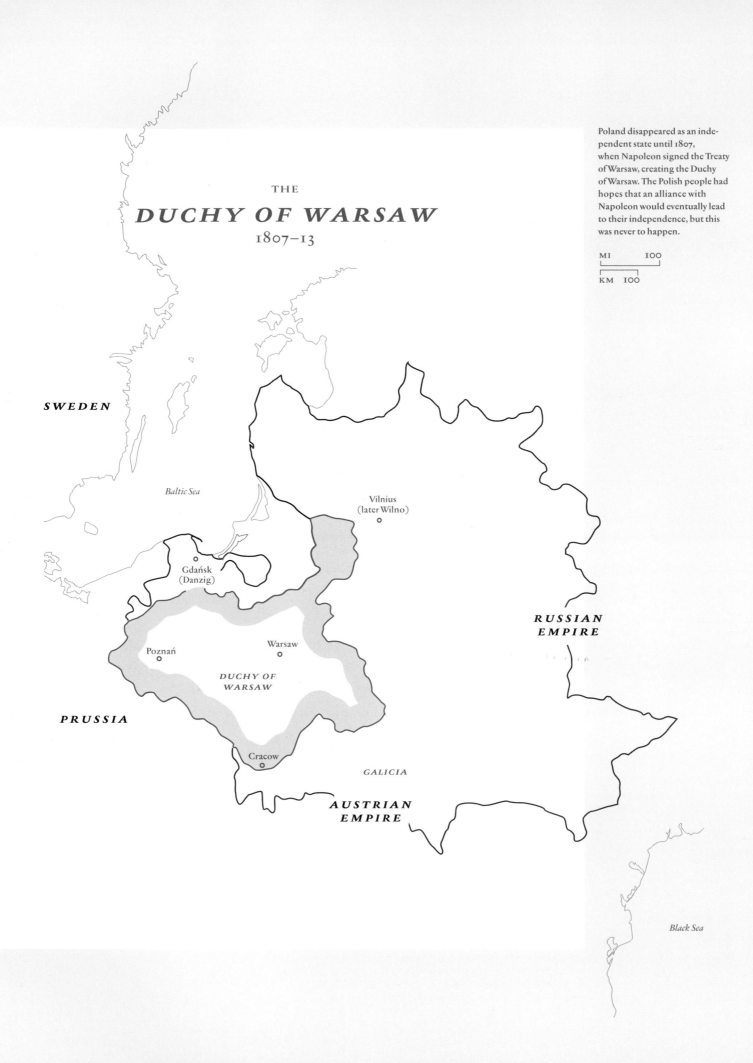

THE

DUCHY OF WARSAW
1807–13

Poland disappeared as an independent state until 1807, when Napoleon signed the Treaty of Warsaw, creating the Duchy of Warsaw. The Polish people had hopes that an alliance with Napoleon would eventually lead to their independence, but this was never to happen.

MI 100

KM 100

SWEDEN

Baltic Sea

Vilnius
(later Wilno)
○

Gdańsk
(Danzig)
○

*RUSSIAN
EMPIRE*

Poznań
○

Warsaw
○

DUCHY OF
WARSAW

PRUSSIA

Cracow
○

GALICIA

*AUSTRIAN
EMPIRE*

Black Sea

While the Industrial Revolution was transforming Europe, it affected significantly only the Russian-ruled Kingdom of Poland – unofficially referred to as the Congress Kingdom since it was a creation of the Congress of Vienna of 1815. The predominantly agrarian character of the partitioned lands changed slowly. True, the peasantry became emancipated under Prussia in the 1820s, in Austrian Galicia in 1848, and in the Russian parts in 1861 and 1864, but the country still belonged to the semiperiphery of Europe.[2] The middle classes and the industrial proletariat were a tiny fraction of their counterparts in Britain or France. The telling exceptions lay in the realm of ideas and the vibrant cultural life. As the Polish historian Jerzy Jedlicki put it: "Intellectual reflection on modernity was almost abreast of that in the West, while industrial capitalism was advancing at a much slower pace."[3]

The spiritual leadership of the nation passed into the hands of a group defined by education rather than wealth: the intelligentsia. Although largely descended from the gentry and sharing much of its ethos, it was a specific group endowed with the feeling of spearheading a national mission. True, the Polish intellectual and artistic elites looked up to Paris, Rome, and other great cultural centers in Europe, and followed the trends of late Classicism, Romanticism, Realism, Naturalism, Symbolism, or Impressionism. Yet art for art's sake was a luxury that the Poles could ill afford, and they felt it essential to propagate patriotic ideas. The national message in one form or another was almost always present in their works. In the vanguard was patriotic literature, especially poetry; the great poets were deemed national bards (*wieszcz*). National accents permeated the music of Chopin and the lesser composers. What was, however, the role of the visual arts? A lively debate on this subject was taking place from mid-century onward.

To understand and appreciate Polish painting of the nineteenth century, it must be considered within the changing political context and fortunes of an oppressed nation.[4] For clarity's sake one may propose the following divisions: the postpartition decades linked with the Napoleonic period and its aftermath, which culminated in the November 1830 Uprising; the tumultuous years that witnessed the Spring of Nations in 1848 and reached a high point with the January 1863 Uprising; and the remaining thirty or so years of the century characterized by a certain stability during which it seemed

2 See Stefan Kieniewicz, *The Emancipation of the Polish Peasantry* (Chicago: University of Chicago Press, 1969).

3 Jerzy Jedlicki, *A Suburb of Europe: Nineteenth-Century Polish Approaches to Western Civilization* (Budapest and New York: Central European University Press, 1999), p. ix.

4 For a survey and attempted synthesis in English with an extensive bibliography, see Piotr S. Wandycz, *The Lands of Partitioned Poland 1795–1918* (Seattle and London: University of Washington Press, 1974). Also see Peter Brock, "Polish Nationalism," in Peter F. Sugar and Ivo J. Lederer, eds.,

Nationalism in Eastern Europe (Seattle: University of Washington Press, 1969); and a short and insightful essay by Agnieszka Morawińska, "Watching for the Dawn of Freedom," in Warsaw, The National Museum, and New York, National Academy of Design, *Nineteenth Century Polish Art* (Warsaw and New York, 1988), pp. 9–19.

that the Poles had abandoned all thoughts of armed struggle.[5] This was deceptive, for fire smoldering beneath the ashes became a flame with the outbreak of World War I. The themes in painting – of which more will be said later – that reflected and related to these developments were the Napoleonic legend (Suchodolski), struggle and martyrology (Grottger), and the historic school (Matejko).

In 1797, only two years after the third partition, the determination of the Poles to fight for independence found a concrete outlet. Throwing their lot in with revolutionary France, a Polish legion led by General Henryk Dąbrowski was formed and attached to Bonaparte's armies fighting the Austrians in Italy. Its song, "Poland Is Not Yet Lost While We Live," was to become the national anthem of the twentieth-century Polish Republic. The hopes of Dąbrowski and his followers were dashed by a French-Austrian peace, but a second and alternative effort, associated with Prince Adam Jerzy Czartoryski, soon came to the fore. A nephew of the last king of Poland, Prince Czartoryski became a friend and then foreign minister of Tsar Alexander I, who confided privately to him that he regarded the partitions of Poland as a crime. A revival of Poland linked with Russia looked like a distinct possibility by 1803–1804. Unexpected international developments prevented the realization of Czartoryski's bold plans, but the collaboration with Alexander bore fruit elsewhere. When named the curator of the Wilno Educational District (the former eastern lands of the Commonwealth annexed by Russia), the prince successfully focused on the promotion of Polish culture. It has been said that had light not shone in Wilno, it would have been extinguished throughout all of Poland.

Renewed war between Napoleonic France and Austria, Russia, and Prussia brought new hope to the Poles. In 1806 Napoleon called on Dąbrowski to assist the French armies entering Prussian Poland by staging an uprising; a small Polish army and administration came into being. Another nephew of the last king, Prince Józef Poniatowski, was put in command of the army and played an important role in the embryonic Polish state that was established in 1807 as a result of the Conference of Tilsit between Napoleon and Alexander. Although it was named the Duchy of Warsaw to dispel fears among the partitioning powers that it was the nucleus of a re-created Polish Commonwealth, it was certainly viewed as such by the Poles, who supported Napoleon despite the heavy financial burden of maintaining a large army as the advance post of the Napoleonic empire. This Polish military effort reached its peak with Napoleon's invasion of Russia in 1812, but although the emperor called this war a Polish Campaign, that was largely rhetoric. His lack of real commitment to the re-creation of the preparti-

tion Commonwealth as an element of the European balance of power was belatedly recognized by Napoleon as a mistake during his exile in St. Helena.[6]

At the Congress of Vienna following Napoleon's final defeat, the powers assigned most of the Duchy of Warsaw to Tsar Alexander, now calling it the Kingdom of Poland with the tsar as king. The Duchy of Warsaw had lasted barely seven years. Still, with the Napoleonic code and other reforms, it underwent a modernization that proved significant in the long run even for Poles living outside its narrow borders. Endowed by Alexander with a fairly liberal constitution, its own government, parliament, and army, the Kingdom of Poland was to exist for fifteen years. Its dependence on Russia and the tsar, and the arbitrary character of this relationship, bore some analogies to the future relationship of Communist Poland to the USSR. Although the Congress Kingdom suffered from two internal contradictions – a constitutional state that was associated with a despotically ruled empire, and a kingdom that did not encompass all the Polish lands that Russia had annexed through the partitions – the opening years seemed to offer hope and promise.

Cultural and artistic life appeared to thrive in this more stable environment. In 1816 the University of Warsaw was established and it developed quickly. It contained a Department of Fine Arts in which the classicist portrait painter Antoni Brodowski held a chair. Beginning in 1819, annual exhibitions were held. At the University of Wilno (where the father of Polish historiography, Joachim Lelewel began to teach), a similar department was established. Significant writings appeared, and the theater in which the first comedies of Aleksander Fredro were performed became an important element of Polish culture transcending the partitioning borders. The dominant Classicism that had been associated with the reign of Stanislaus Augustus Poniatowski in the late eighteenth century was challenged by the emergence of Romanticism. Adam Mickiewicz's poems of the early 1820s symbolized the new trend, as did the first compositions of the youthful Frederyk Chopin. Walenty Wańkowicz's *Portrait of Adam Mickiewicz on the Cliff of Judah* is an early example of Polish Romantic painting {*PL 55*}.

PL 55

5 For an excellent discussion of the uprisings, see Stefan Kieniewicz, Andrzej Zahorski, and Władysław Zajewski, *Trzy powstania narodowe* (Warsaw: Książka i Wiedza, 1992, 1994). Compare Henryk Wereszycki, "Polish Insurrections as a Controversial Problem in Polish Historiography," *Canadian Slavonic Papers* 9 (Spring 1967). Also see the stimulating essay by Andrzej Walicki published as *The Three Traditions in Polish Patriotism and Their Contemporary Relevance*, vol. 4 (Bloomington, Indiana: Polish Studies Center, Indiana University, 1988) and Walicki's numerous works on Polish nineteenth-century political thought.

6 The classics by Marceli Handelsman, *Napoléon et la Pologne* (Paris: F. Alcan, 1909) and Szymon Askenazy, *Napoléon et la Pologne* (Brussels: Editions du Flambeau, 1925) are still well worth reading, as is a short, up-to-date treatment of the Duchy in Barbara Grochulska, *Księstwo warszawskie* (Warsaw: Wiedza Powszechna, 1991).

A relative stability in the Kingdom, however, began to decline in the 1820s. The despotism of Grand Duke Constantine, a neurotic commander of Polish troops; the intrigues of Russian officials suspicious of Polish efforts toward liberty; and the rise to the throne of Tsar Nicholas, nicknamed the "gendarme of Europe," boded ill for the future. Censorship increased, free masonry was forbidden, and all forms of opposition, from legal in the parliament to secret in the army and intellectual circles, were persecuted. News of the July Revolution in France and Belgium led to fears that Polish troops would be forced to participate in a Russian-led crusade in Western Europe. Threatened with arrest, cadets, young officers, and students launched an attack on the grand duke's residence in Belweder Palace. This largely spontaneous revolutionary event transformed itself into a national uprising and subsequently into a war with Russia fought by regular troops on both sides from November 1830 onward.

By October 1831 the Russians had crushed the uprising and severe reprisals deprived the Kingdom of Poland of the attributes of an autonomous state. Cultural losses were also severe: the University of Warsaw was closed; Puławy, an important cultural and artistic center of the Czartoryski family (Prince Adam had been the civilian head of the uprising), was confiscated. Thousands of émigrés, including the elite of the Kingdom of Poland, came to France. Paris became the cultural and ideological capital of Poland and the leaders of the nation turned to a bitter debate on the causes of the defeat. The moderate conservative policies of Czartoryski's Hôtel Lambert clashed with the democratic left. The former sought to gain the support of liberal Western European governments; the latter counted on the revolutionary solidarity of peoples, and invoked the watchword: "For Our Freedom and for Yours."

The November Uprising of 1830 had a profound and multifaceted effect on Polish culture. It was said that the pen replaced the broken sword, as the giants of Polish Romantic poetry, Adam Mickiewicz, Juliusz Słowacki, and Zygmunt Krasiński, became the national prophets seeking to define and maintain Poland's national identity. Polish literature dominated all other cultural manifestations of Romanticism in the 1830s and 1840s. Without entering into all its complex manifestations and interconnections with literary theory, a new emphasis began to be placed on subjects that celebrated the great national and insurrectionary moments in Polish history. Among the painters, only Piotr Michałowski – both on the grounds of his undoubted talent and his representation of

7 See Morawińska (note 4), pp. 12–14.

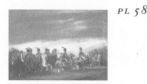

the theme of the Napoleonic legend (evoking Polish struggles on the side of the emperor) – could possibly qualify for the messianic role that would equal the generation of Romantic poets {*PL 58*}; {*FIG 1*}. Otherwise no painter rose to the national – not to mention the international – stature of Mickiewicz, Słowacki, or Krasiński. Interestingly, critical evaluations of art of the period were made by poets and literary critics, not art critics as existed in other countries. The result of this literary influence was an exceptionally strong focus on content rather than form. The literary critic, historian, and politician Julian Klaczko went even further, asserting that the Slav genius did not express itself in visual arts, but in literature.[7]

Writing in the 1840s, the patriotic poet Wincenty Pol, in his work "On Painting and Its Elements in Our Country," opined that a painter needed a real knowledge of national history. The painter-historian was close to the poet because both should recall "the living picture of the past" and both should reveal "the poetic nature of our history." He added that thus far there was no truly "historical" Polish painting. The critic Krystyn Grabowski agreed, stating that historical pictures worthy of that name should come from the "heart of our history" and should imagine and resuscitate figures and feelings from the far past. Painters who "conceived history poetically could ignite the love for historical painting." He suggested as subjects dramatic episodes from Polish battles against the

FIG 1
Piotr Michałowski, *The Battle of Somosierra*, ca. 1837, oil on canvas, Cracow, The National Museum.

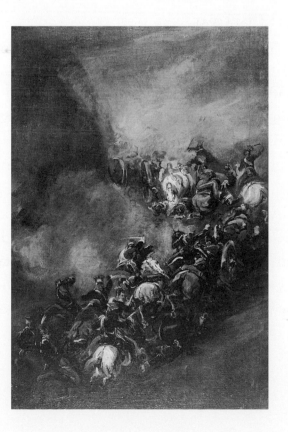

Tartars, prisoners captured and liberated, foreign invaders, and the suffering that accompanied these struggles, articulating the belief of most of his contemporaries that a historical picture was to be simultaneously a drama and an epic.[8]

The democratic émigrés in France did not abandon the idea of a new uprising, and they insisted that it be accompanied by an attempt to emancipate the peasantry. They inspired what turned out to be the abortive outbreak in 1846 in Austrian Galicia, which quickly turned to tragedy. Partly incited by the Austrian authorities, the suspicious peasants turned against the insurgents. Roaming peasant bands killed or captured landowners as well as the rebels and looted their manors. Both conservatives and democrats of the Polish elite realized that the peasant question was a burning issue, but differed in their ways of handling it. These events, and the hopes and frustrations that accompanied them, found reflection in art. The democrats asked painters to turn their attention to the Polish folk and the land; the more romantically inclined conservatives stressed the need to represent the past greatness of Poland.

During the Spring of Nations in 1848 and its aftermath, Galicia was still affected by the peasant question and the growing Polish-Ukrainian antagonism. In the Prussian-occupied lands, the events of 1848 demonstrated the basic incompatibility of German and Polish interests. In the emasculated Kingdom of Poland, the oppressive Russian rule softened somewhat in the late 1850s following military defeats in the Crimean War. Some limited concessions were made to the Poles.

However, as the great Polish publicist Maurycy Mochnacki put it: under harsh conditions uprisings occur because they must; when conditions ease, because they can. Two distinct and potentially incendiary trends began to develop in the Kingdom. A socially moderate movement for a gradual return to the 1815 status of the Kingdom (the Whites) competed with a more radical, revolutionary trend (the Reds) representing the younger generation that sought independence even at the risk of war. Then there was the margrave Aleksander Wielopolski, a conservative hard-boiled realist who obtained important concessions from Russia but, disregarding public opinion, antagonized all Polish groups. As tensions mounted, Wielopolski tried to emasculate the Reds by introducing military conscription that would single them out. They responded by launching a national uprising in January 1863, and appealed to the people of Poland, Lithuania, and Rus (former Ukraine), as well as the Jews, to join them. A clandestine National Government decreed full emancipation of the peasantry, but the decree could be executed only haphazardly, and relatively few peasants joined the insurgents.

The January 1863 Uprising was the bloodiest, most widespread, and longest lasting of any previous Polish uprisings. It also involved the greatest number of people. Many foreign volunteers joined the Poles and Lithuanians in their hopeless struggle – a guerrilla war waged by poorly armed insurgents against a regular army. The uprising was crushed, and in October 1864 its major leaders were publicly hanged at the Warsaw citadel.

Even more than the November 1830 Uprising, that of January 1863 left an indelible mark on ensuing generations. Those who saw in it the culmination of the Romantic spirit with its dogmas of sacrifice for the cause, an idealization of heroic and hopeless struggles, an exalted patriotism heralded by the great poets, condemned the uprising as a folly and a crime against the nation. What was needed was political realism: a concentration of efforts on modernizing and fortifying the nation – "organic work" and a "positivist" philosophy in contrast to the idealistic message. The positivist hero was the teacher, doctor, engineer – not the fallen soldier. Cultural, social, and economic activity had to replace military action.

PL 69

The January Uprising of 1863 profoundly affected Polish painting. Painters like the Munich-trained Józef Brandt, responded to the perceived need for patriotic themes by painting subjects from the Polish past and evoking images of Polish, Cossack, and Tartar warriors {*PL 69*}. Brandt was praised for the "boldness, fearlessness and the iron fortitude" emanating from his pictures.[9] Even portrait painters stressed the patriotism of their subjects or engaged in a historicizing style.

In 1867 the famous Compromise between the Habsburgs and the Hungarians transformed the Austrian monarchy into the dual state of Austro-Hungary. The Poles in Galicia gained an autonomy that allowed them to "polonize" the education and administration of their province. While Galicia was ruled mainly by a conservative nobility attached to the past, the city of Cracow gradually became the spiritual capital of Poland and the center of art and learning.[10] In 1870 the School of Fine Arts was established (the only one after the closing of the Warsaw school), followed a few years later by the Academy of Arts and Sciences, The National Museum, and the Czartoryski Museum. No wonder that a number of painters came from this region or exhibited there, among them Henryk Rodakowski, Juliusz Kossak, and Jacek Malczewski.

8 See Waldemar Okoń, "Polskie dziewiętnastowieczne malarstwo historyczne i mity narodowe," in *Polska Myśl Polityczna XIX i XX*, vol. 9 of *Polskie mity polityczne XIX i XX wieku* (Wrocław: Wydawnictwo. Uniwersytetu Wrocławskiego, 1994), pp. 58–61.

9 Ibid., p. 63.

10 In this connection, see Larry Wolff, "Dynastic Conservatism and Poetic Violence in Fin-de-Siècle Cracow: The Habsburg Matrix of Polish Modernism," *American Historical Review* 106, 3 (June 2001), pp. 735–64.

The Romantic current continued, but it became enriched with a historicism as defined by Artur Grottger and especially by Jan Matejko. Both looked upon art as in the service of an oppressed nation. In Cracow, Jan Matejko, whose poor health prevented him from participation in the January 1863 Uprising which he supported, spent more than two decades painting huge historical compositions that carried a national message {*FIG 2*}. Some were didactic in a moralizing sense and brought Matejko immediate acclaim, honors, and distinction. He became the undisputed ruler of art, director of the School of Fine Arts, and was even presented with a symbolic scepter from the people of Poland {*FIG 3*}. The painting *Stańczyk, the King's Jester* depicts the jester of King Sigismund lost in thought while the court amuses itself {*PL 63*}. Some saw the painting as a critique of the magnates whose private interests and lack of patriotism, in the artist's opinion, brought the state to its downfall. That theme, however, is more prominent in other canvases of Matejko. It is interesting from the point of view of the connection between art and politics, that the reflective Stańczyk was adopted as the symbol of the conservative party, which condemned the 1863 Uprising as an irresponsible act of hotheads. Another painting, *Hanging the Zygmunt Bell*, recalls Poland's early sixteenth-century golden age under Sigismund's rule {*PL 65*}. Indeed, entire generations of Poles came to view the history of their country through Matejko's eyes. Thus Polish painting, which until then had played a minor role in the national culture, came to the fore.

Did Matejko believe that the past should determine the greatness of the nation? Did his painting evoke patriotic nostalgia rather than optimism? There is no doubt that

FIG 2
Jan Matejko, *The Battle of Grunewald*, 1878, oil on canvas, Warsaw, The National Museum.

FIG 3
Jan Matejko, *Self-Portrait*, 1892, oil on canvas, Warsaw, The National Museum.

Polish historical painting stemming from the Romantic ideology of action proclaimed the message that a nation with such a great past was bound to recover its independence.[11]

Matejko's contemporary Artur Grottger, born in Galicia and dead at the age of thirty, also achieved national stature. Even as a teenager he was attracted to historical themes, but his name became inextricably linked with the January Uprising when he produced a series of black-and-white drawings illustrating the events of 1861–63. A contemporary called Grottger the only great "poet" worthy of the 1863 Uprising who "succeeded in portraying the whole range of suffering of these mournful times."[12] His epic cycles begin with scenes of preinsurrectionary Warsaw in 1861 and carry the story to its tragic end. In *The Year 1863 – An Insurgent's Goodbye and The Return of an Insurgent* {PL 62} is the artist's version of idealized classical features that came to be known as the "Grottger type." While subjects taken from the January 1863 Uprising figured in the paintings of such different artists as Maksymilian Gierymski and Jacek Malczewski, the position of Grottger was unique. In the 1894 catalogue of an exhibition in Lwów, Grottger and Matejko were described as watching over the nation's soul by "uniting in spirit what was torn politically."

This sense of artistic mission was not a unique Polish phenomenon; a connection between nationalism and art may be observed in many countries.[13] Yet there was something special in the case of Poland, a country torn into several parts and refusing to accept this fact. While nineteenth-century Polish painters experimented with all styles and genres and were part of the European brotherhood of artists, the fate of a partitioned and oppressed country placed an indelible mark on their works.

PL 62

11 Okoń (note 8), p. 66.

12 Cited in Waldemar Okoń, *Alegorie narodowe: studia z dziejów sztuki polskiej XIX w.* (Wrocław: Wydawnictwo. Uniwersytetu Wrocławskiego, 1992), p. 7.

13 See the interesting article by Piotr Krakowski, "Nacjonalizm a sztuka 'patriotyczna,'" in Dariusz Konstantynow, Robert Pasieczny, and Piotr Paszkiewicz, eds., *Nacjonalizm w sztuce i historii sztuki 1789–1950* (Warsaw: Instytut Sztuki Polskiej Akademii Nauk, 1998), pp. 15–24, the published proceedings from a conference organized by the Institute of Art of the Polish Academy of Sciences held December 5–7, 1995, in Warsaw.

DOROTA FOLGA-JANUSZEWSKA

TEMPLES OF MEMORY

MUSEUMS AND ART SCHOOLS IN THE SERVICE OF NATIONAL IDENTITY

TOWARD THE END OF THE EIGHTEENTH CENTURY, the hitherto existing order of the European world was shaken to its foundations. One consequence of the revolution in France came at the beginning of the following century, when Napoleon transformed the political map of Europe. The profound changes during the last three decades of the eighteenth century included the rise and rapid development of a new cultural phenomenon on the old Continent: the museum as a public institution – a new form of organization, conforming to the mentality of the new society.

Karsten Schubert's statement, "Over time, the museum has responded to political and social shifts with seismic precision,"[1] is especially pertinent to the nineteenth century, when in the territories of Old Poland, divided between Russia, Prussia, and Austria, there appeared the first public and national collections of works of art and historical mementoes. It was then that Poland, politically nonexistent, began to build in full an image of the Polish nation, of its history and culture. Paradoxically, the loss of administrative and territorial independence restored an independence of the spirit.

At the time of the war in defense of the Constitution of the Third of May and its promised reforms, which ended tragically in King Stanislaus Augustus Poniatowski's "betrayal" and the second partition of Poland (1793), a great cultural event was taking place in revolutionary France: a decree transformed the former royal collections into a public museum, today the Musée du Louvre. Napoleon's decision was the realization of an idea conceived during the *ancien régime* by the Comte d'Angevillers, director general of the palaces of King Louis XVI. The magnificent royal art collection was made accessible to the public by its being turned into a museum.[2] King Stanislaus Augustus had entertained a similar idea with his concept of the *Musaeum Polonicum* to be created for the purpose of exhibiting the first Polish national collections. If history had taken a different course, European museums might have had their origins in Warsaw as well.[3] The *Musaeum Polonicum* was linked to a plan to establish the first Academy of Fine Arts in Warsaw, which was submitted to the king by his art advisor, Marcello Bacciarelli, in 1767. The project included studios, masters, a curriculum, and the possible training of students through travels abroad.[4] Some outstanding artists invited from Western Europe were already active at the court: Jean-Baptiste Pillement, Per Krafft, and Bernardo Bellotto.

1 Karsten Schubert, *The Curator's Egg: The Evolution of the Museum Concept from the French Revolution to the Present Day* (London: One-Off Press, 2000), p. 11.

2 Andrew McClellan, *Inventing the Louvre* (Cambridge, Cambridge University Press, 1994), p. 108.

3 It should be remembered that the British Museum, established in 1759, considered to be the oldest, independent, public state museum, was nevertheless actually, until the end of the Victorian epoch, a kind of stronghold for the chosen few who obtained access to the collections only by applying well in advance. These were in fact rather rich collections of books, prints, drawings, and archives – a kind of valuable state library for wealthy lovers of the arts and sciences. Cf. David M. Wilson, *The British Museum, Purpose and Politics* (London: The British Museum, 1989).

4 Kalina Bartnicka, *Polskie szkolnictwo artystyczne na przełomie XVIII i XIX w. 1764–1831* (Wrocław: Zakład Narodowy im. Ossolińskich, 1971).

Although the academy did not formally come into being, its function was performed by the *malarnia* (painters' studio) and *sculptornia* (sculptors' atelier), run by Bacciarelli and André Le Brun respectively.[5] With the addition of excellent architects, Domenico Merlini, Jacopo Fontana, and Efraim Schroeger, also in the service of the king, there existed a lively artistic community. Activities included the education of a new generation of artists in addition to the monarch's commitment to building a collection. A catalogue of the collection published in 1795 listed 2,289 items – sculptures, engravings, and drawings – certainly strong corollary support for understanding the intended master plan for an art academy and a national museum. Although the partitions and political collapse of Poland ended these dreams, even after Stanislaus Augustus had left Poland, he wrote to Bacciarelli, discussing the subjects of the pictures to be painted for the royal gallery.[6]

The idea of the *Musaeum Polonicum* was resumed in 1801 by Princess Izabela Czartoryska, who opened in the park at Puławy The Temple of the Sibyl, initially called The Temple of Memory {*FIG 1*}. Eight years later the Gothic House was erected at Puławy, extending the princess' original concept to be, in the words of Zdzisław Żygulski, Jr., "above all a Polish army museum," whose "main aim was to awaken in Poles a chivalrous spirit and to induce them to struggle for independence."[7]

The establishment of the Puławy museums is regarded in Polish museology as a turning point with regard to the function of a museum as the mirror of the nation. The Russians tried to seize the collection of this small sanctuary of the Polish past during the November Uprising of 1831, but fortunately the collection was evacuated to Paris and its three greatest masterpieces, Leonardo da Vinci's *Lady with an Ermine* {*PL 38*}, Rembrandt's *Landscape with the Good Samaritan*, and Raphael's *Portrait of a Young Man*, became symbols of Polish collections and patronage outside the country.

This first step was needed to stimulate interest in setting up public galleries. In the nineteenth century there existed in Old Poland a great many magnificent private

PL 38

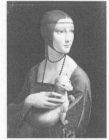

5 Krzysztof Załęski and Ewa Micke-Broniarek, "Kunstlandschaft und Landschaftsmalerei zwischen Aufklärung und Romantik," in Frankfurt am Main, Schirn Kunsthalle, *Die vier Jahreszeiten. Polnische Landschaftsmalerei von der Aufklärung bis heute* (Dresden: Verlag der Kunst, 2000), p. 35.

6 Alina Chyczewska, *Marcello Bacciarelli 1731–1818* (Wrocław: Zakład Narodowy im. Ossolińskich, 1973), pp. 106–107. Cf. also Warsaw, The National Museum, *W kręgu wileńskiego klasycyzmu*, text by Elżbieta Charazińska (Warsaw, 2000), p. 51.

7 Zdzisław Żygulski, Jr., "Dwieście lat muzeum Czartoryskich," *Spotkania z muzeami, Spotkania z zabytkami* 3 (2001), pp. II–III. Cf. also Zdzisław Żygulski, Jr., "Dzieje Zbiorów Puławskich. Świątynia Sybilli i Dom Gotycki," *Rozprawy i sprawozdania Muzeum Narodowego w Krakowie* 7 (1962).

8 Konrad Ajewski, "Polskie siedziby rodowe – muzea w XIX w.," *Spotkania z zabytkami* 4 (2001), pp. 1–8.

9 Stanisław Kostka Potocki, *O sztuce u dawnych, czyli Winckelman polski* (Warsaw, 1815).

enclaves of art. Some of these collections, following the example of the Czartoryski family, were made accessible to the general public.[8] Some of them survived only for a very short time. In all likelihood the collections of natural history and of antiquities, opened to the public by the Jabłonowski family in their palace at Siemiatycze as early as 1778, constituted the oldest private museum. The year 1805 saw the opening to the Warsaw public of the splendid and famous collection of Stanisław Kostka Potocki (1755–1821) in the palace at Wilanów, in a Gothic Gallery designed specifically in 1802 to function as a museum {*FIG 2*}. A distinguished collector, bibliophile, patron, and archaeologist, Potocki carried out excavations at Laurentum and Noli in Italy. In 1815 he translated J. J. Winckelmann's seminal work on art history into Polish.[9] In 1815 he became Minister of Religious Denominations and Public Enlightenment in the Congress Kingdom of Poland, contributing to a thorough reform of education. The Wilanów gallery formed part of the education program, perhaps for the first time carried out with such consistency. Potocki's collections at Wilanów were European in character, with works by the greatest masters, among them his equestrian portrait painted by Jacques-Louis David {*SEE WAŁEK, FIG 1*}.

In the palace at Dowspuda, which belonged to a general, Count Ludwik Pac, who had it built in a Neo-Gothic style (1820–23), the armory and library were designed as

FIG 1
The Temple of the Sibyl at Puławy, ca. 1802, engraving after a drawing by Jean-Pierre Norblin de la Gourdaine, Warsaw, The National Museum.

FIG 2, TOP RIGHT
Jan Zachariasz Frey, *A View of the Gothic Gallery at Wilanów*, 1808, engraving after an 1806 drawing by Zygmunt Vogel, Warsaw, The National Museum.

FIG 3, BOTTOM RIGHT
Jan Feliks Piwarski, *View of the Kazimierzowski Palace in Warsaw*, 1832, drawing, Warsaw, The National Museum. This was the seat of Warsaw University and the first seat of the Museum of Fine Arts in Warsaw.

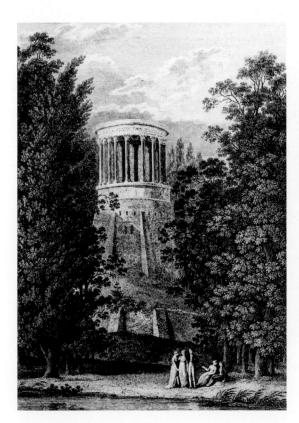

museum exhibitions, showing family and national traditions. The November Uprising brought an end to Dowspuda, as it did to the Puławy collection; the antiquities and pictures were carried to the family palace in Warsaw, where the museum of historical and natural history objects was established at the Gymnasium, to be a visualization of the knowledge acquired at school. In 1820–21 the Płock Scientific Society, in Płock near Warsaw, established the Public and School Museum with a department of antiquities and archaeological objects {*FIGS 4A, B*}.

Furnishings of the residences of the great Polish noble families began to be adapted, as if out of patriotic duty, into small and large "national museums." In 1826, for example, the reception rooms of Tytus Działyński's castle at Kórnik (Wielkopolska – Great Poland) were conceived in this manner, and in 1840, together with the library, they were opened to the public. The Lubomirski Museum in Lvov was established in 1823 and opened to the public in 1827. A ceremonial opening for "enthusiasts" of the Raczyński Library in the family's town palace in Poznań took place in 1829. All represent the development of the national identity.

However, preceding these developments, at about the time when Princess Izabela Czartoryska held meetings in The Temple of the Sibyl at Puławy, the first institution of higher artistic education in the territories of Old Poland was founded in Vilnius (formerly Vilnia in Lithuania, part of the Polish Commonwealth). This School of Fine Arts was subsequently transformed into the Faculty of Fine Arts at Vilnius University,

PL 56

 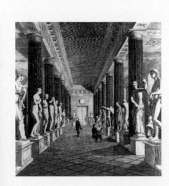

FIGS 4A AND B
The Department of Antiquities and Archaeological Objects at the Public School Museum in Płock, established in 1821, photograph ca. 1890, from the collection Franciszek Tarczyński, Warsaw, The National Museum.

FIG 5
Konrad Krzyżanowski, *Collection of Plaster Models at the Museum of Fine Arts in Warsaw*, ca. 1866, engraving after a drawing by Franciszek Tegazzo, Warsaw, The National Museum.

museum of historical and natural history objects was established at the Gymnasium, to be a visualization of the knowledge acquired at school. In 1820–21 the Płock Scientific Society, in Płock near Warsaw, established the Public and School Museum with a department of antiquities and archaeological objects {*FIGS 4A, B*}.

Furnishings of the residences of the great Polish noble families began to be adapted, as if out of patriotic duty, into small and large "national museums." In 1826, for example, the reception rooms of Tytus Działyński's castle at Kórnik (Wielkopolska – Great Poland) were conceived in this manner, and in 1840, together with the library, they were opened to the public. The Lubomirski Museum in Lvov was established in 1823 and opened to the public in 1827. A ceremonial opening for "enthusiasts" of the Raczyński Library in the family's town palace in Poznań took place in 1829. All represent the development of the national identity.

However, preceding these developments, at about the time when Princess Izabela Czartoryska held meetings in The Temple of the Sibyl at Puławy, the first institution of higher artistic education in the territories of Old Poland was founded in Vilnius (formerly Wilno in Lithuania, part of the Polish Commonwealth). This School of Fine Arts was subsequently transformed into the Faculty of Fine Arts at Vilnius University, founded in 1803, which also had a Faculty of Literature. The university contributed to the development of "Vilnius Classicism," which won renown for coding in antique iconography the events of Polish history. [11] The second Polish institution of higher artistic education, the Department of Fine Arts set up in 1816 at Warsaw University, inaugurated, side by side with the Vilnius school, artistic education aimed not only at training in handicrafts and painting, but also toward enriching the world view of students.

Thus by 1830 there had already developed in the Polish and Lithuanian territories a rich and diversified cultural milieu, for which numerous museums, libraries, and art schools had become manifestations of national identity. The outbreak of the November Uprising in 1830 was the first tragic disruption in this process.

It should be recalled that Poland had not existed as a sovereign state since 1795; however, there had existed a land divided into three nationalistically distinct zones, which tried by various means to combat cultural and religious disintegration. Life in the nineteenth century continued in a varying rhythm measured by successive political collapses and by modifications in the programs of Russification and Germanization of

1 Karsten Schubert, *Curator's Egg* (London: One-Off Press, 2000), p. 11.

2 Andrew McClellan, *Inventing the Louvre* (Cambridge, Cambridge University Press, 1994), p. 108.

3 It should be remembered that the British Museum, established in 1759, considered to be the oldest, independent, public state museum, was nevertheless actually, until the end of the Victorian epoch, a kind of stronghold for the chosen few who obtained access to the collections only by applying well in advance. These were in fact rather rich collections of books,

THE LANDS OF
PARTITIONED POLAND
CA. 1860

Upon Napoleon's collapse, the Congress of Vienna (1814–15) again redrew the map of Europe. Prussia, Russia, and Austria reestablished their authority over Polish lands. The Congress created the Kingdom of Poland (1815–31), consisting primarily of what had been the Duchy of Warsaw, but placed it under Russian control. The Congressional Kingdom of Poland disappeared after the Insurrection of 1831 when it was incorporated into the Russian Empire.

The shaded line indicates the short-lived Congressional Kingdom of Poland.

MI 100

KM 100

SWEDEN

RUSSIAN EMPIRE

Baltic Sea

Vilnius (Wilno)
○

EAST PRUSSIA

Gdańsk (Danzig)
○

Poznań
○

Warsaw
○

CONGRESSIONAL KINGDOM OF POLAND

PRUSSIA

Cracow
○

GALICIA

AUSTRIAN EMPIRE

Black Sea

the Polish people. The strict political system and anti-Polish campaigns that characterized the Austrian partition zone between 1772 and 1809 abated gradually in the years 1867–1914; the southeastern region, by then called Galicia, was granted its own diet and almost full autonomy in economy and education.

In the Prussian and Russian zones (the Kingdom of Poland and the Grand Duchy of Poznań), on the contrary, the relatively liberal tendencies existing before the Napoleonic campaign, including the preservation of considerable autonomy of education, after 1815 gave way to systematic Russification and Germanization actions directed against Polish culture and language, which further intensified after the November Uprising. After the suppression of the insurrection, some national institutions created before 1830 were immediately dissolved by the tsarist authorities and the properties of the insurgents were confiscated. The Great Emigration, which set out through Germany to France, Switzerland, Italy, and the United States, swept along with it the surviving art collections, archives, and libraries. Evacuation preserved the Czartoryski collection, while other collections, such as that of the Wiśniowiecki, were dispersed.

Warsaw, in the Russian zone, probably suffered most. It was there, in the Infantry Officers' School, that the anti-Russian insurrection had broken out. One of the repressive measures taken by the tsarist authorities was the dissolution in 1831 of both the Society of the Friends of Sciences and the first museum in the capital. The Department of Fine Arts at Warsaw University was closed down. Nevertheless, although institutions in Warsaw could no longer include the word "national" in their names, artistic life slowly began to flourish again. In 1835 the private School of Painting of Aleksander Kolular, opened, and in 1844 another art school was set up under the management of Feliks Piwarski. In 1850 Edward Rastawiecki's *Dictionary of Polish Painters* came out in three volumes and the first exhibition of "Polish Fine Arts" was held in the capital. The year 1860 saw the establishment in Warsaw of the Society for the Promotion of Fine Arts (*Zachęta*), and toward the end of 1862 the Museum of Fine Arts was founded and regarded from the very beginning as a National Museum (so named in 1916).

The Museum of Fine Arts in Warsaw was directly connected with the university and to the idea of educating young artists {*FIG 5*}. In 1844 the Department of Fine Arts was dissolved and replaced by the School of Fine Arts, but in 1864 lectures there were also suspended and the school was closed down by order of the tsar in 1866. As a replacement, the Society for the Promotion of Fine Arts created a Drawing Class to educate painters, sculptors, and draftsmen {*FIG 6*}. The Drawing Class housed the collections of

the future National Museum in Warsaw. Pictures were hung on the walls of classrooms that were turned temporarily into exhibition rooms. Direct contact with European paintings surely influenced the artistic orientation of the students.

In the same year, 1866, it was decided that the library and gallery of the Zamoyski Entailed Estate would be extended, just as half a century earlier the noble families had offered a way to continue the tradition of national collections. Only four years later, the Przeździecki Library and Collection were opened and made accessible to the public in a new building on Foksal Street. There arose modern salons and galleries in the French and British fashion, such as Gracjan Unger's Salon of Exhibitions (1879) and Aleksander Krywult's Exhibition Hall (1888) {FIG 7}. The culmination was a new building for the Society for the Promotion of Fine Arts in 1900, which became the largest and most impressive exhibition hall in Warsaw. The last evidence of this flowering of art and nationhood prior to the outbreak of World War I was the opening in 1908 of the Museum of the Tourist Society in Sadowa Street.

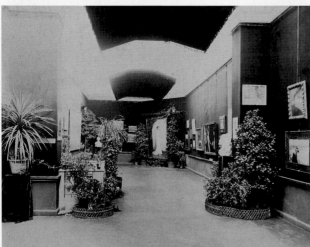

FIG 6, TOP LEFT
Karol Beyer, *Twenty-four Students with Professors of the School of Fine Arts in Warsaw*, 1861, photograph, Warsaw, The National Museum.

FIG 7, BOTTOM LEFT
Łukasz Dobrzański, *Aleksander Krywult's Exhibition Hall in Warsaw*, ca. 1900, photograph, Warsaw, The National Museum.

FIG 8, RIGHT
A. Regulski, *The Archaeological Museum in Vilnius*, late 19th century, woodcut after a drawing by Ksawery Pilatti, Warsaw, The National Museum.

Despite the ongoing Russification, repressions, and deportation to Siberia of stubborn patriots, there was a strong will to create national scientific and artistic institutions in Warsaw. Nevertheless, after the January Uprising in 1863, Warsaw was increasingly a mandatory stop on the route from Paris to Moscow, an international gateway from which Polish artists set off to study in St. Petersburg, Berlin, Munich, Paris, and Rome. It was no accident that the first purchase of works of art for the Museum of Fine Arts, in 1862, supported by the municipal authorities, comprised thirty-six pictures by European Old Masters from the collection of Johann Peter Weyer in Cologne, among them Pinturicchio's *Madonna and Child* and Jacob Jordaens's *Holy Family*. None of the originators of the museum doubted for a moment that the national collection should consist of works of art of the highest quality. The Europeanization of Warsaw, counterbalancing its Russification, gave rise to the conviction that a national collection did not mean Polish art alone, but rather European art as a context for Polish art and, as such, becoming the property of the Polish people.

Warsaw's international character was also maintained for many years thanks to close contacts with Vilnius, the northeastern-most bridgehead of Polish-Lithuanian culture. The centuries-old union of Poland and Lithuania had been responsible for yet another major European artistic route, from Warsaw via Vilnius to the Baltic region. After a long stagnation, in the early twentieth century the Vilnius circle was markedly revived, as evidenced in 1907 by the opening of the Museum of the Society of the Friends of Science {*FIG 8*}, and in 1913 by the ceremonial opening to the public of the Museum Collection at the Wróblewski Library. Relations between the museum institutions, especially between The National Museum in Warsaw and the museums and institutions of higher education in the Vilnius region, are still active today and have formed part of the national consciousness.

Analogies to the situation in Warsaw existed in Poznań, the capital of Wielkopolska (Great Poland). Shortly before the outbreak of the November Uprising, the Raczyński Library was opened in the family's town palace (1829). In 1836 the Society of Fine Arts was established. From 1840 to 1850, the Działyński family invited those interested to view their excellent library collection in the nearby Castle at Kórnik. As was the case with Russification in Warsaw, so the systematic Germanization in Great Poland precluded any overt patriotic program. Nevertheless, the Museum of Polish and Slavonic Antiquities was established in 1857. Its name marks for the first time the association of the Polish character with Slavonic territories – in Poznań, of all places. It came to be an

expression of patriotism for Poznań's Polish families to donate their collections to the city and to the formally nonexistent country. However, the Museum of Polish Antiquities was a thorn in the side of the Prussian authorities and was soon renamed the Mielżyński Museum, from Seweryn Mielżyński, the donor of a collection of foreign paintings, among other objects. In addition, on the strength of the resolution of the German Home Department, another, rival, the Regional Museum (Kaiser Friedrich Museum) was set up in Poznań, which collected works similar to those in the Mielżyński Museum, and in 1903 was enriched with Atanazy Raczyński's famous gallery of European paintings. After Poland regained her independence, in 1919 the two museums were merged to form the Wielkopolskie Museum, the direct predecessor of the present National Museum.

In the period 1872–85, Gołuchów, situated not far from Poznań, was the site of one of the most magnificent Polish collections, created by Izabela Działyńska, née Czartoryska, the granddaughter of the founder of The Temple of the Sibyl at Puławy. Her neo-Renaissance palace designed by E. Viollet-le-Duc became the seat of a museum that existed until 1939, which housed the Czartoryski collection brought back from the Hôtel Lambert in Paris and that of the Działyński family from Kórnik. The pride of the latter collection was one of Europe's finest sets of classical antique vases (now in part in The National Museum, Warsaw). The Gołuchów collection expressed the founders' outlook that great collections added to the international significance of a nation's artistic heritage.

Polish national identity was understood entirely differently in Cracow. While Warsaw played a very specific role in Polish culture during the second half of the eighteenth and first half of the nineteenth centuries, Cracow was "reborn" in its Polish character after the November Uprising. Owing to the more liberal policy of the multinational Habsburg Empire, the "spirit of the nation" – driven out of Russified Warsaw – sought refuge in Cracow, and a great many artistic efforts were undertaken there to nurture this spirit. However, the phenomenon of Jan Matejko's historical painting and its unique place in the Polish consciousness did not stem from the artistic quality of his works, but from a need for the continual staging of "the history of the nation." The Matejko-Cracow relationship in the nineteenth century more and more frequently was associated with an insight into the nation's cycles of prosperity and misery; this history lesson was to help in creating a new, wiser, and better future. It is no accident that in 1873 the "pope" of Polish painting, Jan Matejko, was appointed director of the reestab-

lished Academy of Fine Arts in Cracow (first founded at the Jagiellonian University in 1833), an organization that would inculcate several generations of artists with a proactive understanding of the idea of "a nation" in Polish culture.

Furthermore, folk traditions were stronger in Cracow and were also embraced by the elite. It was in Zakopane, a health resort in the Tatra Mountains that toward the end of the nineteenth century became a meeting place for Polish artists from all three partition zones to discuss art and politics, that the first Ethnographic-Natural History-Art Museum in Poland was founded (1888, The Tytus Chałubiński Tatra Museum). Its mission was to document the role of the folk (highlanders) tradition in the national heritage. The Zakopane circle and the Cracow Academy were responsible for the folk-national-symbolic themes that lay like a heavy rucksack on the shoulders of Polish artists and determined the rhythm of artistic life in Cracow until the end of the nineteenth century.

It became the mission of Cracow's cultural institutions, such as theaters and museums, to document changes in Polish souls and minds and to visualize the history of Poland. In 1871 Józef Dietl, president of Cracow, wrote of the planned municipal gallery in the Cloth Hall (Sukiennice): "a gallery of portraits of Polish kings, heroes, scholars, and artists. There historical pictures perpetuating great events of the nation, there ethnographic collections, there models of the Polish army should adorn the hall, constituting a true National Museum."[12] For Cracow, national collections meant collections of Polish art that best perpetuated the history of the country. The committee preparing the statute of the Cracow museum assumed as the raison d'être of this institution: "presentation of the collected specimens of the state of art in Poland, in its entire historical and current development."[13]

Cracow's Polishness had always been self-reflexive, referring to one's own national consciousness and artistic patrimony. It is no accident that the First Great Exhibition of Polish Art, held in 1887, was mounted in Cracow. Even the presence in Cracow of the Jagiellonian University, the oldest university in Poland, which as far back as the sixteenth century had housed a museum collection, did not contribute to a growing internationalism or contextualization of the local milieu. Hence The National Museum in Cracow, created by the City Council in 1879, considered the collecting of Polish art as its principal aim, in keeping with the intention expressed by the municipal authorities.

Cracow belonged to poor but liberal Galicia, a large territory administered by Vienna, where there were many important collections and cultural centers, such as Lvov in the Ukraine. Lvov was one of the most vigorous and most fascinating cultural centers

12 Cited in Tadeusz Chruścicki, "O muzeach narodowych w Polsce," *Spotkania z zabytkami* 7 (2001), p. I.
13 Ibid., p. II.

THE

POLISH REPUBLIC

1921–39

Poland returned to the maps
of Europe in 1918 after World
War I. This map shows the final
borders of the second Polish
Republic after the war of 1920
with the Soviet Union.

MI 100

KM 100

SWEDEN

LITHUANIA

Baltic Sea

Wilno

*SOVIET
UNION*

Gdańsk
(Danzig)

*EAST
PRUSSIA*

GERMANY

Poznań

Warsaw

Cracow

CZECHOSLOVAKIA

RUMANIA

Black Sea

of Eastern Europe. The Lubomirski Museum was set up as far back as 1827 and in 1870 was made accessible to the public; it was connected with the "Ossolineum" National Institute (which in 1945 was evacuated to Wrocław). In 1850 another important private center, the Baworowski Library and Museum, was opened to the public. Seven years later the Dzieduszycki family moved their library from Poturzyca to Lvov. In 1867 the Lvov Society of Fine Arts was established, and 1874 the Municipal Museum of Art and Industry opened with a very good picture gallery, which at the turn of the century contributed to an unprecedented popularization of Polish art, by arranging an exhibition of Zakopane-style objects. In addition, in 1894 Lvov received a newly erected Palace of the Arts, which inaugurated its activity with the "Retrospective Exhibition of Polish Art 1764–1886." National identity in Lvov had an entirely different dimension.[14] Situated at the intersection of several cultures, this city was an ethnic mosaic of Poles, Ukrainians, Jews, and Armenians, so typical of the Polish eastern borderland; the three religions and many cultural traditions were, however, no doubt dominated by the culture of Polish aristocratic families. The opening of the John III Sobieski National Museum in 1908 was thus a strong statement about the complexity of Polish identity in that territory.

What then did the idea of "national collections" mean in the nineteenth century? For Poznań and Wielkopolska, these surely were Polish and Slavonic collections; for Cracow, collections of the Polish nation; and for Warsaw, European collections. These ideas were essentially the result of the history of Poland; the name "Poland" derived from a Slavonic tribe called Polane, the name Wielka Polska (Wielkopolska – Great Poland) became widespread in the eleventh century, with Gniezno and Poznań functioning as capitals until about 1014. From about 1040 to 1596, Cracow was the capital of Poland (especially of Mała Polska – Małopolska [Little Poland] – in the south), and from 1596, it was Warsaw. During the partition period (1772–95 until 1918), division into historical provinces entailed various spheres of "Polishness" discernible even today in Polish culture.

However, one should not forget that for Poles, national collections in the nineteenth century existed – perhaps even in the first place – outside Poland. The first museum Polish by name – the Polish National Museum – was not established in Warsaw, Cracow, or Poznań, but at Rapperswil, near Zurich in Switzerland. Opened in 1870, it became for the Polish émigrés a point of contact in Europe, lying somewhat off the beaten track, yet "in the heart." The third such institution, after the opening of the Polish

14 Cf. Elisabeth Clegg, "A Question of 'Presence': The Lemberg City Gallery," in Maria Dłutek, ed., Arx *Felicitatis. Księga ku czci Profesora Andrzeja Rottermunda* (Warsaw: Państwowa Akademia Nauk i Towarzystwo Opieki nad Zabytkami, 2001), pp. 34–43.

Library in Paris in 1839, and the Branicki collection at Montresor, accessible from 1852, the museum at Rapperswil[15] was a touchstone of national identity, connected with the homeland practically only since after 1989.

Both the Louvre (in 1797 called the Musée Français, and in 1803 the Musée Napoléon) and the British Museum had a tremendous impact on the development in the nineteenth century of national awareness, a phenomenon that came to be a distinctive feature of that century, especially in the now independent countries of Latin culture. Just as the growth of the British Museum reflects the specific character of British intellectual culture and the history of the Louvre is interwoven with the socio-political events of France, so Polish museums likewise reflect in many dimensions the intellectual and cultural position of the Polish character.

15 Kazimierz Stachurski, "Dziedzictwo narodowe Polaków poza granicami kraju," *Spotkania z zabytkami* 5 (2001), p. 5.

PLATES

55–77

WALENTY WAŃKOWICZ

POLISH, 1799–1842

Portrait of Adam Mickiewicz on the Cliff of Judah depicts the national bard Adam Mickiewicz (1798–1855), the greatest Polish poet of the Romantic epoch, who for his political activity was deported in 1824 to Russia, and from 1829 on remained in forced exile to Western Europe, residing principally in Paris. Walenty Wańkowicz's presentation was the most popular of numerous likenesses of the poet and is considered the artist's best work as well. The two had known one another for a long time; Wańkowicz first portrayed Mickiewicz when they studied together at the university in Vilnius. They met again in St. Petersburg, where Mickiewicz was staying in exile and Wańkowicz was studying at the Academy of Fine Arts (1825–29). They saw each other frequently, and as early as December 1827 Wańkowicz began his portrait, although Mickiewicz disliked sitting for artists.

Wańkowicz was inspired by Mickiewicz's sonnet "Ayudah," one of the *Crimean Sonnets* cycle (1826), which begins: "I love to lean against Ayudah's face and watch..." and concludes with lines expressing the poet's faith in the power and value of his poetry: "And so it is, young poet, in your heart./There passion raises storms, but when you start/Your strains, the whirlwinds harmlessly depart/And sink deep down in pools of memory. Yet/They leave you songs, which after years will set/As shining jewels in your coronet" (trans. Dorothea Prall Radin, 1929). The painting is among the most representative and important examples of the Romantic trend in Poland and captures a kindred Romantic spirit at the moment of inspiration of the poet surrounded by seaside rocks and clouded sky, gazing into the distance and composing his future "immortal songs" (symbolized by a lute lying on the rock) that will be created despite "dangerous storms" and adversities. Expressive light effects, the contrast between the rugged massifs and the figure of the dreamy, lonely poet in a "Byronic" pose, casually dressed with a Circassian cloak nonchalantly thrown over his shoulders – all combine to create the romantic character of the portrait. Even his contemporaries considered Wańkowicz's portrait to be not only a likeness of the poet, but also a universal image of a Romantic hero of the new epoch – a national bard and spiritual leader of a nation living in captivity. For many years the painting functioned as a symbol of Polish character.

Wańkowicz finished the painting in early 1828 and in May exhibited it at the Academy of Fine Arts in St. Petersburg, winning widespread approval. Aided by the artist's lithograph, the portrait became extremely popular and was repeatedly imitated and copied. Even Wańkowicz made a few replicas of it, one of which is the painting presented here; two other pieces are at the Museum of Literature in Warsaw and at the Mickiewicz Museum in Paris. The fate of the original canvas, put up for sale by Wańkowicz at a public lottery and purchased by the writer Michał Borch, remains unknown. AT

WINCENTY KASPRZYCKI

POLISH, 1802–1849

EXHIBITION OF FINE
ARTS IN WARSAW
1828

OIL ON CANVAS
37 ¼ X 43 ¾
INCHES
94.5 X 111
CENTIMETERS
WARSAW,
THE NATIONAL MUSEUM
MP 298 MNW

Wincenty Kasprzycki's *Exhibition of Fine Arts in Warsaw* shows the mineral collection room of the University of Warsaw adapted for the annual Exhibition of Fine Arts. Kasprzycki painted the canvas between May 24 (the date of the opening) and July 14 (the date of a review discussing the painting). He sought to achieve an accurate record of the room and the exhibition, as well as portraits of artists and the public; the painting remains the only visual record of one of nine public art exhibitions held in Warsaw during the first half of the nineteenth century. It is an extremely rare depiction of Warsaw's artistic and social life in the Biedermeier period. Apart from its documentary value, however, the painting betrays the lack of experience of the budding painter, as is evident in the shortcomings in drawing, the simple composition and schematic character of the figures, and the unskillful handling of light.

Hung in three tiers on a specially designed scaffolding that covered the wall facing the windows, works in the exhibition were displayed according to their formats, although some attempt was made to group them by pictorial genre. Identification of the strongly foreshortened pictures has been facilitated by the exhibition catalogue and by critical reviews. Artists showing floral compositions included Henryka Beyer and her pupils; among the portraitists were Antoni Brodowski, Jan Klemens Minasowicz, and Franciszek Lampi. Ranged in the lower row were copies of Dutch paintings. On the distant wall facing the entrance hung two monumental pictures representative of Warsaw classicism: *Tsar Alexander I*

Conferring the Diploma of the Establishment of the University in Warsaw by Brodowski and *Oedipus at Colonus* by Antoni Blank (both now lost). Among the artists grouped below the windows, the following have been identified: the author of the present picture, sitting alone; Antoni Brodowski, professor of painting in the School of Fine Arts (standing against a showcase, fourth from the right); Antoni Blank, another professor, who organized the exhibition (standing farther off, the last of the group); Marcin Zaleski, view painter (sitting below the window, third from the right); and Aleksander Kokular, portraitist (standing in profile in the central group, a snuffbox in his hand).

Painted five years later, *View of the Palace at Wilanów* belongs to a seven-piece cycle featuring the palaces and park pavilions at Wilanów, Natolin, and Morysinek, as well as the church at Służewo, painted by Kasprzycki between 1833 and 1834 for Aleksander Potocki, the proprietor of the Wilanów estate. As early as 1832, the artist painted a smaller picture of the palace as seen from the entrance (The National Museum, Warsaw). Some years later, for the same client, Kasprzycki repeated the series in watercolor, adding interior views of the palace (the series was destroyed in 1944). All of these painting have been important in establishing the pre – World War I appearance of the Palace at Wilanów.

Kasprzycki's view paintings are distinguished by a sentimental Romanticism, and the predominance of landscape over architecture. Following in the *veduta* tradition initiated by Bernardo Bellotto, his meticulous drawing studies from nature formed the

basis of his large, impressive compositions enriched with a genre theme. *View of the Palace at Wilanów*, for example, uses the monumental mass of the palace as a distant backdrop setting the stage for a horseback ride, huntsmen conversing, a tutorial lesson, the arrival of guests, and gardening. The compositions created in Kasprzycki's atelier are distinguished by a correct perspective and proficiency in attaining a smooth, elegant texture. The now skillful handling of light tinges his architectural views against a landscape background with a note of the oncoming Romanticism.

The present painting features the north view of the Baroque seventeenth-century suburban residence built for King John III Sobieski and expanded in the eighteenth century by its successive owners. In 1799 the Wilanów estate passed into the hands of the Potocki family. Stanisław Kostka Potocki, a prominent political activist and consummate art connoisseur and collector, carefully reconstructed the original central part of the palace and, together with a picture gallery that he developed, opened it to the public in 1805. E-CH

57

VIEW OF THE PALACE
AT WILANÓW
1833

OIL ON CANVAS
39 3/4 X 57 1/2
INCHES
101 X 146
CENTIMETERS
WARSAW,
THE NATIONAL MUSEUM
MP 3029 MNW

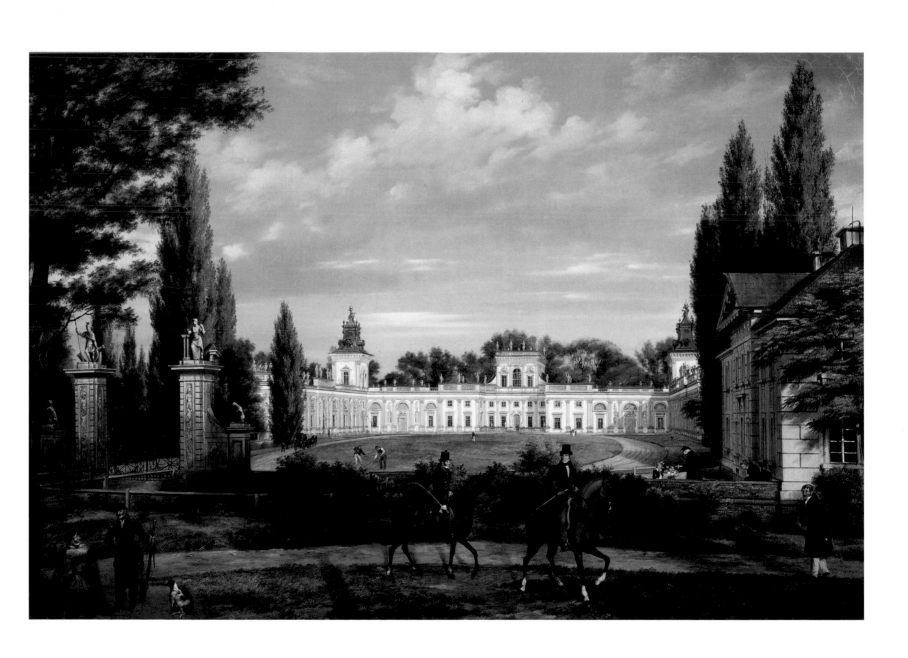

58,59

PIOTR MICHAŁOWSKI

POLISH, 1800–1855

58

PARADE IN FRONT OF
NAPOLEON
1837

OIL ON CANVAS
27 X 37 ¹/₄
INCHES
68.5 X 94.5
CENTIMETERS
WARSAW,
THE NATIONAL MUSEUM
MP 289 MNW

Piotr Michałowski, the greatest Polish Romantic painter, frequently referred in his art to the grandest, even mythic, figure of the epoch: Napoleon. The hero of his boyhood and for a generation of Poles the embodiment of their hopes of regaining political independence, combined with the Bonapartist atmosphere in the studio of his Paris teacher, Charlet, were responsible for the predominance of Napoleonic motifs in Michałowski's battle pieces. In addition to equestrian portraits of Napoleon as a lonely heroic commander, Michałowski painted the military reviews and legendary battles, commemorating the bravery of thousands of soldiers and creating the archetypal war hero. Michałowski also painted monumental equestrian portraits of native heroes and anonymous knights, intended as part of a decorative scheme for the pantheon of national glory at The Royal Castle in Cracow – a Romantic translation of models from the Baroque epoch.

The horizontal composition of *Parade in Front of Napoleon* is accentuated by an even line of cavalry that obscures the low horizon. The mounted riflemen of the imperial guards, in dark-green uniforms, wind-raised red jackets, and tall bearskin caps, gallop in parade deployment. Napoleon, accepting their salute, is seated on a gray horse and surrounded by his staff. By placing the commander off-center and in the middle distance, Michałowski changed the ideological meaning of the work, making the anonymous soldiers the chief, collective hero of the scene. The cavalrymen in the foreground were painted with heavy impasto streaks, in contrast to the thinly painted group of staff officers in the distance. X-ray examinations revealed that in the original version the cavalrymen were less numerous; during the alteration of the composition, the artist left the central chestnut with two pairs of front legs. Despite this error, Michałowski's fine rendering of the fluid movement of ranks of cavalry on thoroughbred horses is typical of his style. He was able to translate his observation of live models, both people and animals, into works memorable in color and composition.

In addition to his grand portraits, Michałowski painted psychologically penetrating likenesses of family, friends, and anonymous ordinary people such as wandering beggars, old soldiers, and peasants. These portraits are remarkable for their crisp representation of a personality, their ability to render the individual features of a person, the coherent and integrated handling of form, and a deep understanding of the human condition. Among his numerous masterful portrait studies, Michałowski's *Jews* deserves special mention. From a dark, murky background emerge busts of five Jews, each representing a

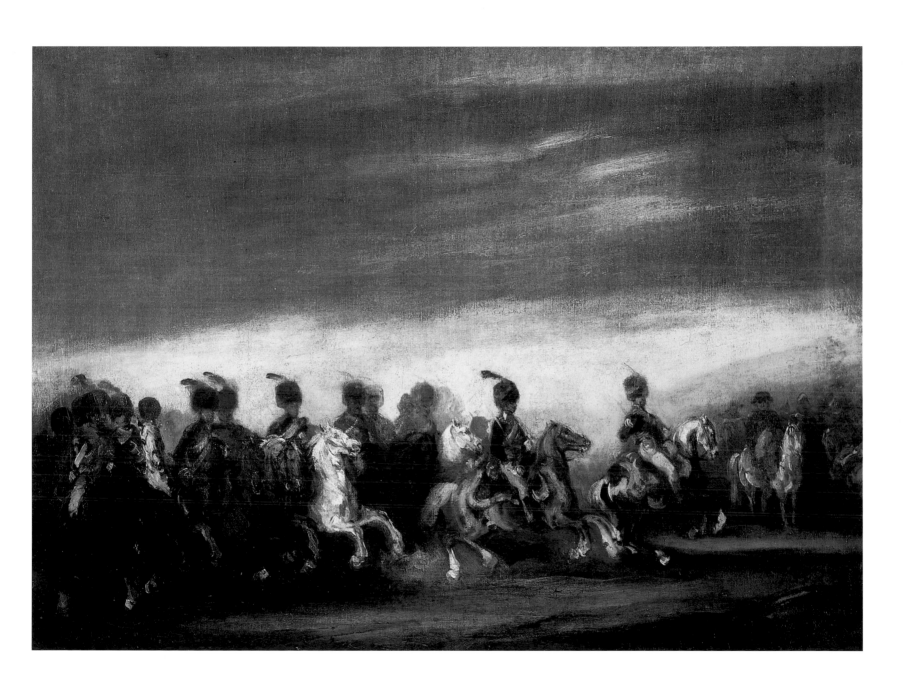

type caught in a specific moment. There are old men wearing tallithes on their heads, as one might observe them at prayer in a synagogue; pensive men in their prime; and a youth smiling ironically. These five studies, put together seemingly independently of one another, constitute a kind of casual group portrait of Poland's Jewish people.

This was noted as far back as the late nineteenth century by Jerzy Mycielski, an eminent Polish art historian, who wrote: "The entire Polish Jewry of the provinces has been perpetuated on canvas in this masterpiece of profound truth and superb character-ization, the types that today also here begin to partly disappear... and that 40 and 30 years ago still flour-ished in all such places as Sokal and Tarnobrzeg, Mielec and Chrzanów, Buczacz and Husiatyn, keep-ing inns and taverns or acting as factors to all the neighboring gentry." The painting's evident nostalgia for the Jewish people and their ancient culture and traditions has been noted as well by present-day critics. To Marek Rostworowski, the painting appeared as "a monument as it were of the tzaddik's proces-sion; a memorial of the Polish Jews and of the Jewish fate." AK and E-CH

59
JEWS
CA. 1845

OIL ON CANVAS
28 3/8 X 46 1/2
INCHES
72 X 118
CENTIMETERS
CRACOW,
THE NATIONAL MUSEUM
MNK II-A-749

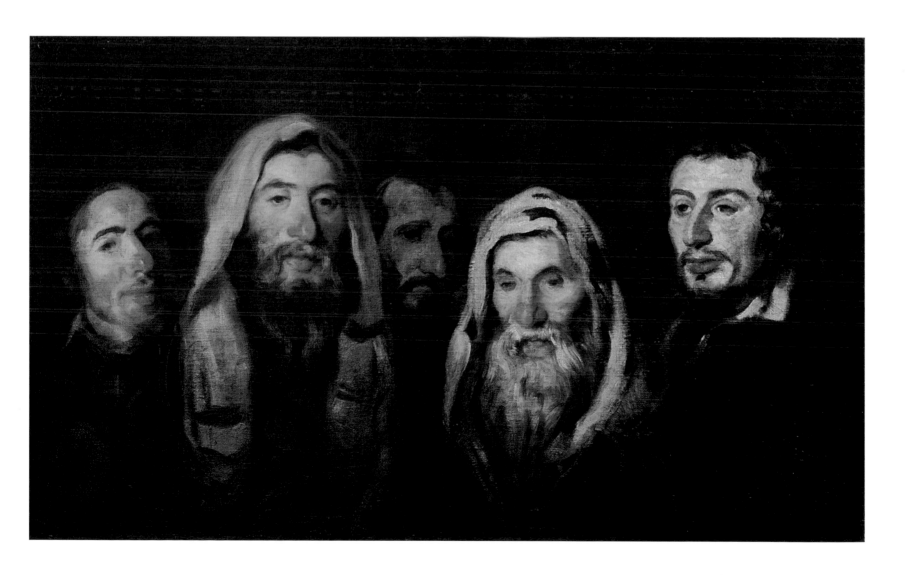

60

FRANZ XAVIER WINTERHALTER

GERMAN, 1805–1873

PORTRAIT OF ELIZA
KRASIŃSKA
1857

OIL ON CANVAS
57 1/2 X 42 1/2
INCHES
146 X 108
CENTIMETERS
WARSAW,
THE ROYAL CASTLE
ZKW 2208

Eliza (Elżbieta), née Branicka, the eldest of the three daughters of Władysław and Róża, née Potocka, was the wife of one of the most eminent Polish poets of the Romantic period, Zygmunt Krasiński. The author of *The Un-divine Comedy* married Eliza in 1843, at the express wish of his father, General Wincenty Krasiński, although he was engaged in a long-term love affair with Delfina Potocka, which was to continue long after he married Eliza. The Krasińskis had two sons and two daughters. Beautiful, well-educated, and multitalented, Eliza had numerous admirers, including the painter Ary Scheffer, a close friend of the Branicki family. In the last years of her marriage, Eliza Krasińska finally received manifestations of her husband's deep attachment in the form of a number of beautiful love poems addressed to her. Within a year after the poet's death, in 1860, Eliza married a relation of her husband, Ludwik Krasiński.

Franz Xavier Winterhalter, court painter to the Grand Duke of Baden, Leopold I, a protégé of Louis Philippe and later of Napoleon III, enjoyed great popularity as a portraitist among the contemporary aristocracy and royalty. He was active in Munich, Karlsruhe, Paris, London, Brussels, and in Switzerland; from 1840 onward he worked in close collaboration with his brother Hermann. In his portraits, painted *alla prima*, with fluent brisk strokes, he succeeded in reconciling a private, intimate mood with the requirements of official state portraiture. This painting is one of several portraits the artist made of Eliza Krasińska and it appears to be the last by his hand. It was painted in 1857 in Paris, where the Krasińskis were residing until mid-July and again

during the winter of 1857–58. The composition follows a formula frequently used by the artist in his female portraits: a life-size model shown in half-length against a landscape. Eliza's still beautiful face, framed by dark hair arranged in the style of the Empress Eugénie, is illuminated by a soft, diffused light. The glow is masterfully reflected as well in the glossy satin gown, whose elegant, silvery tone matches the whiteness of the scarf, the color of the pearls, and also the pale complexion of the subject's face and arms.

The painting remained the property of the subject and passed to her second husband, Ludwik Krasiński, and subsequently to his only daughter (from his second marriage), Maria Ludwika, married to Prince Adam Ludwik Czartoryski. It was surely around 1928, when Edward Krasiński began organizing the Krasiński Entailed Estate Museum in Warsaw, that she presented the portrait for his collection. The museum opened in 1930 and the portrait was hung in the gallery on the second floor. After the Nazis bombed the edifice in 1941, the greater part of the picture collection was evacuated to The National Museum in Warsaw and subsequently removed from Poland. This painting, however, escaped such a fate and eventually found its way into the collection of The Royal Castle. DJ

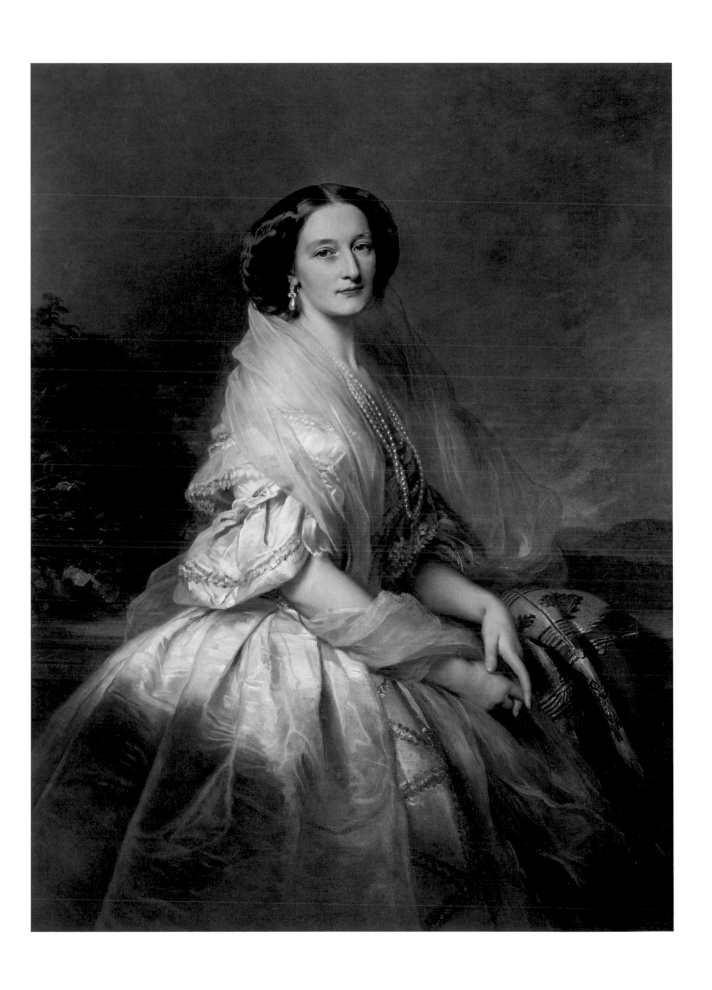

JÓZEF SIMMLER

POLISH, 1823–1868

DEATH OF BARBARA
RADZIWIŁŁÓWNA
1860

OIL ON CANVAS
80 1/4 x 92 1/8
INCHES
205 x 234
CENTIMETERS
WARSAW,
THE NATIONAL MUSEUM
MP 429 MNW

This painting depicts the death of Barbara Radziwiłłówna (1520–1551), the second wife of Sigismund II Augustus (1520–1572), the last king of the Jagiellonian dynasty. The young queen, whom Sigismund married clandestinely in the summer of 1547, was crowned in December 1550 and died on May 8, 1551, in the Wawel Castle in Cracow after a long illness. The dramatic and tragic history of the royal marriage is firmly established in Polish history and culture, giving rise both to a romantic view of the love of Barbara and Sigismund and another interpretation in which Radziwiłłówna is seen as the cause of the fall of the powerful Jagiellonian House. In the nineteenth century, Radziwiłłówna became the heroine of numerous dramas and novels. The best known was Alojzy Feliński's patriotic tragedy *Barbara Radziwiłłówna* (1809–11), which recalled the magnificence and power of the Commonwealth under the Jagiellonians and addressed the conflict between personal happiness and sacrifice for one's country. This play served as the inspiration for Józef Simmler's most famous historical painting. The *Death of Barbara Radziwiłłówna* was commissioned by the experienced collector of Polish art Leopold Burczak-Abramowicz of Wołodarka in the Ukraine. The large-format academic composition was preceded by numerous preparatory studies (most of them in the collections of the National Museums in Cracow and Warsaw).

The painting established Simmler's renown as a history painter. His romantic rendering of the deathbed motif retained its centuries-old, heroic, and moralizing significance and influenced succes-

sive generations of painters in Poland. A success at the National Exhibition of Fine Arts in 1860, the picture was purchased with funds raised by public subscription, initiating the collection of the newly established Society for the Promotion of Fine Arts (Zachęta) in Warsaw. Owing to its popularity, Simmler made replicas of it and additionally it was accessible in lithographs. Simmler's technique supported the appeal of the image. The simple composition is reduced to two figures within a dark chamber furnished with a prie-dieu and a crucifix. Strong light focuses on the pale, deceased queen and on the figure of the king frozen in despair, sitting at the edge of the bed. The subtle gradations of white are masterfully handled and Simmler has introduced classical attributes: a closed prayer book on an empty armchair and a closed censer in front of the bed. The only indication of royalty is in the ermine-lined golden bedspread covering the deceased queen; the majesty of death annihilates the majesty of royalty, a viewpoint discreetly emphasized by the placement of the widowed king on top of the ermines he unwittingly tramples. E-CH

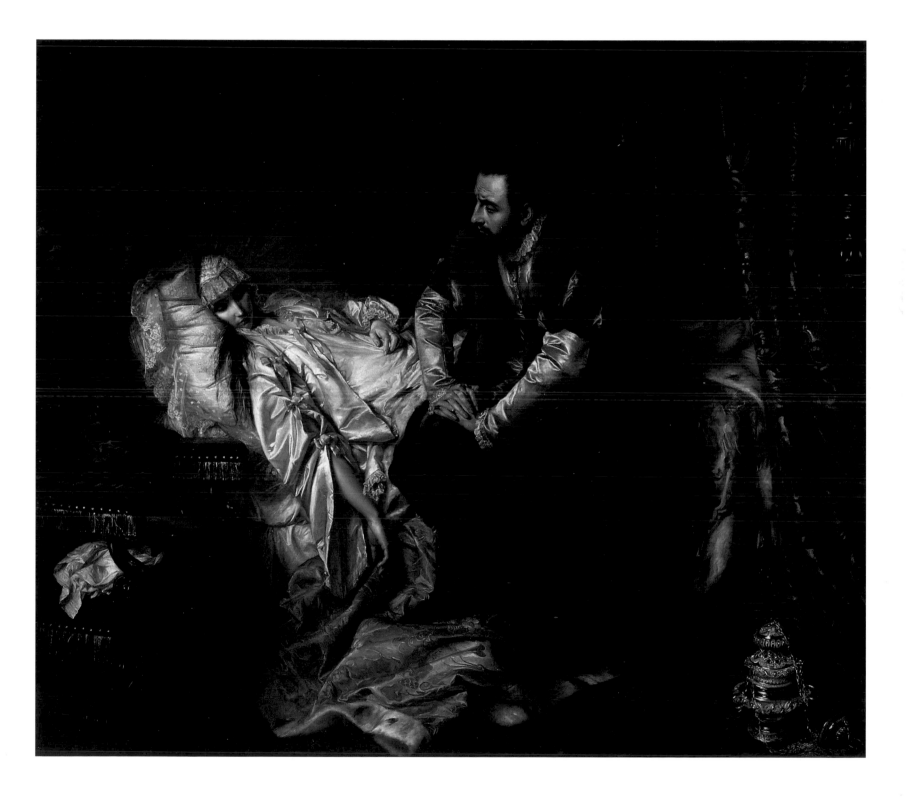

62

ARTUR GROTTGER

POLISH, 1837–1867

AN INSURGENT'S
GOODBYE AND
THE RETURN
OF AN INSURGENT
1866 AND 1865, RESPECTIVELY

DIPTYCH, OIL ON
WOOD PANEL
20 3/4 X 16 1/4
INCHES
52.7 X 41 .3
CENTIMETERS
20 3/4 X 16
INCHES
52.5 X 41
CENTIMETERS
CRACOW,
THE NATIONAL MUSEUM
MNK II-A-249,
MNK II-A-250

One of the best-known works concerning the January Uprising is Artur Grottger's diptych *The Year 1863*, or *An Insurgent's Goodbye and The Return of an Insurgent*. Choosing the motifs of farewell and welcome, which are also present in numerous insurgent verses and songs, Grottger embodied them in his heroine, "a Polish woman at two extreme moments... happy (in the *Return*)...[and] very sad (in the *Goodbye*)." The January Uprising, an event with far-reaching consequences for the entire nation, is depicted from an intimate, personal point of view. A wife, standing on the steps of the manor house, bids farewell to her husband, who is setting out to fight for his country. Dressed in widow's weeds, she fastens a white-and-red cockade to his *konfederatka* cap. His servant, wearing a similar cap, is waiting with a horse at the open gates. The columns of the house are entwined by ivy – a symbol of death and immortality and consequently a sign of the fate of the hero and his family. The welcome can occur only at night, because the insurgents' families were persecuted by the Russian authorities.

Grottger's idealized, allegorical interpretation of the January Uprising became the accepted pictorial vision. He took popular patriotic iconographic themes from earlier lithographs and transformed them in the spirit of Romanticism into a national iconography of contemporary martyrdom. Widely reproduced, his works were known abroad and at home, although those who kept them were subject to repression and imprisonment.

In his famous black-and-white drawing cycles *Warsaw I* and *II*, *Polonia*, and *Lithuania*, Grottger depicted the Warsaw incidents of 1861 and 1862, which preceded the outbreak of the insurrection, as well as its history and the epilogue in Siberia. He also executed oil paintings on these themes, again, as was observed in the nineteenth century, "presenting public calamities in an indirect, roundabout way, in their influence on everyday, family life, in private misfortunes of individuals and families." The artist created the figure of an anonymous insurgent and deportee, wearing a *czamara* (a kind of overcoat) or a frogged sheepskin coat, high boots, and a *konfederatka*, making this cap a symbol of the struggle for liberation. He created physiognomical types: the noble peasant-insurgent, the Jewish patriot, and, above all, the steadfast Polish widow and the "children of the defeat" as embodiments of hope. The artist set his ideal figures in places inseparably associated with the insurrection: a manor house, a blacksmith's forge, a villager's cottage. In his images of the insurrection, Grottger never represented scenes of agony or violence, but by depicting moments before and after drastic events, he emphasized their spiritual rather than physical consequences. AK

JAN MATEJKO
POLISH, 1838–1893

63

STAŃCZYK, THE
KING'S JESTER
1862

OIL ON CANVAS
34 5/8 × 47 1/4
INCHES
88 × 120
CENTIMETERS
WARSAW,
THE NATIONAL MUSEUM
MP 433 MNW

Famous for his biting wit and brilliant mind, Stańczyk (ca. 1480–1560), court jester to successive Jagiellonian kings of Poland – Alexander the Jagiellonian, Sigismund I the Old, and Sigismund Augustus – became known as a national symbol of patriotism and civic conscience. Fascinated all his life by Stańczyk, Jan Matejko in his youth painted two likenesses of the jester and later depicted him several times in historical scenes of the last Jagiellons.

The painting *Stańczyk, the King's Jester* refers to the reign of Sigismund I the Old, in the heyday of Poland as a military, economic, and cultural power. The royal jester sits alone in the semidarkness of a room in Wawel Castle; his caduceus – symbol of his role as clown – lies cast aside on the floor. On the table a sheet of paper with news of the loss of Smolensk relates the cause of his sorrowful meditation on the fate of his country. Behind the door a joyful ball is in progress, while he alone foresees the calamitous aftermath of the loss of the important borderland stronghold, seized by the Muscovite army in July 1514. Stańczyk's tragic forebodings find symbolic confirmation in the falling comet discernible in the sky next to the cathedral tower.

Stylistically the painting still shows the early influence on Matejko of the works of Paul Delaroche, for example in the lonely figure posed like an actor on a stage, the smooth application of paint, and the quiet, dark tone. A distinguishing mark, however, is the intensity of expression and dramatic power emanating from the attitude, gesture, and face of the subject. The painting, originally titled *Stańczyk during the Ball at the Court of Queen Bona,*

when the Message Is Brought of the Loss of Smolensk, is a work of crucial significance to the development of Matejko's art, as the artistic credo of the young painter. His ideology was formed during the period of patriotism preceding the outbreak of the 1863 January Uprising. Far from being a simple history painting, the portrait has profound symbolic meaning. It was Matejko's first historical painting in which the artist tried to express his view on the Commonwealth and the causes of its fall. By portraying the king's jester as a tragic thinker with an ascetic face, Matejko departed from historical truth to present him as a symbol of political perspicacity and wisdom, the personification of civic conscience and concern about the fate of one's country. Lending him his own facial features, the artist also endowed him with his own feelings and the patriotic concerns of a man living in the middle of the nineteenth century. Furthermore, he articulated his own role as a painter of the national history and an artist with insight into the heart of past events and their consequences to the past and present history of the country.

In 1873, in connection with the celebrations of the 400th anniversary of the birthday of the famous astronomer Mikołaj Kopernik (Copernicus) (1473–1543), creator of the heliocentric theory and author of the work *De revolutionibus orbium coelestium* (printed in 1543), Jan Matejko painted the large composition *The Astronomer Mikołaj Kopernik or Conversation with God,* which was purchased by the Polish people through public subscription and donated to the Jagiellonian University, where it has

been kept to this day. The smaller sketch seen here was produced as the model for the finished picture.

The painting occupies an exceptional position in Matejko's oeuvre both for its subject and compositional scheme. It shows the moment of the discovery of the revolutionary theory, which takes place at night, in solitude. In the center of the composition, the monumental figure of the great scholar is shown on a terrace beside the Gothic cathedral in Frombork, where he lived from 1510 to 1516 as a canon of the Chapter of Warmia; it was here that he carried out astronomical observations and began to formulate his most important work. He is depicted half-kneeling, his head and right hand slightly raised, while in his left hand he holds a pair of compasses. Scattered around are books, drawings, instruments, and a table with a model of the solar system. In the background, below the rail of the balustrade, are the town and the Vistula Lagoon.

For his portrait of Copernicus, the artist drew on earlier interpretations, including a copperplate by Jeremiasz Falck of around 1645. Henryk Levittoux (1822–1879), a physician, naturalist, and friend of the Matejko family, sat for the figure of the astronomer. Matejko was well acquainted with the literature on Copernicus, gathered at the Library of the Jagiellonian University, which he frequently used. The scientific instruments in the picture actually date from later periods of the seventeenth and eighteenth centuries; they are now housed in the Museum of the Jagiellonian University. Other accessories, among them the wooden chest on the right, are kept in The House of Jan Matejko.

Copernicus's great discovery is taking place through God's intervention, signified by a mystical light that illuminates the astronomer's face and the surrounding objects. According to the scholar Henryk Słoczyński, the picture is an example of the relationship between the artist's oeuvre and the views of Józef Szujski, an eminent historian and playwright. It is a visual equivalent of the scene of discovery in Szujski's play *Kopernik*, in which the astronomer describes his experience:

It was a clear, starlit night,
I was kneeling on the Frauenburg [Frombork] tower,
listening to the great mystery of the skies,
and towards the arms raised in ecstasy
the mystery of the Lord descended upon me.

Following in the author's footsteps, Matejko took up a polemic with the positivists' thesis about the fundamental contradiction between science and religion. As one nineteenth-century critic wrote: "The artist well understood that moment of rapture, when our astronomer had just ascertained the apprehended truths by indubitable calculation. Then again, knowing precisely his character and ministry, his faith and piety, he could not present him otherwise than as humbling himself before God." The composition may be regarded as the confession of the artist's belief that genuine insight into the mysteries of the universe may be gained solely through one's faith.

Throughout his life, Matejko was particularly fond of the Renaissance, the zenith of prosperity and power of the Polish Commonwealth, and the Zygmunt Bell, resounding from the Wawel Cathedral erected next to the historic seat of the Polish kings, was for him the only true remaining symbol of those days. Its sound accompanied the important events in the nation's life, whether joy or sorrow, and also tolled for the great artist on his final journey, to the Rakowicki Cemetery in Cracow in 1893. The bell appeared as a theme early in Matejko's work: drawing studies for the whole composition and for particular groups of figures along with an oil sketch for *Hanging the Zygmunt Bell* were made as early as 1861.

The title of the present painting does not correspond to its content. Instead of a scene showing the installation of the bell – commissioned in 1521 by King Sigismund I the Old and bearing his name – Matejko depicted the moment when it was removed from the mold and consecrated. The ceremony takes place at the foot of the now vanished Wiślna Gate in Cracow, in the presence of the monarch, his family, and court; outlines of the royal castle and the cathedral on Wawel Hill can be seen in the background. At the left side of the composition, on a canopied dais, stands Sigismund I, his hand resting on the head of Prince Sigismund Augustus; nearby, surrounded by her ladies-in-waiting, sits Queen Bona (with the facial features of Matejko's wife, Teodora), holding close the Princess Isabelle. To the left of her, his back to the viewer, is Piotr Kmita, Palatine of Cracow. On the dais steps sits the famous royal jester Stańczyk. In the center, Jan Chojeński, later bishop of Cracow, is consecrating the bell; next to him, holding a crosier, stands a Gniezno canon, Jan Lubrański. On the right side, the removal of the bell from the mold is supervised by its maker, a bell founder of Nuremberg, Hans Beham. Looking on is the king's lute player, Valentin Bakfark (Bekwark), who, according to legend, had earlier torn the strings from his lute and cast them into the melted metal so

64

SKETCH FOR THE
ASTRONOMER
MIKOŁAJ KOPERNIK OR
CONVERSATION
WITH GOD
1871

OIL ON CARDBOARD
16 ³⁄₈ X 20 ⁵⁄₈
INCHES
41.5 X 52.5
CENTIMETERS
CRACOW,
THE NATIONAL MUSEUM,
THE HOUSE OF JAN MATEJKO
MNK IV-25

that the bell would sound more beautifully. In front of him, holding a scroll, is the royal architect and sculptor Bartolomeo Berrecci.

In its compositional and ideological structure, the picture is clearly divided into two separate scenes. The dramatic expression of the group of workers pulling the bell out of the mold is markedly contrasted with the placid and hieratic character of the left side of the composition, where passive figures view the operation. The dazzling, rich palette enhances the solemn but joyous moment when the largest bronze bell in Poland was unveiled. As he often did, Matejko deviated from historical fact, depicting individuals who could not have taken part in this event, but whose presence serves the ideological concept. By featuring at the important ceremony artists (Bekfark, Berrecci) and lovers and patrons of art and learning (Kmita, Chojeński, Lubrański), Matejko sought to emphasize the impressive culture of Poland's "golden age." The celebratory atmosphere of the Renaissance is additionally communicated through the stately character of the scene and the sumptuous court dresses, shining with colors and jewels. Matejko depicted the grandeur of Polish history to hearten a nation living in captivity.

When exhibited for the first time in Paris in 1875, *Hanging the Zygmunt Bell* was criticized for the cramming of figures in a small area, excessive sumptuousness of costumes and accessories, glaring colors, and a maze of contours blurring the clarity of the composition. However, in 1878, when the painting was on display with two others at the Paris Exposition, Matejko was awarded a gold medal.

AK and EM-B

65
HANGING THE
ZYGMUNT BELL
1874

OIL ON WOOD PANEL
37 × 74 ¹/₂
INCHES
94 × 189
CENTIMETERS
WARSAW,
THE NATIONAL MUSEUM
MP 441 MNW

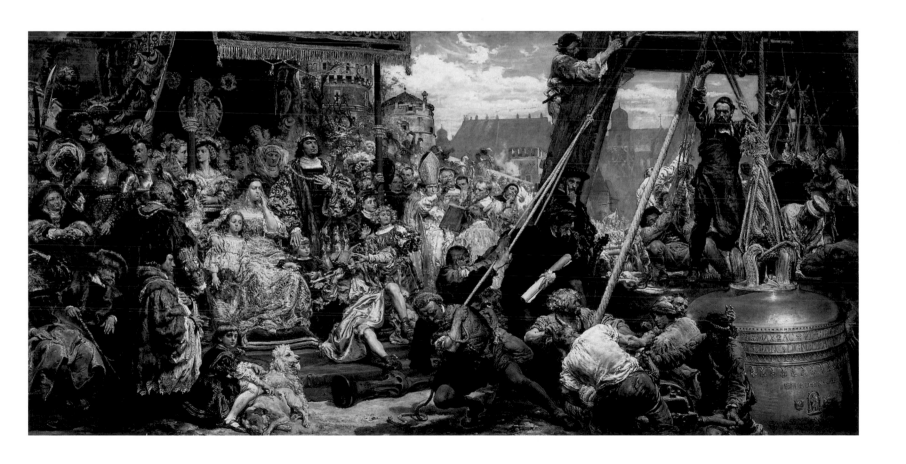

WŁADYSŁAW MALECKI

POLISH, 1836–1900

The *View of Wawel* (also known as the *Royal Castle in Cracow*) dates from the most prosperous period in Władysław Malecki's life. During the 1870s, Malecki studied in Munich and traveled around Europe. Although he never went to France, he learned of the Barbizon School in Munich through his professor, Eduard Schleich. Malecki received a gold medal for his own landscapes at London's Crystal Palace exhibitions in 1874 and 1877. This successful period was exceptional in an otherwise rather dreary existence in which he grappled with poverty and finally died in oblivion in a small provincial town.

View of Wawel was exhibited twice abroad, in 1873 at the Kunstverein in Munich and then in the German section of the World Exhibition in Vienna; the following year it was shown at Warsaw's Society for Promotion of Fine Arts (Zachęta). The strongly horizontal landscape is composed in several planes. Outlined beyond the cow pasture in the foreground are some loosely scattered buildings surrounded by trees, above which rises The Royal Castle at Wawel as seen from the northwestern suburb of Zwierzyniec. The artist has chosen the most picturesque side of Wawel Hill, with the cathedral and its Sigismund, Curates', and Clock towers as well as the castle tower of King Sigismund III Vasa. With the depiction of the landscape into the sun, the details in the foreground and middle distance stand out in sharp relief. Reflected light from the castle and smoke rising from the nearby chimneys envelop the structure.

The Wawel Royal Castle has been an exceptionally long-standing symbol for the Polish nation, especially during the period of the three partitions when the country was deprived of statehood. The former residence and necropolis of the kings constituted a kind of sanctuary, a historical landmark of vivid symbolism, inspiring dramas and paintings that referred to its legend and mythology. For Władysław Malecki, however, it inspired a rational and realistic observation of nature through compositional and formal solutions. KZ

67

JÓZEF CHEŁMOŃSKI
POLISH, 1849–1914

MEETING FOR
THE HUNT
1874

OIL ON CANVAS
25 3/4 × 58 1/4
INCHES
65.5 × 148
CENTIMETERS
POZNAŃ,
THE NATIONAL MUSEUM
MNP MP 92

Józef Chełmoński's career spanned the late 1860s into the first decade of the twentieth century, moving from his academic education to the realism of his mature work. Influencing later generations, Chełmoński's captivating artistic formula reconciled two seemingly opposed modes of depicting reality: a directly recorded impression with an utterly monumental composition. It combined attention to detail and respect for an object with subjective and atmospheric Romanticism. In keeping with the picturesque and ingenious rendition of the motif, technical virtuosity never dominated the emotional expression. Predominant themes were peasant genre scenes, departures for a hunt, sleigh rides, teams of horses, and attacking wolves, frequently set in the vast eastern borderlands of Old Poland. These masterfully painted exotic scenes earned Chełmoński recognition at the Salons in Paris and generated immense demand for his pictures, especially among English and American clients.

Meeting the Polish painter of historical scenes Józef Brandt was of essential importance to the crystallization of Chełmoński's interest in themes connected with the Ukrainian landscape. However, unlike Brandt, Chełmoński painted contemporary Ukraine, directly observed and felt. Enchantment with the eastern parts of Old Poland was common to Chełmoński's entire generation, who found there a new kind of landscape, with an open, infinite expanse and a distant, straight horizon, in which they discovered a metaphysical quality. *Meeting for the Hunt*, painted in the artist's studio in Warsaw, was preceded by outdoor studies during his second artistic journey to the Ukraine early in 1874. It shows an event observed "in the act," in a seemingly casual arrangement, but in fact revealing the artist's facility for conveying the mood of the moment. In composition and coloring akin to *A Case Brought before the Head of the Village [Wójt]* (The National Museum, Warsaw), painted a year before, it likewise attains its expressive power through the contrast between the serenity of the white steppe stretching into the distance and the dynamism of the group of figures silhouetted in dark patches. MG

ALEKSANDER GIERYMSKI

POLISH, 1850–1901

FEAST OF TRUMPETS
1884

OIL ON CANVAS
18 ¹/₂ X 25 ³/₈
INCHES
47 X 64.5
CENTIMETERS
WARSAW,
THE NATIONAL MUSEUM
MP 124 MNW

Aleksander Gierymski was one of the very few nineteenth-century Polish artists who grappled with the problems central to European art of the time. An intellectual artist, he sought to transfer onto canvas with precision and logic the forms and nuances he observed in nature. The painting *Feast of Trumpets* dates from the period of Gierymski's stay in Warsaw (1880–84), when he entered into collaboration with the editors of *Wędrowiec* (Wayfarer), a travel magazine that also dealt with artistic and literary subjects – to which he contributed drawings of contemporary life in the city. At the time the magazine was becoming the main forum for the theory of realism in literature and painting and a platform for a stubborn fight aimed at inculcating the Poles with an understanding of modern art and a taste for and an interest in artistic issues. *Feast of Trumpets* belongs to a series of Gierymski's works depicting everyday life in the poorest districts of Warsaw: Stare Miasto (Old Town), Powiśle, and Solec. Here the artist presented the ritual of washing away sins for the Jewish high holiday Rosh Hashana, connected with atonement for the new year (in Poland popularly called the trumpet holiday in reference to the sounding of the ram's horn, the *shofar*).

A scene of Jews praying at dusk on the bank of the Vistula in Solec was painted in 1871 by Maksymilian Gierymski. Aleksander Gierymski's later painting is closely akin to his elder brother's work in the scenery, compositional scheme, and contemplative and harmonious pictorial atmosphere. In addition to being a faithful depiction of reality, *Feast of Trumpets* is imbued with lyrical poetry and the artist's attachment to his native city. The concentration of the praying men is echoed in the stillness of nature at nightfall. The elegiac, pensive mood is heightened by the light of the waning day – golden sunbeams reflected in the mirror of the water.

Generally recognized as Gierymski's finest work of the Warsaw period and a breakthrough in his artistic development, *Feast of Trumpets* is distinguished by its subtle modulation of light and color and the seemingly casual structure of the composition that in reality relies on logical, strict discipline to create spatial depth. The rhythmic vertical accents (the masts of the boats and the slender figures) against a flat expanse of river and sandy bank establish an almost musical harmony enhanced by the magnificent luminosity of colors. Exhibited in 1888 in Warsaw and Cracow, the painting was a tremendous success and established Gierymski's reputation as a realist painter. The artist repeated this subject twice more, with slight modifications. The second, larger version of the picture (now lost) was painted in 1888 for Ignacy Korwin-Milewski. The third, considered a nocturne (The National Museum, Cracow), was executed in Munich in 1890. EM-B

JÓZEF BRANDT

POLISH, 1841–1915

ENCOUNTER
ON A BRIDGE
1888

OIL ON CANVAS
39 3/8 × 78 3/4
INCHES
100 × 200
CENTIMETERS
CRACOW,
THE NATIONAL MUSEUM
MNK II-A-147

Józef Brandt spent more than fifty years in Munich. In his studio, as documented by descriptions and photographs, he accumulated with a collector's passion historical props and oriental curiosities, which he used as iconographic material for his pictures. Virtually a Polish history and ethnography museum, the studio served as a gathering place for artists, writers, and collectors.

Regarded as one of the most outstanding Polish painters of battle scenes, Brandt often chose to represent life in the Polish eastern borderlands during the seventeenth century. The heroes of these battles, skirmishes, and flights were the exotic figures of the Lisowczyks (seventeenth-century Polish irregular cavalry), Tartars, Cossacks, the almost mythic Polish knights, and the Polish gentry. Brandt knew the borderlands well, as from his early youth he went almost yearly to the easternmost territories of the former Polish Commonwealth: the Ukraine and Podolia, the region of the Wild Fields of Zaporozhe. In addition, Brandt dealt with contemporary genre scenes from Polish country life, finding in such subjects good material for simply painting a picture. In *Encounter on a Bridge*, for example, in which a racing carriage drawn by four horses of different colors is forcing a peasant cart into a ditch, Brandt demonstrated his full artistic capabilities. People and horses are natural in their movements and behavior; the colorful scene is filled with tension and dynamism, decorative touches; and the surface of the painting manifests illusionistic effects. The painting shows the artist's familiarity with the realities of country life. The sense of motion and immediacy is acute: one can almost

hear the galloping horses as they splash through the mud. Such acoustic effects were one of Brandt's artistic aims, enhancing the realism and dynamic force of the composition and making improbable situations feel convincing.

Even a severe critic of his art, Stanisław Witkiewicz, himself a painter and theorist of naturalism, appreciated the pictorial values of Brandt's paintings: "What is Brandt's essential property is his real feeling for a harmony of colors and his understanding of what the effect of the picturesque consists in." The artist's attractive and exotic subjects, brilliant technique, and extraordinary studio proficiency earned him spectacular success. AK

SIR LAWRENCE ALMA-TADEMA

ENGLISH, 1836–1912

PORTRAIT OF
IGNACY JAN PADEREWSKI
1891

OIL ON CANVAS
17 7/8 X 23 1/4
INCHES
45.5 X 59
CENTIMETERS
WARSAW,
THE NATIONAL MUSEUM
M.OB.1850

This magnificent portrait of the young Ignacy Jan Paderewski (1860–1941) was painted by the Dutch-born artist Lawrence Alma-Tadema, who after his studies in Antwerp, Cologne, and Brussels, settled in 1870 in England, where his antique-style compositions and celebrity portraits made him popular throughout Europe. Ignacy Jan Paderewski was one of Poland's most revered native sons, admired for his brilliant musical career, his humanitarianism, and his political service as Poland's Prime Minister at the conclusion of the First World War and as a lifelong champion of Polish independence. Paderewski came to London for the first time in May 1890, when he met Alma-Tadema and the painter Edward Burne-Jones, who created his most famous likeness. This Alma-Tadema portrait, begun in July 1891, was completed in only a month. In his *Memoirs*, Paderewski described the circumstances: "At that time I often saw Alma-Tadema – he asked me to sit for a portrait…. At the very first sitting I was surprised to notice three persons set about painting! These were: Princess Louise, Sir Lawrence himself, and Lady Alma-Tadema…. At last all three portraits were finished. Lady Alma-Tadema, a talented painter, executed a tiny portrait, but Alma-Tadema's portrait in artistic terms was a real masterpiece."

The pianist gave concerts in the Alma-Tademas' home, where the portrait may have been painted. Their eldest daughter, Laurense, was a great lover of Paderewski's musical interpretation, and she also became an ardent advocate of Polish independence. *Portrait of Ignacy Jan Paderewski*, painted at the height of the musician's popularity, is one of Alma-Tadema's late academic works from the turn of the century that depict famous musicians of the Victorian and Edwardian periods. It presents Paderewski against a background composed of two colored surfaces: an orange-yellow Japanese textile and the paneling in a uniform, dark olive-green hue. The composition is based on the juxtaposition of contrasting colors and tonal values, such as the light face and white shirt set against the dark tone of the jacket. Typical of the late academic works are the blurred contours that soften the transitions from light to shadow. Alma-Tadema again used this Japanese fabric in his *Self-Portrait* of 1896 (Galleria degli Uffizi, Florence). The painter was a connoisseur and collector of Japanese art – it was already during his first visit to London in 1872 that he developed an interest in Japanese woodblock prints. In 1892 he joined the Japan Society, which aimed at the popularization of Japanese culture and art. Next to the signature on the present likeness of Paderewski are Roman numerals, with which the artist numbered his compositions; over 400 paintings by him have been identified so far. ID

WŁADYSŁAW PODKOWIŃSKI

POLISH, 1866–1895

NOWY ŚWIAT STREET
IN WARSAW
1892

OIL ON CANVAS
47 ¹/₄ × 33 ¹/₈
INCHES
120 × 84
CENTIMETERS
WARSAW,
THE NATIONAL MUSEUM
MP 340 MNW

When Władysław Podkowiński exhibited this plein-air painting in the 1892 autumn Salon of the Society for the Promotion of Fine Arts (Zachęta), he redeemed himself from the ridicule he experienced at his first exhibition of Impressionist works in Paris in 1889. Toward the very end of his life, he moved away from Impressionism to become an uncompromising champion of Symbolism.

In 1890–95 Podkowiński's atelier was in the Kossakowski Palace at 19, Nowy Świat Street, the most elegant artery of the capital with numerous churches, palaces of the aristocracy, public service buildings, and burgher houses. This was the so-called Royal Way, which linked the monarch's castle with his summer residence, the Łazienki Palace in the southern part of the city. Podkowiński painted *Nowy Świat Street in Warsaw* looking northward from the window of his study toward Krakowskie Przedmieście Street, with the towers of the Holy Cross Church in the background. Warm and cool colors suggest the natural fall of sunlight on either side of the street; the largely white composition tinted with cool pink and blues is enlivened by patches of red and green to create a vibrant, porous surface seemingly suffused with light. The oil version was preceded by at least three watercolors dated February 1892 (two in the National Museums in Cracow and Warsaw, and one lost). The existence of three variants – *Nowy Świat Street in Warsaw on a Winter Day* – different in coloring, composition, and the depiction of the figural staffage and street traffic – is unusual in Polish painting and attests to the painter's independent artistic creation, stemming from the tradition of Polish

naturalists and from the experience of French Impressionists.

Urban subjects were particularly attractive to Podkowiński, who spent many years working as a press reporter-illustrator. His Warsaw street scenes continue the tradition set by Aleksander Gierymski, and also refer to French Impressionist cityscapes featuring the new grand boulevards with their modern structures and animated street traffic glimpsed in fragments seen from above and modified by time of day, season, or gala occasions. EC

STANISŁAW WITKIEWICZ

POLISH, 1851–1915

HALNY (IN THE
TATRA MOUNTAINS)
1895

OIL ON CANVAS
36 ⁵/₈ X 55 ⁷/₈
INCHES
93.5 X 140.5
CENTIMETERS
CRACOW,
THE NATIONAL MUSEUM
MNK II-A-490

In *Halny (in the Tatra Mountains)*, a "pure," impressionistic mountainous landscape free of any staffage, Stanisław Witkiewicz subtly presented the formidable towering massif of Giewont, looming out of the mists and clouds driven by the *foehn*; trees in the snow-covered field sway under its pressure. The desolate landscape and forbidding summits impart to this realistic composition an unexpected symbolism: the brilliant golden light filtering through the clouds evokes the pantheistic visions of the Romantics. From this most famous work of Witkiewicz, the most influential Polish critic of the nineteenth century and a programmatic naturalist, there emanates, paradoxically, a suggestive, dark, and tense atmosphere that is close to Romanticism.

This Tatra nocturne seems to be a pictorial counterpart of the description of a *foehn* in Witkiewicz's novel *On the Mountain Pass*:

A huge billow of clouds swirls over Giewont, pouring with a desperate force into the dark depth of the valleys; the moon behind the flying mists flashes, vanishes, looms with light and dark; in the eddying masses of clouds torn apart, in the black-blue sky twinkle the terrified stars. The moving murk welters in the subalpine forest and, together with the shadow of the clouds, glides across the snow lying heavy in the light dimmed by the penumbrae of violet gauze. A brook shimmers somewhere in moonlight and a pair of spruces, torn by the storm, sway, struggle, incline to the ground, strain and fight in desperate impotence.

After seeing the painting in the exhibition at the Society for the Promotion of Fine Arts (Zachęta) in Warsaw in 1896, the well-known writer and critic Bolesław Prus wrote: "Witkiewicz as a landscapist gives the impression of being not a painter who goes about with paints and canvas, with a large umbrella, and who paints, but a man who in a quiet, almost soft, voice tells his friends of the extraordinary things that he has espied in nature." In turn, Kazimierz Przerwa-Tetmajer, an author of many novels devoted to the mountains, commented as follows:

When I saw his *Halny*, and I recall *On the Mountain Pass*, upon my word, I do not know whether he better writes or paints, but I do see that he does one and the other in a most remarkable manner. He has been staying here, in the mountains, for five years or so and has understood them, got into them with his feet and head as no one else has. He has torn off a chunk of the mountains and a swirl of wind and tossed them onto canvas. When you fix your eyes on it, it blusters, wails, is sultry and terrifying. The landscape is somewhat fantastic: beyond Giewont, which is the center of the composition, The Czerwone Wierchy [Red Peaks] lowered, lower than they are in reality, for better depiction of the clouds; in the foreground, on the plain covered with snow, two spruces bent by the wind, I think that actually they are not there, but they produce a magnificent effect.

Giewont, a peak in the Western Tatras that dominates Zakopane and is characteristic of its scenery, features in numerous legends. In its form has been seen the fabled "Sleeping Knight"; it was also believed that its cave harbors the sleeping knights of King Boleslaus the Bold and hidden treasures guarded by a monk. The *halny* is a strong, gusty south wind of the *foehn* type, which blows in the Tatras and in Podhale in various seasons. As is the case with Giewont, its extraordinary effects have made it a frequent subject in literature and art. AK

OLGA BOZNAŃSKA
POLISH, 1865–1940

Olga Boznańska, a uniquely individual figure in Polish painting, executed still lifes, flower compositions, occasional landscapes, interiors (usually her own atelier), but chiefly both state and intimate portraiture, including adults and children, shown singly or in groups. Boznańska worked almost exclusively in oil paint on cardboard, on a matte, ungrounded surface, applying dry pigment in small strokes. She frequently scraped the paint off with a knife, leaving large areas empty, and she never used varnish. The result of her technique was a light and vibrant surface texture in which the subject and the surrounding space merge into an integral artistic whole. Her palette was a subdued range of grays, browns, and blacks; greens, browns, and blacks; and whites, pinks, and blacks.

Boznańska worked slowly, sometimes taking a few months and several sittings to finish her portraits. Her goal was to render a truthful picture of her subject. "My pictures look magnificent because they are truth, they are honest, noble; there is no pettiness, no mannerism, no bluff in them. They are quiet and vivid, and as if a light veil separated them from the onlookers. They exist in an atmosphere of their own," she wrote in a letter of 1909. And her portraits are indeed distinguished by a masterly, keen, and precise psychological depiction of the model's personality. In the state portraits, the subjects are set in an indefinite space lit by a dim, diffused light that transports them to a spiritual level. Yet the likenesses did not flatter, but were created for connoisseurs who appreciated the exceptional pictorial values of these works.

In Munich, Boznańska painted her most famous symbolic work, *Girl with Chrysanthemums*, and created a masterpiece of Polish Modernism. She broke with the nineteenth-century convention of portraying children usually in drawing rooms, in fancy clothing, holding toys and bouquets of flowers. In this disquieting likeness, a lonely, unidentified girl wearing a steel-gray dress devoid of any trimmings stands against a silvery-gray wall, gazing intensely at the viewer. In her clasped hands she holds some pearl-white chrysanthemums. Coal-black eyes sparkle in her pale face framed by red-blond hair. The girl is no longer a child, but not yet a woman. The picture suggests the imminence of womanhood accompanied by a presage of isolation and loneliness. Boznańska, according to the Swiss critic William Ritter,

has just embodied the modern ideal of the heroine created by Maeterlinck, painting the portrait of a fair-haired pale-faced girl with strange and disquieting eyes like ink drops that seem to pour onto the transparent face. A puzzling child, driving mad those who gaze at it too long. A six-year-old Mélisande, from the aristocratic circles of some metropolis of today: this is how we perceive this sinister girl, with her paleness and whiteness that make our blood run cold.

Olga Boznańska's *Two Boys* [*Two Children on the Stairs*; *Children Sitting on the Stairs*], was formerly in one of the largest and most interesting art collections in Poland at the turn of the century. The Great Poland aristocrat Edward Aleksander Raczyński (1847–1926) acquired nearly 400 paintings, prints,

and drawings by contemporary Polish and European painters, with particular strength in Symbolist art of the period. The Polish section contained large sets of works by the outstanding artists of the time, such as Jacek Malczewski, Stanisław Wyspiański, Wojciech Weiss, and Boznańska. Raczyński purchased his largely academic European works mainly at the Paris Salons, and the Polish pieces at the exhibitions organized by the societies of art lovers active in Poland: at the Warsaw Zachęta and the Cracow Society of Friends of Fine Arts. It was in the latter society, in 1904, that he acquired *Two Boys*, exhibited in Paris in 1898 at Galerie Georges Thomas (as "Petites Filles rouges") and in 1899 at the Grosse Berliner Kunstausstellung.

Painted toward the end of the artist's stay in Munich (1886–98), *Two Boys* is her peak achievement of the period. The assertive frontality, shallow space, and setting of the figures in different but linked planes with a shift toward the viewer of the foreground figure recall the pictorial formulas in Manet's works of the 1860s and 1870s. The warm reds that play over the canvas refer also to the notable achievements in portraiture and the color mastery of the Munich painter Wilhelm Leibl. But Boznańska's mode of handling the subject is her own. The children posing in their Sunday best, adorned with hats (perhaps furnished as props by the painter), have been seated on ordinary, narrow stairs. Only their formal attitude indicates that they are engaged in the act of posing – "caught" by the painter and portrayed outside their proper context of playing or involved in some other daily activity. The viewer can discern their tension and anticipation of being released by the artist. In conveying the psychology of the moment, Boznańska broke with pictorial convention and created a work that hovers between two types of painting: a genre scene and portraiture. AK and MG

74
TWO BOYS
1898

OIL ON CARDBOARD
40 $^1/_8$ X 29 $^1/_2$
INCHES
102 X 75
CENTIMETERS
POZNAŃ,
THE NATIONAL MUSEUM/
THE RACZYŃSKI FOUNDATION
MNP FR 11

75

FERDYNAND RUSZCZYC

POLISH, 1870–1936

Ferdynand Ruszczyc's monumental symbolic landscapes are rooted in the Romantic tradition of Northern European painting, with its tendency toward the fantastic, melancholic, and mystical. Ruszczyc perceived nature through a prism of his own feelings and emotions, drawing special inspiration from his native soil and ancient family home, the manor house at Bohdanów and its immediate environs, which he also rendered in affectionate, intimate scenes and interiors.

Old Apple Trees, which features the orchard at Bohdanów, was painted in the autumn of 1900 after numerous drawn sketches and a small oil study. The theme of apple trees, in blossom or weighed down with fruit, recurred in Ruszczyc's work several times, and obsessed his imagination in autumn 1901, when he was planning a triptych entitled *Life*. He wrote in his diary for August 31, 1901:

I was sitting before an apple tree yesterday and drawing. It occurred to me that one might all year round paint studies from this single place, of only this apple tree in different lighting, during all the seasons. Imagining a long row of studies, I wanted to compress them into one … picture composed of three parts: in the center, a dark-green apple tree weighed down with highlighted green fruit…. Next to it, on one side – an apple tree in white blossom …; on the other side – a sunbeam, snow, a bare apple tree.

On September 21, he recorded: " Since the time of my *Soil* no motif has obsessed me so as the apples I paint. I see them everywhere, everything turns into apples, even the letters when I am reading." These thoughts typify the late nineteenth-century

European focus on the emotional experience of the mysteries of nature and its immutable biological rhythm from birth, to growth, to efflorescence, and to slow decay. Ruszczyc referred to this cycle by imparting symbolic meaning to the landscape motifs of the seasons, emphasizing the revival of life in spring and its transient fading at the end of the year.

The bare, dramatically distorted boughs of *Old Apple Trees* signify a sorrow-stamped tale of old age and transience. Ruszczyc transformed his study from nature into a free, subjective pictorial impression with a simple motif unmarred by superfluous details. The old, gnarled trunks and branches, carefully whitewashed by the human hand and set against a background of dark, muted colors, form aggressive, angularly intertwining linear cadences that signal a nearly morbid refinement, corresponding with the malaise in late nineteenth-century Europe. EM-B

JACEK MALCZEWSKI

POLISH, 1854–1929

POLISH HAMLET,
PORTRAIT OF
ALEKSANDER
WIELOPOLSKI
1903

OIL ON CANVAS
39 3/8 × 58 1/4
INCHES
100 × 148
CENTIMETERS
WARSAW,
THE NATIONAL MUSEUM
MP 369 MNW

The complex symbolic references in Jacek Malczewski's work come from religion, mythology, folk tradition, literature, and the artist's own imagination. During his long life, Malczewski returned to the themes defined at the outset of his artistic career, developing them into extensive cycles. One of the most important is his visionary and semi-autobiographical definition of the artist's mission, his fate, and his role in the world. This theme is present in one of his better-known portraits, *Polish Hamlet, Portrait of Aleksander Wielopolski*, whose long title evokes Shakespeare's tragic Danish prince, Hamlet, a reflective youth full of hesitation and irresolution.

Malczewski portrayed Aleksander Wielopolski (1875–1937), an amateur painter, with a bandolier full of tubes of paint and with a daisy in his hand. He is set between two monumental female figures: an elderly, strong, determined woman wearing a crown of braided straw, an oddly wrapped garment, and a military greatcoat, with manacled hands; and a young, half-naked woman covered with shreds of red cloth and a wreath of poppies, nervously shaking her fetters and displaying a defiant, but stupid, face. Completing the composition is a melancholy, familiar landscape with a road meandering through the fields to a distant village and a church with a cemetery. The interpretation of the painting suggests the hero confronted with the necessity of making a choice between moral values and, consequently, the choice of one's way of life. Malczewski portrayed Wielopolski again in 1920, entitling the portrait *Hercules at the Crossroads* (The National Museum, Kielce). Now a mature man in armor, he is again

depicted between two imaginary female figures, but they are now locked in a sisterly embrace, indicating that a choice has been made.

Adam Heydel, Malczewski's friend and biographer gave the best-known political interpretation of the *Polish Hamlet* as symbolizing the choice between two concepts of Poland: "The two allegorical figures stand for the enslaved Old Poland and the young, revolutionary Poland, shaking her fetters....[Wielopolski] fails to see the drama. He is playing with a daisy." This notion has been expanded in the literature, with various interpretations for each work as well as for both portraits of Wielopolski read together. The dilemma of having to choose between his service to art and to the people and country of Poland was near to the artist's own heart and suggests that the portrait of Wielopolski as Hamlet depicts the painter himself in disguise. E-CH

JÓZEF MEHOFFER
POLISH, 1868–1946

STRANGE GARDEN
1903

OIL ON CANVAS

85 1/2 x 81 7/8
INCHES

217 x 208
CENTIMETERS

WARSAW,
THE NATIONAL MUSEUM

MP 365 MNW

The dramatic conflicts and existential anxieties of art at the turn of the century were alien to Józef Mehoffer, a sophisticated aesthete. His paintings radiate his affirmative attitude toward the world and his fascination with the beauty of nature and people and the objects of their everyday lives. His idea of the joy of living found perhaps its finest expression in the painting *Strange Garden* (originally also called *Sun* or *In the Sun*). Against a background of a lush, green orchard, Mehoffer depicted his wife, young son, and the boy's peasant nanny. The "strangeness" of the garden is evoked by the decorative garlands that stretch across the trees and by a huge golden dragonfly hovering in the air above the women's heads.

The naked, sunlit boy in the foreground focuses the viewer's attention. He has often been interpreted as a symbol of the innocence of childhood or as the image of Cupid. The figures of the nanny and the artist's wife repeat almost the same gesture, yet they belong to two different worlds. Dressed in a folk costume and merged into the landscape, the girl seems to symbolize the bond between man and nature. The elegant Jadwiga Mehoffer, shown in a smart sapphire-blue dress, captivates through the charm of her pose and gesture, perfectly corresponding with the poetic, enigmatic aura of the "strange" garden. Enhancing the dominating human figures is a landscape important in its own right. A garden path creates the impression of perspectival depth and framing elements suggest an enclosed, snug space devoid of horizon line and sky – a safe home idyll.

The puzzling, gigantic dragonfly resembles a decorative ornament applied to the surface of the painting. A dragonfly, with its fragile, delicate body and iridescent wings, was a favorite motif in Secession art, frequently serving as an embodiment of everything that was transient, ephemeral, and variable. The dragonfly soaring over the "strange" garden consequently has sometimes been interpreted as a sinister symbol of the transitoriness of paradise. However, this view contradicts that of the artist, who defined the golden dragonfly as a symbol of the sun.

The painting is a typical example of Mehoffer's art, combining symbolic content with ornamental stylization. The first sketches for the composition were executed during a family holiday at Sielec in 1902. Mehoffer then painted an oil sketch of the picture lacking the enigmatic dragonfly and floral festoons, and a few studies of his wife against the orchard greenery. In the late autumn of 1902, *Strange Garden* was included in the exhibition of the Vienna Secession, and early in 1903 the artist repainted some parts of the canvas. EM-B

WOJCIECH W. KOWALSKI

{ *WAR AND RESTITUTION* }

THE DIFFICULT HISTORY AND PRESENT SITUATION of Polish art collections cannot be correctly understood without making clear right from the beginning that the process of establishing public museums in Poland differed greatly from Western European models. In the spirit of the time, Poland's last king, Stanislaus Augustus Poniatowski, who reigned from 1764 to 1795, had intended to transform his rich collections into a *Musaeum Polonicum*, open to the public. The plan was thwarted, however, when Poland lost its independence. The country's new foreign rulers, Russia in the East, Prussia in the West, and Austria in the Southern Polish lands, were not interested in founding public museums and determinedly impeded any such initiatives. In Warsaw, for example, the Russian authorities, after suppressing the Uprising of 1831, dissolved the Museum of the Warsaw Society of Friends of Sciences and the Museum of the University of Warsaw.

The lack of nationally sponsored museums in nineteenth-century Poland was filled in part by private museums, such as that of Izabela Czartoryska at Puławy (1809–31) and the Działyński family at Kórnik (1845–60). These small private institutions were, however, also viewed with disfavor by the political authorities and as a consequence were relatively short lived. Because of this situation, the first fully public Polish National Museum (Polenmuseum) was actually set up outside of the country by a group of Polish émigrés, in 1870, in Rapperswil, Switzerland. It was not until 1883 that the first National Museum would be founded on Polish soil, in Cracow, where the Austrian authorities' liberal policy was more predisposed to this kind of initiative.

The difficulties in establishing public museums were considerably heightened because of the scope of cultural losses that had resulted from the mass confiscation by Russians of artworks and libraries belonging to Polish nobles who had supported Napoleon and later uprisings against Russia. It is sufficient perhaps to mention that after 1812, the renowned gallery of the Radziwiłł family, consisting of around 2,000 portraits, and the whole of their treasury and armory from their castle in Nieśwież were removed to Moscow and St. Petersburg. Following the Uprising of 1831, the Russians confiscated several Warsaw collections, including paintings and sculptures from The Royal Castle and about 25,000 coins, all given later by Tsar Nicolas I to the Hermitage and the Academy of Fine Arts in St. Petersburg and to the Kremlin's Treasury in Moscow. In Polish lands under the Prussian regime, similar results were seen as the special policy called "Kulturkampf" was put into effect in order to Germanize these lands.

The First World War brought to Poland on the one hand a chance to regain independence, but on the other hand it brought further cultural losses. Due to the country's

geographical location, Poland suffered movements of various armies in almost all possible directions. Several palaces, but also entire towns, such as Kalisz, with their artistic contents, were razed, and their collections stolen or dispersed.[1] In light of the situation, it was not surprising that after the war and almost 150 years of foreign rule, the newly established Polish government tried to reclaim as many objects as possible from its lost cultural heritage. The scope of losses and corresponding expectations of restoration are well illustrated in the claim submitted to the 1919 Paris Conference negotiating a peace treaty with Germany, which indirectly revealed the extent of cultural cleansing administered by Prussia to the transferred territories during their extensive and planned Germanization. Poland insisted that:

> Germany shall likewise restore to Poland all libraries, museum collections, and all objects of art, science and religion, as well as historical relics, which for any reason whatsoever have been sequestrated, confiscated, taken away, or exported into Germany, either by public, civil, or military officials of Germany, or by private persons, nationals of Germany, from any territory of Poland at any date whatsoever, even if said objects have been made part of public or private collections located today in Germany. This obligation applies not only to property of the former Republic of Poland, but also to that of the Polish Crown, of public, religious, communal, scientific, and artistic institutions, as well as of private owners....[2]

For political reasons, these claims could not be incorporated into the Versailles Peace Treaty, so special bilateral negotiations were initiated between Poland and Germany which, in themselves, did not yield positive results. Although as a legal matter Germany was obliged to "deliver to the Polish Government all acts, documents, monuments, works of art {FIG 1} and other scientific or library materials which had been removed from the lands conveyed to Poland,"[3] in the absence of detailed documentation of these removals the only actual attempt that was made involved the so-called *Raczyński Madonna* by Sandro Botticelli. Even in this case, the negotiations were unsuccessful and the painting remained in Berlin, with Poland granted only purely formal supervision of it.

Negotiations with Austria and Hungary, the successors to the former Austro-Hungarian Empire, had similar results. Discussions of restitution and repatriation

1 See, for example, Tadeusz Szydłowski, *Ruiny Polski: opis szkód wyrządzonych przez wojnę w dziedzinie zabytków sztuki na ziemiach Małopolski i Rusi Czerwonej* (Warsaw: Gebethner and Wolff, 1919).

2 For the full text, see Philip Burnett, *Reparations at the Paris Peace Conference from the Standpoint of the American Delegation* (New York: Columbia University Press, 1940), vol. I, doc. 257, pp. 886–87.

3 Polish-German Financial Agreements, in *Rokowania polsko-niemieckie* (Warsaw: Ministry of Foreign Affairs, 1925), January 9, 1920, article VI.

began in an encouraging fashion. Certain provisions of the two relevant peace treaties clearly stipulated that both states had to return the works of art, books, documents, etc., "which had been taken away from the renounced territories since June 1, 1914, excluding the objects purchased from private owners" (St. Germain Treaty, article 192, and Trianon Treaty, article 176). Another provision regulated the repatriation of cultural property tied to the seized territory, if the objects in question had been removed from that territory during the stipulated time before the war. Further stipulations were aimed at reconstructing the national cultural heritage of chosen states by returning cultural property exclusively in the possession of Austria, provided that the property had been illegally removed from the claimant states, with no specified time limit whatsoever.

Although Poland was among the states entitled to advance claims pursuant to these provisions, its claim was relatively modest because once again it was not possible to

FIG I
Lorenzo di Credi, *The Adoration of the Child*, ca. 1520, tempera on wood panel, formerly Poznań, The Poznań Society of the Friends of the Sciences, the Mielżyńskis' Museum.

complete the required documentation of property that had been transferred to Austria and Hungary in the past. The claim focused on one object only – a gold bowl that had belonged to King Ladislas IV Vasa – which in fact was finally not repatriated.[4]

The furthest-reaching grounds for the reconstruction of the integrity of its cultural heritage after the First World War were laid down in another treaty that Poland drew up with Russia and Ukraine. It covered the property "evacuated" to Russia and Ukraine in a "voluntary or compulsory manner" for the period beginning with the outbreak of the war to the end of 1920 (article XI, items 9 and 10). It also regulated repatriation of the entire cultural heritage that had been displaced from the old territories of Poland to Russia since January 1, 1772. Such extensive repatriation included even war trophies, excluding the trophies of the 1920 Polish-Russian War, and all other "cultural heritage" objects. This repatriation was to be executed "irrespective of the circumstances or regulations issued by the relevant authorities, under which the said objects had been displaced, as well as notwithstanding their original or ensuing owners, including both judicial and physical persons" (article XI, item 1).

In their extent and severity, these requirements had no precedent. The basic criterion determining the restitution and repatriation was the principle of territoriality. Theoretically speaking, all items of the cultural heritage removed from historically Polish lands were subject to repatriation. However, the achievement of such advantageous legal grounds for repatriation did not automatically entail their practical execution. The negotiations concerning the return of certain objects lasted more than ten years and were extremely difficult. The relevant documentation just for 1921–23, comprised mainly of lists of objects, memos, and claims submitted before the Soviet authorities, filled seven volumes.[5]

Finally, several hundred important works of art were returned to Poland, including the sculpture of Prince Poniatowski by Bertel Thorwaldsen which had been taken from Warsaw; part of the Załuski Library and Warsaw University Library; the Flemish tapestry collection removed from The Wawel Royal Castle in Cracow; and the Holy Spirit Decoration Insignia, which had been granted by Pope Innocent XI and the French King Louis XIV to King John III Sobieski after his victory against the Turks at Vienna in 1683. Nevertheless, the repossessed objects constituted only a small portion of the total confiscation and plunder carried out by the Russians. Administrative and formal obstructions resulted in the settlement of only thirty-two of the eighty claims that Poland managed to substantiate and submit before the Joint Special Commission.[6]

The above-mentioned facts make clear that Polish museums could begin to develop freely only after Poland regained independence after the First World War. But at that point the country was too devastated to make up for lost time and catch up with major European museums that had been developing successfully throughout the entire nineteenth century. Nevertheless, owing to the commitment of the authorities of the reinstalled state, and, above all, to the patriotic efforts of a generous society that contributed bequests, gifts, and loans from the best private collections, a basic network of nationally organized museums was established between the two world wars.

This strong period of growth and internal organization for Polish museums was, however, very brief, lasting only for twenty years until the outbreak of the Second World War. After the German military campaign of 1939 ended, the invaded Polish territory was formally divided by the Nazis into the so-called "Incorporated Eastern Territories," which was declared a part of the Third Reich, and other lands referred to as "General Gouvernement." This latter territory did not include the eastern part of Poland, invaded by the Red Army after September 17, 1939, and later incorporated within the Soviet Union pursuant to the Ribbentrop-Molotov Treaty.

These separate authorities took control over all of the occupied Republic of Poland, each adopting its own "cultural policies." Using in their legal arguments euphemisms such as "safekeeping" or "secure" in relation to cultural property, these policies in practical terms were aimed at the total robbery and destruction of Polish and Polish-Jewish

4 The story was never closed, as political situations before the next World War made further negotiations impossible. For example, in the case of a piece of armor given by Austria to Hungary as having belonged to King Ludwig II, it was discovered several years after the transfer to have been made in 1533 in Innsbruck for "a young king of Poland." Eminent armor expert Bruno Thomas found this information in correspondence belonging to Ferdinand I, who later became emperor and who had ordered the armor on the occasion of his daughter Elisabetha's engagement to Sigismundus II, king of Poland, who was only thirteen at that time. The monogram "SE" inscribed on the armor was initially interpreted as an acronym for "Sancta Elisabetha," the patron saint of Hungary, but it is now clear that these initials stand for Sigismundus – Elisabetha – the names of the engaged couple. See Bruno Thomas, "Der Knabenharnisch Jörg Seusenhofers für Sigmund II August von Polen." *Zeitschrift des deutschen Vereins für Kunstwissenschaft* 6, 4 (Berlin: Deutscher Verein fur Kunstwissenschaft, 1939), p. 1,184. Despite these disclosures, the armor is still exhibited in the Budapest National Museum as Ludwig II's armor.

5 *Dokumenty dotyczàce akcji Delegacyj Polskich w Komisjach Mieszanych Reewakuacyjnej i Specjalnej w Moskwie*, vols. 1–7 (Warsaw, 1922–23),

6 The reasons negotiations were so ineffective are revealed in the official but confidential report found in the Moscow archives. The report, made by Piotr Wojkov, chief of the Russian Delegation, exposes the Russian efforts undertaken to boycott and minimize the repatriation. For example, as far as the restitution of the archival materials was concerned, Wojkov stated: "finally, from the archives to be repatriated we eradicate all the information that would make it possible for Poland to submit any pecuniary or material claims against us. Such activities, which we used to call 'sterilization of archives,' go on irrespective of the agreements signed with Poland. The work is really hard and difficult and it creates obstacles in the dispatch of the said archives. But it cannot be done otherwise, without the signature of the Peoples' Financial Commissar, the archives are not made available to the Poles." After this report was unofficially obtained from the Moscow archives, it was published in its full form. See Jerzy Kumaniecki, *Tajny raport Wojkowa, czyli radziecka taktyka zwrotu polskiego mienia gospodarczego i kulturalnego po pokoju ryskim* (Warsaw: Gryf, 1991), p. 171.

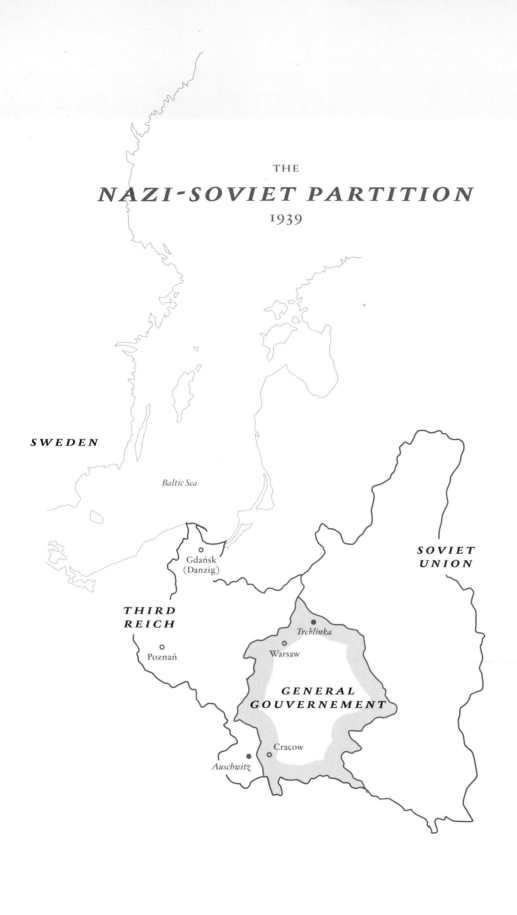

THE
NAZI-SOVIET PARTITION
1939

The shaded line indicates the General Gouvernement (Poland) as it existed in 1939. The black line indicates the border of the Second Republic of Poland (1918–39).

The shaded line indicates the area segregated for the Polish population, but under German control. Treblinka and Auschwitz were two of several major concentration camps in Poland.

MI 100

KM 100

SWEDEN

Baltic Sea

SOVIET UNION

Gdańsk
(Danzig)

THIRD REICH

Poznań

Treblinka

Warsaw

GENERAL GOUVERNEMENT

Cracow

Auschwitz

Black Sea

cultural heritage.[7] These policies were already in place by the end of 1939 or early 1940 and in general were concentrated on seizing property belonging to the Polish state and the personal property of former Polish subjects. Another body of law organized the modes of dealing with confiscated goods that were managed by a special agency called the High Trustee Office East (*Haupttreuhandstelle Ost* [HTO]), established by Reichsmarshal Hermann Goering especially for this purpose. This essay is not the place to discuss these regulations in detail,[8] but the scale of the robbery is made clear in Heinrich Himmler's instructions. Acting as Reich Commissoner for the Strengthening of Germanism, and also as Reichsführer SS and a chief of the German Police, he ordered the police immediately to fulfill the following:

In order to fortify Germanism and the defense of the Reich confiscation is ordered...of all objects mentioned in point II of this order on confiscation found in the territories which have...become a component part of the Reich, as well as those found in the General Gouvernement....Most particularly, subject to confiscation are all objects mentioned in point II found in archives, museums, public collections and in Polish or Jewish possession, but whose security and appropriate treatment lies in German interest.

II. 1. Objects of historical and prehistoric provenance, records, books, documents important for research on the history of civilisation and public life, and those particularly relevant to the question of German contribution to the historic, cultural and economic development of the country as well as documents of importance to current history.

2. Objects of artistic, cultural and historic value, such as paintings, sculptures, furniture, rugs, crystal pieces, books, etc.

3. Objects of interior decoration and objects of precious metals....

5. Weapons, costumes, musical instruments, coins, postage stamps and similar collections....[9]

The confiscated objects regarded by the Nazis as valuable were given to museums in Germany, whereas other works of art were subject to sale. This arrangement was

7 The first account of this policy is given in *The Nazi Kultur in Poland by Several Authors of Necessity Temporarily Anonymous* (London: Published for the Polish Ministry of Information by Her Majesty's Stationery Office, 1945).

8 For the complete "legal basis" of cultural cleansing in occupied Poland, see Wojciech W. Kowalski, "The Machinery of Nazi Art Looting. The Nazi Law on the Confiscation of Cultural Property – Poland: A Case Study," *Art, Antiquity and Law* 5, 3 (2001), also published in John K. Roth and Elisabeth Maxwell-Meynard, eds., *Remembering for the Future: The Holocaust in an Age of Genocide* (Houndmills, England: Palgrave, 2001).

9 Document dated Berlin, December 16, 1939, including HTO instructions of December 1 and December 5, 1939. For more details, see Wojciech W. Kowalski, *Liquidation of the Effects of World War II in the Area of Culture* (Warsaw: Polski Instytut Kultury, 1994), pp. 19ff.

explained by Heinrich Himmler in a letter dated July 9, 1940, forwarded to HTO's head-quarters:

Basically, I agree that the term "cultural good" should not be defined too broadly. But we must be careful to avoid the situation, that objects of folk art and historical value be excluded only because they bring no profit from their sale. We have learned from experience that the following two points must be considered:

1. Identified as cultural goods must be objects that, regardless of their commercial value, have a cultural and historical importance that constitute a historical document and that have some relation to historical events.

2. Of concern also is appropriate care of objects that bring a profit when sold. That is why it has been resolved that, regardless of whether they are of artistic quality and whether they do or do not possess a cultural and historical value, all objects of gold and silver should be delivered to the General Trustee so they could be quickly turned into cash.

As to dealing with other objects, such as paintings of no artistic value, furniture and generally objects that should be regarded as objects of daily use, HTO or its depots shall sell them on site.[10]

Enjoying such broad powers, HTO was an incredibly successful organization. The extent of the confiscation it carried out may be inferred from the abundant documents that record its operation, many of which were published after the war. A telling example is a passage from one of the reports of the General Trustee for Securing German Cultural Material in the Incorporated Eastern Territories that related to his activity up to early 1941:

5. Results already achieved:

Cultural goods were found in: 74 castles, 96 manor-houses and a major number of flats. There were in total 500 castles, manor-houses and flats searched.

There were chosen and secured: 102 libraries, 15 museums, 3 galleries of paint-ings, 8 collections of weapons, 10 collections of coins, 1 collection of Egyptian antiquities, 1 collection of antique vases, 1 ethnographic collection, 21 various private collections (folk art, porcelain, horns, etc.), 1100 paintings and watercolors, some hun-dreds of prints, 25 statues, 500 pieces of furniture, 33 chests with religious objects (not yet opened), some hundred of rugs and carpets, of which only 3 to 5 are of museum value

10 This document, dated Berlin, July 9, 1940, was issued when the HTO branch in Poznań asked for permission to define "cultural good" more narrowly because they had prob-lems with the management of too many objects already confiscated. Kowalski (note 9), p. 20.

FIG 2

Official form showing the confiscation
of Czartoryski Museum treasures for
their safekeeping. The pencil markings
on the left were added after the war and
indicate whether a particular painting
was "returned" or "not returned."

Blatt 35 Zweitschrift.

 Auf Grund der Verordnung des Herrn Generalgouverneurs über
die Sicherstellung von Kunstwerken im besetzten Gebiet des ehemali-
gen Polen vom 16.12.1939 und der dazu erlassenen Durchführungsbe-
stimmungen werden die unten näher bezeichneten Gegenstände sicher-
gestellt und von dem dazu Bevollmächtigten übernommen.

Ort:) K r a k a u nähere Bezeichnung: Czartoryski-Museum

	Gegenstand	kurze Beschreibung	Material
1.	Tafelbild	Verkündigung Mariä. Von Dirck Bouts, um 1470. 48 x 33.	Öl auf Holz Nr.: Inv. V. 114, Kat. 12.
2.	Tafelbild	Maria mit dem Kind. Niederländischer Meister. Anfang 16. Jhdt. 22,5 x 18.	Öl auf Holz Nr.: Inv. V. 115, Kat. 112.
3.	Gemälde	Hereinbrechendes Gewitter. Von Rembrandt. 1638. 46,5 x 66.	Öl auf Holz Nr.: Inv. V. 105, Kat. 155.
4.	Gemälde	Bildnis der Cäcilie Gallerani. Von Leonardo da Vinci. Um 1483. 53,4 x 39,3.	Öl auf [Leinen] Holz Nr.: Inv. V. 180, Kat. 98.
5.	Tafelbild	Maria mit Kind. Von Neroccio di Bartolomeo dei Landi. 52 x 35.	Tempera auf Holz Nr.: Inv. V. 158, Kat. 120.
6.	Gemälde	Bildnis eines jungen Mannes. Von Raffael Santi. 75 x 59.	Öl auf Holz Nr.: Inv. V. 239, Kat. 154.
7.	Tafelbild	Weibliche Heilige mit Buch. Französisch-niederländischer Meister. 2. Hälfte 15. Jhdt. 32,7 x 24,6.	Tempera auf Holz Nr.: Inv. V. 331, Kat. 125.

 Krakau , den 12. IX. 40

ZARZĄD MUZEUM
KSIĄŻĄT CZARTORYSKICH
W KRAKOWIE

and can be recognised as cultural goods, 25 major shipments of precious metals, which have arrived separately or in groups. Apart from jewellery, there was 1 particular object noted as cultural good – Irish golden box of 1760.

There were also chosen and secured numerous other objects of artistic craftsmanship, porcelain, glass, weapon, and alike. The exact numbers will be reported after cultural goods are separated from other objects.[11]

The above description of the machinery of looting would not be complete without a short quotation from the regulation issued especially for that part of occupied Poland called the General Gouvernement. This regulation was devoted specifically to the confiscation of private cultural property, and the main objective of Nazi policy was openly declared in the first paragraph: "Public possession of the works of art in the General Gouvernement is hereby confiscated for the sake of public benefit and use...."[12] Although this provision referred only to "public possession," one should not be misled by this term. As the next paragraph made clear, it covered a very wide range of objects, including: "1. Private collections of works of art....2. The works of art in the exclusive

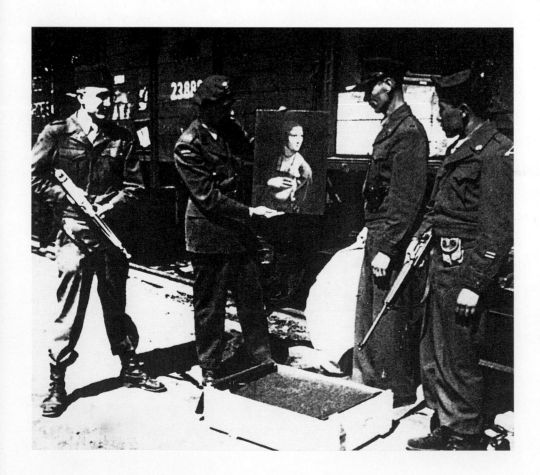

FIG 3
Polish monuments officer Karol Estreicher holding Leonardo da Vinci's *Lady with an Ermine* upon its return to Poland in May 1945.

possession of the Church, except for the property needed for everyday liturgy." All persons who failed to meet these obligations were treated like criminals and subject to imprisonment.

As can be seen from this description of Nazi "law-making" in occupied Poland, in practical terms this "legal framework" paved the way for confiscation of the entire cultural heritage of the occupied Polish territory. S. Lane Faison, Jr., accurately summarized the situation in 1945 in his carefully prepared investigative report for the United States Army: "In Poland, the Germans followed the policy that all works of art (church property, state museums, and private property) were available for confiscation, and that the Poles should keep nothing."[13]

The report also noted that the Germans had a special interest in Leonardo's *Lady with an Ermine (Portrait of Cecilia Gallerani)*, Raphael's *Portrait of a Young Man,* and Rembrandt's *Landscape with the Good Samaritan* from the Czartoryski Museum, as well as other masterpieces from Cracow. In fact, the war history of these three paintings provides typical examples of the fate of artworks in occupied Poland. Just before the war, in August 1939, all three works were hidden in Sieniawa in one of the Czartoryski family palaces. However, they were soon discovered by German soldiers, confiscated, and transported to the Kaiser-Friedrich-Museum in Berlin. After the final organization of the General Gouvernement, the governor, Dr. Hans Frank, arranged the return of the paintings to Cracow as decoration for his residence in The Wawel Royal Castle. Seizing this opportunity, on September 12, 1940, the Czartoryski Museum curator managed to get an official receipt for them as taken for "safekeeping." The subsequent history of these paintings is not completely clear. They probably were taken by Hans Frank to Bavaria as his personal "spoils of war"; the Leonardo and the Rembrandt were found in 1945 in his villa in Schliersee. They were returned to Poland early the following year together with the Veit Stoss altarpiece looted from the church of St. Mary in Cracow and found in Nuremberg. Unfortunately, Raphael's *Portrait of a Young Man* is still missing and remains today Poland's most valuable and eagerly sought masterpiece lost during the war.

It was obviously not an easy task after the war to try to reverse the consequences of such mass confiscation. Restitution of works of art looted during the Second World War

11 Werner Röhr, ed., *Die faschistische Okkupationspolitik in Polen (1939–1945)* (Berlin: VEB Deutscher Verlag der Wissenschaften, 1989), p. 197.

12 Regulation dated December 16, 1939. For the English text, see Wojciech W. Kowalski, *Art Treasures and War. A Study on the Restitution of Looted Cultural Property, pursuant to Public International Law* (Leicester, England: Institute of Art and Law, 1998), p. 91.

13 S. Lane Faison, Jr., Strategic Services Unit. War Department. Art. Looting Investigation Unit APO 413, U.S. Army, *Consolidated Interrogation Report No. 4,* December 15, 1945, pp. 5, 6.

constituted the most complex and difficult task of this kind ever undertaken {*FIGS 4–7*}. Apart from the necessity of solving purely technical problems in relation to the search for cultural material looted from all over Europe, the identification and recovery of such a huge number of highly valued objects required a legal framework of international scope.

The first successful international step towards the creation of this framework was the Inter Allied Declaration of January 5, 1943, against Acts of Dispossession Committed in Territories under Enemy Occupation or Control.[14] The Allied Nations declared their intention: "to do their utmost to defeat the methods of dispossession practised by the governments with which they were at war against countries and peoples who have been so wantonly assaulted and despoiled." To achieve this effect, they reserved "all their rights to declare invalid any transfers of, or dealing with, property, rights and interests situated in the territories which have come under the occupation or control, direct or indirect," of the enemy, "or belonged, or have belonged, to persons, including juridical persons, residents in such territories." The declaration referred to every form of transfer of property, irrespective of "whether such transfers or dealings have taken the form of open looting or plunder, or of transactions apparently legal in form, even when they purport to be voluntarily effected." After the war the Allies tried to put into practice the declared objectives, which proved, however, to be quite complicated because they had to reconcile them with various other interests.

Attempts at restitution achieved their best results just shortly after the war. Later, during the Cold War, restitution attempts were for all practical purposes blocked, as can be seen in the case of so-called restitution-in-kind. The Control Council for Germany officially adopted this policy in 1946 as a method of replacing goods of unique character whose restitution was impossible. For various reasons, however, mainly political, this form of restitution has never been implemented, and has had no tangible effect on the restitution of cultural losses sustained during the war.[15]

Despite the clearly established objectives of restitution, it has not been easy to realize them. As the Nazi documents themselves reveal, many objects were sold on the

14 For the text of the declaration, see Kowalski (note 12), p. 93.

15 For more details on the restitution-in-kind, see ibid., pp. 70ff.

16 The 1998 catalogue of Poland's lost paintings gives more precise data referring only to 442 pictures, while the office responsible for the work on this catalogue gathered more general and often only fragmentary information on about 4,600 lost paintings. It is generally acknowledged that even the second number does not reflect real losses. Anna Tyczyńska and Krystyna Znojewska, *Wartime Losses. Polish Painting. Oil Paintings, Pastels, Watercolours, Lost between 1939–1945 within Post-1945 Borders of Poland* (Poznań: Ministerstwo Kultury i Sztuki. Biuro Pełnomocnika Rządu do Spraw Polskiego Dziedzictwa Kulturalnego za Granicà, 1998).

market; others, for example, made of silver, were often melted down. The main problem both after the war and still today is the lack of proper documentation. Acting in 1991–94 as a Government of Poland Commissioner for Cultural Property Abroad, this author tried again, and possibly for the last time, to collect information from various institutions, museums, etc., as well as private collectors on losses sustained during the Nazi occupation of Poland. The results of these efforts were not very promising. The current number of around 60,000 known losses of artworks does not match the real magnitude of devastation.[16]

FIG 4
Sculpture removed from many nations awaits identification and repatriation at the Munich collecting point.

FIG 5
A fragment of the artworks returned from Germany, stored temporarily in the atrium of The National Museum, Warsaw.

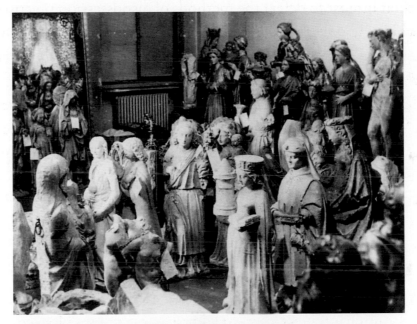

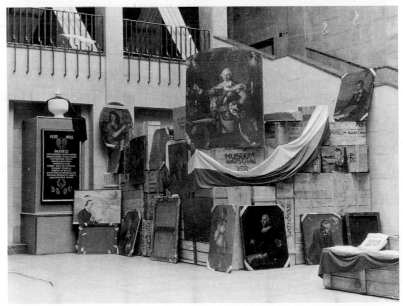

It must be remembered, for example, that this number was calculated on the postwar configuration of Poland, which had lost one third of its eastern territory with all its cultural heritage to the neighboring Soviet republics of Lithuania, Belarus, and the Ukraine.

The end of the Second World War did not bring an end to the problems of Poland's museums. In addition to the enormous robbery and devastation they confronted during the war, the museums in Poland now face an onslaught of claims of ownership for works that entered their collections as a direct result of the Nazi occupation and the postwar political changes. Today, over half a century later, many cultural artifacts currently on display in museums have disputed or unsubstantiated claims of ownership of a wide variety.

Numerous objects ended up in museums as a direct result of the Nazi occupation. This is an extremely diversified group of works that includes items abandoned by

FIG 6
A group of Polish soldiers participating in the return of looted artworks, in front of The National Museum in Warsaw.

FIG 7
Professor Stanisław Lorentz, director of The National Museum in Warsaw, watching the unpacking of an Antique vase looted by the Germans from the Gołuchów Collection and restituted in 1956 from the Soviet Union.

the Germans or found in vacated offices formerly used by the occupying authorities. They are probably stolen objects that could not be evacuated because of lack of time. For the most part, their origins have proven impossible to trace. Occasionally a possible provenance can be inferred from an object's unique character, as in the case of typical synagogue objects, or from documents found accidentally in a drawer of a piece of antique furniture, as happened in The National Museum in Cracow.

Other objects fall into the category of prewar, wartime, and postwar deposits. With the threat of war coming ever closer, the depositing, or loan, of works to museums began before its actual outbreak and continued under Nazi occupation. In this case, objects were deposited first and foremost to save them from loss or destruction, in the belief that in contrast to remote country residences and churches, museums in major cities, such as The National Museum in Warsaw, would be relatively safe.[17] Once the occupier's true intentions and policy were realized, these deposits, like other valuable objects, had to be hidden among the mass of assets making up museum collections. The most common and effective way to conceal such objects was to falsify the records of their origins and even their descriptions.[18]

This strategy of concealment was severely hampered in several well-known instances when German officials and art historians showed up at The National Museum in Warsaw and demanded objects that had been documented on professional "lists" made before the war. Such "visits" were paid, among others, by the renowned art historian Professor Dagobert Frey, from the University of Breslau, and Hans Pose, director of the Dresden Gallery.[19] Under such circumstances, Cracow's National Museum completely abandoned its deposit register as early as October 1939. Objects placed on loan to The National Museum in Cracow after that date appear in the museum's register without any indication whatsoever of the owner's identity.

This category also includes objects "deposited" under duress. The Nazi authorities created a special regulation that applied to objects of an exceptional nature that could not be officially "confiscated" because of their owners' international, mostly aristocratic, connections. In these cases, objects were deposited in their owners' presence and certain procedures were followed; however, the very fact that their deposit was mandatory compels us to classify them as simple confiscation.

17 Lynn H. Nicholas, *The Rape of Europa: The Fate of Europe's Treasures in the Third Reich and the Second World War* (New York: A. Knopf, 1994), p. 58.

18 Stanisław Lorentz, "Muzeum Narodowe w Warszawie w latach 1939–1945" *Rocznik Muzeum Narodowego w Warszawie* (Warsaw: The National Museum, 1957), vol. 2, p. 9.

19 Ibid., p. 17.

The last group, the postwar deposits, involves the objects that during the Nazi occupation were placed by private individuals for safekeeping in ecclesiastical institutions and subsequently were acquired as a result of nationalization after the war and handed over to museums. This last group should be enlarged to include cultural objects transferred to museums from palaces and country manors as a result of the postwar political changes. These holdings, substantial both in quantity and quality, often referred to as "former manor property," were incorporated into museum collections under special land reform (nationalization) regulations.[20] This category of cultural property includes objects confiscated under court sentences passed between 1944 and 1956 for political activity relating to "an independent existence of the Polish State." These sentences were declared null and void at the beginning of political changes in 1989–90.[21]

In light of the above complexities, what is the current policy of museums in Poland? On the one hand they are obligated to respect the right of ownership, while on the other hand they must also do their best to retain the most important objects within the public domain. Consequently, museums are resolved to make restitution of the objects owned by particular persons, provided that the ownership has been established beyond any doubt. While guided by this principle, they must seek, nevertheless, to keep the centerpieces of their collections. This has been and continues to be accomplished, first and foremost, by offering to purchase such objects, or by requesting their donation. Mindful of the difficult history of Polish museums and their wartime devastation, owners claiming restitution, or their heirs, are quite often agreeable to such proposals. This has been the case with both deposited objects and postwar acquisitions resulting from the land reform.

The issue of deposits would seem, by definition, to be the simplest, yet in practice a number of these cases have aroused serious questions. The greatest obstacle to the restitution of wartime deposits are the gaps in documentation that make it impossible to establish actual title beyond any doubt. The intentional falsification of museum records for the purpose of concealment only adds further to the level of complexity. This is frequently true for both the person interested in recovering an object and for the museum. It should be pointed out that a considerable number of gifts of wartime deposits have been made to museums around Poland as a token of gratitude for having safeguarded objects from the vicissitudes of war.

As for those objects acquired by the Communist Security Service as a result of nationalization under the land reform, which are numerous in some museums, a rather

straightforward program has been adopted by several museum officials to resolve the problems of restitution. The objects have been divided into three categories: "A," "B," and "C." Category "A" is composed of works of art of supreme artistic and historical value, essential for preserving the integrity of a museum's collection and crucial to its importance as an institution. Category "B" includes objects of study that complement gallery collections and are used in exhibitions, often of a negligible market value, yet important for documentation purposes, such as architectural plans, etc. Category "C" involves items of little value to the museum, though often of considerable market value. Obviously, the museums' principal efforts are to acquire the ownership of category "A" objects, and secondly of category "B" objects; category "C" items are as a rule earmarked for restitution.

The magnitude of the problems facing Poland's museums as a result of war-related issues requires an ongoing effort. However, there is a shared general belief within the museum community that serving justice will help rather than obstruct the fulfillment of their cultural mission.

20 Works of art found in palaces and manor houses were nationalized under "The Regulation of the Minister of Agriculture and Land Reforms of 1 March 1945, on the Execution of Land Reform," *Journal of Laws 1945*, number 10, item 51.

21 See "Act of February 23, 1991 on the Declaration as Null and Void of Sentences for activity for an Independent Existence of Polish State," *Journal of Laws 1991*, number 34, item 149.

ANDRZEJ ROTTERMUND

A HISTORY

of

IMPERMANENCE

DURING THE NAZI OCCUPATION OF 1939–45, all museums in Poland were closed down. Numerous museum buildings were destroyed and many others, after their collections had been taken to the Third Reich, were used as makeshift offices by the Nazi invaders. The collections of learned and social organizations as well as most private collections were likewise annihilated or confiscated.

The history of Polish museums during World War II and the Nazi occupation may be divided into two stages. The first stage covers the period of preparations for the approaching cataclysm and the first weeks of the war, shortly before the successive invasions of Polish territory. This was a heroic period for museum staff in Poland, who, frequently aided by people from the community, packed, transported, and hid the most valuable parts of the collections. Thanks to them a great many works of art were saved, among them the royal tapestry collection from The Wawel Royal Castle in Cracow, which was evacuated abroad, and some priceless historical relics such as "Szczerbiec," the coronation sword of the Polish kings. These objects were finally returned to Poland from Canada in 1961.

The second stage is the actual period of German occupation, when the Nazis methodically searched out the hidden museum objects and carried them off to the Third Reich. This activity usually took place under the direction of a highly qualified cadre of German and Austrian art historians and conservators, under the general supervision of the Secretary of State for Art, Dr. Kajetan Mühlmann {*FIG 1*}. The Germans looted not only museum collections, but also works of art deposited in museums for safekeeping by private collectors. In The National Museum in Warsaw alone, depositors who had entrusted their collections to it numbered several hundred.

One of the many consequences of World War II was the enormous losses suffered by Polish museums and private collections. Notwithstanding the postwar restitution campaign, it was not and will never be possible to repair those losses. The most extensive ravages were wrought in Warsaw {*FIGS 2 AND 3*}. In the capital The Royal Castle was razed to the ground: Łazienki Palace (once a summer residence of King Stanislaus Augustus) was gutted; and the remaining museum edifices in the city, including The National Museum and the Polish Army Museum, were seriously damaged. More than sixty members of the Polish museum staff were murdered by the Gestapo or perished in concentration camps; Dr. Kazimierz Brokl, the curator of the collections of the Royal Castle, was killed in the castle courtyard on September 17, 1939, while trying to protect castle furnishings from German bombs {*FIGS 4 AND 5*}. Besides Warsaw, among the completely demolished museum buildings was that of the Silesian Museum in Katowice.

FIG 1, LEFT
Governor General Hans Frank and
Kajetan Mühlmann confer at The Wawel
Royal Castle in Cracow, photograph,
Washington, D.C., National Archives.

FIG 2, TOP RIGHT
Miodowa Street with the church of the
Capuchin Fathers, Warsaw, 1945, photo-
graph, Warsaw, Institute of Art, Polish
Academy of Sciences.

FIG 3, BOTTOM RIGHT
Sculpture of Christ in front of the
church of the Holy Cross, Warsaw, 1944,
photograph.

Out of one hundred and seventy-five prewar museums, only twenty-two existed in 1945. The postwar geography of Poland that reconfigured former German territories within Polish boundaries did little to enhance the cultural property of Poland, as their collections had also been plundered and most of their buildings demolished. The rich collections of Gdańsk (formerly Danzig) had practically ceased to exist, while a great many works of art from Wrocław and Szczecin had been carried off to Germany.

It is extremely difficult to establish precisely the extent of losses sustained by the Polish museums during World War II. Most inventory books and archives were either lost or destroyed. Documenting losses in private collections is even more problematic, as in the majority of cases they had not been inventoried at all. Stanisław Lorentz, former director of The National Museum in Warsaw, has assessed the losses of the Polish museums at 2,500 paintings representing various European schools, about 10,000 paintings by Polish artists, over 1,300 sculptures, tens of thousands of drawings and engravings, as well as countless numismatic items and objects of decorative art. Attempts to create a complete register of the art losses suffered in Poland are currently being undertaken by the Bureau of the Plenipotentiary of the Government for the Polish Cultural Heritage Abroad. There are also ongoing efforts among museum officials both in Poland and internationally to recover works of art that were lost or stolen during World War II.

What happened to Poland's collections under the red banner of the Communists is a separate story that only adds to the complex history of Poland's museums. As early as February 1945, the Provisional Government created within the Ministry of Culture and

FIG 4
The Royal Castle in Warsaw after its destruction, 1944, photograph, Warsaw, The Royal Castle.

FIG 5
The Royal Castle in Warsaw after its reconstruction, 1971–84, photograph, Warsaw, The Royal Castle.

Art an office called the Chief Management of Museums and the Protection of Historical Monuments. Several more specialized sub-departments were also established to handle specific areas, such as the Management of Museums, Conservation, Restitution, Art History, the Preservation of Monuments to Martyrdom (war heroes), and the Cataloguing of Historical Monuments. In the immediate postwar years, the Department of Museums undertook three main tasks. The first was the reconstruction of former museums and the reorganization of museum management in Poland. The second was the recovery of museum collections that had been lost or stolen during the war. And the third was the collection and transport of artworks confiscated from their owners in accord with the Agrarian Reform Decree of September 6, 1944. The three tasks set forth by the Chief Management of Museums and the Protection of Historical Monuments would have complex and long-lasting ramifications for the development of Poland's museums in the second half of the century.

The first task of reconstruction and reorganization was handled swiftly by the Communist authorities. The vast majority of the surviving museums were nationalized, beginning with The National Museum in Warsaw {*FIG 6*}. The creation of a centralized system actually proved helpful in solving a number of organizational problems that had plagued museum management before the war. By 1949 as many as 136 museums – including all of the most important ones – had been subordinated to the Chief Management. By 1950 all of the remaining museums had been nationalized, except for smaller regional museums of primarily local importance and those belonging specifically to religious organizations. The National Museum and the larger museums in the capitals of *voivodships* (regional governments) were given the formal title of district museums and were subsequently expected to oversee the regional and local museums

FIG 6
The National Museum, Warsaw, as it looks today, photograph.

within their respective administrative areas. Specialized museums, such as the Polish Army Museum, State Ethnographic Museum, State Archaeological Museum, Museum of Technology, and Earth Museum, were to advise their respective specialized departments in regional museums.

The reorganization of the Polish museums allowed for central planning of management and the creation of a uniform government policy toward museums. This policy was officially put forward in 1950 under the title *Museum Management at the Stage of a Struggle for Socialist Culture*, a program for the development of museum management that had been worked out in the spirit of a Marxist ideology enriched by Leninist and Stalinist theories about nationhood. The formation of this official policy had profound consequences. Between 1950 and 1951, the office of the Chief Management of Museums and the Protection of Historic Monuments, an organization that had encouraged the participation of professionally trained museum officials, had been completely dissolved. The management of museums was subsequently consigned to politically reliable party officials in the newly established Central Board of Museums. The Union of Polish Museums, a self-managed organization of Polish museum professionals, active from 1914, was also officially dissolved in 1951.

Directors of larger museums entered a particularly difficult period after Włodzimierz Sokorski was appointed Minister of Culture in 1952. Sokorski summoned the director of the National Museum in Warsaw, Professor Stanisław Lorentz, to inform him of the Communist Party's expectations of him. The minister ordered: "You will take the red banner in your hands, professor, and lead your fellow professors under it."[1] Under constant scrutiny of the Communist Party, many directors were obliged to join the Polish United Workers' Party; others, such as Professor Lorentz and his assistant at The National Museum, the outstanding classical archaeologist Professor Kazimierz Michałowski, were subject to incessant threats and inspections in search of a pretext for dismissing them. The slightest pretext – for example, the discovery in a provincial museum subordinate to The National Museum of a bust of Marshal Józef Piłsudski (chief of the Polish State, 1918–23) – was sufficient to launch an attack on the professors.[2] Fortunately, among the high-ranking ministry officials, there were a few who were willing to risk harassment and potential political persecution for supporting the professors and

1 Verbal communication with Professor Stanisław Lorentz.
2 Letter of September 25, 1951, from Deputy Minister Włodzimierz Sokorski to Professor Stanisław Lorentz (copy in the possession of the author). Professor Lorentz told the author years ago that the letter had indeed concerned the bust of Józef Piłsudski.

their museums. The then director of the Central Board of Museums often found himself forced to resort to the following defense of his professors:

The citizen directors are representatives of the prewar intelligentsia reared in an alien bourgeois ideology, who are only now getting accustomed to socialist construction, and they still quite often betray their class taints....The C.B.M. undertakes...to take special care of the citizen directors for a longer period by initiating staff conferences, by closely binding the scholarly staff of the Museum with the executive of the Basal Party Organization, and by the cooperation of the Directorate with the District and Town Committees of the PUWP.[3]

The second essential task in the immediate postwar years – recovering the museum collections that had been taken to Germany and Austria – involved organizing a wide-scale restitution campaign. The campaign had begun during wartime, in the areas occupied by the Soviet Army, and developed in the years 1945–50, extending into the German and Austrian territories. Its scale is best demonstrated by a document drawn up by the Restitution and Reparation Office, dated August 19, 1950. It lists, among other items, the return in 1945 from Lower Silesia of twenty-eight railway cars and one hundred and eighteen trucks loaded with works of art, including paintings by Jan Matejko; and in 1946 from the American zone, of twenty-seven railway cars, that included Leonardo da Vinci's *Lady with an Ermine*, Veit Stoss' altar from the church of St. Mary in Cracow, and the famous views of Warsaw by Bernardo Bellotto. All in all, those years saw the return of more than one hundred railway cars and several hundred truckloads of art. Literally thousands of artworks were retrieved in the years immediately after the war.

Later came the return of objects from Polish collections that after the war found their way to the Soviet Union. Some of these works were confiscated initially by the Germans and then later plundered by the Russians; still others were taken secretly under the red banner to the Soviet Union after 1945. Whether or not all of the works have been returned from the inaccessible storerooms in Russian museums remains an open question. In 1989, for example, museum workers at Pushkino identified two landscapes by Jean-Baptist Pillement as ones that came originally from The Royal Castle in Warsaw, and Soviet authorities graciously agreed to return them to Poland {*PLS 35 AND 36*}.

The third task posed by the Chief Management of Museums and the Protection of Historical Monuments was "to secure objects formerly belonging to manors," that is, both land and objects of cultural value that had been seized in connection with the

PL 35

PL 36

September 1944 enforcement of the Agrarian Reform Decree. Under the Minister of Agriculture, museums were ordered to take possession of all objects of cultural value. As a consequence, the contents of museum collections expanded substantially and the lands, parks, and palaces associated with the former magnate residences were turned into public parks and museums. Many of the most beautiful and magnificent palace-cum-park complexes today – Wilanów, Łańcut, Nieborów, Pszczyna, Kozłówka, Gołuchów, Rogalin, Pieskowa Skała, among others – were nationalized as part of the Agrarian Reform Decree.[4] Now, more than more than fifty years later, with the negation of Agrarian Reform, the ownership of these institutions as well as the ownership of the often large collections they once housed are again subject to serious and ongoing political and legal debates.

In addition to the three fundamental tasks set before Polish museums after 1945 was the necessity to create a hitherto unknown kind of museum that would commemorate the martyrdom of the last war. A few such museums were founded, mostly on the grounds of former Nazi concentration camps, including Oświęcim, Majdanek, and Sztutowo. Moreover, quite a large number of museums of overtly political character were constructed. They were intended to disseminate propaganda and commemorate revolutionary movements and their heroes, such as Lenin. Furthermore, a considerable change in the state's frontiers brought about the disappearance from the Polish museum map of important cultural centers such as Vilnius and Lvov, while there arose the necessity to create museums in territories joined to Poland, for instance, in Wrocław, Gdańsk, Szczecin, Olsztyn, Zielona Góra, Koszalin, and Słupsk.

The nationalized museum network that had been created in 1950 survived largely unchanged for four decades. Some decentralizing amendments occurred in 1956 when only national museums, those of central character, and martyrdom museums were allowed to continue under the direction of the Minister of Culture; other smaller institutions were subject to the state regional authorities, creating a somewhat denser museum network. February 15, 1962 marks the next important date in the postwar history of the Polish museum system; the Act of the Protection of Cultural Values and Museums was passed,

3 Letter of February 7, 1953, from the director of the Central Board of Museums to the director of the Department of Personnel Management of the Ministry of Culture and Art (copy in the possession of the author).

4 However, the former aristocratic residences were not taken over for the purpose of using the collections or the architecture to demonstrate the refinements manor life in Old Poland. Quite the contrary, from 1945 to 1952, the palace at Rogalin housed the Department of Crafts and Documentation of Progressive Ideas, and one second-floor room of the castle

at Łańcut was used to house a "chicken hut" (a primitive cottage inhabited by the poorest peasants). The latter was certainly a political statement in keeping with current Marxist ideologies. The palace at Pszczyna and Malbork Castle were in an even worse situation because of their early German origins and magnate class associations. As a consequence, they were simply allowed to fall into disrepair.

establishing a legal framework for the activity of museums in Poland. On the one hand, it consolidated a centralized organizational model, but on the other, it ensured satisfactory regulation of the management of museum pieces and provided security for museum collections, assigning all basic decisions regarding objects to the museum directors; it also ensured the protection of private collecting. In retrospect, this act should be acknowledged as a considerable achievement in the advancement of museums in Poland.

The political changes at the end of 1970 helped create an atmosphere of change. Under the direction of the First Secretary of the PUWP, Edward Gierek, Poland adopted a relatively liberal cultural policy, more open to the West than the other states of the Soviet bloc. A large number of Polish museologists participated for the first time in the activities of the International Council of Museums (ICOM). They were exposed to changes that had taken place in Western museology and a younger generation of Polish museum professionals sought to modify a model they now viewed as anachronistic.

In the autumn of 1979, a symposium organized by the Committee for Art Sciences, entitled "A Museum in the Age of Mass Culture," was a watershed event, revealing a fundamental museological divergence between the generations. This was to find full expression in 1981, during preparations for the first independent Congress of Polish Culture, which, although brutally interrupted by the enforcement of martial law in Poland, had a broad and strong impact on the cultural community of Poland. Radical changes proposed to the current museum system included the decentralization of museum management, a higher degree of independence, and the creation of an elected body of professionals at provincial and state levels, attached to the Minister of Culture and Art. It also stipulated that the role of administration be limited to implementation of the elective bodies and that a new system of financing institutions be created that would, for instance, create a greater autonomy in the retention and investment of profits.

The period of martial law, from 1981 to 1983 and in later years, was characterized by the authorities' stubborn efforts to turn back the wheel of history. Contact with the West aroused special fear and contacts with foreign countries were restricted. The possibilities remained limited. No new museum building was erected. No new technologies were introduced for protecting and conserving museum collections. Research activities were censored. Any attempt to reform the existing system of organization and methods of managing museums was suppressed. Nevertheless, despite a cultural policy heavily encumbered with Communist ideology, in spite of the distortions, censorship, opposition to any thinking outside the limits of the prevailing doctrine, to say nothing of the

criminal practices of the Stalinist years, not everything that happened to Polish museums between 1945 and 1989 is to be utterly condemned.

Thanks to men such as Professors Stanisław Lorentz, Jerzy Szablowski (director of The Wawel Royal Castle in Cracow), Zdzisław Kępiński (director of The National Museum in Poznań), and Aleksander Gieysztor (director of The Royal Castle in Warsaw), the Polish museums became veritable bulwarks against Sovietization. They became not only a refuge for the Polish intelligentsia, but repositories for the preservation and cultivation – through exhibitions, publications, and especially educational activity – of traditional moral values and national identity, at the same time reminding Poles of their long-standing connection with the Western world, from which Poland had been separated for over forty years by the Iron Curtain. Exhibitions such as "The Self-Portrait of the Poles," "Romanticism and Romanticness," and "The Way to Independence," held in 1979–80 – and the list could be extended – focused on highly charged symbols of the past and validated the historical awareness of the nation. They contributed to the consolidation of the national identity at a moment when the country eagerly anticipated a great political breakthrough.

The breakthroughs came in 1989 and launched a shockwave of transformations. The first attempts at cultural reform post-1989 were made in 1991: some dozen museums were subordinated to local government administration. That same year a new museum act was initiated. Passed in November 1996, it replaced the largely obsolete act of 1962. Among other issues, the new statute sanctioned the profession of the museum worker; introduced a Register of Museums in Poland; defined the management of museum objects and the principles of establishing, merging, and closing museums; and laid down a legal foundation for organizing private museums, appointing museum boards of trustees, and creating an advisory body of prominent museum experts attached to the Ministry of Culture.

The introduction in 1999 of a new administrative system in Poland was a shock to museum management. One of the many consequences of this reform was the decentralization and transformation of the overwhelming majority of cultural institutions, including museums, into independent, self-governing bodies. Today almost 450 museums in Poland have been turned into self-governing bodies at communal, district, and provincial levels. Only thirteen museums remain state institutions: in Cracow, The Wawel Royal Castle and The National Museum {*FIGS 7 AND 8*}; in Warsaw, The Royal Castle, The National Museum, and Łazienki Palace-Museum (former summer royal

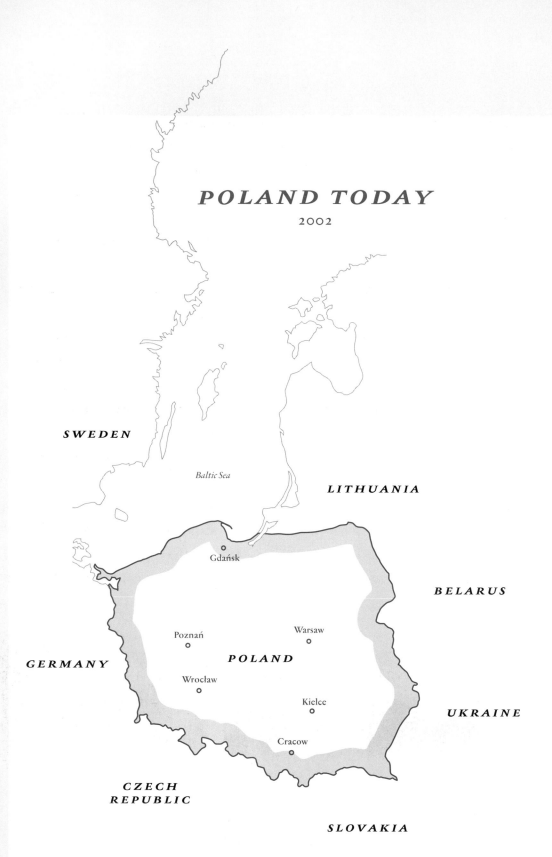

POLAND TODAY

2002

SWEDEN

Baltic Sea

LITHUANIA

Gdańsk

BELARUS

Poznań Warsaw

GERMANY POLAND

Wrocław

UKRAINE

Kielce

Cracow

CZECH
REPUBLIC

SLOVAKIA

Black Sea

residence); The National Museum in Poznań {*FIG 9*}; the Palace-Museum at Wilanów near Warsaw (once a suburban royal residence); the Salt Mine Museum at Wieliczka; the Castle-Museum in Malbork; the Central Maritime Museum in Gdańsk, and three former concentration camp sites, the museums at Oświęcim-Brzezinka (Auschwitz-Birkenau), Majdanek, and Sztutowo.

The rapidity of these transformations coupled with poor preparation on the part of both the self-governing bodies and the museums created profound frustration in museum circles. One fear was that state grants hitherto allocated would be reduced and that museums might even be closed down because of financial difficulties. Regrettably, after three years, many of the initial fears have come true. Although only a small number of museums have been closed, many operate under grave financial difficulties and many others are neglected or completely ignored by their local governments. On the other hand, the radical reform of 1999 has compelled museums, especially those controlled by the local authorities, to engage more fully and actively in the social, economic, and political milieus of their communities. This direct contact with local communities may even now be seen as providing the greatest possible potential for the construction of a new order.

The numerous institutional transformations and new economic and legal regulations are scarcely comprehensible to the average museum employee and are often perceived as direct threats to professional status. This is particularly poignant among senior curators who are faced with the necessity of adapting the functioning of a museum

FIG 7, TOP LEFT
The Wawel Royal Castle, Cracow, as it looks today, photograph.

FIG 8, BOTTOM LEFT
The National Museum, Cracow, as it looks today, photograph.

FIG 9, RIGHT
The National Museum, Poznań, as it looks today, photograph.

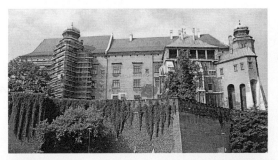

to the demands of a market economy. In many cases this is tantamount to staff reduction, increased professional qualifications, and – perhaps most difficult – the need to accept as a museum model an institution responsive to the expectations of a wider public. To cope with the problem and to mitigate the shock caused by such radical changes, constant attempts are being made to find adequate forms of financing and managing cultural institutions.

The greatest threat to the stability of Poland's museums since 1989, however, may come from the numerous claims for the restitution of artworks currently displayed as part of their collections. The demands for restitution have come from former owners who were illegally deprived of their collections as a consequence of the Agrarian Reform in 1944 and from churches that after 1945 had their works transferred to museums. The issue of the latter works is particularly complex because they belong to churches that originally had been Roman Catholic, then were German Protestant, and stood closed from 1945 until they were finally returned to the Roman Catholic Church. There has also been a wave of withdrawals of works that had been placed on deposit for safekeeping in museums before and during the war. Now that prices of works of art in Poland have markedly risen and the standard of living has improved, the heirs of the depositors often wish to retrieve family "treasures" in order to sell them or place them in their new dwellings. Current claims of restitution staggeringly may include as many as 600,000 objects – and these are usually of the highest artistic and material value.

FIG 10
The National Museum, Kielce, as it looks today, photograph.

FIG 11
The National Museum, Gdańsk, as it looks today, photograph.

The museums most exposed to claims are The National Museum in Warsaw, The National Museum in Kielce {*FIG 10*}, The National Museum in Gdańsk {*FIG 11*}, and the museums that were formerly aristocratic residences at Wilanów and at Łańcut. As solutions to the problems are being sought, special mention should be given to two Polish aristocratic families, the Czartoryskis and the Raczyńskis, who have left their collections in museums as family foundations in order to keep the works of art within the public domain (The Czartoryski Foundation at The National Museum in Cracow and The Raczyński Foundation at The National Museum in Poznań). The creation of these foundations in 1991 set an important and much-followed precedent for addressing issues of restitution in Poland.

The majority of private collections in Poland were destroyed or dispersed as a result of World War II. Numerous works of art were burnt in family palaces in Warsaw, for example, the collections of the Zamoyski and the Przeździecki families; some disappeared without a trace, like the *Portrait of a Young Man* by Raphael from the Czartoryski collection in Cracow; still others, such as the collection of Alfred Potocki of Łańcut, were carried out of Poland. Consequently, the nation lacks the large private collections that exist in Western Europe, the United States, and Japan, but their creation is going on, promoted by a steadily improving economic situation and the development of an antiques market. Increasingly there are cases in which Polish museums are receiving important donations to their collections. While the heirs of earlier depositors are reclaiming artworks from museums, representatives of the new wealthy class are beginning to give objects to museums. Particularly of note are bequests and gifts from Poles living abroad, such as gifts from Julian Godlewski for The Wawel Royal Castle, Andrzej Ciechanowiecki and Teresa Sahakian for The Royal Castle in Warsaw, Janina and Karol Porczyński for the Archdiocesan Museum in Warsaw, and Birgitta and Wawrzyniec Węclewicz for The National Museum in Warsaw. The Ciechanowiecki and Sahakian collections form the basis of a foundation at The Royal Castle in Warsaw. Other collections are frequently shown in Poland in temporary exhibitions; among the richest are those of Barbara Piasecka-Johnson (United States), Tomasz Niewodniczański (Germany), Tom Podl (United States), and Wojciech Fibak.

The museums of Poland are today at a dramatic and critical juncture in their history. In their continuing evolution and development, they will inevitably look to their own rich history for guidance and to the international community of museums for support.

CATALOGUE
OF THE EXHIBITION

SIR LAWRENCE ALMA-TADEMA
ENGLISH, 1836–1912

1 *Portrait of Ignacy Jan Paderewski*
1891, oil on canvas
17 7/8 x 23 1/4 in, 45.5 x 59 cm
Warsaw, The National Museum: M.Ob.1850
Plate 70

MARCELLO BACCIARELLI
ITALIAN, 1731–1818

2 *Portrait of King Stanislaus Augustus Poniatowski*
with an Hourglass
1793, oil on canvas
43 7/8 x 33 5/8 in, 111.5 x 85.5 cm
Warsaw, The National Museum: MP 312 MNW
Plate 29

3 *State Portrait of King Stanislaus Augustus Poniatowski*
1792, oil on canvas
109 1/2 x 62 1/4 in, 278 x 158 cm
Poznań, The National Museum: MNP Dep. 768
Plate 28

BERNARDO BELLOTTO
ITALIAN, 1721–1780

4 *Ideal Architecture with Self-Portrait of the Artist*
ca. 1765–66, oil on canvas
60 1/4 x 44 7/8 in, 153 x 114 cm
Warsaw, The Royal Castle: ZKW 357
Plate 30

5 *The Church of the Bernardine Nuns and the Sigismund*
Column in Warsaw, Looking Along Grodzka Street
ca. 1768–70, oil on canvas
45 1/8 x 66 3/8 in, 114.5 x 170.5 cm
Warsaw, The Royal Castle: ZKW 440
Plate 33

6 *The Krakowskie Przedmieście, Warsaw,*
View from Nowy Świat
1778, oil on canvas
33 1/4 x 42 3/8 in, 84.5 x 107.5 cm
Warsaw, The Royal Castle: ZKW 446
Plate 34

7 *View of Warsaw from the Terrace of the Royal Castle*
1773, oil on canvas
65 3/8 x 105 7/8 in, 166 x 269 cm
Warsaw, The National Museum: MP 228 MNW
Plate 32

8 *View of Warsaw with the Ordynacki Palace*
1772, oil on canvas
67 1/2 x 102 1/8 in, 171.5 x 259.5 cm
Warsaw, The Royal Castle: ZKW 439
Plate 31

FERDINAND BOL
DUTCH, 1616–1680

9 *Hagar and the Angel*
mid-17th century, oil on canvas
38 3/8 x 45 in, 97.3 x 114.4 cm
Gdańsk, The National Museum: MNG/SD/269/ME
Plate 14

10 *Portrait of an Old Woman*
ca. 1640–42, oil on canvas
31 7/8 x 26 3/4 in, 81 x 68 cm
Warsaw, The National Museum: M.Ob.555
Plate 15

11 *Portrait of Johanna de Geer-Trip*
1661, oil on canvas
49 5/8 x 35 7/8 in, 126 x 97 cm
Warsaw, The National Museum: M.Ob.556
Plate 16

PARIS BORDONE
ITALIAN, 1500–1571

12 *Portrait of Italian Goldsmith Gian Giacomo Caraglio*
ca. 1552, oil on canvas
54 3/4 x 42 in, 139 x 106.5 cm
Cracow, The Wawel Royal Castle,
State Art Collections: inv. 5882
Plate 27

ALBRECHT BOUTS
FLEMISH, CA. 1452–1549

13 *Mater Dolorosa*
ca. 1500, tempera on wood panel
16 x 10 1/2 in, 40.7 x 26.6 cm
Cracow, The Princes Czartoryski
Museum: inv. XII – 258
Plate 42

OLGA BOZNAŃSKA
POLISH, 1865–1940

14 *Girl with Chrysanthemums*
1894, oil on cardboard
34 7/8 x 27 1/8 in, 88.5 x 69 cm
Cracow, The National Museum: MNK-b-1032
Plate 73

15 *Two Boys*
1898, oil on cardboard
40 1/8 x 29 1/2 in, 102 x 75 cm
Poznań, The National Museum/The Raczyński
Foundation: MNP FR 11
Plate 74

JÓZEF BRANDT
POLISH, 1841–1915

16 *Encounter on a Bridge*
1888, oil on canvas
39 3/8 x 78 3/4 in, 100 x 200 cm
Cracow, The National Museum: MNK 11-a-147
Plate 69

CECCO DEL CARAVAGGIO
ITALIAN, ACTIVE IN ROME
CA. 1610–1620

17 *The Martyrdom of St. Sebastian*
1620, oil on canvas
48 7/8 x 64 in, 124 x 162.5 cm
Warsaw, The National Museum: M.Ob.645
Plate 22

JÓZEF CHEŁMOŃSKI
POLISH, 1849–1914

18 *Meeting for the Hunt*
1874, oil on canvas
25 3/4 x 58 1/4 in, 65.5 x 148 cm
Poznań, The National Museum: MNP MP 92
Plate 67

FRANÇOIS CLOUET, FOLLOWER OF
FRENCH, CA. 1510–1572

19 *Male Portrait* (formerly *Don Juan of Austria*)
ca. 1570s, oil on wood panel
12 1/4 x 9 in, 31 x 23 cm
Cracow, The Princes Czartoryski
Museum: inv. XII – 298
Plate 43

GIOVANNI BATTISTA CRESPI
(CALLED CERANO)
ITALIAN, 1557–1632/38

20 *Christ and the Woman of Samaria*
ca. 1620s, oil on canvas
39 1/2 x 28 in, 100.5 x 71.2 cm
Warsaw, The National Museum: M.Ob.649
Plate 21

FRANÇOIS-XAVIER FABRE
FRENCH, 1766–1837

21 *Portrait of Michał Bogoria Skotnicki*
ca. 1806, oil on canvas
64 x 49.5 cm
Cracow, The National Museum:
inv. XIIA – 4
Plate 51

ALEKSANDER GIERYMSKI
POLISH, 1850–1901

22 *Feast of Trumpets*
1884, oil on canvas
18 1/2 x 25 3/8 in, 47 x 64.5 cm
Warsaw, The National Museum: MP 124 MNW
Plate 68

JAN VAN GOYEN
DUTCH, 1596–1656

23 *Huts by a Canal*
1630, oil on canvas
39 x 36 in, 99 x 91.5 cm
Gdańsk, The National Museum:
MNG/SD/275/ME
Plate 9

GREAT POLAND PAINTER
POLISH, ACTIVE EARLY 16TH CENTURY

24 *Virgin and Child with St. Felicity and St. Perpetua*
ca. 1525, tempera on wood panel
73 1/4 x 60 1/4 in, 186 x 153 cm
Warsaw, The National Museum: Śr. 37
Plate 2

ARTUR GROTTGER
POLISH, 1837–1867

25 *An Insurgent's Goodbye and The Return of an Insurgent*
1866 and 1865, respectively,
diptych, oil on wood panel
20 3/4 x 16 1/4 in, 52.7 x 41. 3 cm
20 3/4 x 16 in, 52.5 x 41 cm
Cracow, The National Museum: MNK 11-a-249,
MNK 11-a-250
Plate 62

JAN SANDERS VAN HEMESSEN
FLEMISH, CA. 1500–1566

26 *Holy Family*
mid-1540s, oil on wood panel
38 x 27 3/4 in, 96.7 x 70.4 cm
Cracow, The Wawel Royal Castle, State Art
Collections: inv. 1151
Plate 6

ABRAHAM HONDIUS
DUTCH, CA. 1625/30–1691

27 *Dog and Heron*
1667, oil on canvas
53 1/2 x 45 1/4 in, 135 x 115 cm
Warsaw, The National Museum: M.Ob.446
Plate 19

JEAN-AUGUSTE-DOMINIQUE INGRES
FRENCH, 1780–1867

28 *Academic Figure*
1801, oil on canvas
38 3/8 x 31 3/4 in, 97.5 x 80.6 cm
Warsaw, The National Museum: M.Ob.292
Plate 50

WINCENTY KASPRZYCKI
POLISH, 1802–1849

29 *Exhibition of Fine Arts in Warsaw*
1828, oil on canvas
37 1/4 x 43 3/4 in, 94.5 x 111 cm
Warsaw, The National Museum: MP 298 MNW
Plate 56

30 *View of the Palace at Wilanów*
1833, oil on canvas
39 3/4 x 57 1/2 in, 101 x 146 cm
Warsaw, The National Museum: MP 3029 MNW
Plate 57

HANS SÜSS VON KULMBACH
GERMAN, CA. 1480–1522

31 *St. Catherine of Alexandria*
ca. 1511, oil and tempera on wood panel
22 x 15 in, 56 x 38.2 cm
Cracow, The Princes Czartoryski Museum:
inv. XII-328
Plate 39

LEONARDO DA VINCI
ITALIAN, 1452–1519

32 *Lady with an Ermine (Portrait of Cecilia Gallerani)*
ca. 1490, oil and tempera on wood panel
21 3/8 x 15 1/2 in, 54.4 x 39.3 cm
Cracow, The Princes Czartoryski Museum:
inv. XII – 209
Plate 38

JAN LIEVENS
DUTCH, 1644–1680

33 *Portrait of a Young Man*
ca. 1660–65, oil on canvas
39 ³/₈ x 31 ⁷/₈ in, 100 x 81 cm
Cracow, The Wawel Royal Castle, State Art
Collections: inv. 600
Plate 45

LITTLE POLAND PAINTER
POLISH, ACTIVE MID-15TH CENTURY

34 *Pietà*
ca. 1450, tempera on wood panel
51 ¹/₈ x 33 ¹/₄ in, 130 x 84.5 cm
Warsaw, The National Museum: Śr. 312
Plate 1

SIMON LUTTICHUYS, ATTRIBUTED TO
DUTCH, 1610–1661

35 *Still Life with Skull*
ca. 1635–40, oil on canvas
17 ⁷/₈ x 13 ⁵/₈ in, 45.2 x 34.8 cm
Gdańsk, The National Museum:
MNG/SD/330/ME
Plate 10

JACEK MALCZEWSKI
POLISH, 1854–1929

36 *Polish Hamlet, Portrait of Aleksander Wielopolski*
1903, oil on canvas
39 ³/₈ x 58 ¹/₄ in, 100 x 148 cm
Warsaw, The National Museum: MP 369 MNW
Plate 76

WŁADYSŁAW MALECKI
POLISH, 1836–1900

37 *View of Wawel*
1873, oil on canvas
26 x 62 ³/₄ in, 66 x 159.3 cm
Warsaw, The National Museum: MP 406 MNW
Plate 66

JAN MASSYS
FLEMISH, 1509–1575

38 *Venus and Cupid*
ca. 1560, oil on wood panel
52 x 37 in, 132 x 94 cm
Cracow, The Museum of the Jagiellonian
University, *Collegium Maius*: inv. 15790
Plate 7

**MASTER OF THE FEMALE
HALF-LENGTHS**
*FLEMISH, ACTIVE SECOND QUARTER
OF THE 16TH CENTURY*

39 *Mary Magdalene Writing*
ca. 1530, oil on wood panel
21 ¹/₄ x 15 ³/₄ in, 54 x 40 cm
Cracow, The Princes Czartoryski
Museum: inv. XII – 254
Plate 41

**MASTER OF THE LEGEND OF ST.
MARY MAGDALENE, ATTRIBUTED TO**
FLEMISH, CA. 1490–CA. 1526

40 *Portrait of Isabella, Queen of Denmark*
ca. 1514–15, oil on wood panel
12 ¹/₄ x 9 ¹/₈ in, 34.2 x 24.5 cm
Cracow, The Princes Czartoryski
Museum: inv. XII-299
Plate 40

JAN MATEJKO
POLISH, 1838–1893

41 *Stańczyk, the King's Jester*
1862, oil on canvas
34 ⁵/₈ x 47 ¹/₄ in, 88 x 120 cm
Warsaw, The National Museum: MP 433 MNW
Plate 63

42 *Sketch for the Astronomer Mikołaj Kopernik or
Conversation with God*
1871, oil on cardboard
16 ³/₈ x 20 ⁵/₈ in, 41.5 x 52.5 cm
Cracow, The National Museum, The House of Jan
Matejko: MNK IV-25
Plate 64

43 *Hanging the Zygmunt Bell*
1874, oil on wood panel
37 x 74 ¹/₂ in, 94 x 189 cm
Warsaw, The National Museum: MP 441 MNW
Plate 65

JÓZEF MEHOFFER
POLISH, 1868–1946

44 *Strange Garden*
1903, oil on canvas
85 $^1/_2$ x 81 $^7/_8$ in, 217 x 208 cm
Warsaw, The National Museum: MP 365 MNW
Plate 77

HANS MEMLING
NETHERLANDISH, ACTIVE 1465–1494

45 *The Last Judgment*
1467–71, tempera and oil on wood panel
central panel: 92 $^1/_4$ x 71 $^1/_8$ in, 242 x 180.8 cm
wings: 92 $^1/_4$ x 35 $^3/_8$ in, 242 x 90 cm each
Gdańsk, The National Museum: SD/413/M
Plate 4
(Milwaukee only)

PIOTR MICHAŁOWSKI
POLISH, 1800–1855

46 *Parade in Front of Napoleon*
1837, oil on canvas
27 x 37 $^1/_4$ in, 68.5 x 94.5 cm
Warsaw, The National Museum: MP 289 MNW
Plate 58

47 *Jews*
ca. 1845, oil on canvas
28 $^3/_8$ x 46 $^1/_2$ in, 72 x 118 cm
Cracow, The National Museum: MNK II-a-749
Plate 59

ANTON MÖLLER
POLISH, CA. 1563/65–1611

48 *Portrait of a Gdańsk Patrician Female*
1598, oil and tempera on wood panel
39 $^1/_2$ x 30 $^7/_8$ in, 100.5 x 78.4 cm
Gdańsk, The National Museum:
MNG/SD/287/M
Plate 20

CASPAR NETSCHER
DUTCH, 1639–1684

49 *Boy in Polish Costume*
ca. 1668–72, oil on wood panel
10 $^1/_4$ x 8 $^1/_2$ in, 26 x 21.5 cm
Cracow, The Princes Czartoryski
Museum: inv. XII – 263
Plate 46

JAN RUTTGERS NIEWAEL
DUTCH, CA. 1620–1661

50 *A Young Woman Dressed as a Shepherdess*
1635, oil on wood panel
25 $^1/_8$ x 19 $^1/_4$ in, 63.8 x 49 cm
Gdańsk, The National Museum:
MNG/SD/288/ME
Plate 13

JEAN-PIERRE NORBLIN
DE LA GOURDAINE
FRENCH, 1745–1830

51 *A Company Trip*
ca. 1777, oil on canvas
55 $^1/_4$ x 81 $^1/_4$ in, 140.5 x 206.5 cm
Warsaw, The National Museum: MP 294 MNW
Plate 37

JOHANN FRIEDRICH OVERBECK
GERMAN, 1789–1869

52 *The Marriage of the Virgin*
1834–36, oil on canvas
45 $^5/_8$ x 37 $^1/_4$ in, 116 x 94.5 cm
Poznań, The National Museum/The Raczyński
Foundation: MNP FR 509
Plate 53

JEAN-BAPTISTE PILLEMENT
FRENCH, 1728–1808

53 *Seaside Landscape with a Ruin*
1765, oil on canvas
33 $^7/_8$ x 52 $^3/_4$ in, 86 x 134 cm
Warsaw, The Royal Castle: ZKW 2453a,b
Plate 35

54 *Shepherds by a River with a Romantic Ruin*
1765, oil on canvas
33 $^7/_8$ x 52 $^3/_4$ in, 86 x 134 cm
Warsaw, The Royal Castle: ZKW 2454a,b
Plate 36

WŁADYSŁAW PODKOWIŃSKI
POLISH 1866–1895

55 *Nowy Świat Street in Warsaw*
1892, oil on canvas
47 $^1/_4$ x 33 $^1/_8$ in, 120 x 84 cm
Warsaw, The National Museum: MP 340 MNW
Plate 71

MATTIA PRETI
ITALIAN, 1613–1699

56 *Adoration of the Shepherds*
1656, oil on canvas
58 1/2 x 77 3/4 in, 148.5 x 197.5 cm
Warsaw, The National Museum: M.Ob.666
Plate 23

JUSEPE DE RIBERA
SPANISH, 1591–1652

57 *John the Baptist in the Wilderness*
ca. 1640, oil on canvas
70 1/8 x 63 3/8 in, 178 x 161 cm
Poznań, The National Museum: MPN Mo 1292
Plate 26

MARCO RICCI
ITALIAN, 1676–1730
SEBASTIANO RICCI
ITALIAN, 1659–1734

58 *Landscape with a Winding Road*
ca. 1720, oil on canvas
48 x 67 5/8 in, 122 x 172 cm
Warsaw, The National Museum: M.Ob.676
Plate 25

ALEXANDER ROSLIN
SWEDISH, 1718–1793

59 *Portrait of Princess Izabela Czartoryska,*
née Flemming
1774, oil on canvas
25 x 20 1/2 in, 63.5 x 52 cm
Cracow, The National Museum:
inv. XIIA – 616
Plate 47

FERDYNAND RUSZCZYC
POLISH, 1870–1936

60 *Old Apple Trees*
1900, oil on canvas
33 1/2 x 64 7/8 in, 85 x 165 cm
Warsaw, The National Museum: MP 349 MNW
Plate 75

HERMAN SAFTLEVEN
DUTCH, 1609–1685

61 *Winter Landscape*
ca. 1665, oil on wood panel
20 5/8 x 27 in, 52.5 x 68.5 cm
Poznań, The National Museum: MNP Mo 85
Plate 18

STANISŁAW SAMOSTRZELNIK
POLISH, CA. 1480–1541

62 *Portrait of Piotr Tomicki*
1530–35, tempera on wood panel
94 7/8 x 55 7/8 in, 241 x 142 cm
Cracow, Cloisters of the Franciscan
Friary
Plate 3

DANIEL SEGHERS
FLEMISH, 1590–1661

63 *Flowers with a Portrait of Poussin*
1650–51, oil on canvas
38 1/2 x 31 3/8 in, 98 x 79.8 cm
Warsaw, The National Museum: M.Ob.566
Plate 17

JÓZEF SIMMLER
POLISH, 1823–1868

64 *Death of Barbara Radziwiłłówna*
1860, oil on canvas
80 1/4 x 92 1/8 in, 205 x 234 cm
Warsaw, The National Museum: MP 429 MNW
Plate 61

ELISABETTA SIRANI
ITALIAN, 1638–1665

65 *Portrait of Vincenzo Ferdinando Ranuzzi as Cupid*
1663, oil on canvas
28 x 23 in, 71 x 58.5 cm
Warsaw, The National Museum: M.Ob.669
Plate 24

CARL FERDINAND SOHN
GERMAN, 1805–1867

66 *The Two Leonoras (The Two Allegories)*
1836, oil on canvas
27 x 22 7/8 in, 68.5 x 58 cm
Poznań, The National Museum/The Raczyński
Foundation: MNP FR 492
Plate 54

FLEMISH, 1546–1611

67 *Vanitas*
ca. 1600, oil on canvas
26 3/8 x 38 in, 67 x 96.5 cm
Cracow, The Wawel Royal Castle, State Art
Collections: inv. 9354.
Plate 8

MATTHIAS STOM[ER]
DUTCH, CA. 1600–CA. 1652

68 *St. Peter with Candlelight*
1633–40, oil on canvas
40 x 50 1/2 in, 104 x 128.5 cm
Warsaw, The National Museum: M.Ob.1890
Plate 11

VEIT STOSS
GERMAN, 1447–1533

69 *Design for an Altar at the Carmelite Church in*
Nuremberg
ca. 1520, pen and ink on paper
17 3/4 x 13 in, 45.2 x 33.1 cm
Cracow, The Museum of the Jagellonian
University, *Collegium Maius*: inv. 9600-2617/11
Plate 5
(Milwaukee only)

DAVID TENIERS THE YOUNGER
FLEMISH, 1610–1690

70 *Daniel in the Lions' Den*
ca. 1634, oil on panel
18 3/4 x 24 3/4 in, 47.5 x 63 cm
Warsaw, The National Museum: M.Ob.2167
Plate 12

MICHELE TOSINI
ITALIAN, 1503–1577

71 *Venus Victrix*
ca. 1530–50, oil on wood panel
17 3/8 x 13 in, 44 x 33 cm
Cracow, The Princes Czartoryski
Museum: inv. XII – 208
Plate 44

ELISABETH-LOUISE
VIGÉE-LEBRUN
FRENCH, 1755–1842

72 *Portrait of Prince Adam Kazimierz Czartoryski*
1793, oil on canvas
39 x 30 3/8 in, 99 x 77 cm
Warsaw, The Ciechanowiecki Foundation at
The Royal Castle: ZKW (on loan to a private
collection, London)
Plate 48

73 *Portrait of Princess Pelagia Sapieha, née Potocka*
1794, oil on canvas
54 3/4 x 39 3/8 in, 139 x 100 cm
Warsaw, The Royal Castle: ZKW 2090a,b
Plate 49

CARL WILHELM WACH
GERMAN, 1785–1845

74 *Portrait of Countess Anna Raczyńska*
1827, oil on canvas
49 1/4 x 49 1/4 in, 125 x 125 cm
Poznań, The National Museum/The Raczyński
Foundation: MNP FR 532
Plate 52

WALENTY WAŃKOWICZ
POLISH, 1799–1842

75 *Portrait of Adam Mickiewicz on the Cliff of Judah*
1827–28, oil on canvas
58 1/4 x 49 1/4 in, 148 x 125 cm
Warsaw, The National Museum: MP 309 MNW
Plate 55

FRANZ XAVIER WINTERHALTER
GERMAN, 1805–1873

76 *Portrait of Eliza Krasińska*
1857, oil on canvas
57 1/2 x 42 1/2 in, 146 x 108 cm
Warsaw, The Royal Castle: ZKW 2208
Plate 60

STANISŁAW WITKIEWICZ
POLISH, 1851–1915

77 *Halny (in the Tatra Mountains)*
1895, oil on canvas
36 5/8 x 55 7/8 in, 93.5 x 140.5 cm
Cracow, The National Museum:
MNK II-a-490
Plate 72

BIBLIOGRAPHY

"Act of February 23, 1991 on the Declaration as Null and Void of Sentences for Activity for an Independent Existence of Polish State." *Journal of Laws 1991*, number 34, item 149.

Aftanazy, Roman. *Województwo wołyńskie*. Vol. 5 in *Dzieje rezydencji na dawnych kresach Rzeczypospolitej*. Wrocław: Zakład Narodowy im. Ossolińskich, 1994, p. 250, ill. 272.

Ajewski, Konrad. "Polskie siedziby rodowe – muzea w XIX w." *Spotkania z zabytkami* 4 (2001), pp. 1–8.

Alexandria, Virginia, Art Services International. Ed. Jan K. Ostrowski. *Land of the Winged Horsemen. Art in Poland 1572–1764*. Alexandria, 1999.

Ameisenowa, Zofia. *Kodeks Baltazara Behema*. Warsaw: Auriga, 1961.

Andrzejewska, Halina, et. al., eds. *Polish Painting*. Trans. Bogna Piotrowska. Warsaw: Wydawnictwa Artystyczne i Filmowe, 1997.

Antoniewicz, Jan Bołoz. "Głos w dyskusji." *Sprawozdania Komisji do Badania Historii Sztuki w Polsce*, 7, 4, col. CCCLXX (1905).

Antwerp, Koninklijk Museum voor Schone Kunsten. *De prinselijke pelgrimstocht. De "Grand Tour" van Prins Ladislas van Polen (1624–1625)*. Ghent: Snoeck-Ducajn, 1997, pp. 47–59.

Askenazy, Szymon. *Napoléon et la Pologne*. Brussels: Editions du Flambeau, 1925.

Baden, Staatliche Kunsthalle Baden. *Impressionismus and Symbolismus: Malerei der Jahrhundertwende aus Polen*. Baden, 1998.

Bain, R. Nisbet. *The Last King of Poland and His Contemporaries*. New York: Arno Press and The New York Times, 1971.

Banach, Jerzy, ed. *Kraków – miasto muzeów*. Warsaw: Arkady, 1976, pp. 21–22.

Banaszewski, Roman. *Skarby Uniwersytetu Jagiellońskiego*. Cracow: Uniwersytet Jagielloński, 1999.

Bartnicka, Kalina. *Polskie szkolnictwo artystyczne na przełomie XVIII i XIX w. 1764–1831*. Wrocław: Zakład Narodowy im. Ossolińskich, 1971.

Bassi, Elena. "Notizie di artisti veneti nei carteggi del re Stanislao Poniatowski." *Archivio Vento*, 1979, pp. 175–89.

Batowski, Zygmunt. *Jean Pillement na dworze Stanisława Augusta*. Warsaw: Nakład Towarzystwa naukowego warszawskiego, 1936 (offprint), pp. 4, 35–37.

___. *Norblin*. Lwów: Altenberg, 1911, p. 19.

___. "Portret Stanisława Augusta 'z klepsydrą.'" *Biuletyn Historii Sztuki* 14, 2 (1952), p. 19.

Belluno, Palazzo Crepadona. *Marco Ricci e il paesaggio veneto del Settecento*. Ed. Dario Succi and Annalia Delneri. Milan: Electa, 1993.

Benesch, Otto. "Die Rembrandt-Ausstellung in Warschau." *Kunstchronik* 9 (1956).

___. "Die Rembrandt-Ausstellung in Warschau." In *Rembrandt. Collected Writings*. Vol. 1. London: Phaidon Press, 1970, p. 200.

Bergmans, Simone. "Le Problème du Monogrammiste de Brunswick." *Bulletin Musées Royaux des Beaux-Arts de Belgique* 14 (1965), p. 150.

Bernatowicz, Aleksandra. "Jean Pillement na dworze Stanisława Augusta a schyłek rokoka w dekoracji wnętrz." *Ikonotheka* 14 (2000), pp. 14, 49.

Bernouilli, J. *Reisen durch Brandenburg, Pommern, Preussen, Russland und Polen in den Jahren 1777 und 1778.* Vol. 1. Leipzig: C. Fritsch, 1779.

Białostocki, Jan. *The Art of the Renaissance in Eastern Europe: Hungary, Bohemia, Poland.* Oxford: Phaidon Press, 1976.

___. "Au Sujet de deux portraits de Ferdinand Bol." *Bulletin des Musées Royaux des Beaux-Arts de Belgique* 5 (1957), pp. 43–51.

___. "Jan Brueghel a Polska." *Biuletyn Historii Sztuki* 12 (1950), pp. 322–23.

___. *Malarstwo niderlandzkie w zbiorach polskich, 1450–1550.* Warsaw: Muzeum Narodowe w Warszawie, 1960.

___. *Les Primitifs flamands. Les Musées de Pologne. Corpus de la peinture de anciens Pays-Bas méridionaux au XVe siècle.* Vol. 9. Brussels: Centre National de Recherches, 1966.

___. "Rembrandt et ses élèves: trois problèmes." *Biuletyn Historii Sztuki* 18 (1956), pp. 349–69.

___. *Sztuka cenniejsza niż złoto: opowieść o sztuce europejskiej naszej ery.* 3rd ed. Warsaw: Państwowe Wydawnictwo Naukowe, 1969.

___. "'Zdjęcie z krzyża' w twórczości P.P. Rubensa i jego pracowni. (Uwagi o znaczeniu obrazu w Kościele św. Mikołaja w Kaliszu)." In Warsaw, The National Museum. *Sztuka i historia. Księga pamiątkowa ku czci profesora Michała Walickiego.* Warsaw: Wydawnictwo Artystyczne i Filmowe, 1996, pp. 117–39.

Białostocki, Jan and Janina Michałkowa. "Nabytki Galerii Malarstwa Obcego 1945–1957." *Rocznik Muzeum Narodowego w Warszawie* 5, 64 (1960).

Białostocki, Jan and Michał Walicki. *Malarstwo europejskie w zbiorach polskich 1300–1800.* Warsaw: Państwowy Instytut Wydawniczy, 1955 (vol. 1), 1958 (vol. 2).

Blankert, Albert. *Ferdinand Bol 1616–1680: Rembrandt's Pupil.* Doornspijk: Davaco, 1982, no. D9, p. 160.

Blejwas, Stanislaus A. *Realism in Polish Politics: Warsaw Positivism and National Survival in Nineteenth Century Poland.* New Haven, Connecticut: Yale Russian and East European Publications, Yale Concilium on International and Area Studies, 1984.

Blunt, Anthony. *The Paintings of Nicolas Poussin. A Critical Catalogue.* London: Phaidon Press, 1966.

Bogucka, Maria. "Polish Towns Between the Sixteenth and Eighteenth Centuries." In Fedorowicz, Jan. K., ed. *A Republic of Nobles.*

Studies in Polish History to 1864. Cambridge, England: Cambridge University Press, 1982, pp. 135–52.

Bogucka, Maria and Henryk Samsonowicz. *Dzieje miast i mieszczaństwa w Polsce przedrozbiorowej.* Wrocław: Zakład Narodowy im. Ossolińskich, 1986.

Bok, Martin Jan. "Biography of Matthias Stommer." In Utrecht, Centraal Museum. *Nieuw Licht op de Gouden Eeuw, Hendrick Ter Brugghen en tijdgenoten.* Utrecht, 1986, p. 333.

Bordeaux, Galerie des Beaux Arts. *Trésors d'art polonais. Chefs d'oeuvre des musées de Pologne.* Text by Gilberte Martin-Méry. Bordeaux, 1961.

Bordeaux, Musée des Beaux-Arts. *Delacroix, ses maîtres, ses élèves.* Bordeaux, 1963, no. 296, ill. 16.

Braunschweig, Herzog Anton Ulrich-Museum. *Europäische Malerei des Barock aus dem Nationalmuseum Warschau.* Braunschweig, 1988.

Bräutigam, Günther. "Ehemaliger Hochaltar der Karmeliterkirche in Nürnberg." In Nuremberg, Germanisches Nationalmuseum. *Veit Stoss in Nürnberg: Werke des Meisters und seiner Schule in Nürnberg und Umgebung.* Ed. Gerhard Bott. Munich: Deutscher Kunstverlag, 1983, pp. 333–50.

Brink, Jean R. and William F. Gentrup, eds. *Renaissance Culture in Context. Theory and Practice.* Aldershot, England: Scolar Press, 1993.

Brock, Peter. "Polish Nationalism." In Sugar, Peter F. and Ivo J. Lederer, eds. *Nationalism in Eastern Europe.* Seattle: University of Washington Press, 1969.

Brown, Alison. *The Renaissance.* 2nd ed. London and New York: Longman, 1999.

Brown, David Allen. *Leonardo da Vinci: The Origins of a Genius.* New Haven and London: Yale University Press, 1998.

Brussels, Archives Générales. *Autour de J. Brueghel l'Ancien, P.P. Rubens, A. van Dyck....* Brussels, 1999.

Brussels, Musées Royaux des Beaux-Arts de Belgique. *Le Siècle de Bruegel. La Peinture en Belgique au XVIe siècle.* Brussels, 1963, no. 130.

Buijnsters-Smets, Leontine. *Jan Massys.* Zwolle, The Netherlands: Waanders, 1995.

Burnett, Philip Mason. *Reparations at the Paris Peace Conference from the Standpoint of the American Delegation.* New York: Columbia University Press, 1940, vol. 1, doc. 257, pp. 886–87.

Butterwick, Richard. *Poland's Last King and English Culture: Stanisław August Poniatowski, 1732–1798.*

Oxford: Clarendon Press, 1998.

Canova, Giordana Mariani. "Paris Bordon: Problematiche Cronologiche." In *Paris Bordon e il suo tempo – Atti del Convegno Internazionale di Studi – Treviso, 28–30 ottobre, 1985*. Treviso: Canova, 1988, p. 54.

Carapelli, Ricardo. "Annibale Ranuzzi e i suoi rapporti con la Firenze medicea del'600" *Il Carrobio* 10 (1984), p. 79.

Catalogue des Tableaux Anciens, Portraits du XVIIIe siècle, Pastels [...] Vente [...] Madame la Comtesse André Mniszech. Paris, Hôtel Druot, May 9–10, 1910, lot 8.

Cavanaugh, Jan. *Out Looking In: Early Modern Polish Art, 1890–1918*. Berkeley-Los Angeles-London: University of California Press, 2000.

Cemka, Frenuszeh. "Struktura i finansowanie muzeów w Polsce po reformie samorządowej." In *Muzealnictwo w Polsce i Holandii*. Warsaw, 2000, pp. 5–12.

Chicago, The Art Institute of Chicago. *Rembrandt After Three Hundred Years*. Chicago, 1969, no. 31.

Chodyński, Antoni Romuald. "Kolekcjonerstwo." In Gdańsk, The National Museum. *Aurea Porta. Sztuka Gdańska od Połowy XV od końca XVII wieku*. Ed. Teresa Grzybowska. Warsaw, 1997, pp. 348-63.

Chrościcki, Juliusz A., ed. *Ars auro prior. Studia Ioanni Białostocki sexagenario dicata*. Warsaw: Państwowe Wydawnictwo Naukowe, 1981.

___. "De 'kunstkamer' van de Poolse Kroonprins van 1626." In Antwerp, Koninklijk Museum voor Schone Kunsten. *De prinselijke pelgrimstocht. De "Grand Tour" van Prins Ladislas van Polen (1624–1625)* (Antwerp, 1997), pp. 47–59.

___. "Een reis van de Poolse Kroonprins Westeuropas (1624–1625)." In Antwerp, Koninklijk Museum voor Schone Kunsten. *De prinselijke pelgrimstocht. De "Grand Tour" van Prins Ladislas van Polen (1624–1625)*. Antwerp, 1997, pp. 33–42.

___. "Obrazy religijne Petera Paula Rubensa." In Warsaw, The National Museum. *Arcydzieło Petera Paula Rubensa "Zdjęcie z krzyża" ze zbiorów Państwowego Ermitażu w Sankt Petersburgu. Z tradycji przedstawień pasyjnych w malarstwie i grafice północnoeuropejskiej XVI i XVII wieku*. Warsaw, 2000, pp. 32–38.

___. "Rubens w Polsce." *Rocznik Historii Sztuki* 12 (1981), pp. 133–219.

Chruścicki, Tadeusz. "O museach narodowych w Polsce." *Spotkania z zabytkami* 7 (2001), pp. 1, 2.

Chrzanowski, Tadeusz and Zdzisław Żygulski, Jr. *Poland: Treasures of the Past*. Trans. Krzysztof Kwaśniewicz. Cracow: Wydawnictwo Ryszard Kluszczyńskiego, 2001.

Chudzikowski, Andrzej. *Krajobraz holenderski*. Warsaw: Sztuka, 1957, no. 35, ill.34.

Chyczewska, Alina. *Marcello Bacciarelli, życie-twórczość-dzieła*. Poznań, 1968 (vol. 1), 1970 (vol. 2).

___. *Marcello Bacciarelli 1731–1818*. Wrocław, 1973, pp. 106–107.

Ciechanowiecki, Andrzej and Bohdan Jeżewski. *Polonica na Wyspach Brytyjskich*. London: Taurus, 1966, pp. 197f.

Clegg, Elisabeth. "A Question of 'Presence': The Lemberg City Gallery." In Dłutek, Maria, ed. *Arx Felicitatis. Księga ku czci Profesora Andrzeja Rottermunda*. Warsaw: Państwowa Akademia Nauk i Towarzystwo Opieki nad Zabytkami, 2001.

Cracow, The National Museum. *Muzeum Narodowe w Krakowie, Zbiory Czartoryski: Historia i wybór zabytków*. Warsaw: Arkady, 1978.

Cracow, The Princes Czartoryski Museum. *The Czartoryski Museum*. Text by Adam Zamoyski. London: Azimuth Editions on behalf of The Princes Czartoryski Foundation, 2001.

Cynarski, Stanisław. "The Shape of Sarmatian Ideology in Poland." *Acta Poloniae Historica* 19 (1968), pp. 5–17.

___. *Zygmunt August*. Wrocław: Zakład Narodowy im. Ossolińskich, 1988.

Czartoryska, Izabela. *Poczet pamiątek zachowanych w Domu Gotyckim w Puławach*. Warsaw: Drukarnia Banku Polskiego, 1828, p. 2.

Czok, Karl. *August der Starke und Kursachsen*. Leipzig: Koehler und Amelang, 1987.

Davies, Norman. *God's Playground. A History of Poland*. 2 vols. New York: Columbia University Press, 1982.

___. *Heart of Europe: A Short History of Poland*. Oxford: Oxford University Press, 1986.

De Callatay, Edouard. "Cornelis Massys paysagiste, collaborateur de son père et son frère et auteur de l'album Errera." *Bulletin Musées Royaux des Beaux-Arts de Belgique* 14 (1965).

Dębicki, Ludwik. *Puławy (1762–1830). Monografia z życia towarzyskiego, politycznego i literackiego na podstawie archiwum Ks. Czartoryskich w Krakowie*. Vol. 1. Lwów: Nakład Księgarni Gubrynowicza i Schmidta, 1887, p. 66.

Detloff, Szymon. "Krakowski projekt na ołtarz bam-

berski Wita Stwosza." *Rocznik Krakowski* 26 (1935), p. 94.

Detroit, The Detroit Institute of Arts. *Symbolism in Polish Painting 1890–1914*. Detroit, 1984, p. 78, no. 35.

Dłutek, Maria, ed. *Arx Felicitatis. Księga ku czci Profesora Andrzeja Rottermunda*. Warsaw: Państwowa Akademia Nauk i Towarzystwo Opieki nad Zabytkami, 2001.

Dobrowolski, Witold. "Hamlet czy Herakles." *Art & Business* 4 (1997), p. 34.

Dobrzycka, Anna. *Jan van Goyen 1596–1656*. Poznań: Państwowe Wydawnictwo Naukowe, 1966, pp. 36, 167, ill. 32.

Dokumenty dotyczące akcji Delegacyj Polskich w Komisjach Mieszanych Reewakuacyjnej i Specjalnej w Moskwie. Vols. 1–7. Warsaw: Delegacje Polskie w Komisjach Reewakuacyjnej i Specjalnej w Moskwie, 1922–23.

Dresden, Staatliche Kunstsammlungen and Warsaw, The Royal Castle. *Unter einer Krone: Kunst und Kultur der sächsisch-polnischen Union*. Leipzig: Edition Leipzig, 1997.

Drost, Willi. *Die Danziger Gemäldegalerie. Neuerwerbungen 1940/4*. Danzig, 1943, pp. 8, 12, 13, 16.

Dunbar, Burton L. "The Question of Cornelis Massys' Landscape Collaboration with Quinten and Jan Massys." *Jaarboek van het Koninklijk Museum voor Schoone Kunsten te Antwerpen* (1979).

Dunin-Karwicki, Stanisław. *Pałac Łazienkowski w Warszawie*. Lwów: Książnica-Atlas, 1930, pp. 44–52.

Duverger, Eric. "Annotations conserant 'Sieur Jefan Bierens, agent et domesticque de son Alteze le Serenissime Prince Wladislaus Sigismundus, Prince de Pologne et de Suede à Anvers." *Gentse Bijdragen tot de Kunstgeschiedenis en Oudheidkunde* 30 (1995), pp. 119–57.

___. "Le Commerce d'art. Entre Flandre et l'Europe Centrale au XVIIe siècle, Evolution générale et developpements régionaux en histoire de l'art." *Actes du XXII-ème Congrès International d'Histoire de l'art*. Budapest, 1972, pp. 157–81.

Essen, Germany, Kulturstiftung Ruhr, Villa Hugel. *Breughel-Brueghel. Pieter Breughel der Jüngere – Jan Breughel der Ältere. Flämische Malerei um 1600. Tradition und Fortschritt*. Text by Klaus Ertz. Essen, 1997.

Estreicher, Karol. *Collegium Maius. Dzieje Gmachu.*

Cracow: Uniwersytet Jagielloński, 1968, pp. 66–117.

Faison, S. Lane, Jr. *Consolidated Interrogation Report No. 4*. Strategic Services Unit. War Department. Art. Looting Investigation Unit APO 413, U.S. Army, December 15, 1945, pp. 5, 6.

Fedorowicz, Jan K., ed. *A Republic of Nobles. Studies in Polish History to 1864*. Cambridge, England: Cambridge University Press, 1982.

Fiszman, Samuel, ed. *The Polish Renaissance in Its European Context*. Bloomington and Indianapolis: Indiana University Press, 1988.

Fort Worth, Texas, Kimbell Art Museum. *Elisabeth-Louise Vigée-LeBrun, 1755–1842*. Text by Joseph Baillio. Fort Worth, 1982.

Fried, Johannes. *Otto III. und Boleslaw Chrobry*. 2nd ed. Stuttgart: F. Steiner Verlag, 2000.

Friedländer, Max J. *Altniederländische Malerei 12*. Leiden: A. W. Sijthaff, 1935, no. 209a, p. 91.

Fritzsche, Hellmuth Allwill. *Bernardo Bellotto, gennannt Canaletto*. Magdeburg, Germany, 1936.

Gdańsk, The National Museum. *Aurea Porta. Sztuka Gdańska od połowy XV do końca XVII wieku*. Ed. Teresa Grzybowska. Gdańsk, 1997.

___. *Katalog Muzeum pomorskiego w Gdańsku. Zbiory sztuki*. Gdańsk, 1969, no. 52.

___. *Malarstwo flamandzkie i holenderskie w zbiorach Museum Narodowego w Gdańsku. Przewodnik po wystawie*. Text by Krystyna Górecka-Petrajtis. Gdańsk, 1993, p. 24.

Gilbert, Creighton. "What Did the Renaissance Patron Buy?" *Renaissance Quarterly* 51 (1998), pp. 392–450.

Gołubiew, Zofia. "Czym jest Muzeum Narodowe? Trudne słowo." *Tygodnik Powszechny* 46 (November 18, 2001).

Gosieniecka, Anna. "Muzealnictwo." In *Wystawa rewindykowanych zbiorów gdańskich*. Poznań, 1958, p. 46, nos. 7, 8.

Grochulska, Barbara. *Księstwo warszawskie*. Warsaw: Wiedza Powszechna, 1991.

de Groot, Hofstede. *Beschreibendes und Kritisches Verzeichnis der Werke der Hervorragendsten Holländischen Maler des XVII Jahrhunderts*. Esslingen-Paris: P. Neff, 1907–28, vol. 8, 1923, no. 783.

Grzybowska, Teresa. *Artyści i patrycjusze Gdańska*. Warsaw: Wydawnictwo DiG, 1996, p. 16.

___. *Złoty wiek malarstwa gdańskiego na tle kultury artystycznej miasta; 1520–1620*. Warsaw: Państwowe Wydawnictwo Naukowe, 1990.

Handelsman, Marceli. *Napoléon et la Pologne.* Paris: F. Alcan, 1909.

van Heel, S.A.C. Dudok. "Het maecenaat Trip. Opdrachten aan Ferdinand Bol en Rembrandt van Rijn." *De Kroniek van he Rembrandthuis* 31, 1 (1979), pp. 14–26.

Helsinki, Finnish National Gallery, Museum of Foreign Art. *The Chessplayers: Italian Paintings from the Collections of the Muzeum Narodowe in Poznań.* Helsinki, 1999.

Hennel-Bernasikowa, Maria. *Arrasy Zygmunta Augusta.* Cracow: The Wawel Royal Castle, 1998.

Henning, Michael. *Die tafelbilder Bartholomäus Spranger (1546–1611). Höfische Malerei zwischen "Manierismus" und "Barock."* Essen: Blaue Eule, 1987, pp. 146–47.

Hentzen, Alfred. "Abraham Hondius." *Jahrbuch der Hamburger Kunstsammlungen* 8 (1963), pp. 33–56.

Heydel, A. *Jacek Malczewski, człowiek i artysta.* Cracow: Wydawnictwo Literacko-Naukowe, 1933, p. 171.

Hutten-Czapski, Emeryk. *Spis rycin przedstawiających portrety przeważnie polskich osobistości w zbiorach Emeryka hrabiego Hutten-Czapskiego w Krakowie.* Cracow, 1901, no. 1829.

Inventaire des tableaux, dessins, marbres et plâtres dans le Chateau Royale à Varsovie 1797. Warsaw: MS at AGAD (Head Office for Old Documents), Archive of Prince Józef Poniatowski and Maria Tyszkiewicz.

Inwentarz mebli i różnych efektów w Zamku Warszawskim Jego Królewskiej Mości znajdujących się na Zamku w roku 1808. Warsaw: MS at AGAD, Administrative Division of the Demesne Restored to the Polish Kingdom and Treasury.

Janson, Horst Waldemar. "The Putto with the Death's Head." *The Art Bulletin* 19 (1937) p. 429, ill. 7.

Jardine, Lisa. *Worldly Goods. A New History of the Renaissance.* London: Doubleday, 1996.

Jedlicki, Jerzy. *A Suburb of Europe: Nineteenth-Century Polish Approaches to Western Civilization.* Budapest and New York: Central European University Press, 1999, p. ix.

Józefowiczówna, Maria, ed. *Inwentarz Archiwum Księcia Józefa Poniatowskiego i Marii Teresy Tyszkiewiczowej z lat 1516, 1647–1843.* Warsaw: Państwowe Wydawnictwo Naukowe, 1987.

Juszczak, Wiesław. *Malarstwo polskie. Modernizm.* Warsaw: Auriga, 1977, p. 74.

Kahsnitz, Rainer, ed. *Veit Stoss: die Vorträge des Nürnberger Symposions.* Munich: Deutscher Kunstverlag, 1985.

Kalinowski, Lech and Franciszek Stolot, eds. *Wit Stwosz w Krakowie.* Cracow: Państwowe Wydawnictwo Naukowe, 1987.

Kaufmann, Thomas Da Costa. *Court, Cloister, and City. The Art and Culture of Central Europe 1450–1800.* Chicago: University of Chicago Press, 1995.

___. *The School of Prague, Painting at the Court of Rudolf II.* Chicago: University of Chicago Press, 1988, p. 272, no. 20, fig. 71.

Kępińska, Alicja. *Jan Piotr Norblin.* Wrocław: Zakład Narodowy im. Ossolińskich, 1978, p. 33.

Kępiński, Zdzisław. *Wit Stwosz w starciu ideologii religijnych Odrodzenia, Ołtarz Salwatora.* Wrocław: Ossolineum, 1969, pp. 99–139, 197.

Kieniewicz, Stefan. *The Emancipation of the Polish Peasantry.* Chicago: University of Chicago Press, 1969.

Kieniewicz, Stefan, Andrzej Zahorski, and Władysław Zajewski. *Trzy powstania narodowe.* Warsaw: Książka i Wiedza, 1992, 1994.

Kłoczowski, Jerzy. "Kościół katolicki a kultura artystyczna w dziejach Polski przedrozbiorowej." In Mrozowski, Przemysław and Artur Badach, eds. *Ornamenta Ecclesiae Poloniae. Skarby sztuki sakralnej wiek X–XVIII.* Warsaw: Dom Polski, 1999, pp. 11–19.

Knoll, Paul W. "Italian Humanism in Poland: The Role of the University of Kraków in the Fifteenth and Early Sixteenth Centuries." In Brink, Jean R. and William F. Gentrup, eds. *Renaissance Culture in Context. Theory and Practice.* Aldershot, England. Scolar Press, 1993.

___. "Jadwiga and Education." *The Polish Review* 44 (1999), pp. 419–31.

Kociatkiewiczówna, M. *Przewodnik po Muzeum Ordynacji Krasińskich.* Warsaw, 1930, pp. 24–25 (no. 1132).

Konstantynow, Dariusz, Robert Pasieczny, and Piotr Paszkiewicz, eds. *Nacjonalizm w sztuce i historii sztuki 1789–1950.* Warsaw: Instytut Sztuki Polskiej Akademii Nauk, 1998.

Kowalski, Wojciech W. *Art Treasures and War. A Study on the Restitution of Looted Cultural Property, Pursuant to Public International Law.* London: Institute of Art and Law, 1998, p. 91.

___. *Liquidation of the Effects of World War II in the Area of Culture.* Warsaw: Polski Instytut Kultury, 1994, pp. 19ff.

___. "The Machinery of Nazi Art Looting. The Nazi Law on the Confiscation of Cultural Property – Poland: A Case Study." *Art, Antiquity and Law* 5, 3 (2001).

Kozakiewicz, Helena and Stefan Kozakiewicz. *The Renaissance in Poland*. Warsaw: Arkady, 1976, pp. 7–124.

Kozakiewicz, Stefan. *Bernardo Bellotto*. 2 vols. London: Elek, 1972.

Krakowski, Piotr. "Nacjonalizm a sztuka 'patriotyczna.'" In Konstantynow, Dariusz, Robert Pasieczny, and Piotr Paszkiewicz, eds. *Nacjonalizm w sztuce i historii sztuki 1789–1950*. Warsaw: Instytut Sztuki Polskiej Akademii Nauk, 1998, pp. 15–24.

Król-Kaczorowska, Barbara. "'Svolta dei lavori forniti alla corte' di Varsavia ed altri documenti bellottiani." *Bulletin du Musée National de Varsovie* 7 (1966), pp. 68–75.

Kumamoto, Japan, The Prefectural Museum of Art. *Exhibition of Polish National Treasury of Art*. Kumamoto, 1979, fig. 15.

Kumaniecki, Jerzy. *Tajny raport Wojkowa, czyli radziecka taktyka zwrotu polskiego mienia gospodarczego i kulturalnego po pokoju ryskim*. Warsaw: Gryf, 1991, p. 171.

Kwiatkowski, Marek. *Stanisław August. Król-Architekt*. Wrocław: Zakład Narodowy im. Ossolińskich, 1983.

Labrot, Gérard. *Collections of Painting in Naples 1600–1780*. Munich: K.G. Saur, 1992, p. 217.

Labuda, Adam Stanisław, ed. *Malarstwo gotyckie w Wielkopolsce*. Poznań: Wydawnictwo Poznańskiego Towarzystwa Przyjaciół Nauk, 1994.

___. *Wit Stwosz: Studia o Sztuce i Recepcji*. Warsaw: Państwowe Wydawnictwo Naukowe, 1986.

de Lavergnée, A. Brejon. "Nouveaux tableaux caravaggesques français apparus depuis l'exposition 'Valentin' Rome-Paris 1973–1974." *Bulletin de la Société des Amis des Musées de Dijon*, 1973–75, p. 57.

Lechicki, Czesław. *Mecenat Zygmunta III, życie umysłowe na jego dworze*. Warsaw: Kasa im. Mianowskiego – Instytut Popierania Nauki, 1932.

Lepszy, Kazimierz, ed. *Dzieje Uniwersytetu Jagiellońskiego w latach 1364–1764*. Cracow: Państwowe Wydawnictwo Naukowe, 1964.

Lewicka-Kamińska, Anna. "Biblioteka Jagiellońska w latach 1492–1655." In Zathey, Jerzy, Anna Lewicka-Kamińska, and Leszek Hajdukiewicz, eds. *Historia Biblioteki Jagiellońskiej, vol. I: 1364–1775*. Cracow: Uniwersytet Jagielloński, 1966, pp. 133–75.

Łódź, Museum Sztuki w Łodzi. *Arcydzieła malarstwa holenderskiego*. Text by Mieczysław Potemski. Łódź, 1967, no. 16.

London, Dulwich Picture Gallery. *Treasures of a Polish King: Stanislaus Augustus as Patron and Collector*. London, 1992.

London, The Royal Academy and the Victoria & Albert Museum. *The Age of Neoclassicism*. London, 1972, p. 94.

Lorentz, Stanisław. "Muzeum Narodowe w Warszawie w latach 1939–1945." *Rocznik Muzeum Narodowego w Warszawie* 2 (1957), p. 9.

___. *Przewodnik po muzeach i zbiorach w Polsce*. 3rd ed. Warsaw: Wydawnictwo Interpress, 1982.

Lorentz, Stanisław and Andrzej Rottermund. *Neoclassicism in Poland*. Trans. Jerzy Bałdyga. Warsaw: Arkady, 1986.

Lossnitzer, Max. *Viet Stoss. Die Herkunft seiner Kunst, seine Werke und sein Leben*. Leipzig: J. Zeitler, 1912, pp. 94–100.

Mączak, Antoni. "The Structure of Power in the Commonwealth of the Sixteenth and Seventeenth Centuries." In Fedorowicz, Jan K., ed. *A Republic of Nobles. Studies in Polish History to 1864*. Cambridge, England: Cambridge University Press, 1982, pp. 113–34.

Magier, Antoni. *Estetyka miasta stołecznego Warszawy*. Wrocław: Zakład Narodowy im. Ossolińskich, 1963, p. 139.

Małachowski-Łempicki, Stanisław. *Wykaz polskich lóż wolnomularskich oraz ich członków w latach 1738 –1821*. Cracow: Gebethner i Wolff, 1929, p. 173, no. 2891.

Malvasia, Carlo Cesare. *Felsina Pittrice*. Bologna: Tip Guidi all' Ancora, 1841, vol. 2, p. 398.

Manikowska, Ewa. "Kolekcjonerstwo obrazów mistrzów europejskich w dawnej Polsce." In Warsaw, The National Museum. *Sztuka cenniejsza niż złoto. Obrazy, rysunki i ryciny dawnych mistrzów europejskich ze zbiorów polskich*. Warsaw, 1999, p. 26.

Mańkowski, Tadeusz. *Galeria Stanisława Augusta*. Lwów: Wydawnictwo Zakładu Narodowego imienia Ossolińskich, 1932.

Mansfeld, Bogusław. *Muzea na drodze do samoorganizacji. Związek Muzeów w Polsce 1914–1951*. Warsaw: Wydawnictwo DiG, 2000.

Marani, Pietro C. *Leonardo da Vinci: The Complete Paintings*. Trans. A. Lawrence Jenkens. New York:

Harry N. Abrams, Inc., 2000.

Marconi, Bohdan. "Jedenaście obrazów z nieznanej galerii Sułkowskich w Rydzynie." *Biuletyn Historii Sztuki* 19 (1957), pp. 169–77.

Marinelli, Sergio. "I 'lumi' e las ombre della città del principe." In Verona, Museo di Castelvecchio. *Bernardo Bellotto: Verona e le città europee.* Ed. Sergio Marinelli. Milan: Electa, 1990, pp. 39–50.

Martin, John Rupert "A Portrait of Rubens by Daniel Seghers." *Record of the Art Museum, Princeton University* 17 (1958), pp. 2f.

___. "Portraits of Poussin and Rubens in Works by Daniel Seghers." *Bulletin du Musée National de Varsovie* 3 (1961), pp. 67–74.

Martin, W. *Gerard Dou, des Meister Gemälde.* Stuttgart: Deutsche Verlags-Anstalt, 1913, p. xxi.

McClellan, Andrew. *Inventing the Louvre.* Cambridge, England: Cambridge University Press, 1994, p. 108.

Mehoffer, Józef. *Dziennik.* Cracow: Wydawnictwo Literackie, 1975, p. 338.

Michałkowa, Janina. *Obrazy mistrzów obcych w polskich kolekcjach.* Warsaw: Auriga, 1992, pl. 40.

Mickiewicz, Władysław. *Żywot Adama Mickiewicza; podług zebranych przez siebie materyałów oraz z własnych wspomnień.* Vol. 1. Poznań: Dziennik Poznański, 1890, p. 333.

Miłobędzki, Adam. "Architecture under the Last Jagiellons in Its Political and Social Context." In Samuel Fiszman, ed. *The Polish Renaissance in Its European Context.* Bloomington, Indiana: Indiana University Press, 1988, pp. 291–301.

___. *Architektura Polska XVIII wieku.* Warsaw: Stwone Wydawnictwo Naukowe, 1980.

Ministerstwo Kultury i Sztuki w dokumentach 1918–1998. Warsaw: Instytut Kultury, 1998.

Morawińska, Agnieszka. "Hortus deliciarum Józefa Mehoffera." In Chrościcki, Juliusz A., ed. *Ars auro prior. Studia Ioanni Białostocki sexagenario dicata.* Warsaw: Państwowe Wydawnictwo Naukowe, 1981, pp. 713–18.

Mrozowski, Przemysław i Artur Badach, eds. *Ornamenta Ecclesiae Poloniae. Skarby sztuki sakralnej wiek X–XVIII.* Warsaw: Dom Polski, 1999.

Munich, Bayerische Staatsgemäldesammlungen. *Polens letzter König und seine Maler: Kunst am Hofe Stanislaus August Poniatorskis reg. 1764–1795.* Munich, 1996.

Murray, Peter. *Dulwich Picture Gallery: A Catalogue.* London: Philip Wilson Publishers Ltd. for Sotheby Parke Bernet Publications and the Governors of Dulwich College, 1980.

Mycielski, Jerzy and Stanisław Wasylewski. *Portrety polskie Elżbiety Vigée-Lebrun.* Lwów-Poznań: Wydawnictwo Polskie, R. Wegner, 1928, appendix, pp. 4, 43–46, 129–31.

Mytariewa, K. "O wzajemnych kontaktach Wileńskiej Szkoły malarstwa i Akademii Sztuk Pięknych w Petersburgu." *Rocznik Museum Narodowego w Warszawie* 16 (1972), p. 273.

Naples, Museo di Capodimonte. *Mattia Preti tra Roma, Napoli e Malta.* Text by M. Utili. Naples: Electa Napoli, 1999, pp. 124–26.

The Nazi Kultur in Poland by Several Authors of Necessity Temporarily Anonymous. London: Published for the Polish Ministry of Information by H.M. Stationery Office, 1945.

New York, Kościuszko Foundation. *The Fifth Annual Exhibition of Paintings by American Artists of Polish Descent, jointly with Selected Polish Paintings from 1793 to 1939.* New York, 1951, p. 5, no. 1.

Nicholas, Lynn H. *The Rape of Europa: The Fate of Europe's Treasures in the Third Reich and the Second World War.* New York: A. Knopf, 1994.

Niedzielska, Magdalena. "Obraz Jana Massysa 'Wenus z amorkiem' i jego konserwacja." *Opuscula Musealia* 6 (1992).

Nuremberg, Germanisches Nationalmuseum. *Veit Stoss in Nürnberg: Werke des Meisters und seiner Schule in Nürnberg und Umgebung.* Ed. Gerhard Bott. Munich: Deutscher Kunstverlag, 1983.

Oberhuber, Konrad. "Die stilistische Entwicklung im Werk Bartolomäcus Spranger." PhD dissertation, University of Vienna, 1958, p. 222.

Okoń, Waldemar. *Alegorie narodowe: studia z dziejów sztuki polskiej XIX w.* Wrocław. Wydawnictwo Uniwersytetu Wrocławskiego, 1992, p.7.

___. "Polskie dziewiętnastowieczne malarstwo historyczne i mity narodowe." In *Polska Myśl Polityczna XIX i XX,* vol. 9 of *Polskie mity polityczne XIX i XX wieku.* Wrocław: Wydawnictwo Uniwersytetu Wrocławskiego, 1994, pp. 58–61.

Paderewski, Ignacy Jan. *Pamiętniki.* Recorded by Mary Lawton. Warsaw: Polskie Wydawnictwo, 1986, p. 230.

Pallucchini, Rodolfo. "L'arte del Bellotto." In *Venezia e la Polonia nei secoli dal XVII al XIX.* Venice: Istituto per la collaborazione culturale, 1965, pp. 65–85.

___. *Vedute del Bellotto.* Milan: Rizzoli, 1961.

Papi, Gianni. "Caravaggio e Cecco." In Gregori, Mina, ed. *Come dipingeva il Caravaggio: atti della*

giornata di studio. Milan: Electa, 1996.

___. *Cecco del Caravaggio*. Florence: Opus libri, 1992.

Paris, Galeries Nationales du Grand Palais. *L'Esprit Romantique dans l'Art Polonais*. Paris, 1997.

Paris, Musée de l'Orangerie. *La Nature morte de l'antiquité à nos jours*. Text by Charles Sterling. Paris: Editions des Musées nationaux, 1952, note 92.

"Polish-German Financial Agreements. January 9, 1920, article VI." In *Rokowania polsko-niemieckie*. Warsaw: Ministry of Foreign Affairs, 1925.

"Polski portret wolnomularski (do 1821 roku)." In *Portret. Funkcja-Forma-Symbol*. Materials of the Session of the Association of Art Historians, Toruń, December 1986. Warsaw, 1990, pp. 258–60.

Poprzęcka, Maria. *Masterpieces of Polish Painting*. Trans. Aleksandra Rodzińska-Chojnowska. Warsaw: Wydawnictwo Arkady, 1997.

Porębski, Mieczysław. *Interregnum. Studia z historii sztuki polskiej XIX I XX wieku*. Warsaw: Państwowe Wydawnictwo Naukowe, 1975.

Potocki, Stanisław Kostka. *O sztuce u dawnych, czyli Winckelman polski*. Warsaw, 1815.

Poznań, The National Museum. *Galeria Rogalińska Edwarda Raczyńskiego*. Text by Maria Gołąb, Agnieszka Ławniczakowa, and M. Piotr Michałowski. Ed. Agnieszka Ławniczakowa. Poznań, 1997.

___. *"Galeria Hiszpańska." Muzeum Narodowego w Poznaniu*. Text by Konstanty Kalinowski. Poznań, 1998.

___. *Italian Painting before 1600*. Poznań, 1995.

___. *Jacek Malczewski und seine Zeitgenossen: Polnische Malerei um 1900 aus der Sammlung des Nationalmuseums in Poznań*. Poznań, 1999.

___. *Jacek Malczewski. Wystawa dzieł z lat 1890–1926*. Text by Agnieszka Ławniczakowa. Poznań, 1990, pp. 79–80, cat. 38.

___. *Portret holenderski XVII wieku w zbiorach polskich*. Text by Anna Dobrzycka. Poznań, 1956.

Prószyńska, Zuzanna. "'Fidem Fati- Virtute Sequemur.' The Portrait of Stanislaus Augustus with an Hourglass." *Bulletin du Musée National de Varsovie* 1–4 (1993), pp. 1–9.

Przyboś, Adam, ed. *Podróż królewicza Władysława Wazy do krajów Europy Zachodniej w latach 1624–1625 w świetle ówczesnej relacji*. Cracow: Wydawnictwo Literackie, 1977.

Purc-Stępniak, Beata. "Martwa natura z czaszką Gerrita Dou – kula jako symbol vanitas." Materials from the session *A Controversy over the*

Origins of Still Life. Toruń: Mikołaj Kopernik University, 2001.

Quebec, Musée du Québec. *Le Retour des trésors polonais*. Quebec, 2001.

Raleigh, North Carolina Museum of Art. *The Naked Soul: Polish fin-de-siècle Paintings from the National Museum, Poznań*. Text by Maria Gołąb, Agnieszka Ławniczakowa, Jan K. Ostrowski, and Andrew Jenner. Ed. Agnieszka Ławniczakowa. Trans. Anna Dvorák, Krzysztof Sawala, and Leonarda Zbierska. Raleigh, 1993.

"The Regulation of the Minister of Agriculture and Land Reforms of 1 March 1945, on the Execution of Land Reform." *Journal of Laws 1945*, number 10, item 51.

Ridolfi, Carlo. *La Meraviglie dell'Arte ovvero le Vite degli illustri Pittori Veneti e dello Stato*. Venice: G. B. Sgaug, 1648, p. 212.

Rizzi, Alberto. *Bernardo Bellotto Warschauer Veduten*. Munich: Hirmer Verlag, 1991.

___. *La Varsavia di Bellotto*. Milan: Berenice, 1990.

Röhr, Werner, ed. *Die faschistische Okkupationspolitik in Polen (1939–1945)*. Berlin: VEB Deutscher Verlag der Wissenschaften, 1989, p. 197.

Romein, Jan and Annie *Twórcy kultury holenderskiej*. Warsaw, 1973.

Rostworowska, Maria. *Czas nie stracony: życie i działalność Xawerego Pusłowskiego*. Cracow: Terra Nova, 1998.

Rostworowski, Marek. *Rembrandta przypowieść miłosiernym Samarytaninie*. Warsaw: Wydawnictwo Artystyczne i Filmowe "Auriga," 1980, p. 110.

Roth, John K. and Elisabeth Maxwell-Meynard, eds. *Remembering for the Future: The Holocaust in an Age of Genocide*. Houndmills, New York: Palgrave, 2001.

Rottermund, Andrzej. "Historia muzeów w Polsce. Zarys problematyki." In *Muzealnictwo w Polsce i Holandii*. Polish-Dutch Workshops in Nieborów. Warsaw, 2000, pp. 25–37.

___. *Zamek Warszawski w epoce Oświecenia. Rezydencja monarsza – funkcje i treści*. Warsaw: The Royal Castle, 1989.

Ruszczyc, Ferdynand. *Dziennik. Ku Wilnu 1894–1919*. Ed. Edward Ruszczyc. Warsaw: Secesja, 1994, pp. 135–36.

Ryszkiewicz, Andrzej. *Kolekcjonerzy i miłośnicy*. Warsaw: Państwowe Wydawnictwo Naukowe, 1981, pp. 180–81, no. 48.

___. "Les Portraits polonais de Madame Vigée-

LeBrun. Nouvelles données pour servir à leur identification et histoire." *Bulletin du Musée National de Varsovie* 1 (1979), pp. 23, 40.

Sammlung Graf Raczyński: Malerei der Spätromantik aus dem Nationalmuseum Poznań. Munich: Hirmer Verlag, 1992.

Samsonowicz, Henryk. "Polish Politics and Society under the Jagiellonian Monarchy." In Fedorowicz, Jan K., ed. *A Republic of Nobles. Studies in Polish History to 1864*. Cambridge, England: Cambridge University Press, 1982, pp. 49–69.

Scaff, Villy. "Joannes Quintini Massiis Pingebat." *Mélanges d'Archéologie et d'Histoire de l'Art, offerts au professeur Jacques Lavalleye*. Louvain, France: Bureaux du recueil, Bibliothèque de l'Université, 1970.

Schneider, Hans. *Jan Lievens, sein Leben und seine Werke*. Haarlem: De eerven F. Bohn, 1932, pp. 66, 157, no. 279. Reprinted Amsterdam: Israel, 1973, with supplementary material by Rudolf E. O. Ekkart.

___. "Rafael und Lievens." *Oud Holland* 35 (1917), pp. 34.

Schubert, Karsten. *The Curator's Egg: The Evolution of the Museum Concept from the French Revolution to the Present Day*. London: One-Off Press, 2000.

Schustcrowa, A. "Nieznany obraz Jana Massysa: Wenus w zbiorach Pusłowskich w Krakowie." *Biuletyn Historii Sztuki i Kultury* 3–4 (1949).

Secker, Hans. *Die Stadtische Gemäldegalerie in Franciskanerkloster (Stadtmuseum)*. Danzig: Erste Illustrierte Ausgabe, 1913, pp. 30–31, ill. 8.

Segel, Harold B. *Renaissance Culture in Poland. The Rise of Humanism, 1470–1543*. Ithaca, New York: Cornell University Press, 1989, pp. 18–106.

Sichergestellte Kunstwerke im Generalgouvernement. Cracow, 1940, no. 85.

Simon, K.E. "Ausländische Kunst in Polen." *Zeitschrift für Kunstgeschichte* 5 (1936), p. 143.

Skubiszewski, Piotr. *Rzeźba nagrobna Wita Stwosza*. Warsaw: Państwowy Instytut Wydawniczy, 1957.

Sobieraj, Małgorzata. "Quaesivit coelo lucem. Portret Stanisława Augusta z 'klepsydrą.'" In Bielska-Lach, Monika, ed. *Sztuka i historia: Materiały Sesji Stowarzyszenia Historyków Sztuki, Kraków, listopad 1988*. Warsaw: Państwowe Wydawnictwo Naukowe, 1992, pp. 249–60.

Somov, Andrei Ivanovich. *Katałog Kartin Nachodiaszczichsja v Impieratorskom Łazienkovskom Dvorcev v Varszavie*. Warsaw, 1895, no. 1.

Stachurski, Kazimierz. "Dziedzictwo narodowe Polaków poza granicami kraju." *Spotkania z zabytkami* 5 (2001), p. 5.

Strzelczyk, Jerzy. "Das Treffen in Gnesen und die Gründung des Erzbistums Gnesen." In *Europas Mitte um 1000. Beiträge zur Geschichte, Kunst und Archäologie*. 2 vols. Stuttgart: Theiss, 2000, vol. 1, pp. 494–97.

Sumowski, Werner, ed. *Gemälde der Rembrandt-Schüler in vier Bänden*. Vols. 1,5. Landau: Edition PVA, 1983.

Swanson, Vern G. *The Biography and Catalogue Raisonné of the Paintings of Sir Lawrence Alma-Tadema*. London: Garton & Co. in association with Scolar Press, 1990.

Swaten, R. V. "Early Works by Lievens and Rembrandt in Two Unknown Still Lifes." *Artibus et Historiae* 26 (1992), pp. 121–42.

Świerz-Zaleski, Stanisław. *Zbiory Zamku Królewskiego na Wawelu w Krakowie*. Cracow: Wydawnictwo Ministerstwa W. R. i O.P., Drukarnia Narodowa, 1935.

Szablowski, Jerzy. *Arrasy flamandzkie w Zamku Królewskim na Wawelu*. Warsaw: Arkady, 1975.

___. "Introduction." In *Die Sammlungen des Königsschlosses auf dem Wawel*. Warsaw: Arkady, 1969.

___. "Krakowianin z Werony." *Polska* 1 (January, 1973), p. 31.

Szablowski, Jerzy, ed. *The Flemish Tapestries at Wawel Castle in Cracow. Treasures of King Sigismund Augustus Jagiello*. Antwerp: Fond Mercator (under the auspices of the Banque de Paris et des Pays-Bas), 1972.

___. *Zbiory Zamku Królewskiego na Wawelu*. Vol. 1. 2nd expanded ed. Warsaw: Arkady, 1974, pp. 16, 395, pls. 86, 87.

___. *Zbiory Zamku Królewskiego na Wawelu*. Vol. 2. Warsaw: Arkady, 1990, pls. 55, 60.

Szmydki, Ryszard. "Joris Deschamps, agent du roi de Pologne." In Brussels, Archives Générales. *Autour de J. Brueghel l'Ancien, P.P. Rubens, A. van Dyck*. Brussels, 1999.

___. *Wyprzedaż mienia po Janie Kazimierzu w roku 1673*. Warsaw: Arx Regia, 1995.

Szpor, Joanna. *Michałowski nieznany: materiały i technika w obrazach olejnych Piotra Michałowskiego*. Warsaw: Państwowe Wydawnictwo Naukowe, 1991.

Szydłowski, Tadeusz. *Ruiny Polski; opis szkód wyrządzonych przez wojnę w dziedzinie zabytków sztuki na ziemiach Małopolski i Rusi Czerwonej.* Warsaw: Gebethner i Wolff, 1919.

Tatarkiewicz, Władysław. *O sztuce polskiej XVII i XVIII wieku: architektura, rzeźba.* Warsaw: Państwowe Wydawnictwo Naukowe, 1966, pp. 329ff.

Tazbir, Janusz. *Kultura szlachecka w Polsce.* Warsaw: Wiedza Powszechna, 1978.

Thieme, Ulrich and Felix Becker. *Allgemeines Lexikon der Bildenden Künstler.* Vol. 20. Leipzig: Seeman, 1931, p. 471.

Thomas, Bruno. "Der Knabenharnisch Jörg Seuesenhofers für Sigmund II August von Polen." *Zeitschrift des deutschen Vereins für Kunstwissenschaft* 6, 4 (1939), p. 1184.

Tomkiewicz, Władysław. *Z dziejów polskiego mecenatu artystycznego w wieku XVII.* Wrocław, 1952.

___. *Pisarze polskiego odrodzenia o sztuce.* Vol. 4 of Starzyński, Juliusz, ed. *Teksty źródłowe do dziejów teorii sztuki.* Wrocław: Zakład im. Ossolińskich, 1961.

Tomkiewicz, Władysław, ed. *Katalog obrazów wywiezionych z Polski przez okupantów niemieckich w latach 1939–1945.* Vol. I: *Malarstwo obce.* Warsaw: Ministerstwo Kultury i Sztuki. Biuro Rewindykacji i Odszkodowań. Prace i materiały, 1949, no. 118, ill.113.

___. "Le Mécénat artistique en Pologne à l'époque de la Renaissance et du début du Baroque." *Acta Poloniae Historica* 16 (1967), pp. 91–108.

Tomkowicz, Stanisław. "Krakowski szkic ołtarza Bamberskiego." *Sprawozdania Komisji Historii Sztuki* 8 (1912), pp. 371–79.

Trzeciak, Przemysław. *Tryptyk Sądu Ostateczenego w Gdańsku.* Warsaw: Akademia Sztuk Pięknych, 1990.

Tyczyńska, Anna and Krystyna Znojewska. *Straty wojenne, malarstwo polskie, obrazy olejne, pastele, akwarele utracone w latach 1939–1945 w granicach Polski po 1945 – Wartime Losses. Polish Painting. Oil Paintings, Pastels, Watercolours, Lost between 1939–1945 within Post-1945 Borders of Poland.* Poznań: Ministerstwo Kultury i Sztuki. Biuro Pełnomocnika Rządu do Spraw Polskiego Dziedzictwa Kulturalnego za Granicą, 1998.

Ulewicz, Tadeusz. "Polish Humanism and Its Italian Sources: Beginnings and Historical Development." In Fiszman, Samuel, ed. *The Polish Renaissance in Its European Context.* Bloomington, Indiana: Indiana University Press, 1988, pp. 215–35.

Venice, Istituto di Storia dell' Arte (Fondazione "Giorgio Cini"). *Le vedute di Dresda di Bernardo Bellotto. Dipinti e incisioni dai musei di Dresda, Isola di S. Giorgio Maggiore, Venezia.* Text by Allessander Bettagno. Vicenza, Italy: N. Pozza, 1986, pp. 17–30.

Venice, Museo Correr. *Bernardo Bellotto 1722–1780.* Ed. Bożenna Anna Kowalczyk and Monica Da Cortà Fumei. Milan: Electa, 2001.

___. *Bernardo Bellotto and the Capitals of Europe.* Ed. Edgar Peters Bowron. New Haven and London: Yale University Press, 2001.

Venice. *Varsavia 1764–1830: da Bellotto a Chopin.* Ed. Wojciech Fijałkowski, Marek Kwiatkowski, and Alberto Rizzi. Venice: Arsenale, 1985.

Verona, Museo di Castelvecchio. *Bernardo Bellotto: Verona e le città europee.* Ed. Sergio Marinelli. Milan: Electa, 1990.

Vienna, Akademie der Bildenden Künste in Wien, Gemäldegalerie. *Die holländischen Gemälde Künste in Wien.* Text by Renate Trnek. Vienna: Böhlau, 1992, no. 59.

Vienna, Niederösterreichisches Landesmuseums. *Polen im Zeitalter der Jagiellonen 1386 –1572.* Text by Gottfried Stangler and Franciszek Stolot. Vienna: Die Abteilung, 1986.

Walicki, Andrzej. *The Three Traditions in Polish Patriotism and Their Contemporary Relevance.* Bloomington, Indiana: Polish Studies Center, Indiana University, 1988.

Walicki, Michał. "Rembrandt w Polsce." *Biuletyn Historii Sztuki* 18 (1956), pp. 319–48.

___. "Wstęp." In Białostocki, Jan and Michał Walicki. *Malarstwo europejskie w zbiorach polskich 1300–1800.* Vol. 2. Warsaw: Państwowy Instytut Wydawniczy, 1958, pp. 18–24.

___. "Z zagadnień pozy portretowej." *Przegląd Artystyczny* 1 (1954), pp. 32, 36.

Walicki, Michał and Jan Białostocki. *Hans Memling. Sąd Ostateczny.* Warsaw: Auriga, 1981.

Wallis, Mieczysław. *Sztuka obca w zbiorach polskich.* Warsaw, 1935, p. 14.

Waltoś , Stanisław. "Losy rysunku Wita Stwosa i innych 'stwoszianów' z Museum Uniwersytetu Jagiellońskiego." *Kraków w czasach Wita Stwosza: Materiały sesji naukowej z okazji Dni Krakowa w 1983 roku.* Cracow: Towarzystwo Miłośników Historii i Zabytków Krakowa, 1986, pp. 67–80.

Wandycz, Piotr S. *The Lands of Partitioned Poland 1795–1918.* Seattle and London: University of Washington Press, 1974.

Warsaw, The National Museum. *Akademizm w XIX wieku. Sztuka europejska ze zbiorów Muzeum Narodowego w Warszawie i innych kolekcji polskich.* Ed. Iwona Danielewicz. Warsaw, 1998.

___. *Arcydzieło Petera Paula Rubensa "Zdjęcie z krzyża" ze zbiorów Państwowego Ermitażu w Sankt Petersgurgu. Z tradycji przedstawień pasyjnych w malarstwie i grafice północnoeuropejskiej XVI i XVII wieku.* Warsaw, 2000.

___. *Caravaggio "Złożenie do grobu" – arcydzieło Pinakoteki Watykańskiej. Różne oblicza caravaggionizmu: wybrane obrazy z Pinakoteki Watykańskiej i zbiorów polskich.* Ed. Antoni Ziemba. Warsaw, 1996, pp. 206–208.

___. *European Academicism in the Nineteenth Century: Paintings and Drawings from the National Museum in Warsaw and other Polish Collections.* Warsaw, 1997.

___. *The Exhibition of Italian Paintings in the Polish Collections of the 17th–18th Centuries.* Text by Jan Białostocki. Warsaw, 1956.

___. *Malarstwo europejskie; katalog zbiorów.* Ed. Jan Białostocki and Andrzej Chudzikowski. Warsaw, 1967, no. 205, p. 78.

___. *Medieval Paintings. A Catalogue of Medieval Art in the Gallery of the Medieval Art.* Text by Tadeusz Dobrzeniecki. Warsaw, 1977.

___. *Narodziny krajobrazu nowożytnego 1550–1650.* Ed. Janina Michałkowa. Warsaw, 1972, p. 69, cat. 37, ill. 94.

___. *Portrety osobistości polskich znajdujące się w pokojach i w galerii Pałacu w Wilanowie; katalog.* Ed. Stefan Kozakiewicz. Warsaw, 1967.

___. *Przewodnik po galeriach stałych i zbiorach studijnych.* Warsaw, 1998

___. *Serenissima, the Light of Venice.* Warsaw, 1999.

___. *Sztuka cenniejsza niż złoto. Obrazy, rysunki i ryciny dawnych mistrzów europejskich ze zbiorów polskich.* Ed. Anna Kozak and Antoni Ziemba. Warsaw, 1999.

___. *Sztuka czasów Michała Aniola. Wystawa w czterechsetną rocznicę śmierci artysty.* Warsaw, 1963, pl. 39.

___. *Sztuka warszawska od średniowiecza do połowy XX wieku; katalog wystawy jubileuszowej zorganizowanej w stulecie powstania museum, 1862–1962.* Vol. 2. Warsaw, 1962, p. 51, no. 55.

___. *W kręgu wileńskiego klasycyzmu.* Ed. Elżbieta Charazińska, Ewa Micke-Broniarek, and Ryszarda Bobrowa. Warsaw, 1999.

Warsaw, The National Museum, and New York, National Academy of Design. *Nineteenth Century Polish Art.* New York, 1988.

Warsaw, The Royal Castle. *Orzeł Biały. 700 lat herbu Państwa Polskiego.* Warsaw, 1995, pl. 4, p. 11.

___. *Pod Jedną Koroną: Kultura i Sztuka w Czasach i Unii Polsko-Saskiej.* Warsaw, 1997.

___. *Romantyzm. Malarstwo w czasach Fryderyka Chopina.* Text by Dorota Juszczak. Warsaw, 1999.

Washington, D.C., National Gallery of Art. *Collection for a King. Old Master Paintings from the Dulwich Picture Gallery in London.* Ed. Giles Waterfield et al. Washington, 1985.

___. *The Splendor of Dresden: Five Centuries of Art Collecting.* Washington, 1978.

Washington, D.C., The Trust for Museum Exhibitions. *Master European Drawings from Polish Collections.* Washington, 1993.

Wereszycki, Henryk. "Polish Insurrections as a Controversial Problem in Polish Historiography." *Canadian Slavonic Papers* 9 (Spring 1967).

Wessem, J.N. van, and A.J. de Lorm. "Jan van Goyen." *Biuletyn Historii Sztuki* 23, 2 (1961), p. 162.

Widacka, Hanna. "Ikonografia króla Stanisława Augusta w grafice XVIII wieku." *Rocznik Historii Sztuki* 15 (1985), pp. 216–17, ill. 57.

Wiliński, Stanisław. "Krzysztofa Opalińskiego stosunek do sztuki." *Biuletyn Historii Sztuki* 17 (1955).

Williams, George Hunston. "Erasmianism in Poland: An Account and an Interpretation of a Major, Though ever Diminishing, Current in Sixteenth-Century Polish Humanism and Religion, 1518–1605." *The Polish Review* 22, 3 (1977), pp. 3–50.

Williamstown, Massachusetts, Sterling and Francine Clark Art Institute. *Empires Restored, Elysium Revisited. The Art of Sir Lawrence Alma-Tadema.* Text by Jennifer Gordon Lovett and William R. Johnston. Williamstown, 1991, p. 24.

Wilson, David M. *The British Museum, Purpose and Politics.* London: The British Museum, 1989.

Wisner, Henryk. *Zygmunt III Waza.* Warsaw: Wydawnictwa Szkolne i Pedagogiczne, 1988.

Wójcicki, Kazimierz Władysław, ed. *Albumy Warszawskie.* Warsaw, 1845, p. 167.

Wojciechowski, Jerzy. "Caraglio w Polsce." *Rocznik Historii Sztuki* 25 (2000), pp 34, 35, and *passim.*

Wolff, Larry. "Dynastic Conservatism and Poetic Violence in *Fin-de-Siècle* Cracow: The Habsburg Matrix of Polish Modernism." *American Historical Review* 106, 3 (June 2001), pp. 735–64.

___. *Inventing Eastern Europe: The Map of Civilization on the Mind of the Enlightenment.* Stanford, California: Stanford University Press, 1994.

Wyrobisz, Andrzej. "The Arts and Social Prestige in Poland Between the Sixteenth and Eighteenth Centuries." In Fedorowicz, Jan K., ed. *A Republic of Nobles. Studies in Polish History to 1864.* Cambridge, England: Cambridge University Press, 1982, pp. 153–78.

Wyrozumski, Jerzy. *Dzieje Krakowa. Kraków do schyłku wieków średnich.* Vol. 1. Bieniarzówna, Janina and Jan M. Małecki, eds. *Dzieje Krakowa.* Cracow: Wydawnictwo Literackie, 1992, pp. 331–71.

Załęski, Krzysztof. "Alegoryczny portret Stanisława Augusta z 'klepsydrą.'" *Rocznik Museum Narodowego w Warszawie* 21 (1977), pp. 242–45.

Załęski, Krzysztof and Ewa Micke-Broniarek. "Kunstlandschaftmalerei und Landschaftmalerei zwischen Aufklärung und Romantik." In Frankfurt am Main, Schrin Kunsthalle. *Die vier Jahreszeiten. Polnische Landschaftsmalerei von der Aufklärung bis heute.* Dresden: Verlag der Kunst, 2000, p. 35.

Zamoyski, Adam. *The Polish Way. A Thousand-year History of the Poles and Their Culture.* London: John Murray, 1987.

Żantuan, Konstanty. "Erasmus and the Cracow Humanists: The Purchase of His Library by Łaski." *The Polish Review* 10, 2 (1965), pp. 3–36.

Zaremska, Hanna. "Jewish Street (*Platea Judeorum*) in Cracow: the 14th–the First Half of the 15th C." *Acta Poloniae Historica* 83 (2001), pp. 27–57.

Zathey, Jerzy. "Biblioteka Jagiellońska w latach 1364–1492." In Zathey, Jerzy, Anna Lewicka-Kamińska, and Leszek Hajdukiewicz, *Historia Biblioteki Jagiellońskiej, vol. I: 1364–1775.* Cracow: Uniwersytet Jagielloński, 1966, pp. 87–130.

Zathey, Jerzy, Anna Lewicka-Kamińska, and Leszek Hajdukiewicz. *Historia Biblioteki Jagiellońskiej, vol. I: 1364-1775.* Cracow: Uniwersytet Jagielloński, 1966.

Zerner, Henri. "Giovanni Jacopo Caraglio." *Biuletyn Historii Sztuki* 34, 3–4 (1972), pp. 691–95.

Ziemba, Antoni. "Dwa obrazy z kolekcji Lanckorońskich: Rembrandt i Bol." *Ikonotheka* 13 (1998), pp. 11–24.

___. "Obrazy Rembrandta w Polsce." In Warsaw, The National Museum. *Sztuka cenniejsza niż złoto. Osbrazy, Rysunki i ryciny dawnych mistrzón europejskich ze zbidrów polskich.* Ed. Anna Kozak and Antoni Ziemba. Warsaw, 1999, pp. 56–68.

___. "Stanisława Augusta holenderski 'pochop.' Obrazy holenderskich mistrzów XVII wieku w kolekcji królewskiej." In Pasieczny, Robert et al., eds. *De gustibus. Studia ofiarowane przez przyjaciół Tadeuszowi Stefanowi Jaroszewskiemu.* Warsaw: Wydawnictwo Naukowe: Państwowe Wydawnictwo Naukowe, 1996, pp. 41–52.

Ziemba, Antoni et al. "'Bildnis eines jungen Mannes' aus der Werkstatt Rembrandts im Lichte physikalisch-chemischer Untersuchungen, part II: Bericht über die Untersuchungen zum Gemalde, seine Geschichte, Probleme mit der Identifizierung des Porträtierten und mit der Zuschreibung des Werkes." *Bulletin du Musée National de Varsovie* 38, 1–4 (1998), pp. 52–68.

Zins, Henryk. "Leonard Coxe i erazmiańskie koła w Polsce i Anglii." *Odrodzenie i Reformacja w Polsce* 17 (1972), pp. 27–62.

Zug, S.B. *Ogrody w Warszawie i jej okolicach opisane w r. 1784.* Reprinted in *Kalendarz Powszechny na rok przestępny 1848.* Warsaw, 1848, pp. 15–16.

Żygulski, Zdzisław, Jr. "Dwieście lat museum Czartoryskich." *Spotkania z zabytkami* 3 (2001), pp. ii–iii.

___. "Dzieje zbiorów puławskich. Świątynia Sybilli i Dom Gotycki." *Rozprawy i sprawozdania Muzeum Narodowego w Krakowie* 7 (1962).

INDEX

Page numbers in *italics* refer to illustrations.

COLOPHON

Jannon, the typeface used throughout this book, is a contemporary revival of a face originally published in 1621 by Swiss typographer Jean Jannon. Jannon's work, itself a Baroque reinterpretation of Claude Garamond's earlier Renaissance faces, was digitally recast in 2001 by František Štorm. *Jannon* is distributed by the Storm Type Foundry located in the Czech Republic and is notable for its full complement of Eastern European diacritical marks.

COORDINATION AND EDITING
Terry Ann R. Neff
t. a. neff associates, inc., Tucson, Arizona

TRANSLATION FROM THE POLISH
Krystyna Malcharek, Cracow

DESIGN AND PRODUCTION
studio blue, Chicago, Illinois

PRINTING
Arti Grafiche Amilcare Pizzi, Italy

Leonardo da Vinci and the Splendor of Poland: A History of Collecting and Patronage was published on the occasion of the exhibition of the same name organized by the Milwaukee Art Museum and on view there from September 13, 2002 through November 24, 2002; at The Museum of Fine Arts, Houston, from December 8, 2002 through February 16, 2003; and at the Fine Arts Museums of San Francisco, California Palace of the Legion of Honor, from March 8, 2003 through May 18, 2003.

The exhibition and accompanying publication have been sponsored by
We Energies and Christopher Seton Abele.

Additional support comes from Polish National Alliance; Trust for Mutual Understanding; Spirit of Milwaukee; the Kościuszko Foundation, Inc., An American Center for Polish Culture; Polanki, Inc., The Polish Women's Cultural Club of Milwaukee; Sotheby's; and Fine Arts Society of the Milwaukee Art Museum. The project was also funded in part by a grant from the Wisconsin Humanities Council and the National Endowment for the Humanities and has been supported by an indemnity from the Federal Council on the Arts and Humanities. Promotional support has been provided by the Milwaukee Journal Sentinel. Transportation has been provided by LOT Polish Airlines.

Library of Congress
Cataloging-in-Publication Data

Winters, Laurie.
Leonardo da Vinci and the Splendor of Poland:
A History of Collecting and Patronage / Laurie
Winters; essays by Dorota Folga-Januszewska ...
[et al].
p. cm.
"Published on the occasion of the exhibition of
the same name organized by the Milwaukee Art
Museum and on view there from September 13,
2002 through November 24, 2002; at The
Museum of Fine Arts, Houston, from December
8, 2002 through February 16, 2003; and at the
Fine Arts Museums of San Francisco, California."
Includes bibliographical references and index.

ISBN 0-944110-95-9 (softcover)
ISBN 0-300-09740-9 (Yale University)

1. Painting, European – Exhibitions. 2. Painting –
Collectors and collecting – Poland – Exhibitions.
3. Leonardo, da Vinci, 1452–1519. Lady with an
ermine – Exhibitions. 4. Painting – Poland –
Exhibitions. I. Folga-Januszewska, Dorota.
II. Milwaukee Art Museum. III. Museum of Fine
Arts, Houston. IV. Fine Arts Museums of San
Francisco. V. Title.

ND454 .W53 2002
750'.74'438 – dc21

2002006970

© 2002 Milwaukee Art Museum
700 North Museum Drive
Milwaukee, Wisconsin 53202
www.mam.org

COVER AND FRONTISPIECE
Leonardo da Vinci, *Lady with an Ermine (Portrait of Cecilia Gallerani)*
plate 38, detail